PAUL R. WILLIAMS

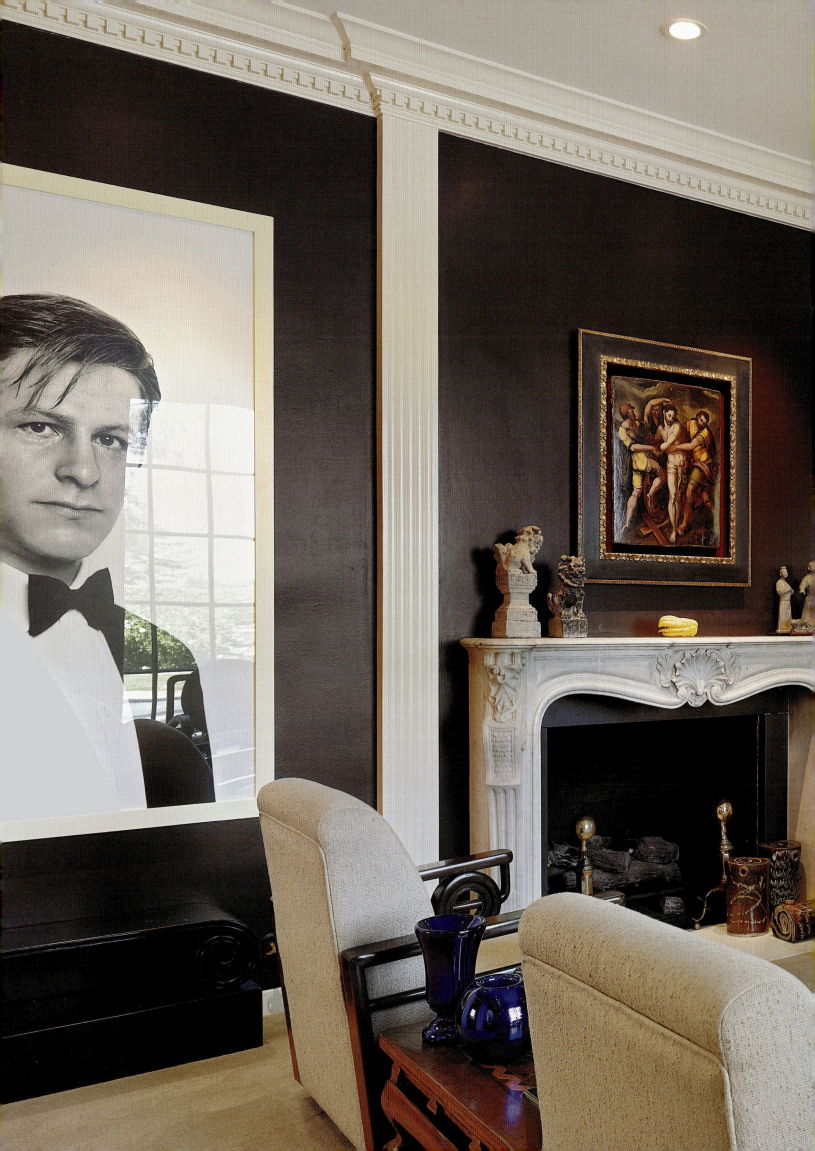

PAUL R. WILLIAMS
CLASSIC HOLLYWOOD STYLE

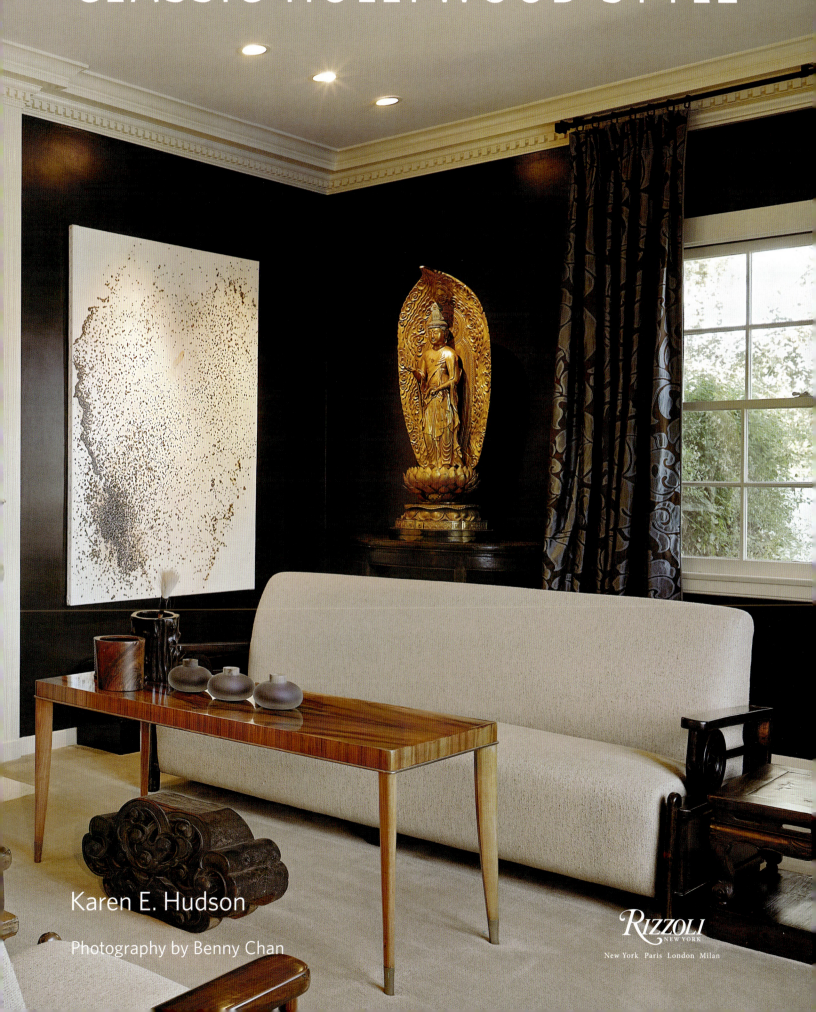

Karen E. Hudson

Photography by Benny Chan

RIZZOLI
NEW YORK

New York Paris London Milan

I dedicate this book to my loving husband,

DON E.,

who shares my visions and allows me the
freedom to pursue my passions

Contents

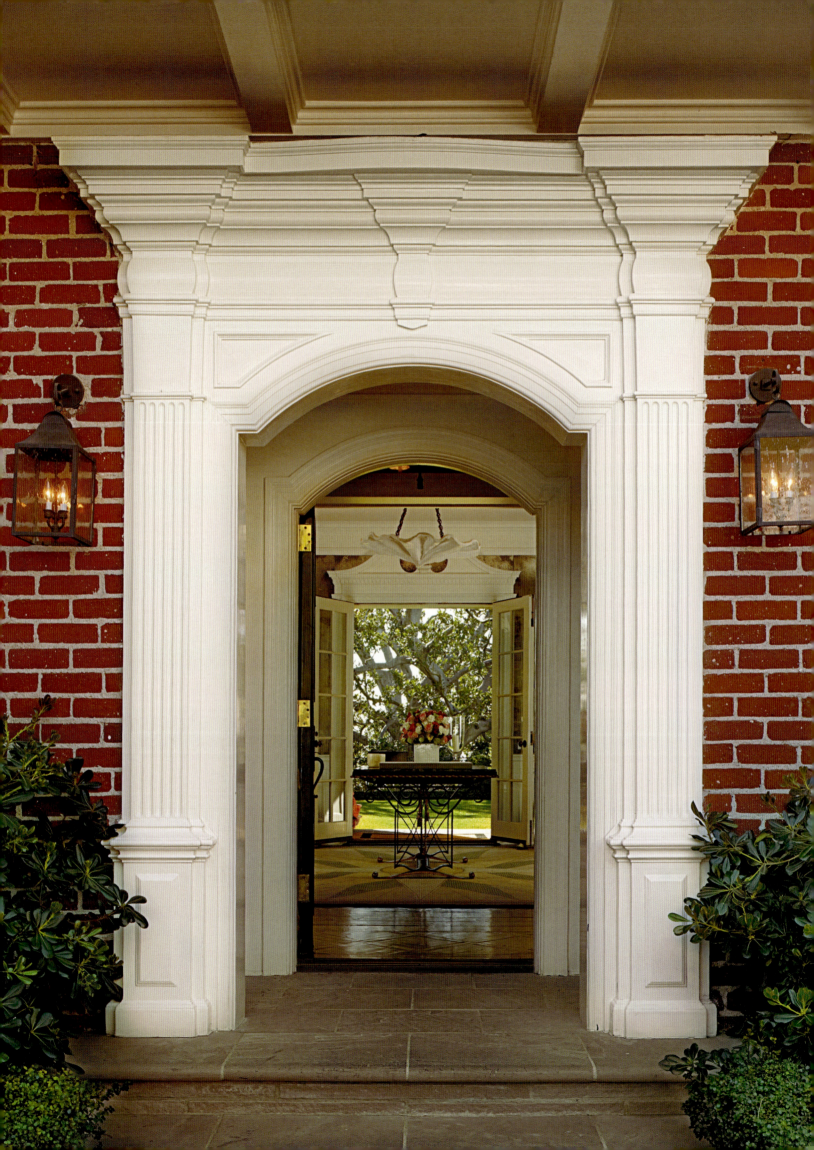

Foreword

Michael S. Smith

HAVING LONG ADMIRED TRAILBLAZING ARCHITECT Paul Revere Williams, it was an honor to be asked to contribute to this reissued monograph of his iconic work, a book I have regularly turned to for inspiration over the past decade. It was a timely request, as not only have I been fortunate to have worked on several of Williams's historic, incredibly detailed projects, but I recently lived in one of his classically styled houses for a few years while my Los Angeles home was undergoing a major renovation, a remarkable experience that made me appreciate the elegance of his work even more.

Paul R. Williams produced an extraordinary legacy. Over the course of his decades-long career he designed close to three thousand projects, both residential and commercial and embracing a wide range of architectural styles. This was an inconceivable, unparalleled achievement during an era of nearly nonexistent opportunity for Black creative talents, and his work was as powerful as it was prolific.

Somehow, each house was distinctive in a way that set it apart from the hundreds of designs the architect had built before, almost like an author with a series of novels on a shelf, all in a similar style and written from the same creative place but each one different, with unique characters and situations that work together to create both intrigue and delight.

The defining qualities of a Paul Williams house are a profound sense of grace and the subtle strength of myriad design decisions—from the fluidity of space and how rooms flow into one another, to the lyrical sweep of a staircase, the mindful proportions of steps and risers, the touch of a railing at exactly the right height. Even a floor plan that at first glance might seem conventional was imbued with a sense of cinematic magic that became the architect's signature. With a focus on capturing the play of sunlight, Williams would often extend the footprint of a room into the surrounding landscape to allow natural light to flood the space from multiple angles, or he might softly round a room's corners, making the space feel at once more refined and sophisticated. Interior views were cleverly crafted to extend from the foyer all the way through the main floor of a house, with rooms sequenced to be experienced in a dynamic, even cinematic, way; the floors were likely connected by a dramatic curved stairwell, a sculptural form with generous landings.

Though Paul Williams interiors were known to offer the drama and excitement his star-studded clientele expected, the architect also had a thoughtful understanding of utility and technology—he built residences that were beautiful but also functioned beautifully. For instance, bedrooms opened onto small terraces, as air-conditioning was not yet common; generous bathrooms were fashioned with built-in dressing tables; cedar closets were standard. Even in modestly scaled houses there was a back stair for staff, a spacious butler's pantry with service sinks and wonderful storage for tableware, and pull-down ironing boards installed in special cupboards in the laundry so the work of the day could be done as efficiently as possible.

Williams often borrowed from the past to give a sense of tradition, but he seemed highly aware of how lives should be well lived in the present. In my house, the former home of actor Tyrone Powell, there was an intimate bar next to the library—a cozy, seductive room with rounded walls and a curved counter. I upholstered the walls in leopard print and it became everyone's favorite spot after dinner, as it must have been ever since it was designed in the 1930s.

I think what is really interesting is the idea that the majority of people Williams worked for were self-made. They might have come from small-town America, but they had made it big and they wanted Williams's design to echo the memory of the grandest house in their hometown. These clients wanted not only a house, but a physical experience—a place that felt glamorous but perhaps also looked like a rambling Spanish Mediterranean, a low-slung California ranch house, a stately English Tudor, or a charming New England Colonial. In truth, Williams wasn't just an architect, he was a set decorator and film director; he understood the aspirations of his clientele and he knew how to build them the house of their dreams.

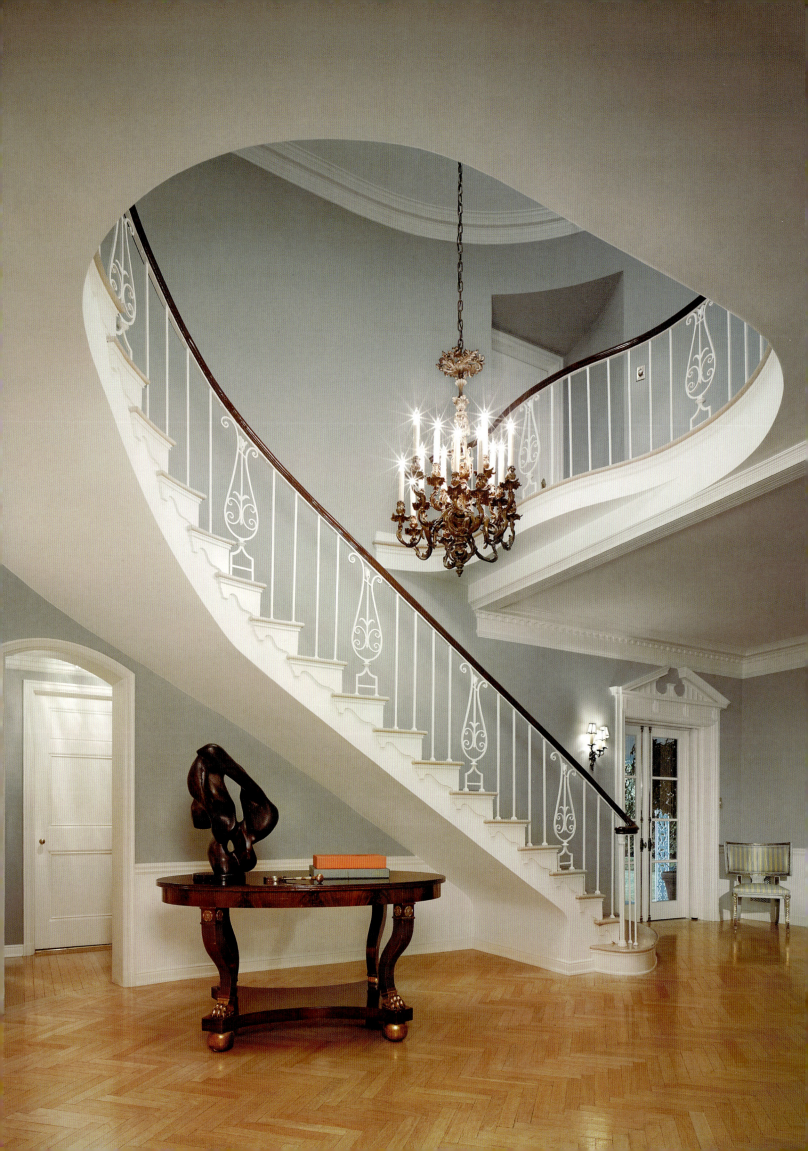

Introduction

Karen E. Hudson

BORN IN DOWNTOWN LOS ANGELES IN 1894, Paul Revere Williams journeyed from orphan to world-renowned architect along a path that was long and arduous, tinged with luck and what he believed were incredible blessings.

Williams's parents, armed with southern fortitude and a belief that Los Angeles would be an idyllic setting for overcoming their tuberculosis, set off from Memphis, Tennessee, in the early 1890s hoping to find health and prosperity in their new home. While they found prosperity in a fruit stand on Olvera Street, both parents would succumb to their illness by the time Paul was four years old. Williams was then taken in by a member of their church, raised by a loving foster mother who encouraged his dreams.

Growing up, Williams's Los Angeles was one of bean fields and orange groves. He learned Chinese from the laundry man, and German from the new friends who were just beginning to move into the neighborhood. His afternoons were filled with wonder and exploration, and more often than not he and his playmates could be found catching quail with wheat soaked in whiskey.

As the class artist, young Paul found joy in the visual arts, and experienced his first rebuff when he expressed an interest in being an architect. His teachers told him he would never be an architect, because white people would never hire him, and black people built neither fine homes nor significant office buildings. Undeterred, Williams began his quest to influence the look and the built environment of his beloved Los Angeles, not just as an architect, but as the best architect he could be.

Understanding that our society still required African Americans to be better than anyone else just to play the game, he sought to level the playing field. He mapped out a plan that included attending various art schools that offered individual study in drafting, rendering, and design while also undertaking engineering studies at the University of Southern California.

Seeking employment among the finest architects in landscape, residential, and commercial design, Williams found work with Wilbur D. Cook, Reginald D. Johnson, and finally John C. Austin.

By the early 1920s, just as Los Angeles began to experience significant growth, Williams ventured out on his own, opening his own firm. A quiet, gentle man, he found his "voice" in his designs. When others attempted to silence him with racism, he "spoke" as others could not—for himself, and for his community. He also found his voice in community participation. Appointed to the first City Planning Commission of Los Angeles, in 1920, he understood the importance of civic responsibility and representation. From then on he would serve on city and county boards in the arts and planning, allowing him to again "speak" volumes whether selecting artwork for public buildings or laying the groundwork for public spaces.

His obstacles were great, but nothing could extinguish his brilliance. Unable to participate in the "old boys" network that boosted the careers of most architects of the day, he found ways to distinguish himself and garner clients. He believed that it was important to design "homes" rather than houses. His passion for residential design was coupled with his understanding of the importance of home ownership to the viability and substance of a community. Having mastered small homes, he realized his reputation would depend on his commercial "voice" and commissions. Williams felt strongly that people should work in environments that were as pleasing as their homes, and he began to build a reputation for incorporating residential design in commercial buildings. Perhaps his finest example of residential design in a commercial building is the Music Corporation of America (MCA) building in Beverly Hills. Designed in 1937, Williams would make additions and alterations forty years later when Litton Industries acquired it. Headquarters of Global Crossing for a short time, the building is now home to Platinum Equity.

From his first home in the La Cañada Flintridge area in 1922, when land deeds prohibited a black person from spending the night in the area, to his last home in the 1960s, just down the street from the first, he adapted and changed with the times and the wishes of his clients, designing homes for families that would last for generations. His style ranged over the years from the Spanish Mediterranean influence of early California to Georgian, Tudor, Colonial, Hollywood Regency, and postwar modernism and updated traditional. Over the years he has been thought to be less serious as an architect because he did not practice one identifiable style over others. One may be surprised by his multitude of styles, but, to him, his worth as an architect was his ability to listen and to please his clients. But, as one looks closely, attention to detail was the hallmark of all of his work and is found in each and every building of his design.

Perhaps he "spoke" loudest in the details. He labored over the design of a modest home with the same enthusiasm and attention to detail as he would a grand estate. When one wonders why there are hidden closets or short counters, the answer can always be found in the wishes and needs of the original owner. He understood the importance of first impressions and demanded that those working for him dress in a proper manner and carry themselves with grace and confidence. And the attention to detail permeated all aspects of his life. He may have seen a jacket in a window display of a closed haberdasher when traveling out of town, and, believing it was "perfect," would have his secretary order it upon his return. He did not carry a briefcase but rather took meticulous notes on personalized note cards he carried in his jacket pocket. He chose the palm trees to adorn a new residence for their height and shape, and consulted with homeowners on interiors as well as landscaping.

Williams enjoyed sharing ideas and welcomed a spirituality of positive thinking that served him all the days of his life. He relished conversations with religious leaders such as spiritual writers Lewis Browne and Ernest Holmes, both owners of homes designed by Williams. When

others may have been discouraged, Williams found strength in his personal beliefs. He faced racism head on, and, more often than not, won. When it was inappropriate for him to lean across the shoulder of a white person, he learned to draw upside down. This enabled him to sit on one side of the desk, with the clients firmly planted a safe distance away on the other side, and as he asked what you'd like in your home, he sketched it upside down, so it came alive before one's eyes. When clients entered his office not knowing he was black, they often made excuses to leave. He would ask, "How much are you planning to spend on your home?" And then he would shock them by saying he never took jobs for that little. With their interest piqued, he usually won them over with his talent and graciousness. Perhaps a bit Barnum and Bailey, but it allowed him to open doors for future architects.

Williams believed that his name on a home's plans was like the stamp of "sterling" on silver. He inspired excellence in others and continues to do so today through the examples he has left us.

Hollywood and Williams were a good match because for each imagination was everything.

Often referred to as "architect to the stars," Williams designed for such luminaries as Frank Sinatra, Barbara Stanwyck, Tyrone Power, Lucille Ball and Desi Arnaz, Lon Chaney, Bill "Bojangles" Robinson, Bud Abbot, and Eddie "Rochester" Anderson, to name a few. Through the years, Hollywood stars have continued to enjoy the homes. Perhaps Pauletta Washington best conveys the feeling families have when living in a Paul Williams home:

> When Denzel and I moved into our first home, we always admired another house and would make trips that would take us past that house for the two years we were in that neighborhood. Then we learned that the owner of that house was considering selling. We jumped at that opportunity. We learned at that time that Paul Williams had built the house. It then made sense why we *so* admired *that* house. We raised our four children in what we *all felt* was where *we* were supposed to call Home. I knew in my spirit that Mr. Williams was pleased to have us reside in his creation. We were able to share numerous happy, joyous times with many people while there. It remains our *dearest of times* and it all centers around our incredible, beautiful, comfortable, cozy, Paul Williams creation.

In a career that spanned over fifty years, and a portfolio that included nearly three thousand projects, Williams traveled the world and was licensed to practice in Washington, D.C., New York, Tennessee, and Nevada, as well as California, and he had offices in Washington, D.C., Los Angeles, and Bogotá, Colombia. He took particular pride in designing within the African American community.

Paul Williams was, and will always be, a gentle man with a dream.

Quincy Jones Jr. Remembers

WHEN I THINK ABOUT YOUR GRANDDADDY, I think about my Daddy. They were two of a kind. My Daddy was a master carpenter; fiercely independent and armed with the most positive attitude of anyone you'd ever want to know. When I was growing up he wanted me to be an architect—he thought I should get a "real" job instead of being a musician—but as it worked out, he thought I did OK.

Honey, let me just speak from my heart. When Daddy would come to California for his annual visit, he never missed spending time with his hero and friend Paul. He was so proud of his accomplishments, and loved their time together.

You know music has the same sensibility as architecture. My friend Frank Gehry used to always say to me, "If architecture is frozen music, then music is liquid architecture." And in architecture, as in music, you have to learn your craft and master the fundamentals. You have to work hard and accept obstacles as challenges, not roadblocks.

I was fifteen years old when I began my passion of wanting to score a movie, but I was thirty before I got the opportunity to finally write a score, for *The Pawnbroker*. Your granddaddy was the same way—he never gave up. He had the vision and the talent, and the way he drew upside down to deal with the social circumstances of the day . . . he was something else!

To this day, when I walk into the Beverly Hills Hotel I feel his spirit—the staircase, the coffee shop, the ballrooms, and the Polo Lounge—classic, elegant, absolutely timeless!

I've been to what seems like a million events at the hotel and used to eat at the coffee shop with Mike Nichols, Tony Bennett—all the guys. And I've partied with the best of them in Paul Williams's homes, especially with my friend Frank Sinatra. They all loved him!

The Beverly Hills Hotel, Saks Fifth Avenue, the Coconut Grove, Litton, the airport—I know his trademark by heart. He's a legend.

He knew that "if you know where you came from, it's easier to get where you're going." And he faced his racial challenges, never forgetting where he came from.

I'd be willing to bet that in his heart he believed just as I do that you must have humility with your creativity and grace with your success.

A trailblazer, classic, amazing, brilliant . . . a giant. Like Duke Ellington and Charlie Parker, you could see his style a mile away. He took time for others, he had the grace—he was *something else!*

QUINCY JONES JR.

Paul R. Williams

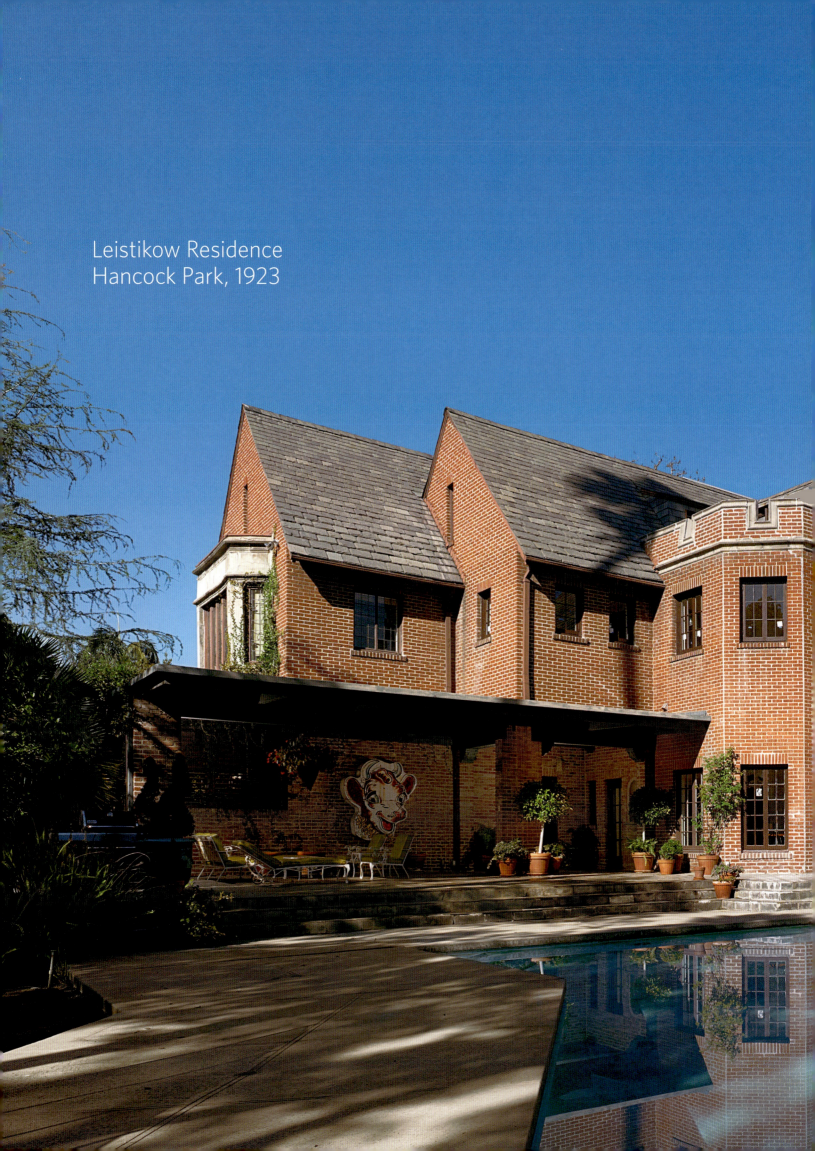

Leistikow Residence
Hancock Park, 1923

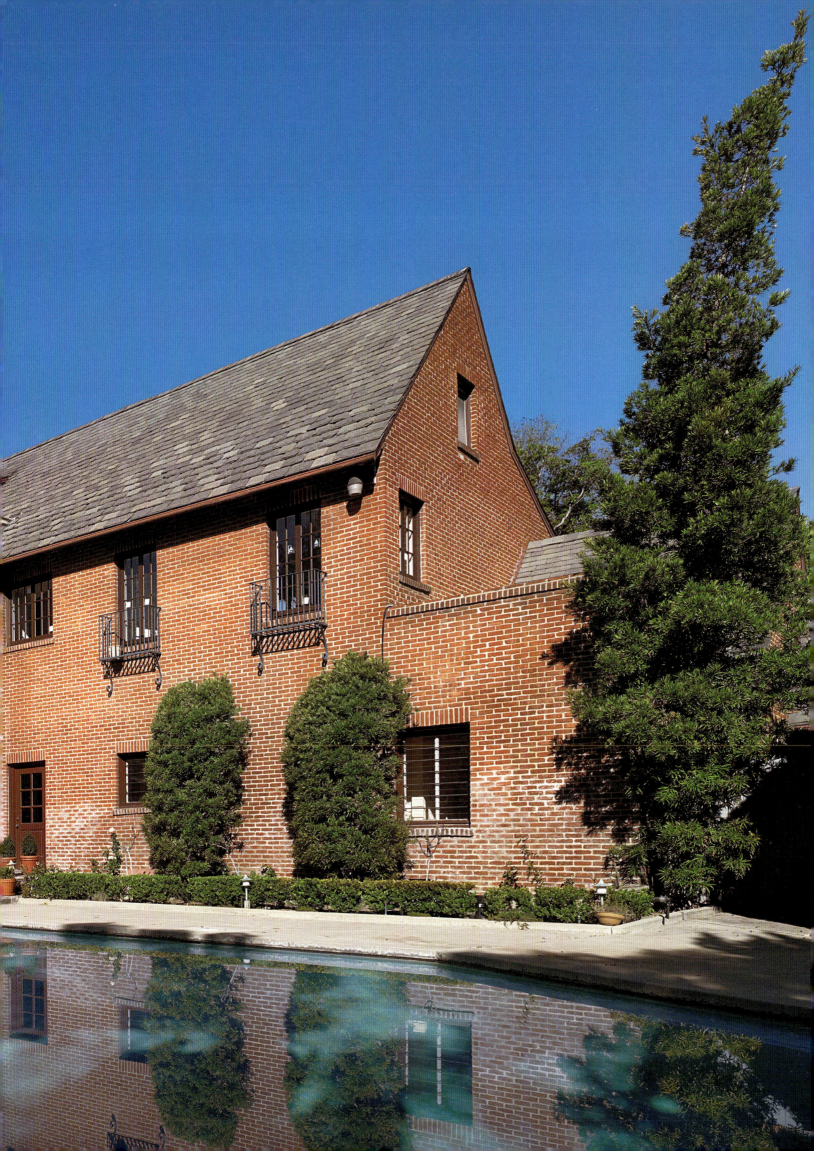

Before I embarked on my architectural career, I had never been in a home that cost more than $10,000. I was dumbfounded. I couldn't image how you could spend so much on a home. My employer sent me to look at some homes in Santa Barbara and I soon found out. That trip taught me more than where money was spent. I'd say the most important lesson I learned was restraint. A room should have a single focal point regardless of how much money is spent on it.

— AUTOBIOGRAPHICAL NOTES

SCARCELY A YEAR AFTER opening his own practice, Williams designed this English cottage-style house for Frederick and Esther Leistikow. This commission, routed to Williams through his former employer John Austin, proved to be an eye-opener for the young architect. Having never been in a house costing more than $10,000, Williams found himself sent by Austin to Montecito to see what $100,000 houses looked like. Williams returned energized and looking forward to spending other people's money. Little is known about the Leistikows other than Frederick heralded from Winnipeg, Manitoba, and Esther was a native Angeleno. Clearly Frederick Leistikow was involved in the design, ensuring his initials would adorn the living room's Tudor-style mantel and the extensive ironwork throughout the house. Though the Leistikows sold the house shortly after moving in, no doubt they still found Williams's designs appealing as they commissioned him to design a house for them in Las Vegas. It is unclear whether the Nevada residence was ever built, but the Leistikow house continues to be known as Williams's first in the exclusive Hancock Park area of Los Angeles. The residence has been home to only four families and is most noted for its second resident, Ernest Holmes, founder of the Religious Science movement, who lived there until his death in 1960. One can only imagine the conversations Williams and Holmes must have shared in the wood-paneled library in front of the fire. Raised as an African Methodist Episcopalian (AME), Williams soon found solace and encouragement in the teaching of "positive thinking"

espoused by Holmes and his emerging religion. Williams sought advice and guidance from Holmes, who early on told him to "stop feeling sorry for yourself and look within, you can do anything." These words proved to be instrumental to Williams's career, and he incorporated Holmes's positive, supportive philosophy into his daily life and his lifelong AME beliefs. And Williams was in good company: during Holmes's life, celebrities such as Cary Grant, Peggy Lee, and Doris Day followed his teachings of positive thinking and unity.

Arriving at the house, one is struck by its quiet, traditional exterior. On closer inspection, the irregular placement of the leaded windows gives the house a somewhat whimsical, comfortable feeling. The arched doorway leads to a checkerboard floor and stately staircase. Perhaps this is one of the first examples of what would become Williams's hallmark of marrying traditional styles with modern touches for family living.

Each room is filled with sunlight and allows the landscape to enhance the charm of the room. He was never afraid to mix styles to suit the desires of his client; indeed, he measured his worth as an architect on his ability to please his clients.

When asked about their favorite room, the current owners did not hesitate to name the living room. From the lead- and stained-glass windows to the stenciled wood and finely detailed coffered ceiling, they find the architectural details stunning without being overwhelming. Whether they are entertaining a group of twenty friends or just lounging on the sofa with a fire in the fireplace and

OPPOSITE:
The simplicity of the arched door opens to the sweeping staircase and black-and-white checkerboard floor, while the stair-stepped stained-glass windows give neighbors a glimpse into Williams's originality.

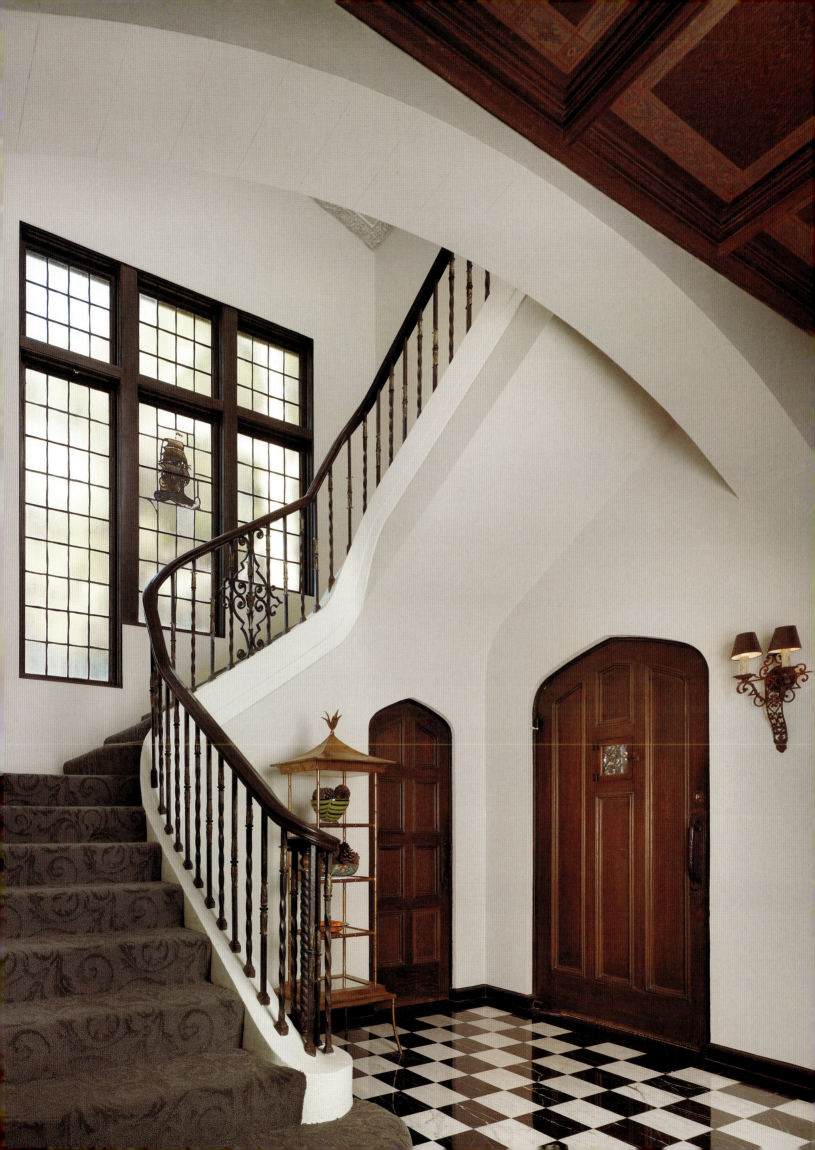

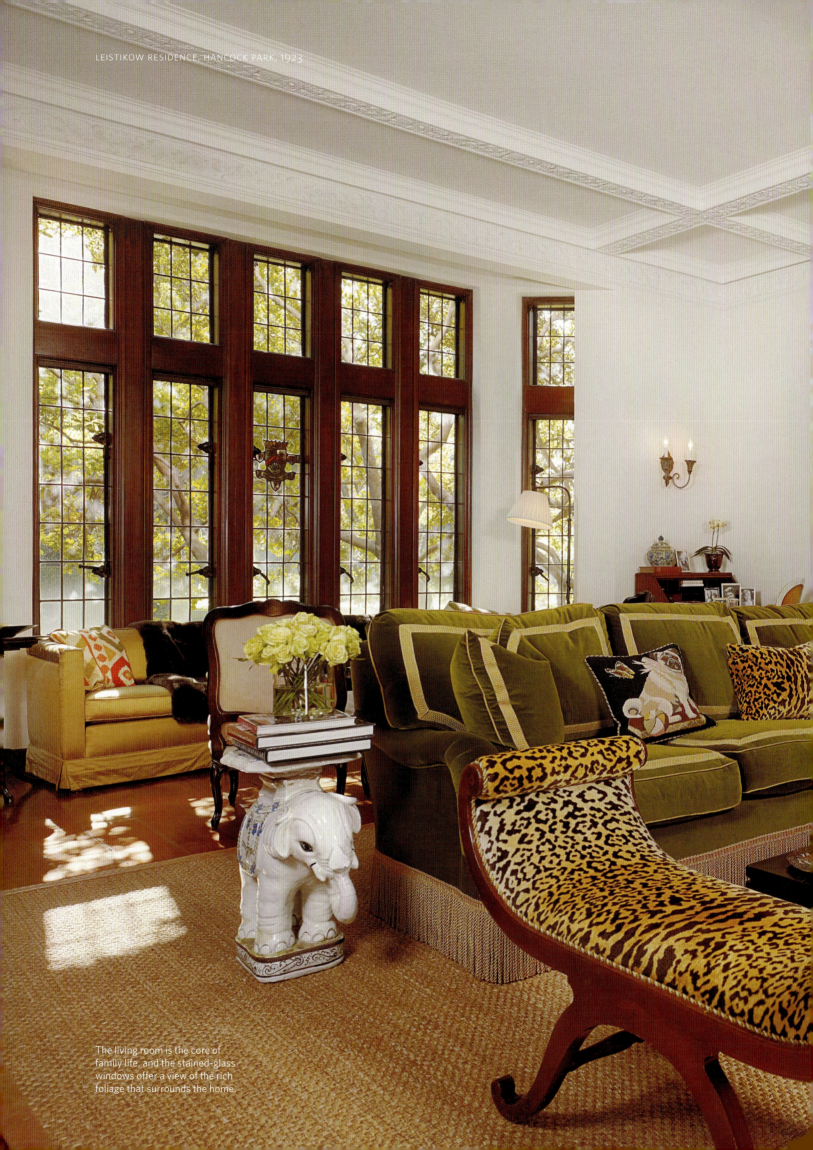

The living room is the core of family life, and the stained-glass windows offer a view of the rich foliage that surrounds the home.

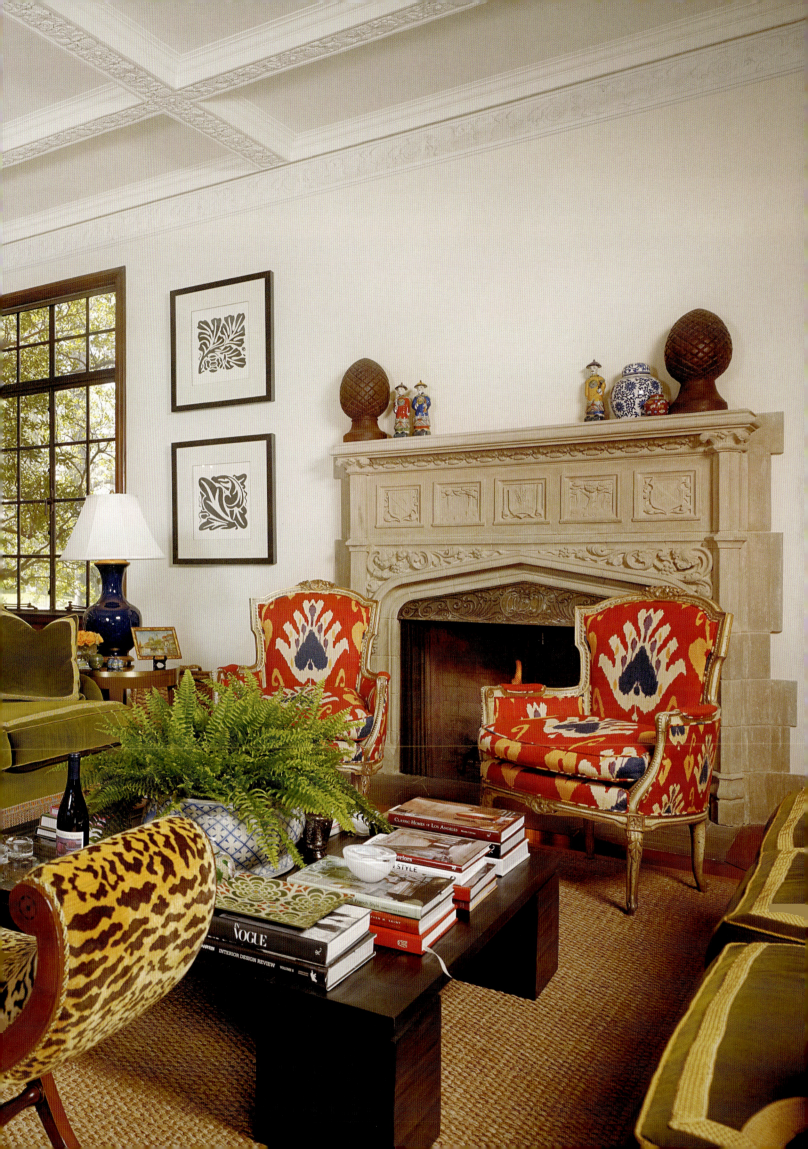

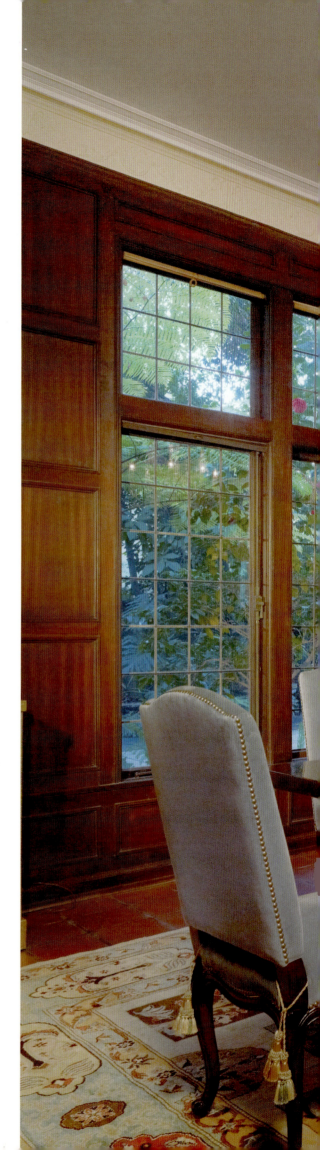

a good book, the living room feels cozy and welcoming, never overwhelming.

Like many owners of Williams-designed houses, the current owners feel they are preserving something for the future, and it's not just "your home." They feel an innate sense of responsibility: "You are temporary and very fortunate custodian-caretakers charged with maintaining and preserving its architectural integrity for future owners, knowing the home will be there embracing future families, long after you are gone." When they have undertaken projects to upgrade the house's plumbing and electrical systems, or do something as simple as paint, they often ask themselves, "What would Paul have done?"

More than anything, Williams loved the idea of families enjoying their homes and entertaining. The dinner parties the current owners throw for friends, usually including not more than ten or twelve guests, remain their most memorable. With a spectacular wood-paneled formal dining room, an octagonal breakfast room, and an "outdoor room" bringing the wonderful backyard indoors, the house never fails as the backdrop for spending time with family and friends. "It could be filet mignon or ribs and mac and cheese, but the house always plays a major role in making even the most casual occasions extra special," says the current lady of the house. "When we entertain, there are three hosts . . . myself, my husband, and the house." ★

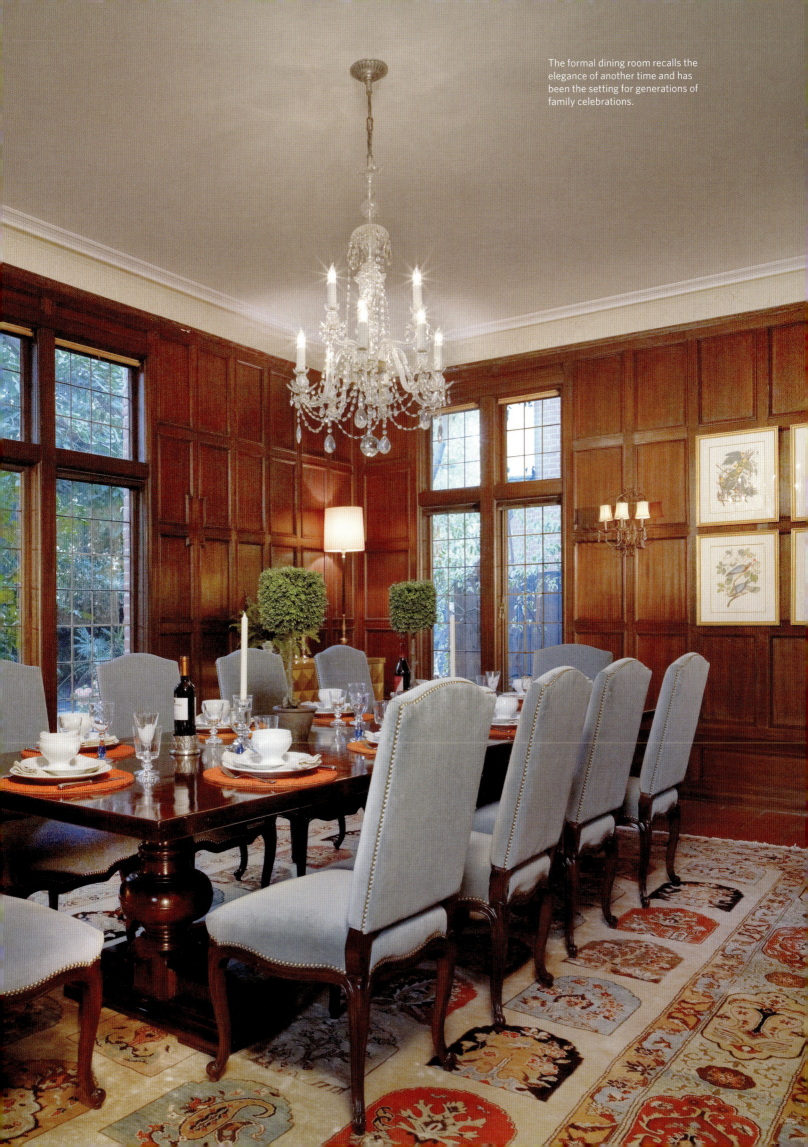

The formal dining room recalls the elegance of another time and has been the setting for generations of family celebrations.

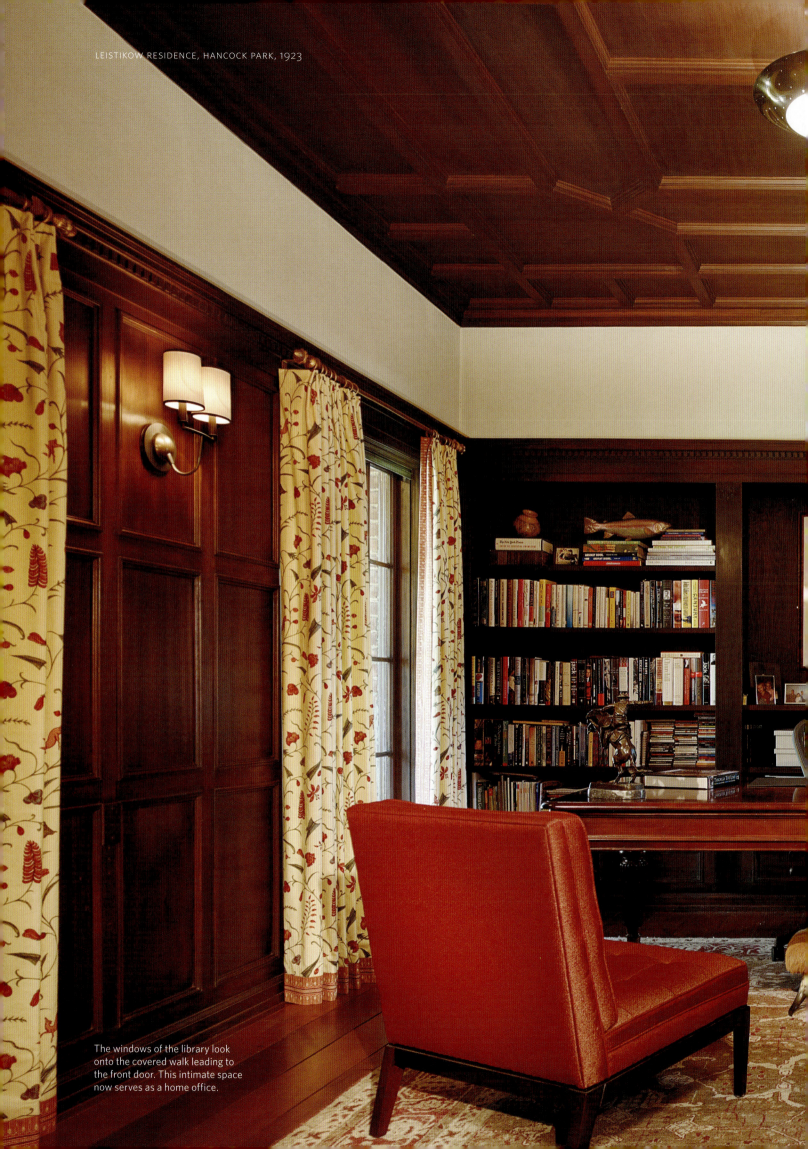

The windows of the library look onto the covered walk leading to the front door. This intimate space now serves as a home office.

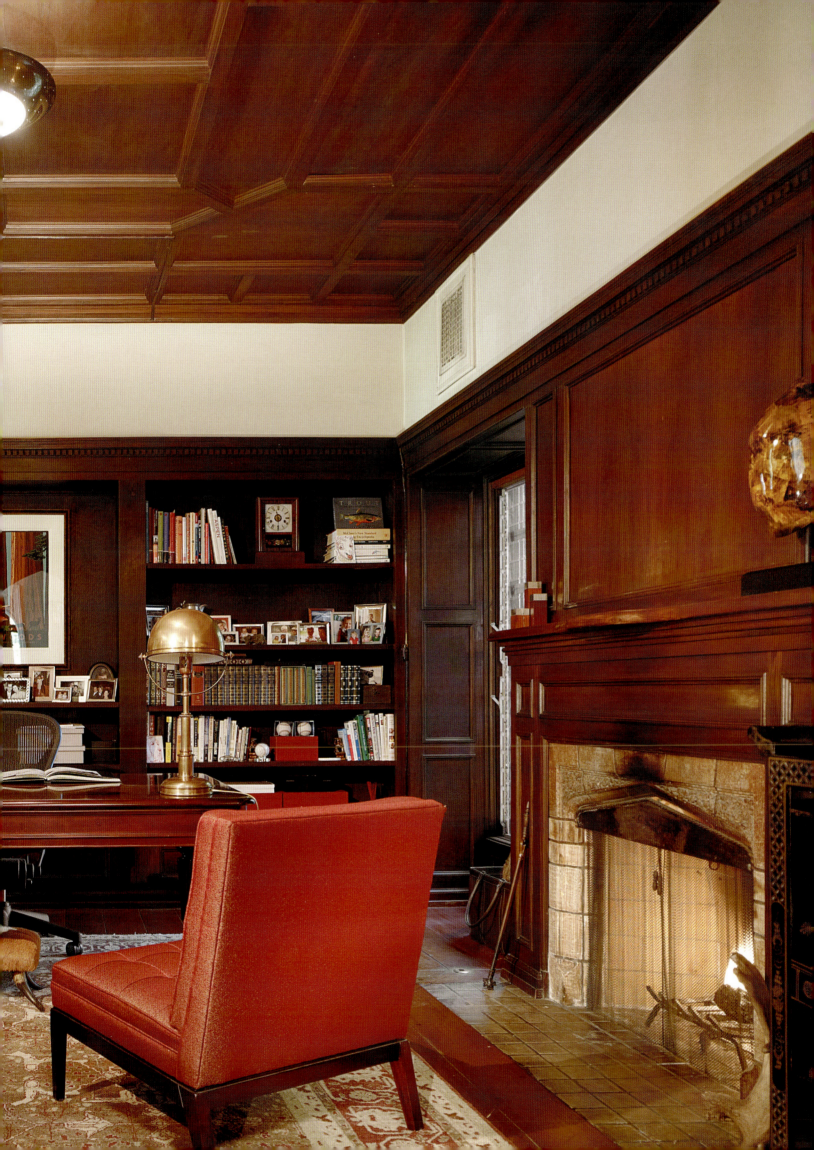

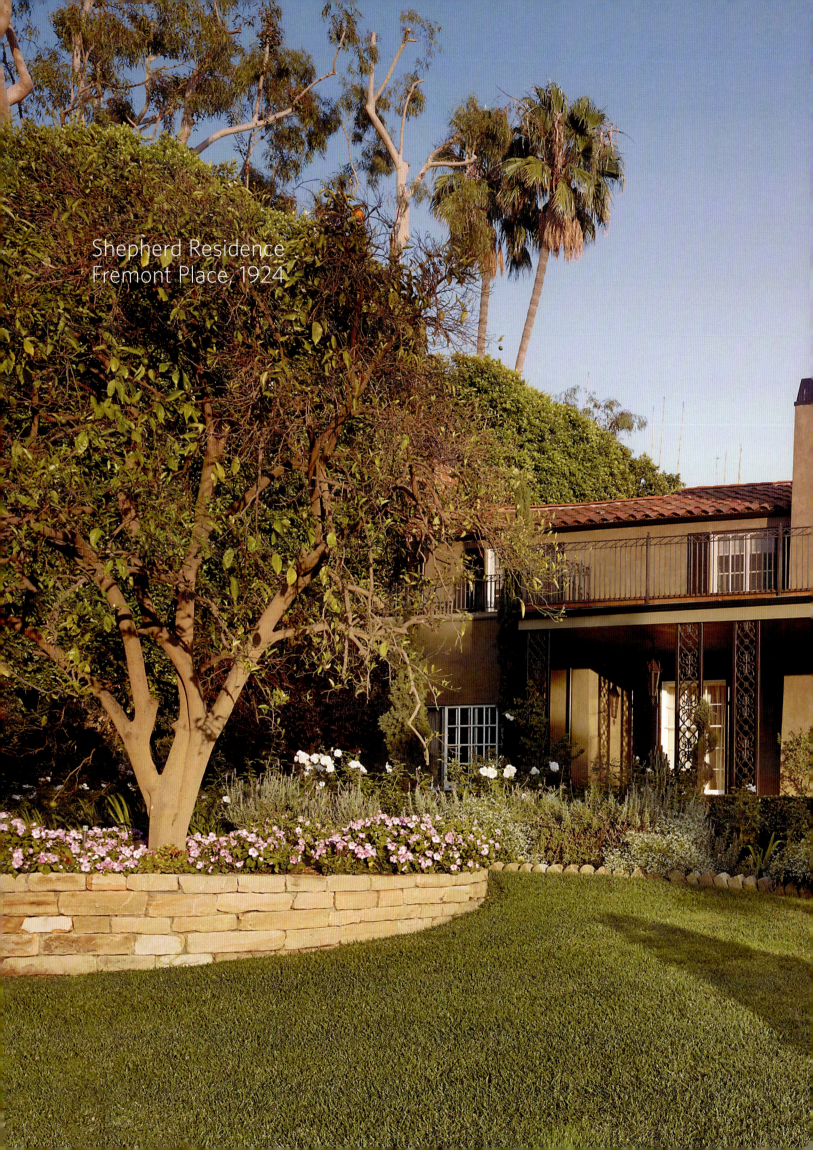

Shepherd Residence
Fremont Place, 1924

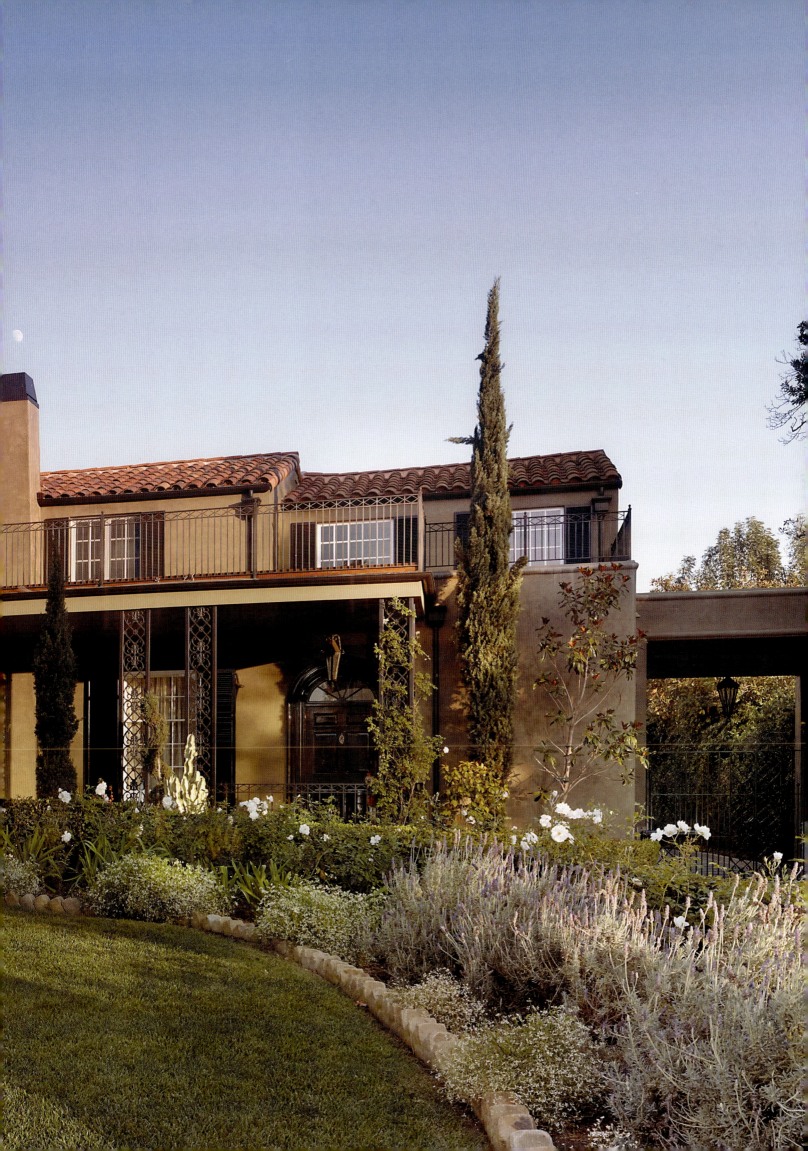

The weight of my racial handicap forced me, willy-nilly, to develop salesmanship. The average, well-established white architect, secure in his social connections, might be able to rest his hopes on his final plans. I, on the contrary, had to devote as much thought and ingenuity to winning an adequate first hearing as to the execution of the detailed drawings.

— "I AM A NEGRO"

OFTEN REFERRED TO AS ITALIAN REVIVAL STYLE, the Shepherd Residence may be more accurately described as being fashioned in the rural Italian vernacular style. Situated in Fremont Place, a gated community within walking distance of Hancock Park, the Shepherd Residence is unlike any of the other houses in the neighborhood. At first glance, it appears as a vision of New Orleans with its wrought iron and shutters, but inside it is pure Williams. The formal living room, distinguished by an impressive fireplace, leads into the walnut-paneled library, also with a trademark Williams fireplace. A distinctive pattern of windowpanes appears throughout the house, including the living room, kitchen, stair hall, and dining room. Looking at the house from the garden at sunset, the simplicity and elegance of the house is striking.

The original owner, John S. Shepherd, was an insurance adjuster who, within three short years, sold the home to Berne Stacy Barker, cofounder and secretary-treasurer of Pacific Ready Cut Kit Homes, later known as Pacific Building Systems. It is interesting that Williams's career included many clients who were in the building profession, a testament to their belief in the quality of his work. Undoubtedly, Williams was intrigued by Barker's ready-to-assemble houses, which were sold throughout the Southwest and in Central and South America. Subsequent owners of the Shepherd Residence include Phoebe and Alva Brockway, who entertained often in their Fremont Place home for Phoebe's many charities, including the League of Crippled Children, which she founded, and in support of her husband, who served as chief of staff at Orthopaedic Hospital while they lived in the house. In 1957, Ernest Duque, president of the California Portland Cement Company, and his wife, Louise, commissioned Williams to remodel and update the house. In 1972, Walter Danielson and his wife, Beryl, became owners while serving as consul general for Sweden in Los Angeles. They made their home an "open house" for visiting royalty, diplomats, and other dignitaries. Mrs. Danielson was heralded as a prominent hostess and was a founding board member of Muses, the fund-raising group of the California Museum of Science and Industry.

The current owners, restaurateurs Craig and Amy Nickoloff, were already living in a Willians house but were hoping for a larger yard when they went to an open house on a whim. This house had exactly what they were looking for: easy circulation from inside to outdoors, space for a large koi pond, an impressive central kitchen, and Williams's signature touches, such as a jaw-dropping stairway and a sensitive, efficient use of space.

The house needed some love and attention, and fortunately the Nickoloffs were able to locate the 1957 plans, which allowed them to renovate the house to reflect that period. As restaurateurs, they, not suprisingly, say their favorite room is the kitchen, with its incredible light and view to the pool and the garden. They combined the pantry and kitchen to make the perfect cooking space, and though their busy schedules do not allow them to entertain quite as much as they would like, they gather their friends on the patio off the kitchen when they have the chance.

OPPOSITE, TOP:
The light-filled music room.

OPPOSITE, BOTTOM:
The book-lined library continues to be a refuge following a busy day.

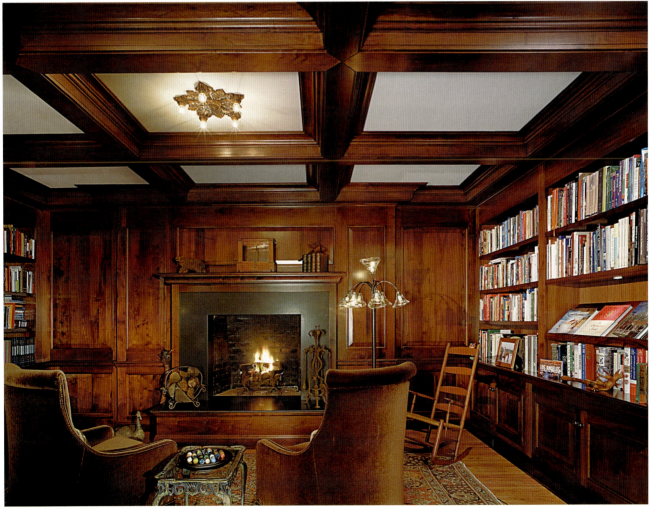

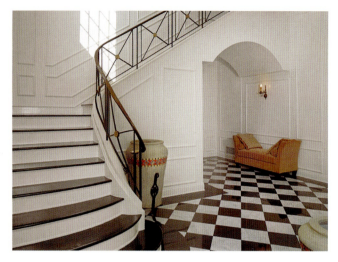

ABOVE:
Williams's use of moldings and
clean lines in the stairway adds to
the unexpected elegance of this
grand entry.

RIGHT:
Following the specifications of a
1957 renovation, the owners took
particular care in re-creating the
flagstone surrounding the pool.
The view of the house from the
garden includes the vine-covered
outdoor dining area as well as the
second-floor balcony.

The space functions well in its role as an indoor-outdoor room and
is both convenient and comfortable, complete with fireplace.

Guests are first greeted by the grand hallway, which acts as
a portal to the rest of the house. One is first impressed by the
interior's elegance, but within moments the incredible light and
open spaces draw the visitor into the cozy, comfortable rooms.
With an appreciation for how well the residence works for
entertaining, the Nickoloffs' favorite event is their annual Super
Bowl party. Guests move effortlessly from the theater to the den
to the kitchen to the patio and enjoy the game in every room
while they mingle and savor the Nickoloffs' specially created
edible delights. ✭

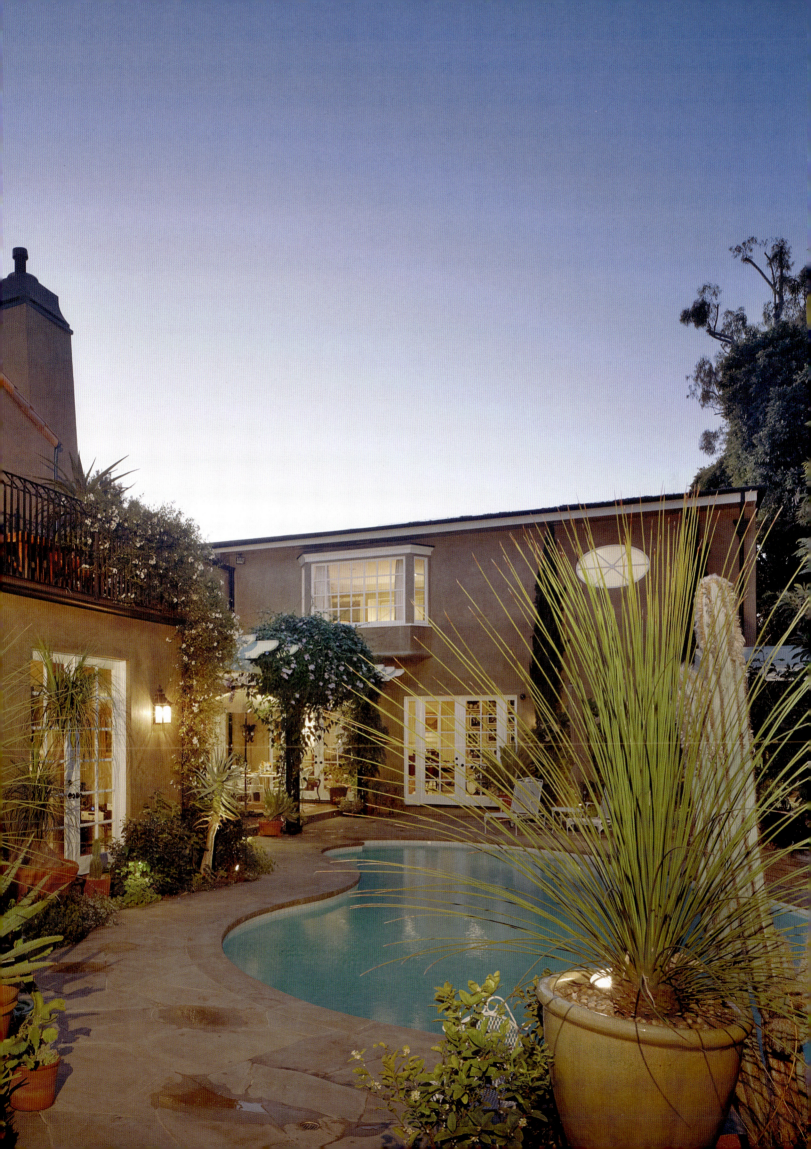

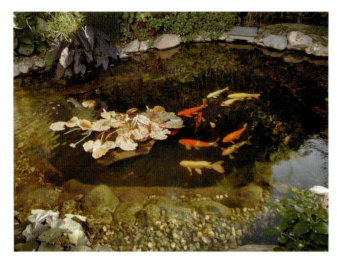

ABOVE:
The koi pond completes the garden's serene ambience.

RIGHT:
The lush landscaping of the garden creates a private retreat.

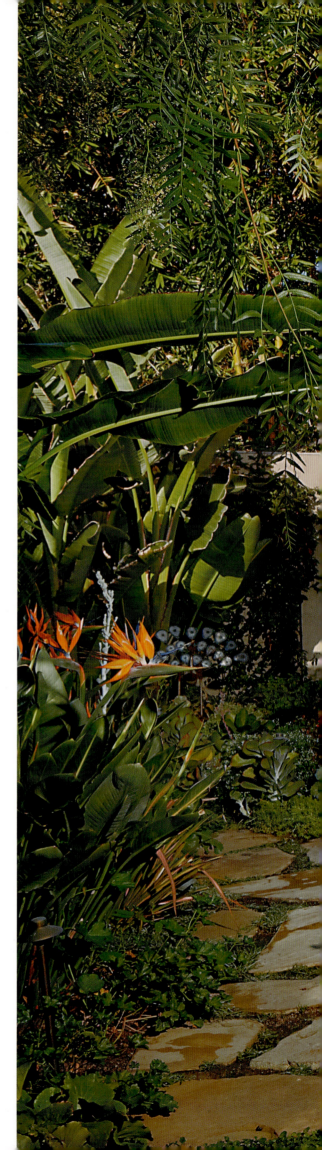

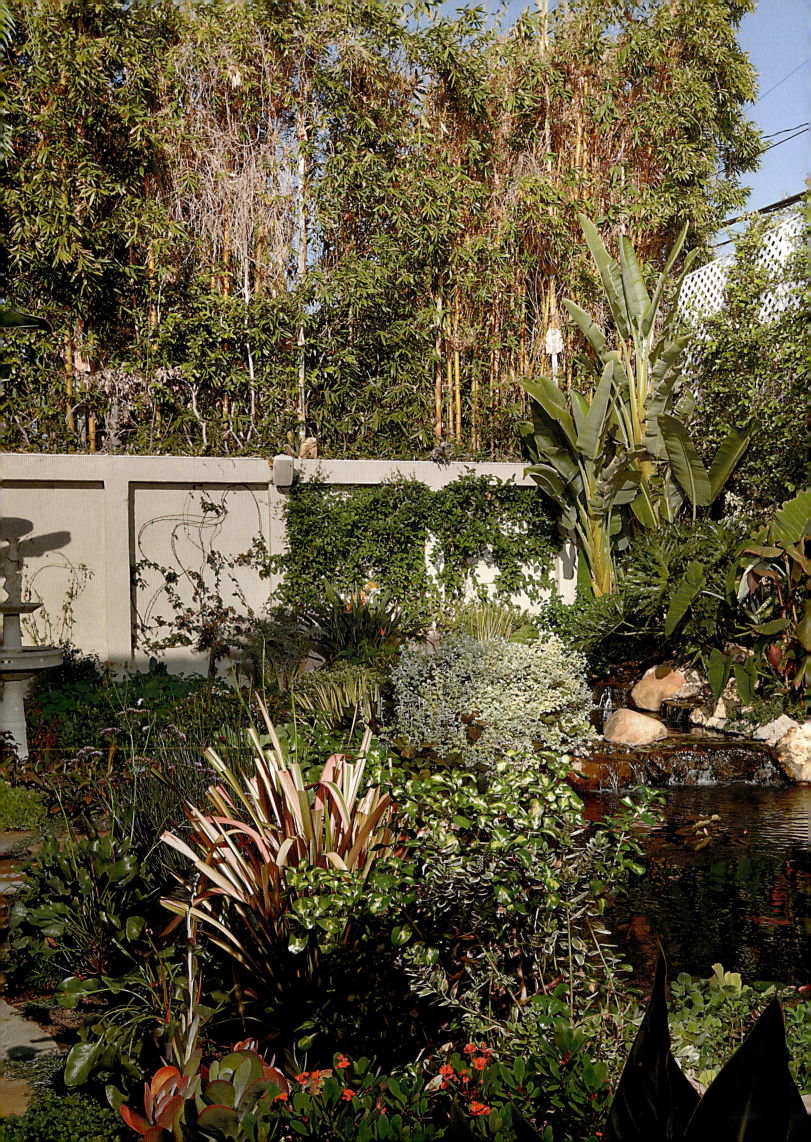

Preminger Residence
Brentwood, 1925

Planning is thinking beforehand how something is to
be made or done and mixing imagination with the
product—which in a broad sense makes all of us
planners, the only difference is that some people get
a license to get paid for thinking and the rest of us just
contribute our good thoughts to help fellow man.

— "THE INFLUENCE OF PLANNING ON MAN'S DESTINY"

THIS COLONIAL HOUSE is most often associated with Ingwald
"Ingo" Preminger, though he was not its orginal owner. The
younger brother of Otto Preminger and producer of the 1970's hit
*M*A*S*H*, Ingo Preminger was also remembered for his loyalty to
writers blacklisted during the McCarthy era. Following Preminger,
the house was owned by film producer Harold Hecht, who
"discovered" Burt Lancaster and made *Birdman of Alcatraz* and
Separate Tables.

When the current owners purchased the house more than
thirty years ago, they fully embraced its beauty and Williams's
vision, going so far as to place a respectful call to the architect's
family to share their plans for building a glassed-in conservatory
to join the two sides of the house. The magnificent new space
embraces the light and becomes part of the garden, and it is the
owners' favorite room. This house, perhaps more than any other,
represents a renovation and remodel that most effectively honors
Williams's vision and design philosophy while upgrading the
house with modern conveniences to adapt to the current owners'
lifestyle. By meticulously re-creating moldings, proportions, and
curves with great attention to detail, the owners realized the house
as Williams would have remodeled it had he been here today.

The owners love to entertain, especially in both their indoor
and outdoor kitchens. A casual night with friends means lighting
the outdoor fireplace and cooking pizza in their wood-burning
pizza oven with their guests. From the sweeping staircase to the
warm and inviting living room, from the dining room with its

Once a simple U-shaped house, its central open area
was enclosed in glass to create a solarium and allow
guests to flow from one side of the house to another
without going outside.

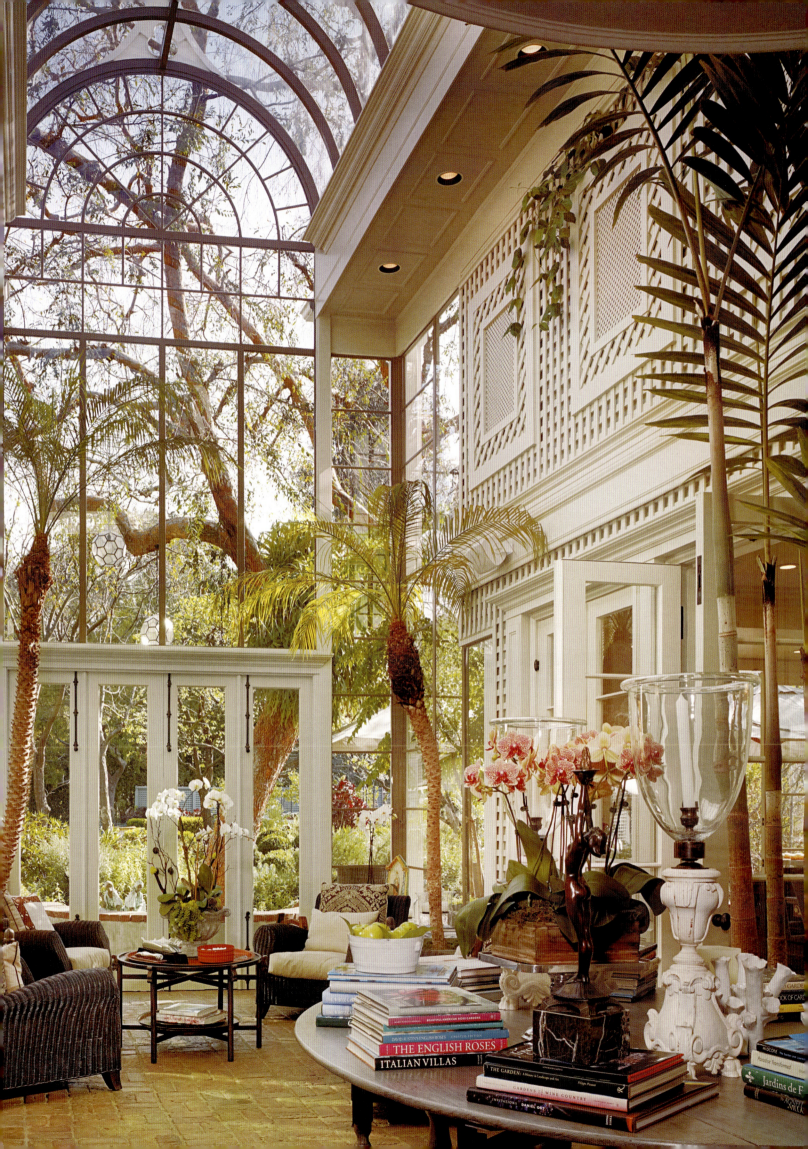

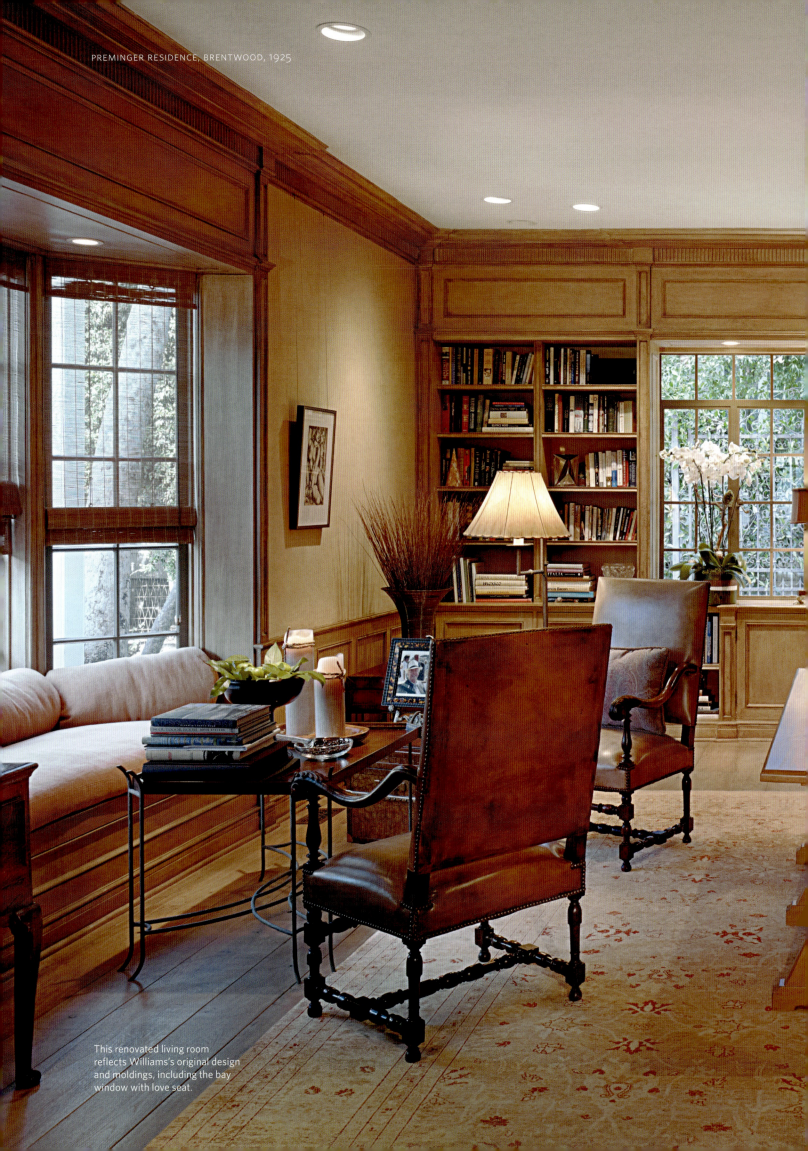

This renovated living room reflects Williams's original design and moldings, including the bay window with love seat.

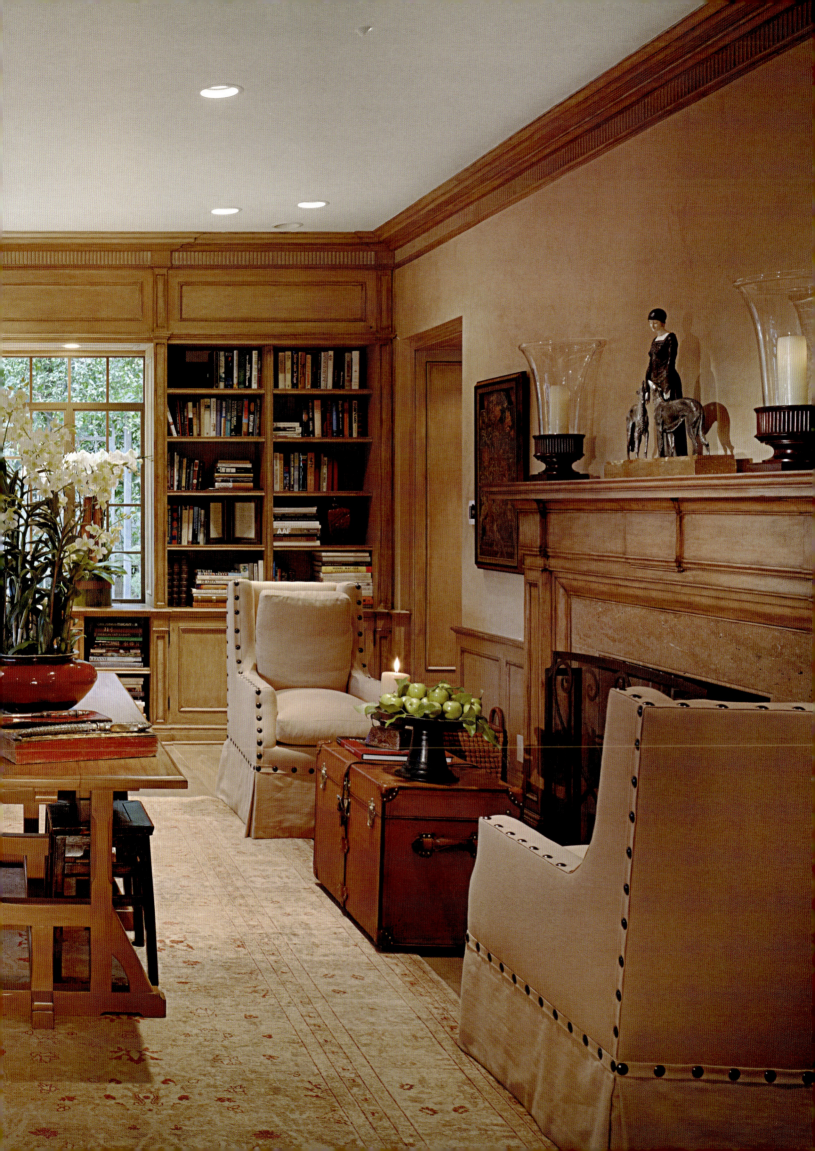

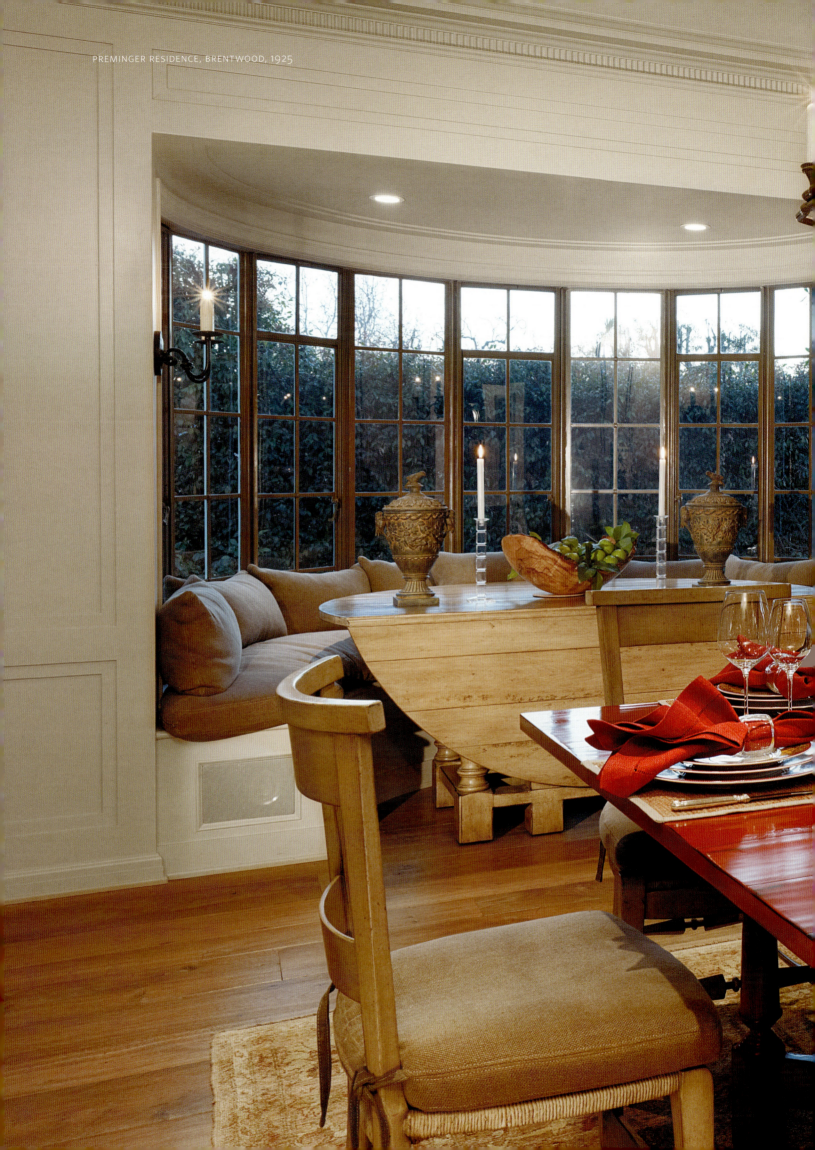

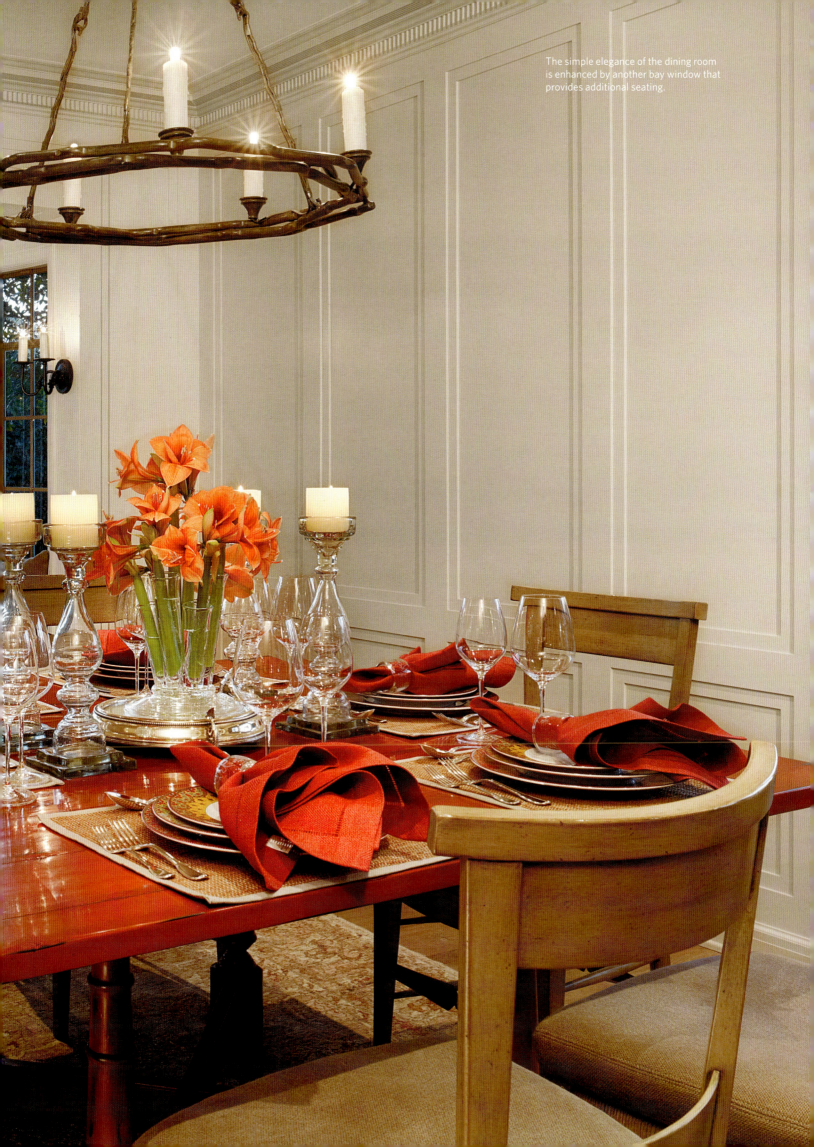

signature bay window seat to the lush gardens, this is truly a home meant to be shared with friends and family.

As collectors of historic automobiles, the owners relish their role as custodians of significant design from the past. To house a portion of their collection of rare French automobiles from the 1930s, they created a subterranean automobile museum beneath the organic garden. Above the museum they planted a beautiful raised-bed organic herb and vegetable garden. The original garage is now a quaint guest cottage, affording visitors views of the pool and the garden while maintaining their privacy.

Like Williams, the current owners love integrating outdoors and indoors, which they have done here with love and expertise: "We love the proportions and the classic nobility one finds in our home, and in Williams's homes in general. We live in several different countries—in a Scottish manor house, in a fourteenth-century fortress, and in a Frank Lloyd Wright home perched above the water in Big Sur, California. Our home by Paul Williams remains our favorite place to be." ★

Williams often advised clients to update kitchens and bathrooms for their individual and modern needs. This completely renovated kitchen is a state-of-the-art complement to the original design.

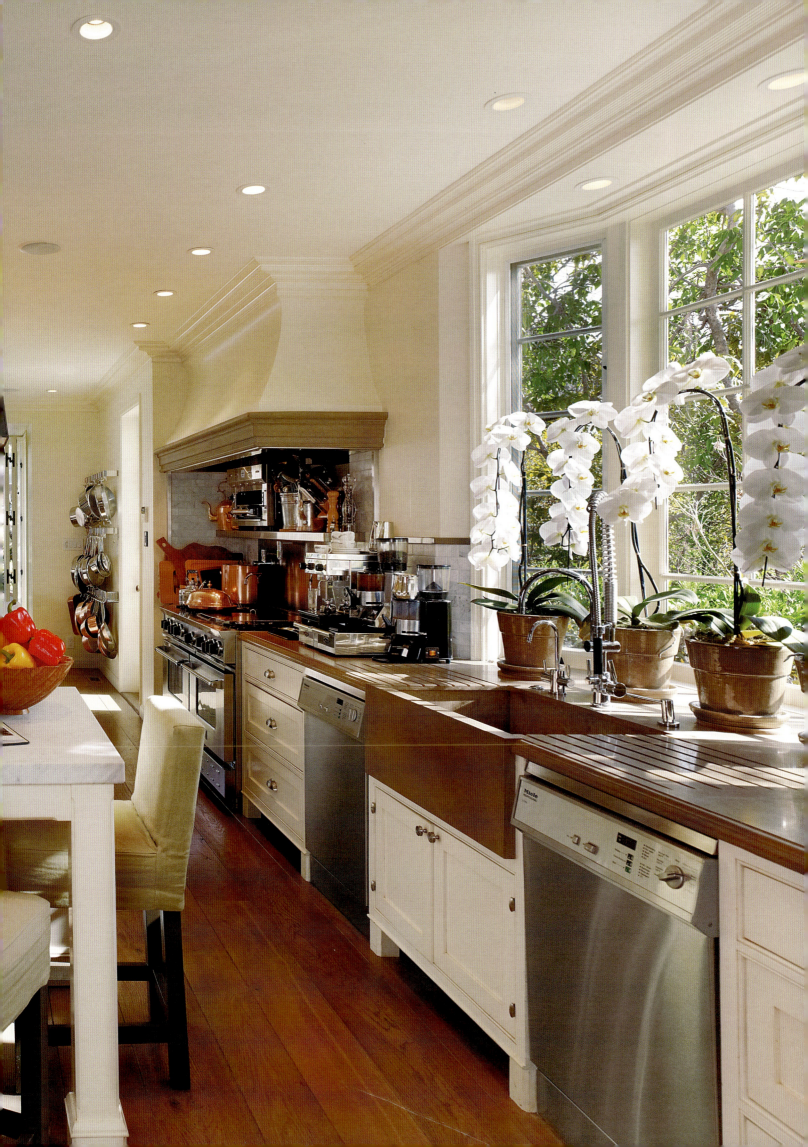

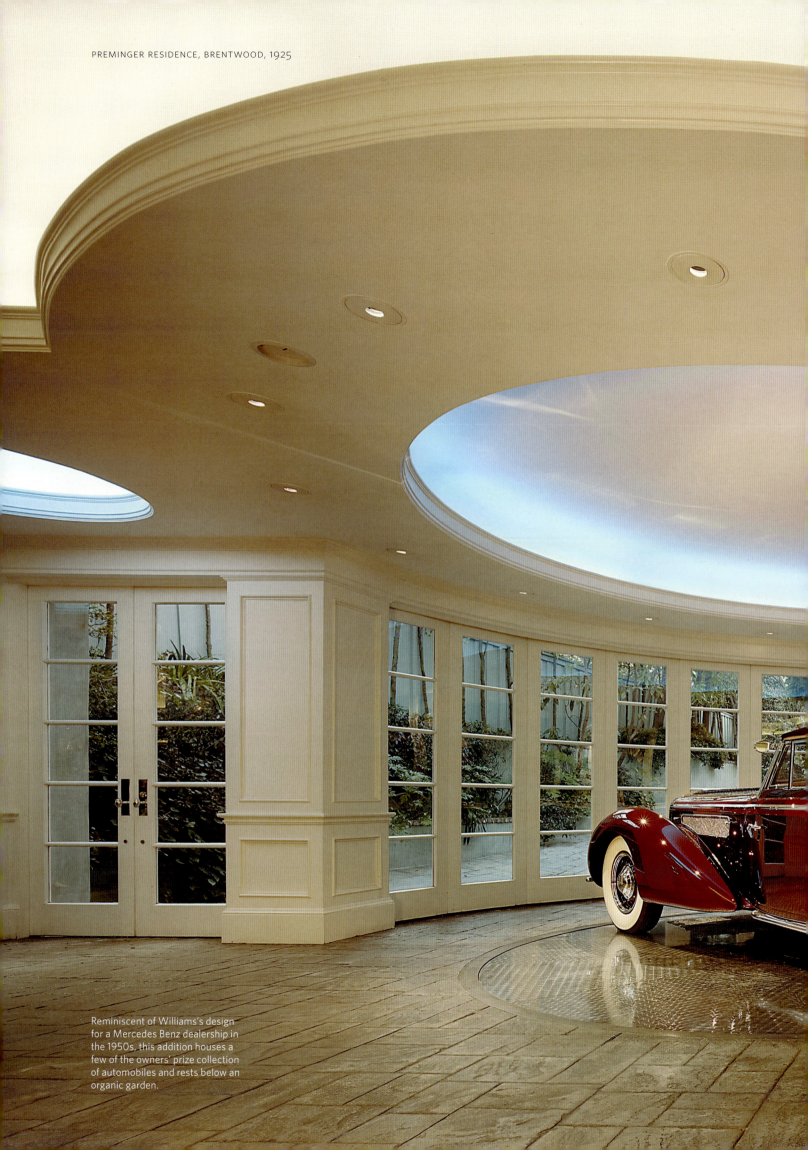

Reminiscent of Williams's design for a Mercedes Benz dealership in the 1950s, this addition houses a few of the owners' prize collection of automobiles and rests below an organic garden.

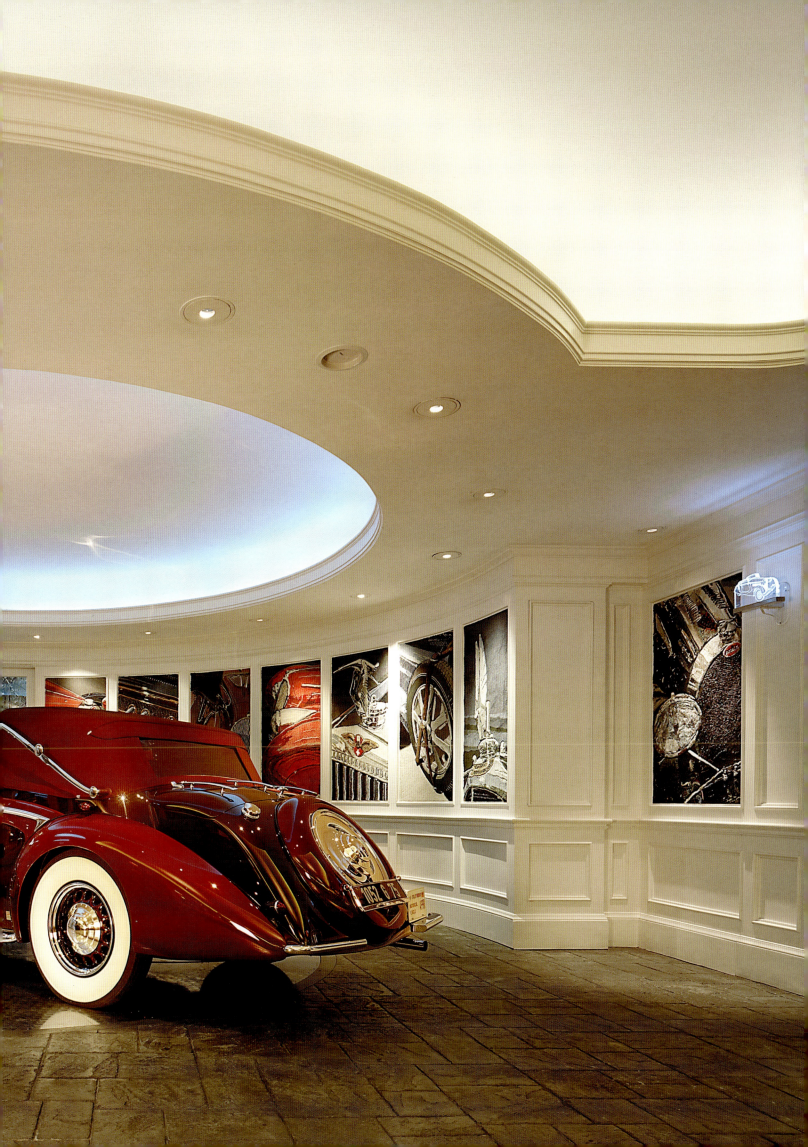

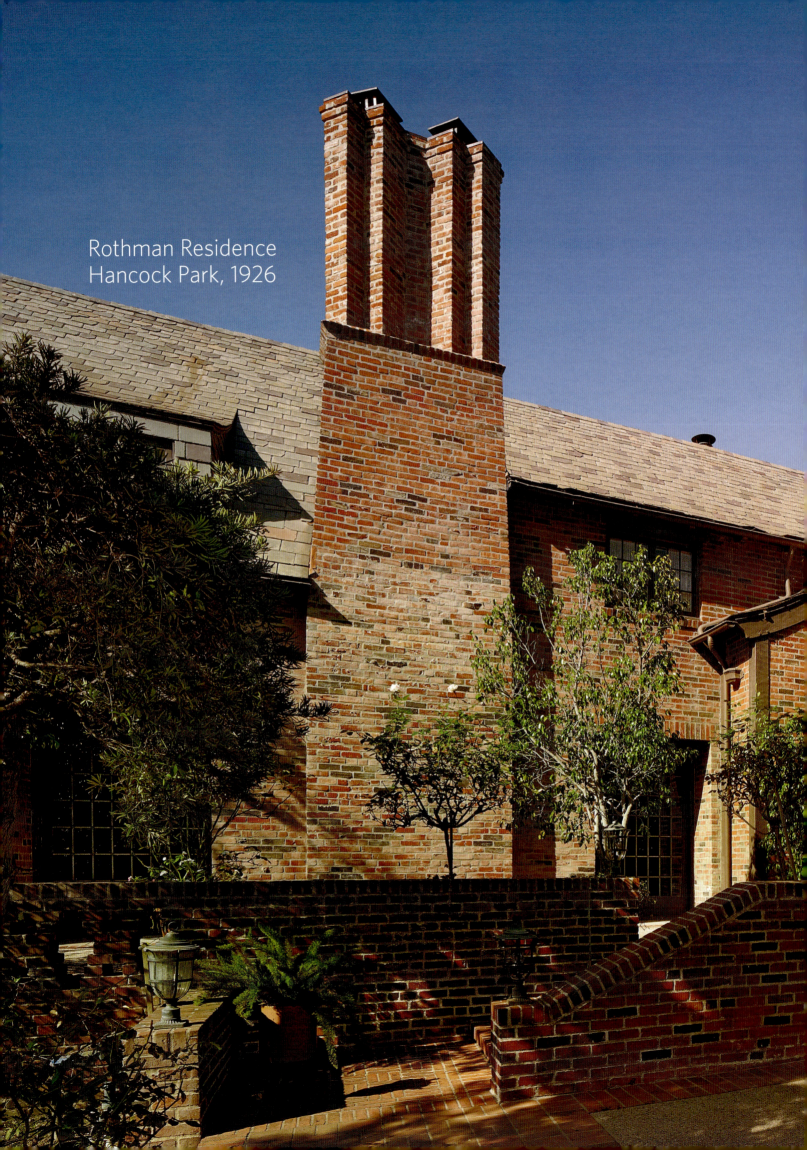

Rothman Residence
Hancock Park, 1926

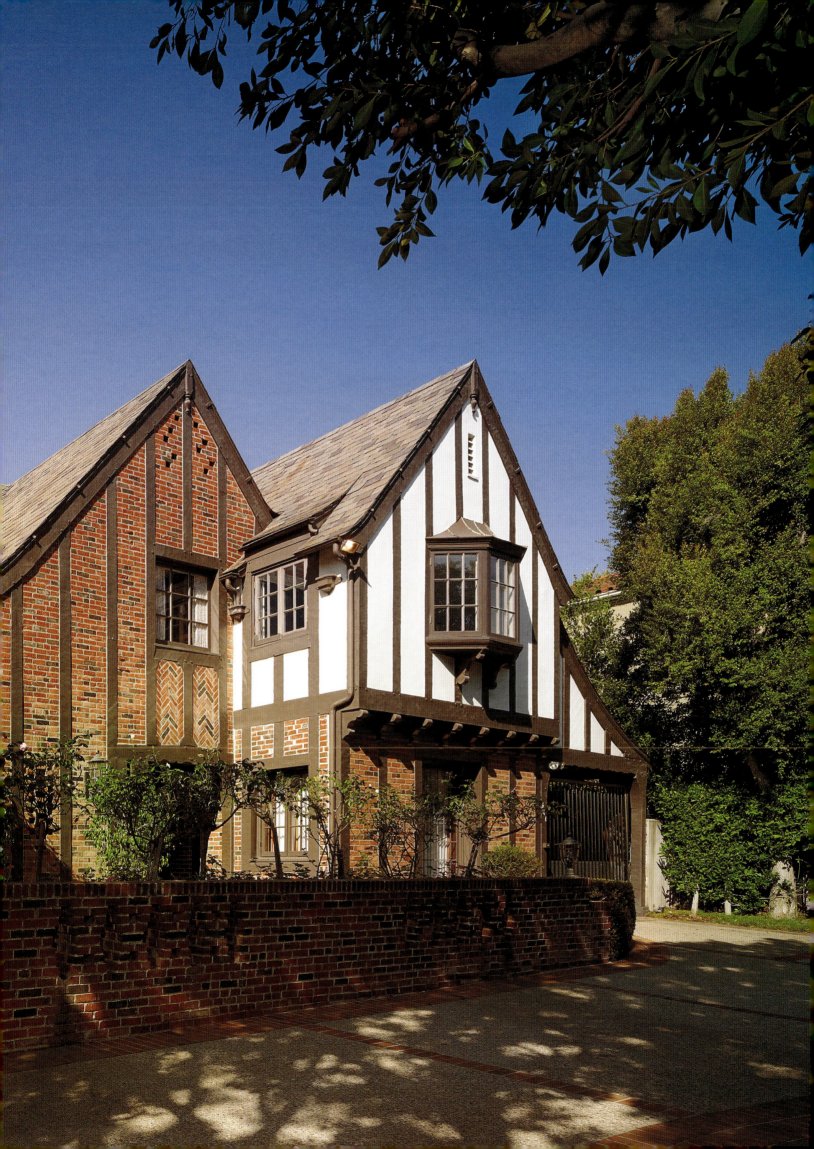

To be sincere in my work, I must design homes, not houses. I must take into consideration each family's mode of living, its present economic problems, and its probable economic future, its entertainment needs.

— "I AM A NEGRO"

UNLIKE OTHER ARCHITECTS of his time, Williams did not have the advantage of studying the great architecture of Europe. Yet surely he must have relied on his many pattern books as he brought to life this rural English Tudor cottage in the heart of Los Angeles, for Philip Rothman. Typical of the style, the house is one and a half stories in some sections, sheathed in brick, and the smaller two-story sections are half-timbered with infill of brick and stucco. Upon entering the formal entry hall, one is greeted by a black-and-white checkerboard floor and sweeping staircase with hand-carved railings. An elegant wood-paneled ceiling and graceful arches adorn each passageway.

The living room is a burst of light in an otherwise dark interior. Leaded-glass windows frame the fireplace, and the traditional bay window showcases a sailing ship, most likely a nod to Rothman's interest in the sea. The library, once a haven for law books, has been converted into a home for the current homeowner's treasured Napoleonic history collection. Although the room is large, with beamed, vaulted ceilings, it exudes the warmth of an intimate space with its fireplace and fabric-covered ceiling.

Current owners Carol Goodson and Lawrence Berkowitz love to entertain, and the home has been the venue for countless family celebrations. "We entertain on a weekly basis and enjoy moving from room to room—cocktails in the living room, dinner in the dining room, and to the library for after-dinner drinks and conversation," says Goodson. "The dining room is so romantic with its mahogany walls that we highlight with candles and flowers." The parties have been large and small, casual and formal. Most notably, Goodson and Berkowitz were married here, have married off children in grand style here, and most recently have welcomed grandchildren, as the house adapts to each generation. ✦

OPPOSITE:
Decidedly stately, this entry hall features hand-carved balusters and an original stenciled ceiling.

FOLLOWING PAGES:
The library exemplifies the extensive use of wood, hand-carved moldings, and inclusions of a majestic fireplace and mantel, popular at the time of its construction.

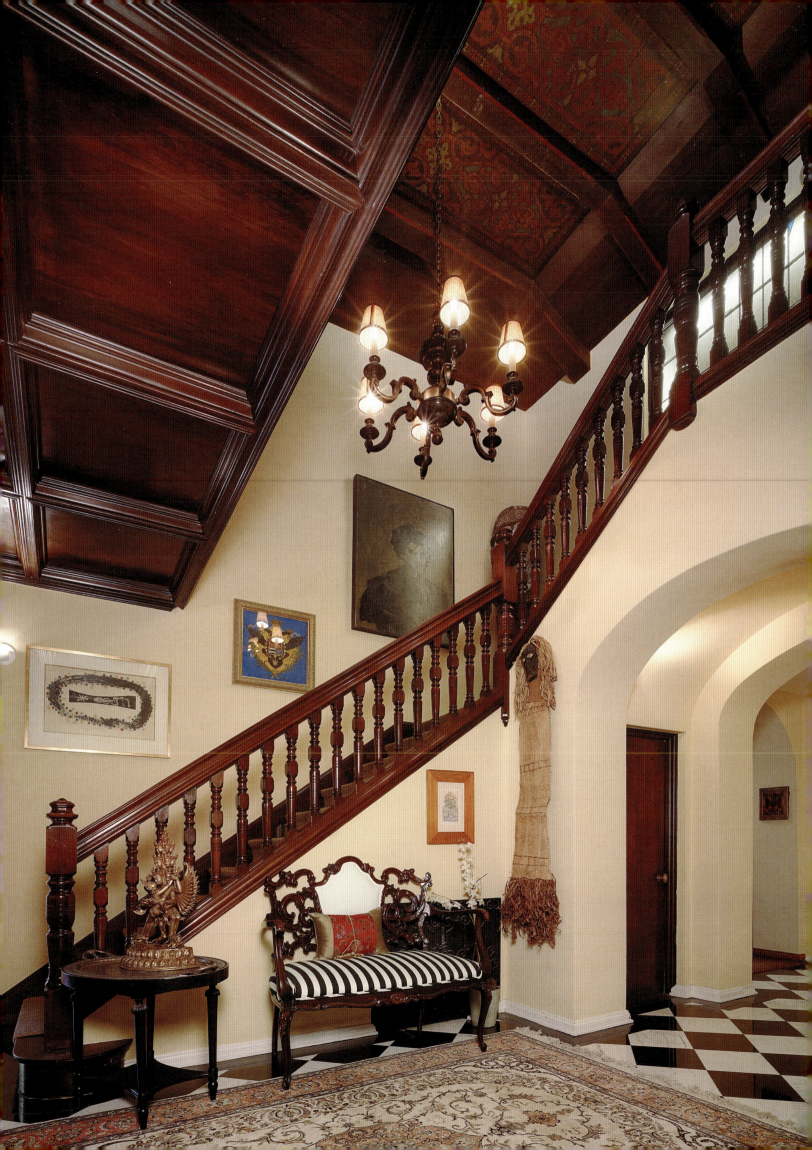

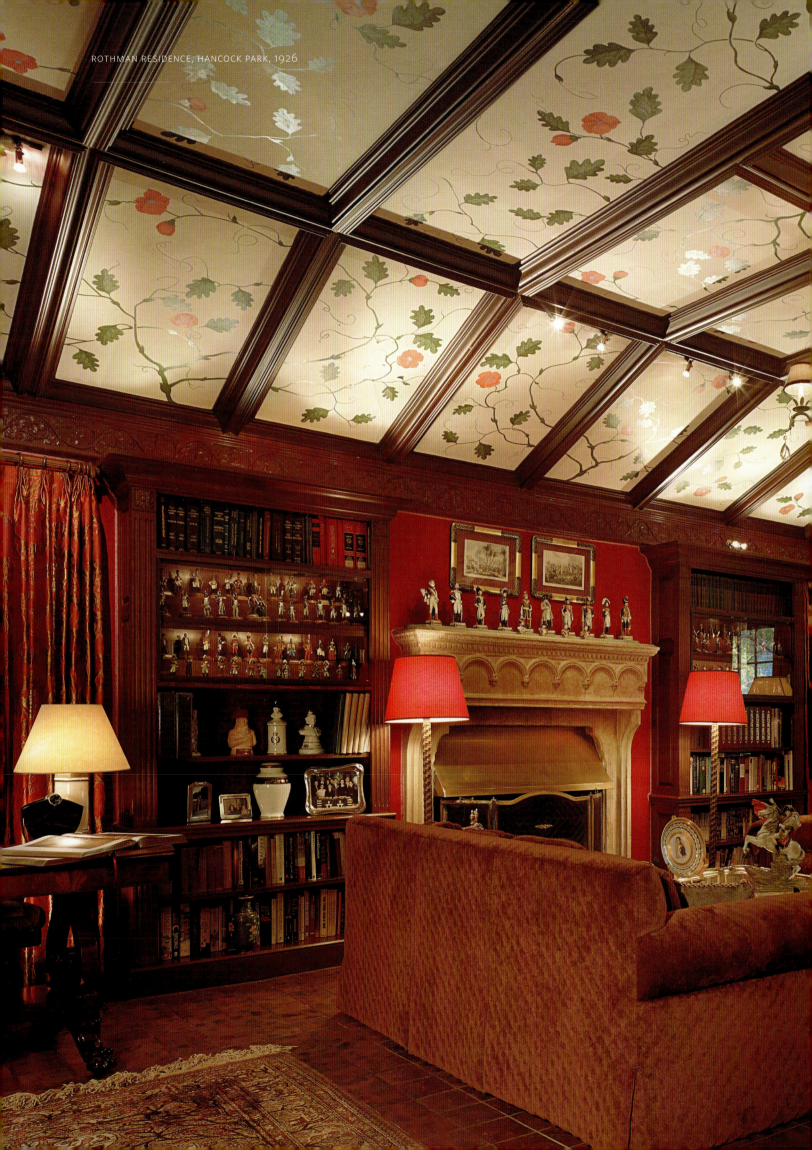

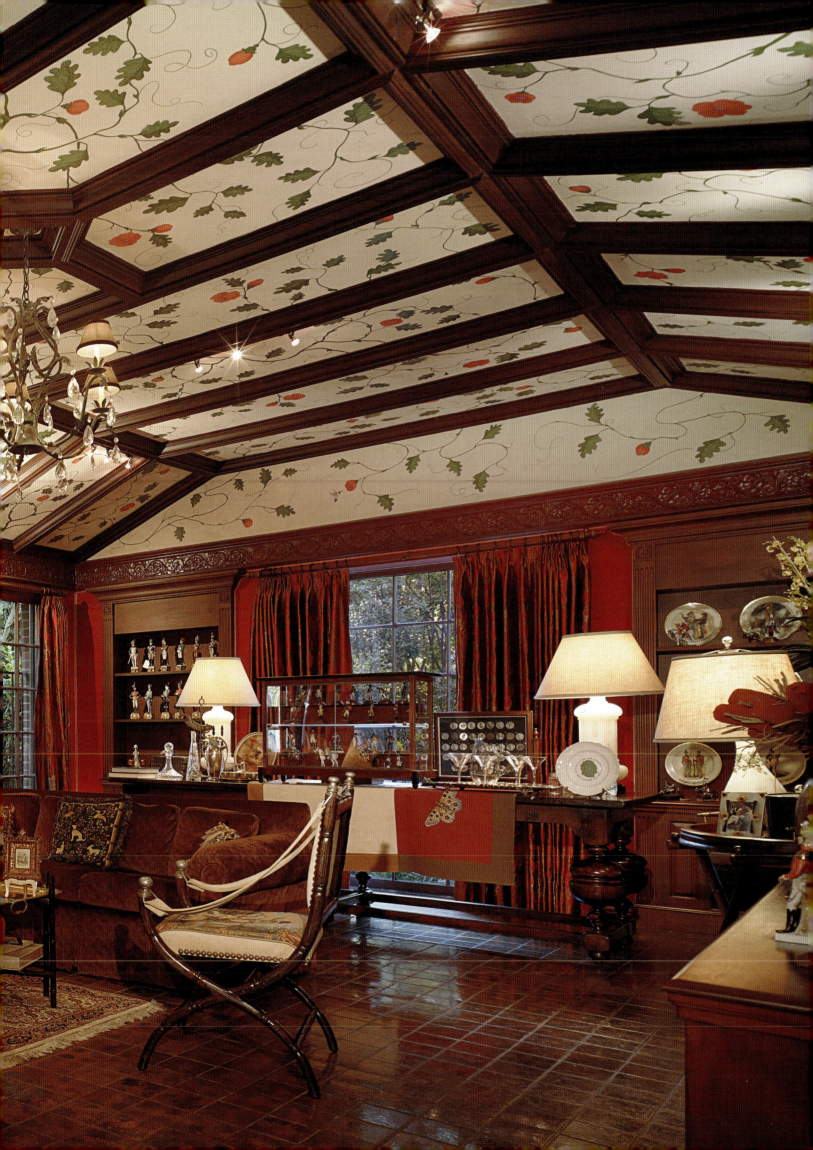

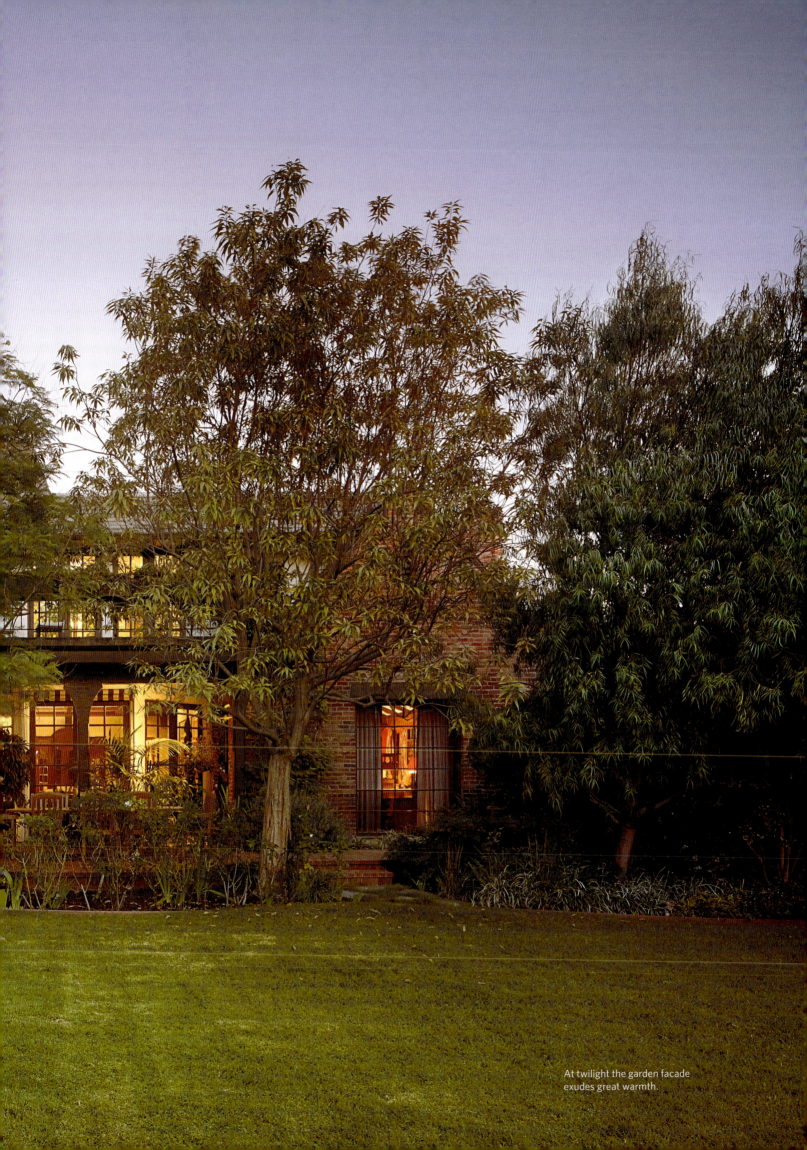

At twilight the garden facade
exudes great warmth.

Degnan Residence
La Cañada Flintridge, 1927

Good planning, good design, and good construction are the three essentials necessary to fight obsolescence, and it is the quality of our designing today that will definitely stamp this decade as being of good taste.

— "AN ARCHITECT'S APPROACH TO PLANNING"

THE LA CAÑADA FLINTRIDGE AREA of Los Angeles boasts the first house Williams completed in private practice, as well as the last. This Mediterranean-style house was built for prominent Los Angeles attorney James Degnan and his family. Like many of Williams's clients, Degnan lived in the city and commissioned Williams to design a new house as a weekend retreat. Both Degnan and the house would go on to be part of Los Angeles history. Degnan had a street named after him, and the house would be home to memorable parties hosted by a succession of residents.

Earl Morner, better known by his stage name, Dennis Morgan, lived in the home with his wife, Lillian, and often entertained the Hollywood crowd, including the legendary Errol Flynn. Morgan, who in 1945 portrayed Jefferson Jones in *Christmas in Connecticut*, starring Barbara Stanwyck, obviously enjoyed opening his home to friends. He sold the home shortly after retiring in the mid-1950s, but felt that the grand dining room set should be enjoyed by future residents, including the Edelbrocks, who raised their five children in the home, so he left it there. The Edelbrocks loved the home, and it remained the centerpiece of their family until their deaths.

By the time Gina and Rod Guerra purchased the home, it was in a state of disrepair having sat empty and on the market for years. For Gina, it was the initial glance at the facade that touched her heart and made her know she wanted this home, and Rod joined her in that sentiment within minutes, as he stepped down from the grand hall and sat in the living room with its beamed ceiling and arched windows.

The grand scale of the entry hall, with its trademark black-and-white floor and carved columns, is pleasantly offset by the delicacy of the wrought-iron railing on the upstairs balcony that rings the space. Series of arches appear throughout the home,

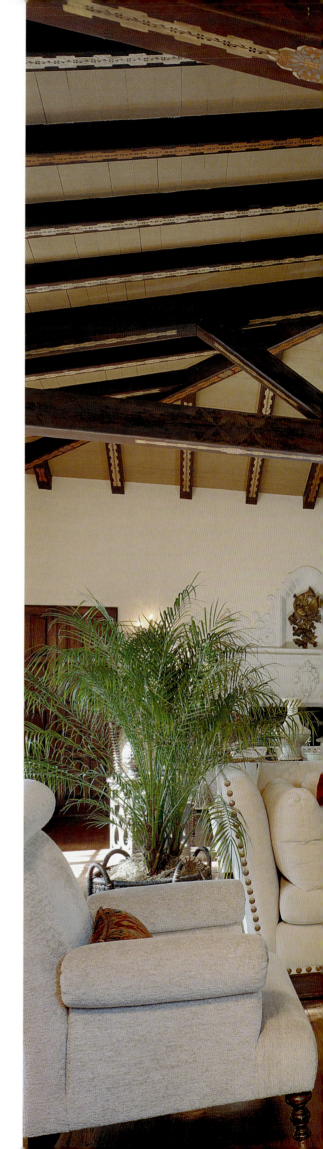

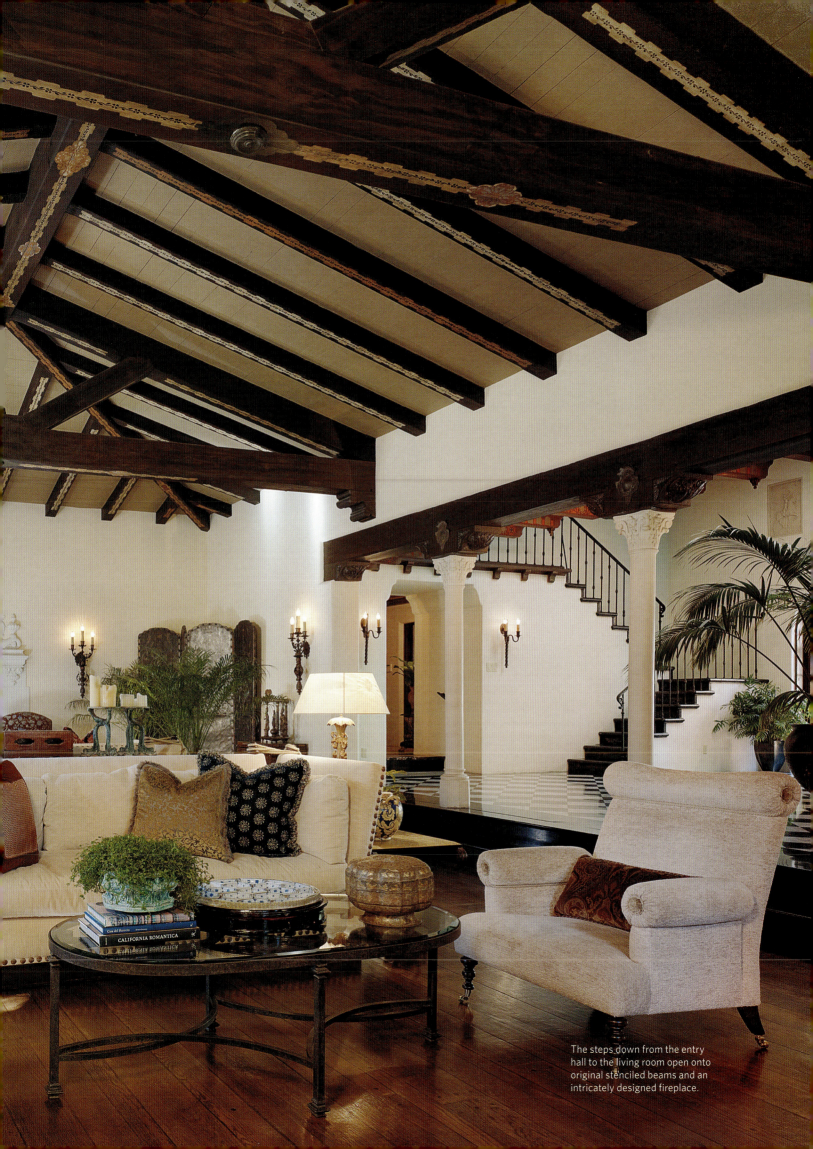

The steps down from the entry hall to the living room open onto original stenciled beams and an intricately designed fireplace.

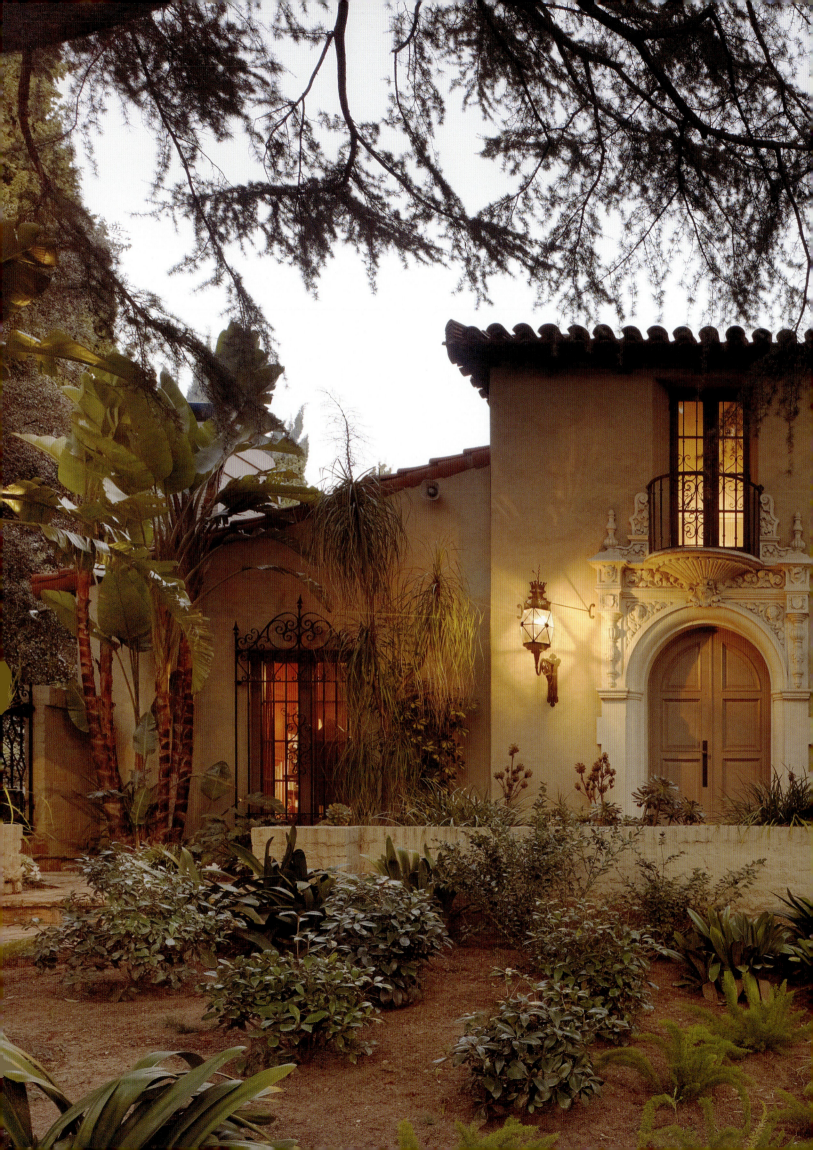

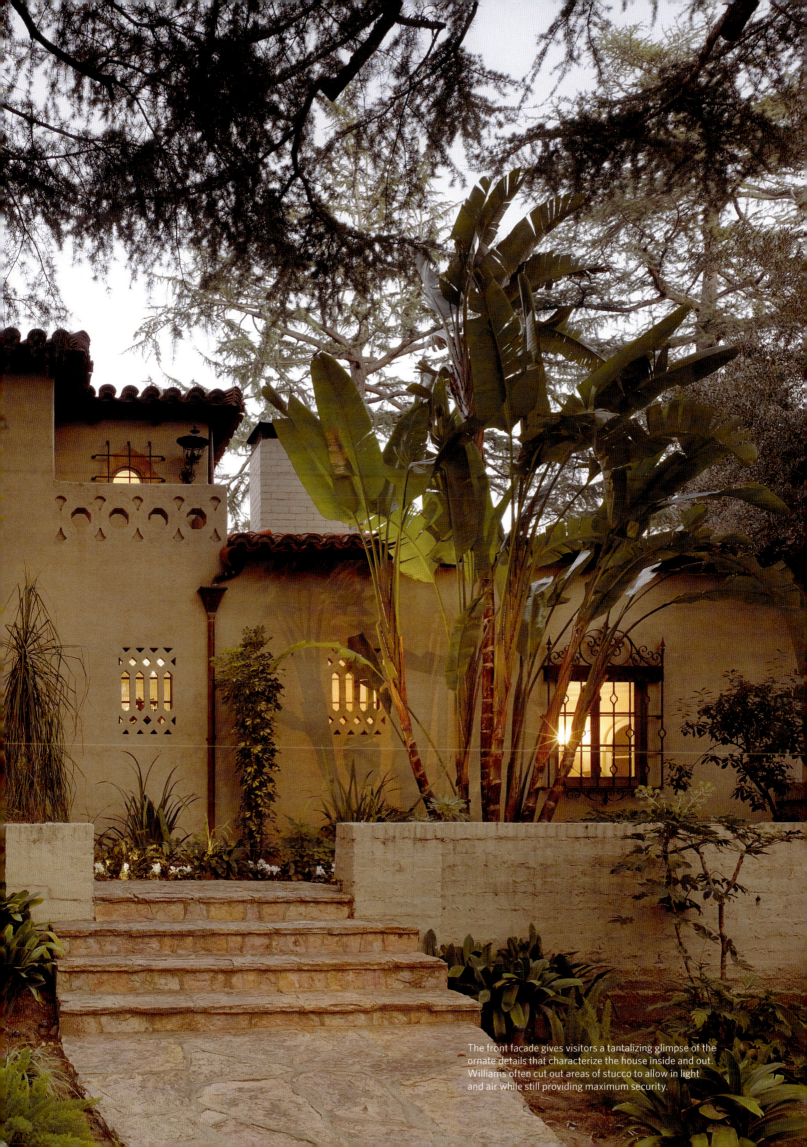

The front facade gives visitors a tantalizing glimpse of the ornate details that characterize the house inside and out. Williams often cut out areas of stucco to allow in light and air while still providing maximum security.

Arches frame the view to the gardens.

both on the interior and exterior. From the entry hall, one can peer into the garden through the ornately carved threshold. The graceful entrance to the garden is a seamless walkway, as though it were part of the home's interior. The pool reflects the extensive, lavish gardens surrounding it and perfectly completes the exquisite estate.

The ornate dining room ceiling and leaded windows continue to frame the majestic dining room set. Stories differ as to whether the set was a gift from an actor friend or if Morgan brought it back from Europe. Whatever the case, the hand-carved set found a home in Morgan's dining room and has remained with the house ever since. The kitchen has been meticulously restored with modern appliances, all the better to entertain family and friends.

Gina Guerra offers a sentiment often stated by owners of Williams's homes: "The architectural details and the craftsmanship are incredible, as are the overall design and flow of the house. While built on a grand scale, the house does not feel cold or sterile and is extremely livable today as it must have been when first built."

Their favorite room to entertain in is the dining room, particularly with its dining room set, the history of which has not been lost on them. The Guerras renewed their wedding vows five years after they were married, and here they celebrated with a big reception. "The purchase and restoration of this Paul Williams house has inspired us in so many ways, including to learn more about the architecture and furnishings of the 1920s, to understand the period landscaping and plantings, and to grow and maintain our own organic vegetable garden and fruit trees. The house has changed the way we live and how we relax. It is a wonderful, tranquil place that never ceases to amaze us with its timeless beauty." ★

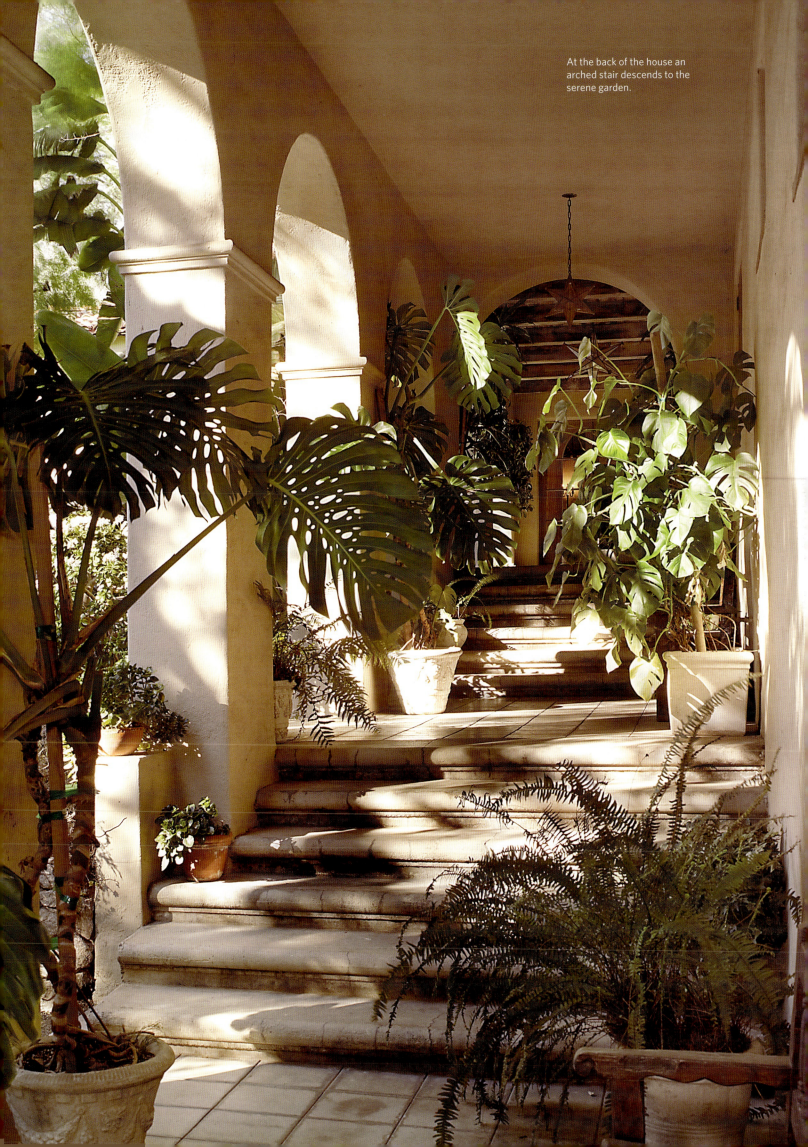

At the back of the house an arched stair descends to the serene garden.

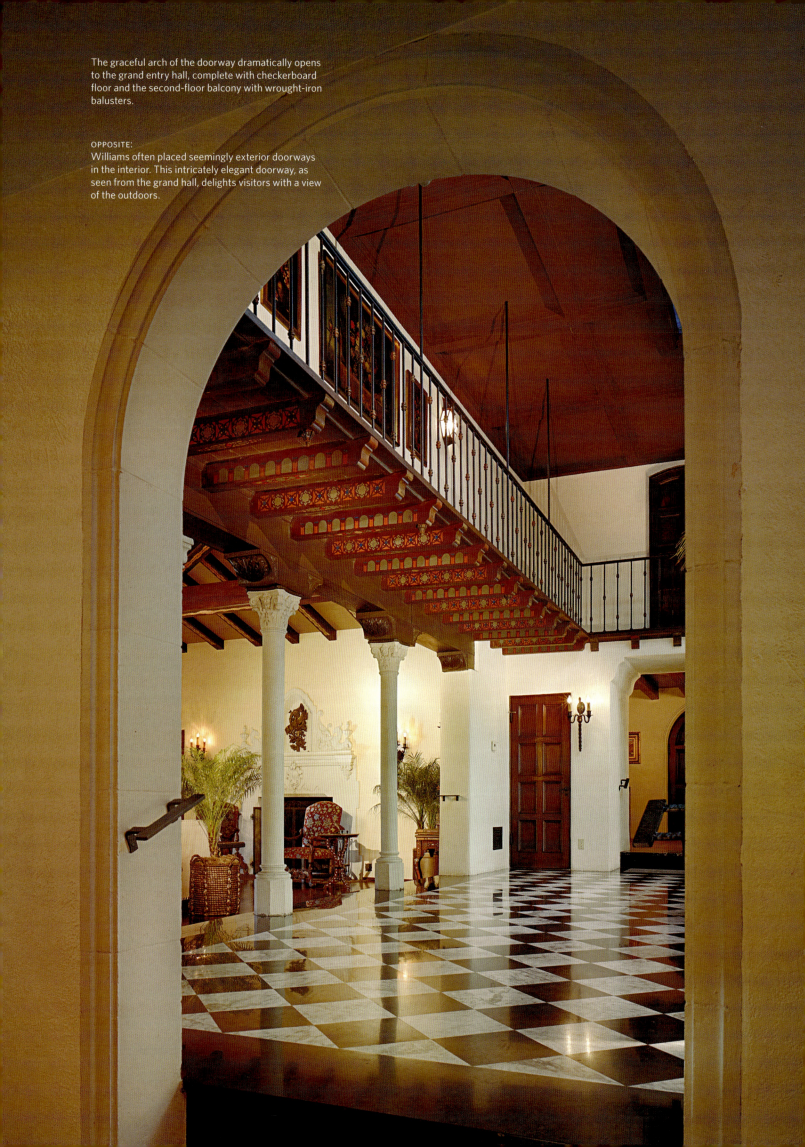

The graceful arch of the doorway dramatically opens to the grand entry hall, complete with checkerboard floor and the second-floor balcony with wrought-iron balusters.

OPPOSITE:
Williams often placed seemingly exterior doorways in the interior. This intricately elegant doorway, as seen from the grand hall, delights visitors with a view of the outdoors.

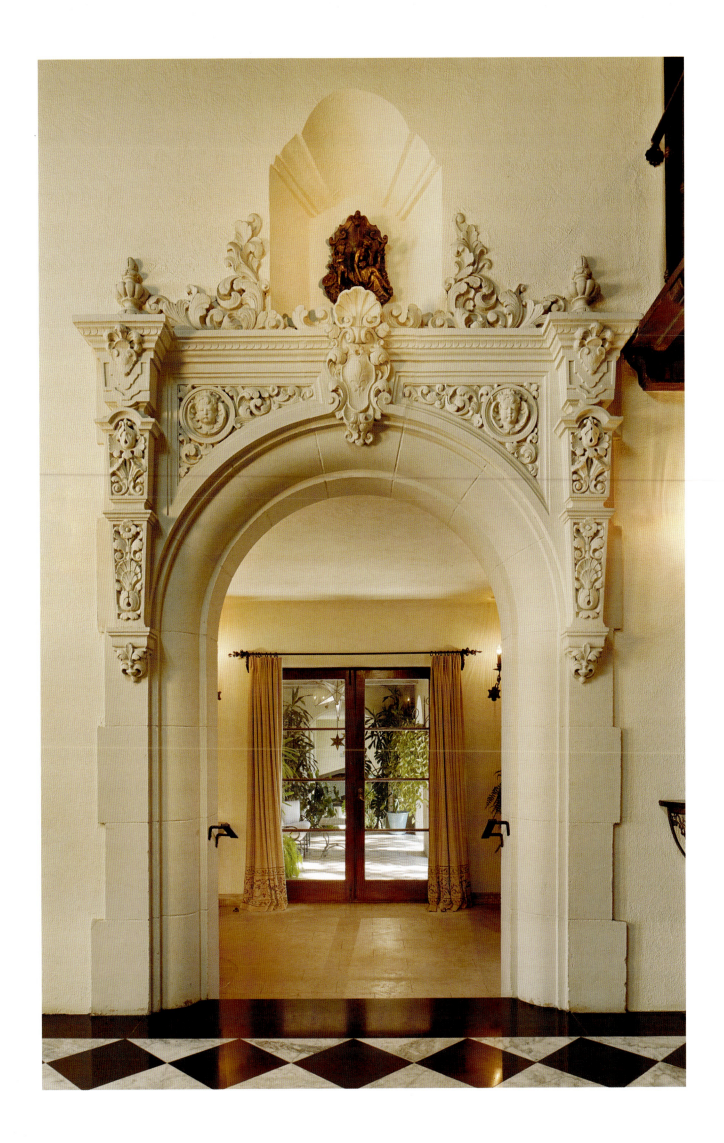

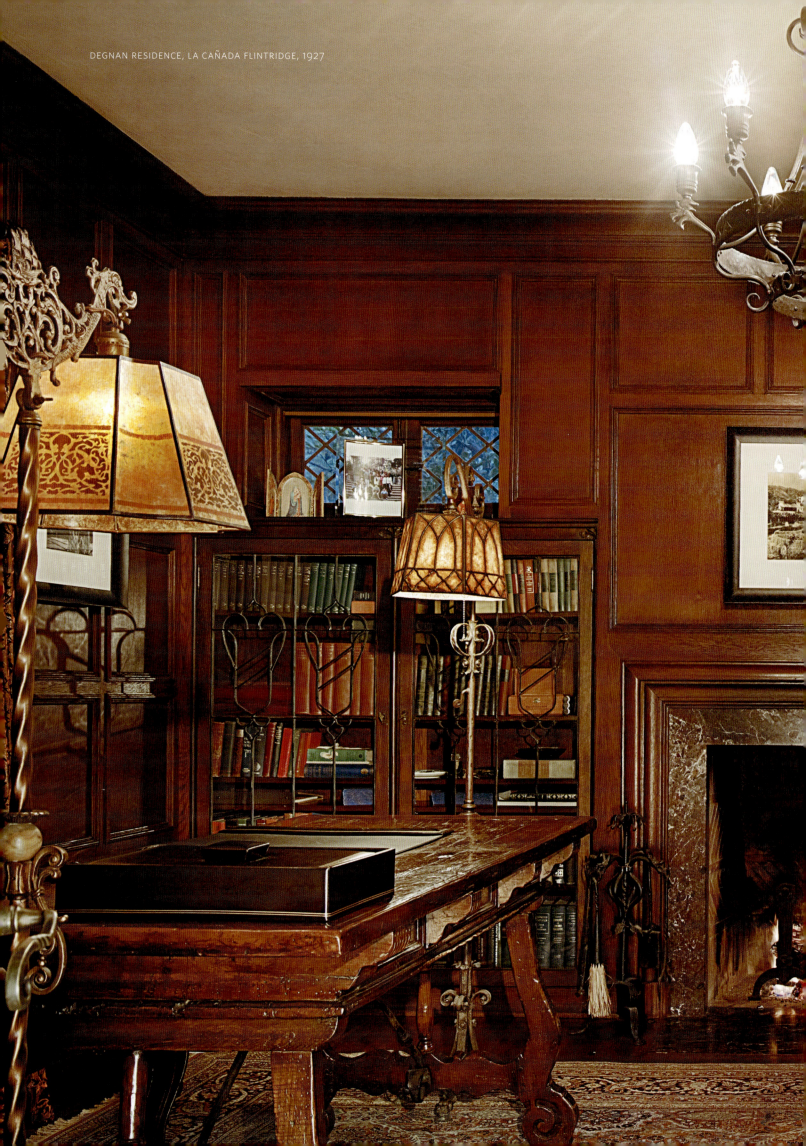

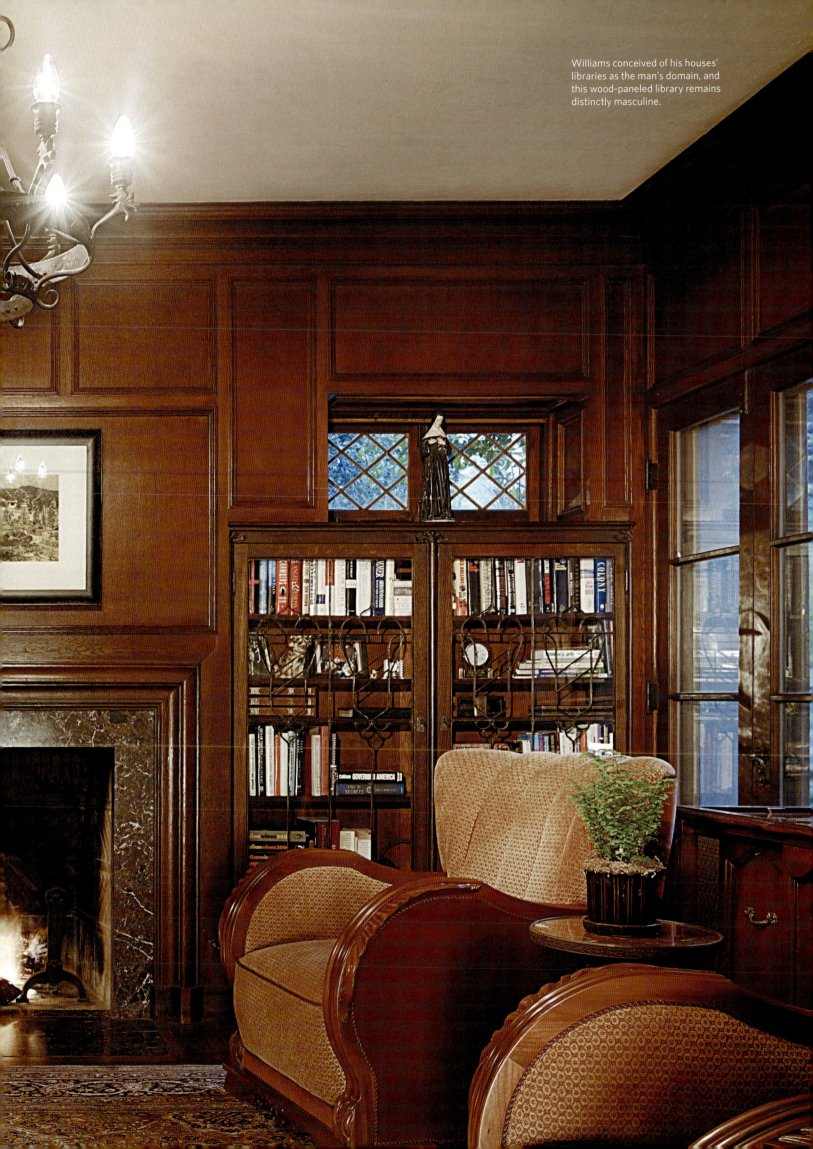

Williams conceived of his houses'
libraries as the man's domain, and
this wood-paneled library remains
distinctly masculine.

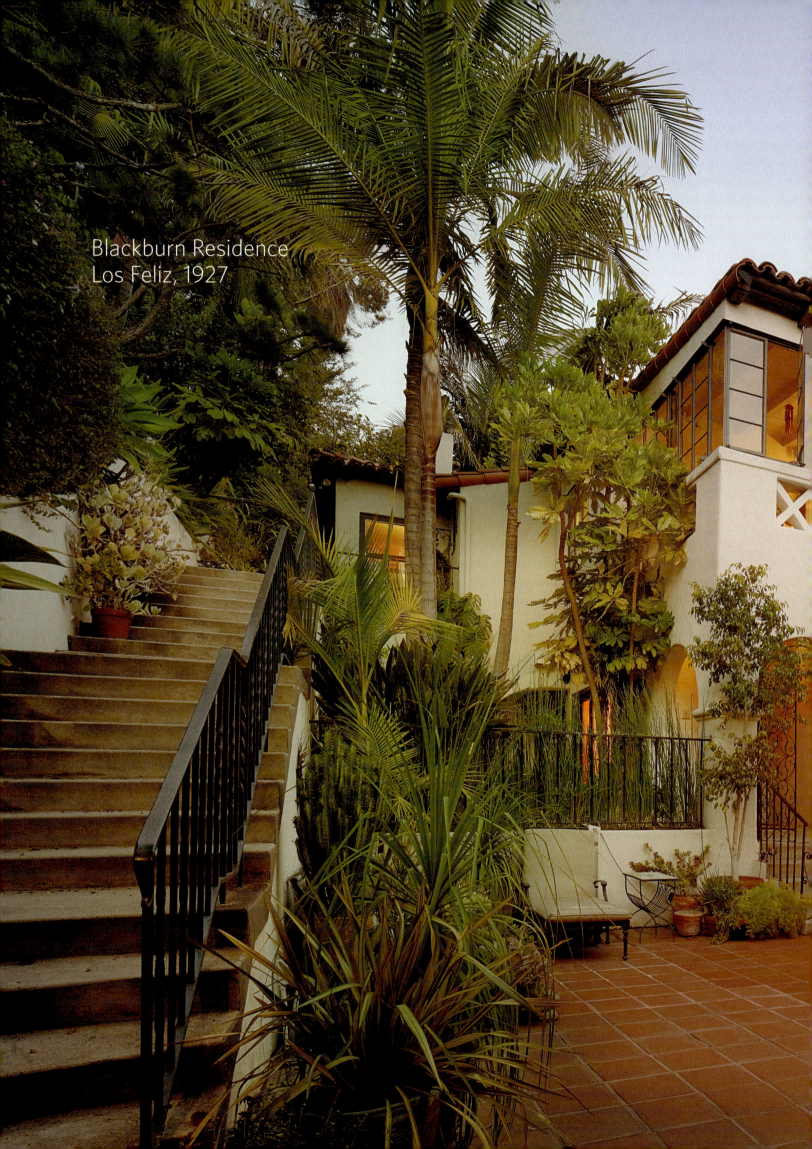

Blackburn Residence
Los Feliz, 1927

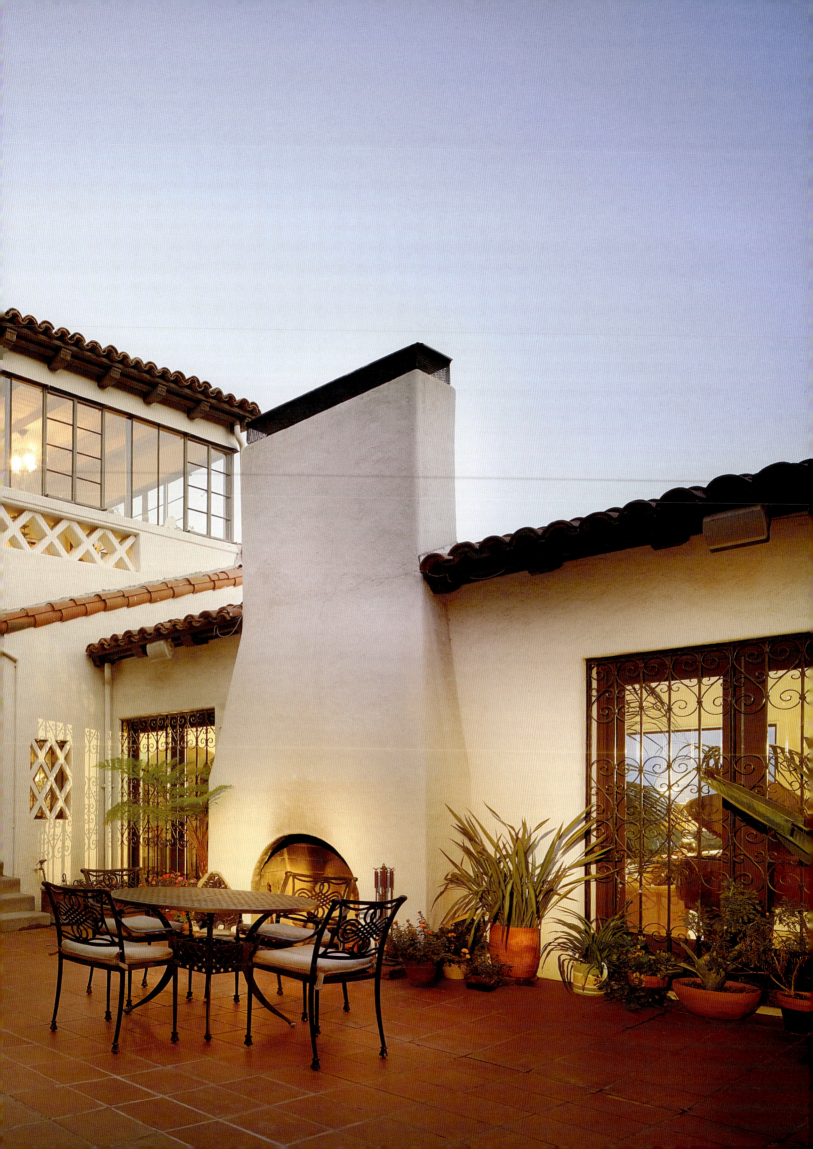

I came to realize that I was being condemned, not by a lack of ability, but by my color. I passed through successive stages of bewilderment, inarticulate protest, resentment, and finally, reconciliation to the status of my race. Eventually, however, as I grew older and thought more clearly, I found in my condition an incentive to personal accomplishment, an inspiring challenge. Without having a wish to "show them," I developed a fierce desire to "show myself." I wanted to vindicate every ability I had. I wanted to acquire new abilities. I wanted to prove that I, as an individual, deserved a place in the world.

— "I AM A NEGRO"

THIS HILLSIDE SPANISH COLONIAL REVIVAL HOUSE was built for Bruce and Lila Blackburn. Bruce, an inventor and manufacturer, owned the house until 1978. Like many of Williams's favorite clients, he used his imagination for creative problem solving, inventing a system of screens that roll up and disappear into a casement, which is still sought after today. And like many other clients, Mrs. Blackburn was active in women's clubs, including the prominent Ebell Club, so the home was often featured in society pages as an important gathering place for eager guests. The original house had pipes for a pipe organ, clearly a sign they enjoyed entertaining. Perhaps it is the way the home is situated on the hillside that most embodies Williams brilliance and expertise. Its elegance can be felt long before you enter the house.

If you decline a ride on the elevator that connects the garage to all the levels of the house, it's a stroll up more than eighty steps to the front door. The turned wood and handcrafted columns that grace the arched openings of the facade and the two-story turret become visible as one takes the final steps to the multipaneled, arched front door. The extensive use of wrought iron and stenciled ceilings in the double-height arched and wood-paneled main hall are indicative of Williams's details of the time.

Once again he brings the outdoors in with the patio and fireplace, which were meant to be an extension of the main house. Owners John and Cheryl Sweeney love hosting family gatherings, especially at Christmas. Their family is very important to them, and they believe Williams's design showcases how he too believed that the family and their comfort was of utmost importance. The lush gardens and terraced landscaping were enhanced in 1962 when Williams returned to design a lath house. The Sweeneys "don't believe it is a mere coincidence that we found and purchased this home," says John. "We believe that Mr. Williams wanted us to have it and there was some divine intervention at work." Their favorite room remains the living room because the large picture windows frame a view of the downtown skyline. But for this family the real treasure lies in the house's history. As John says, "Being African American, it is so special to live in a home that, when it was built, had a racially restrictive covenant, yet it was designed by a black man." ✮

PREVIOUS PAGES:
The backdrop for many memorable family celebrations over the decades, this outdoor patio with fireplace remains a favorite gathering place. The stairs lead to the terraced garden.

OPPOSITE:
The view into the stair hall reveals arch after arch. The unique handcrafted wrought-iron balusters, with their bowed bottoms, attest to the ever-present individuality of Williams's designs.

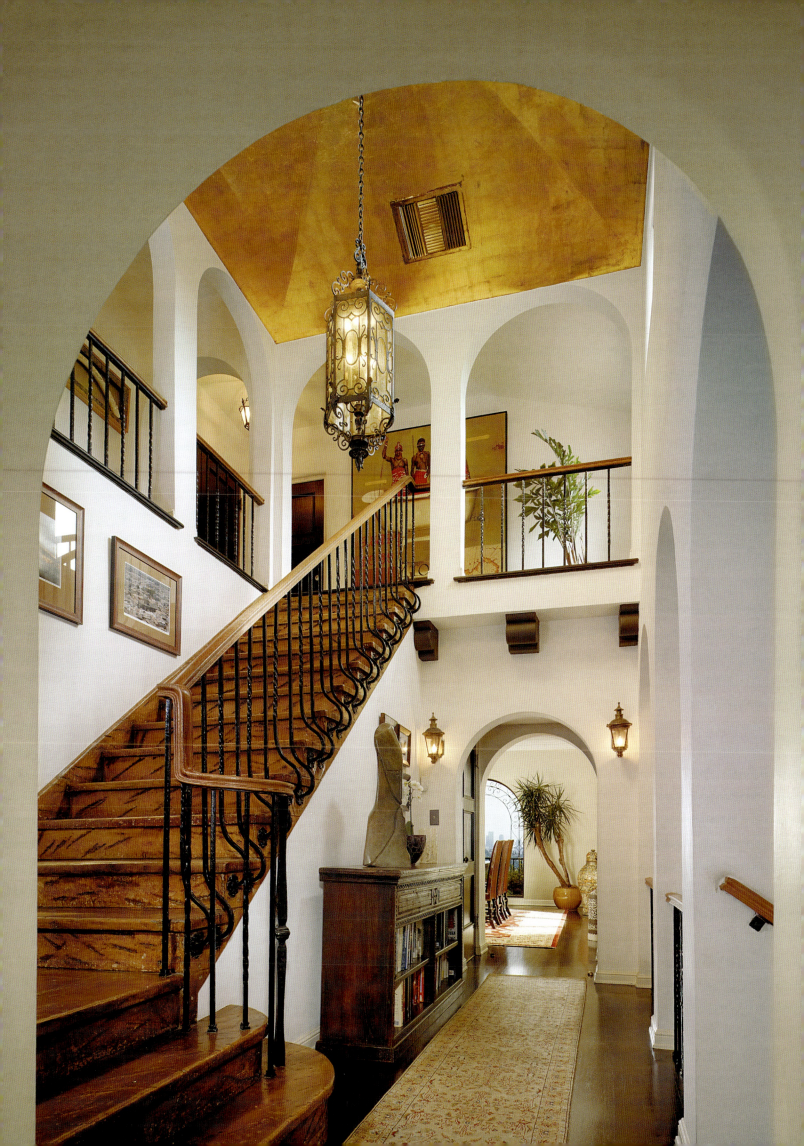

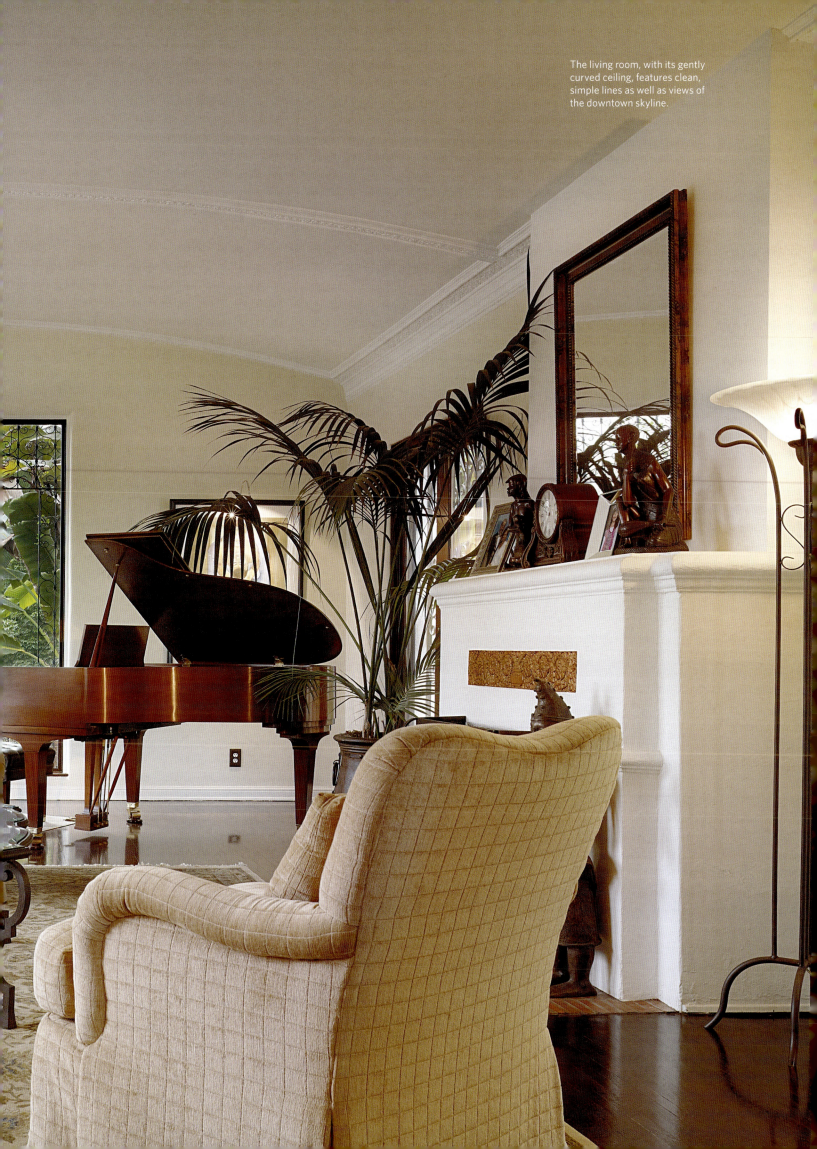

The living room, with its gently curved ceiling, features clean, simple lines as well as views of the downtown skyline.

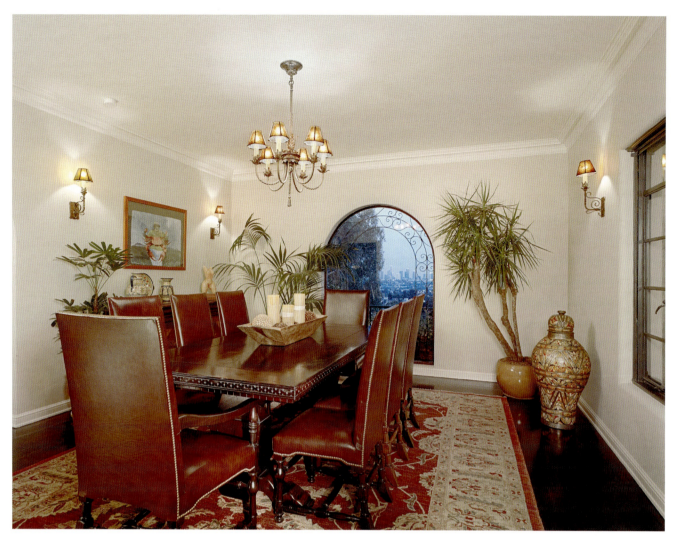

ABOVE:
The dining room's window is
framed in wrought iron.

OPPOSITE:
Like all of Williams's breakfast
rooms, morning light fills the
space.

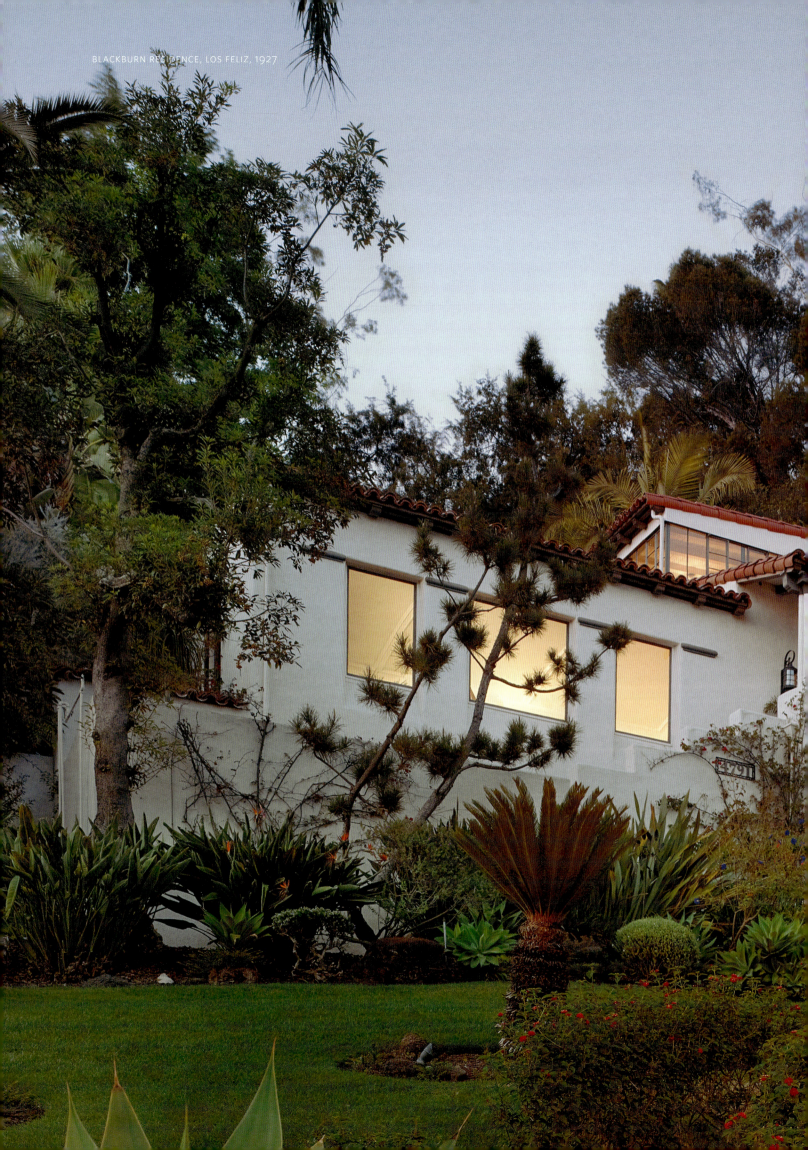

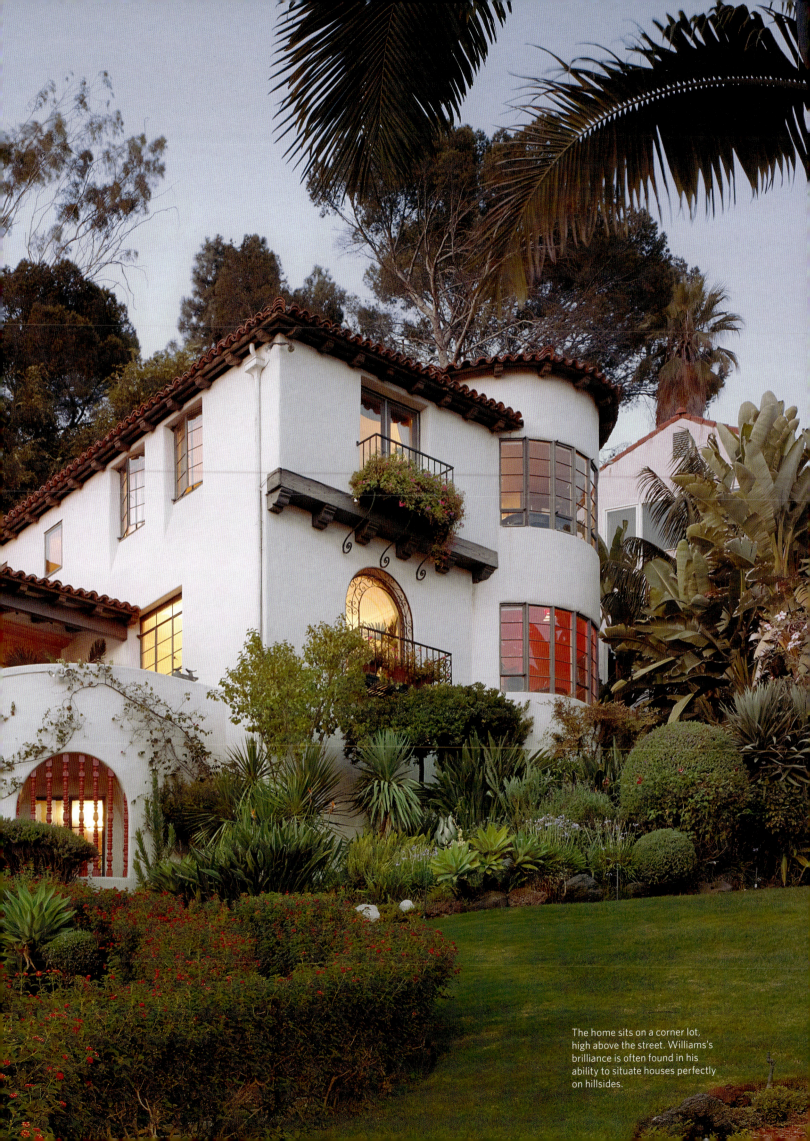

The home sits on a corner lot, high above the street. Williams's brilliance is often found in his ability to situate houses perfectly on hillsides.

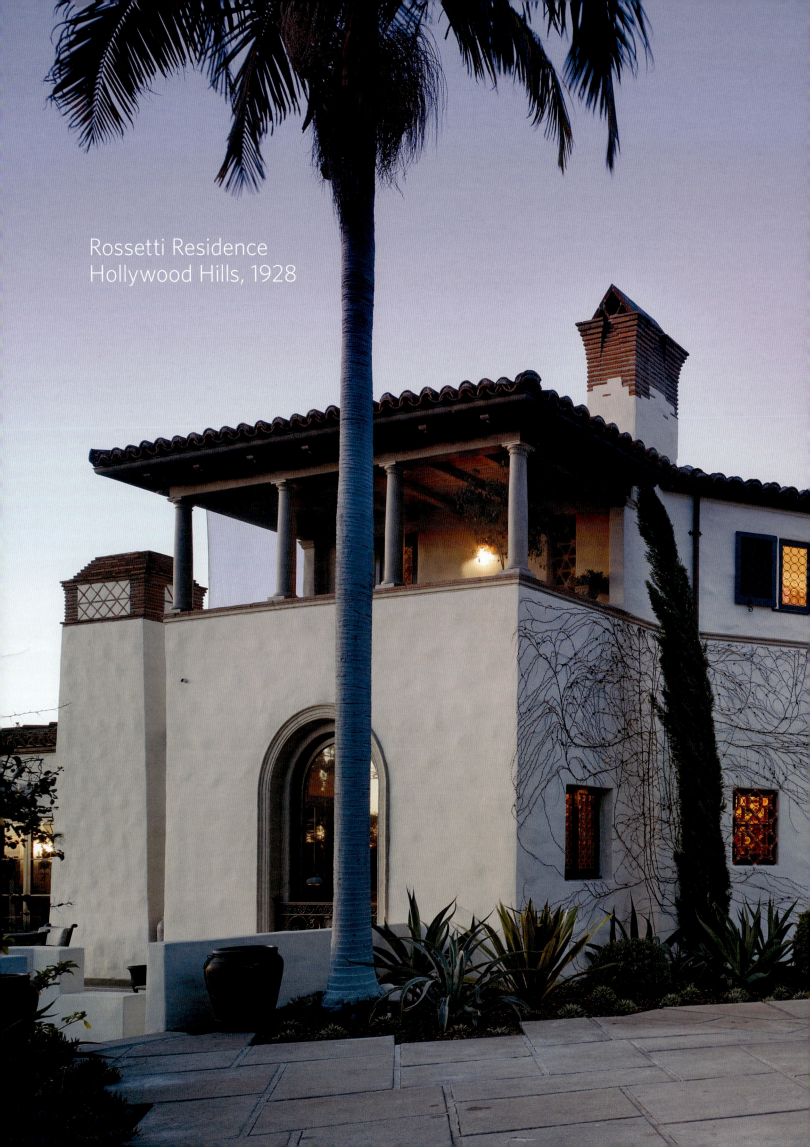

Rossetti Residence
Hollywood Hills, 1928

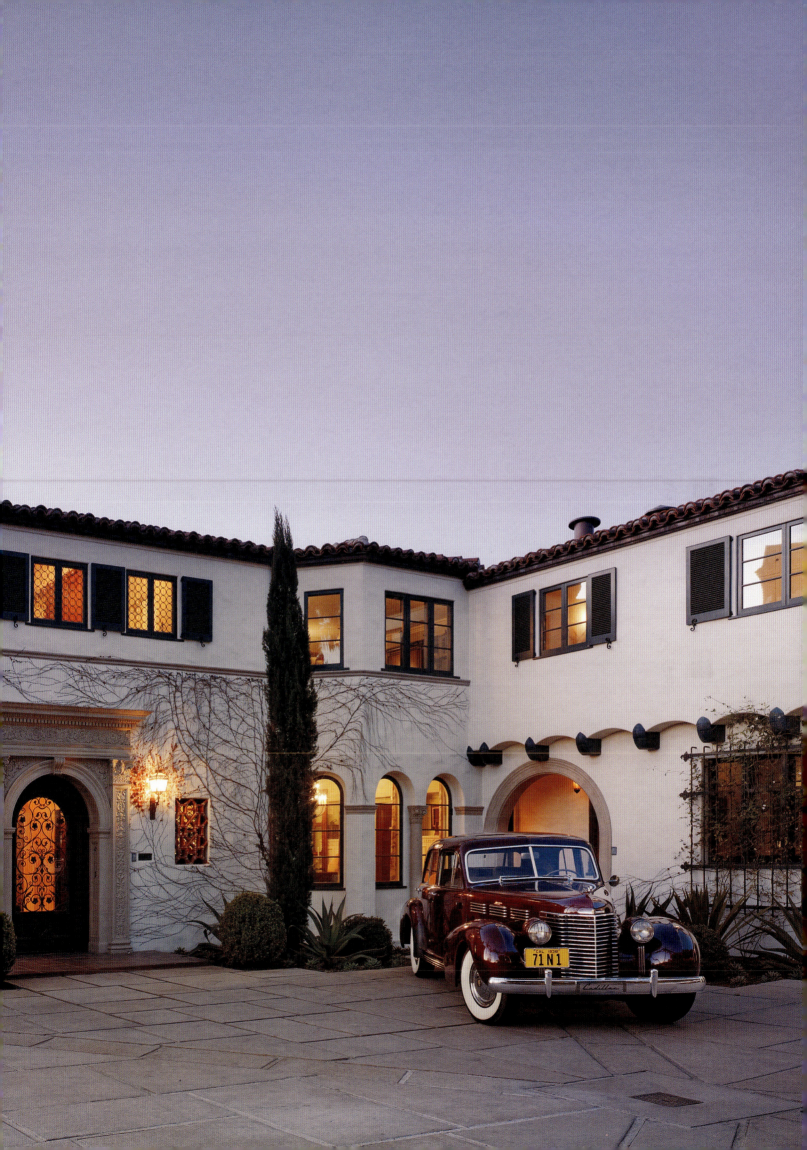

There is also the matter of style versus design. Design concerns itself with the overall formal solution to a problem of building. But buildings too must wear styles which give them an association to a certain period of time. How carefully the architect balances the elements in his work to a good degree determines the stature attained by him in his profession. Buildings are monuments which are meant to be functional, lived in, and to serve a definite purpose. They are meant to be more than fashionable for it is not the purpose of good design to be merely fashionable but rather to create something which has an enduring effect on the beholder as does the material from which it is made.

— "AN ARCHITECT'S APPROACH TO PLANNING"

VICTOR ROSSETTI, who was vice president of Farmers and Merchants Bank at the time this Spanish Colonial Revival house was being constructed, became its president in 1931 and lived in the home with his wife, Irene, and their children until his retirement in 1950. Years ago, their daughter, Eleanor Hunt of Pasadena, shared with me her favorite memories of the house, including the announcement of her engagement in 1943, as well as the fact that when the Rossettis moved in, the Griffith Park Observatory, which sits on a knoll above the house, had yet to be built.

Williams returned to the house in 1937 to design the addition of a porch, extending the home's outdoor living space. And, in keeping with the times, there was a hidden bar in the recreation room, a nod to Prohibition. The current residents, Bruce Hatton and Tom Young, are only the third owners of the house. They purchased their dream home from the Warren Hasler family after it sat vacant for a number of years. Fearful they would not be able to afford the house, they appealed to the family, sharing their vision for restoring the house to its original brilliance. And what was once a distant dream was suddenly a promise to keep.

Once again, the entrance is particularly impressive, this time distinguished by a glass, wood, and wrought-iron door that allows a glimpse through the house, arches to arches. The vines on the exterior change with the seasons, from lush green to bare vines, adding to the classic elegance of the house in any season.

One immediately enters a two-story foyer featuring a grand staircase and views into the formal living room with its coffered and stenciled ceiling and massive fireplace and mantel. The views from the living room could not have been an accident, for they are indeed grand. A few steps away is the library, a welcoming space in many Williams-designed houses and a favorite room of the current owners. The arched ceiling boasts a hand-cast plaster ribboned detail in raised relief. The eight-foot-high arched window, with original hand-wrought iron grill mounted at its base, faces the meditation garden. The hand-carved walls with built-in bookcases, of English oak, and marble fireplace complete this jewel of a room and make it perfect for whiling away an afternoon with a good book.

It is the loving restoration, with its incredible attention to detail, that is the real star of this home. From the kitchen's original tile ceiling and warming oven and butler's pantry, which sit side by side with updated appliances, to the cabinetry built from Williams's original plans, which have been handed down from owner to owner, no detail has been overlooked. Even the original servants' call system has been meticulously restored, complete with the name of the original maid, Corine. The proportions of each unique room fit seamlessly into a logical, elegant floor plan that is as relevant today as when it was first conceived.

For Hatton and Young, the most special thing about living in a Williams house is becoming aware, again and again, of the quiet attention to detail that was conceived and implemented in the design and construction of their home. They notice the most minute details, whether "in the continuity of the wrought-iron

PREVIOUS PAGES:
Depending on the season, one is greeted with either green ivy or barren vines covering the home. The regal entrance frames the glass door, intricately detailed with wrought iron.

OPPOSITE:
Corinthian columns, which are repeated throughout the house, brace the multiple arches of this entry hall. The coffered ceiling, uniquely tiled floor, and ornate stair rails are characteristic of the details that grace the entire home.

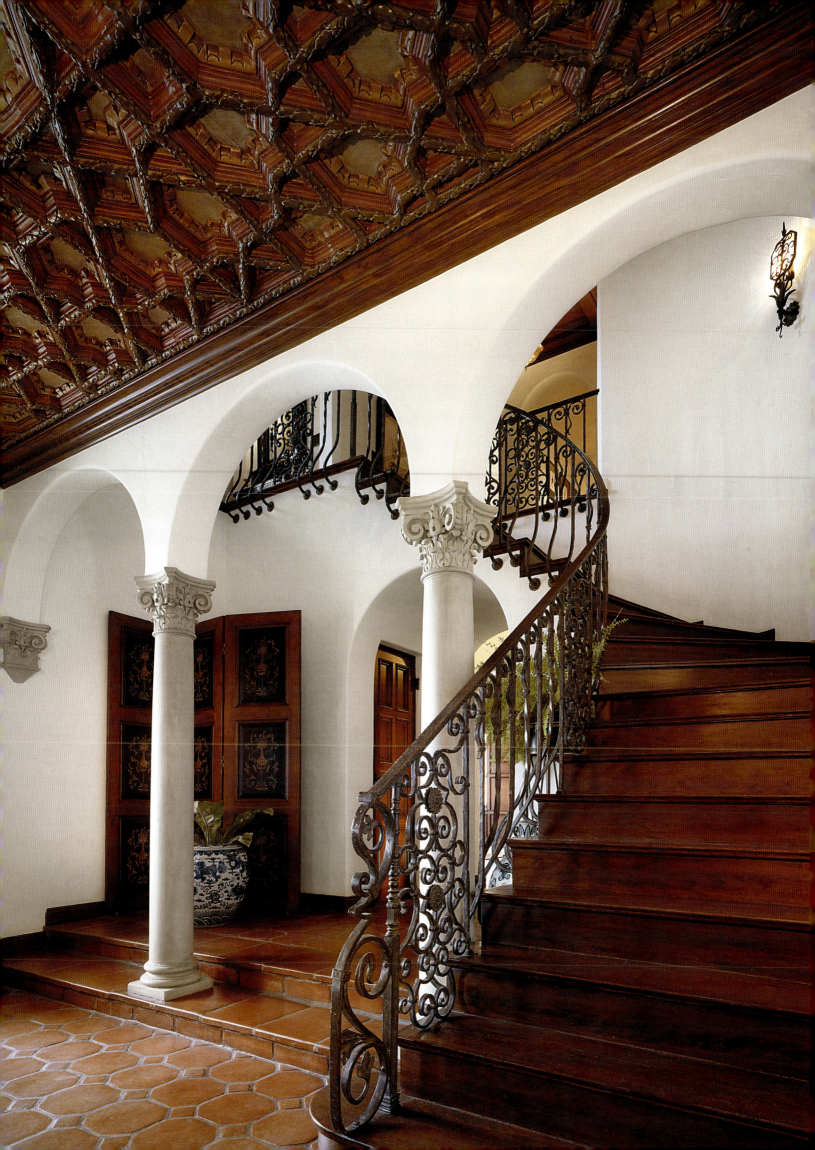

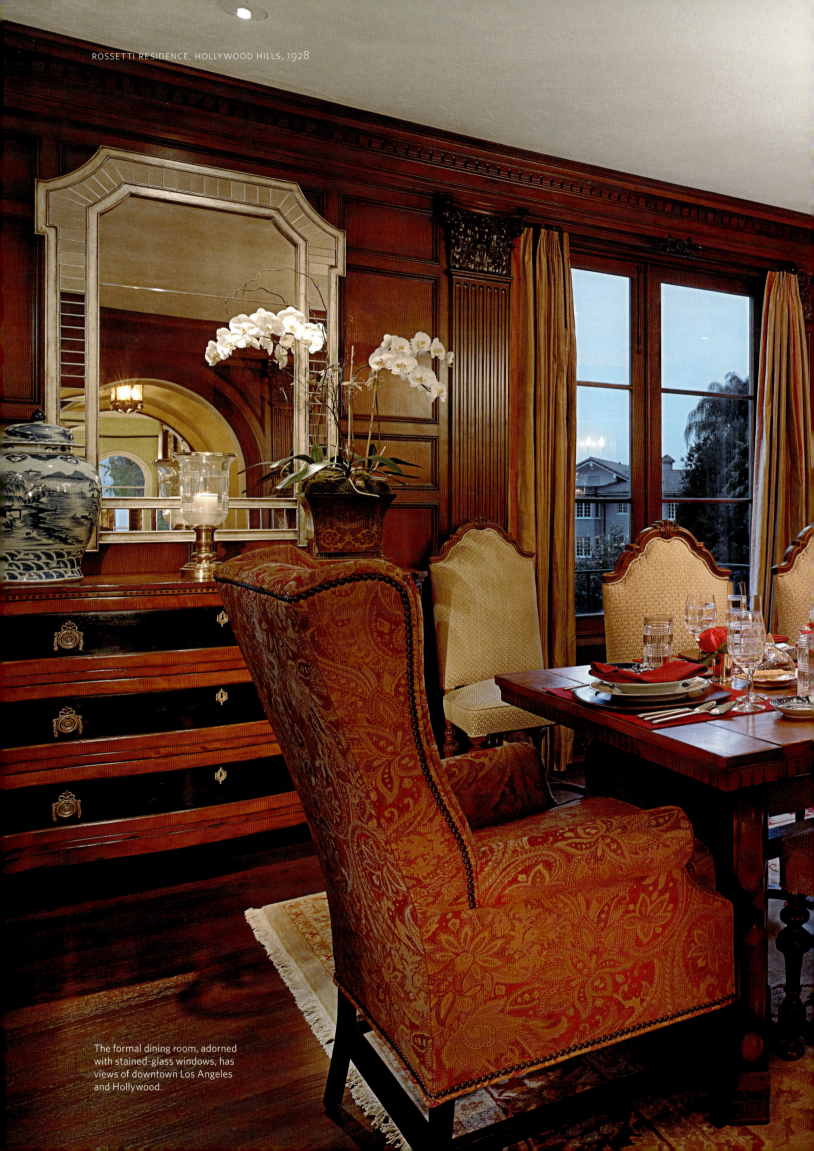

The formal dining room, adorned with stained-glass windows, has views of downtown Los Angeles and Hollywood.

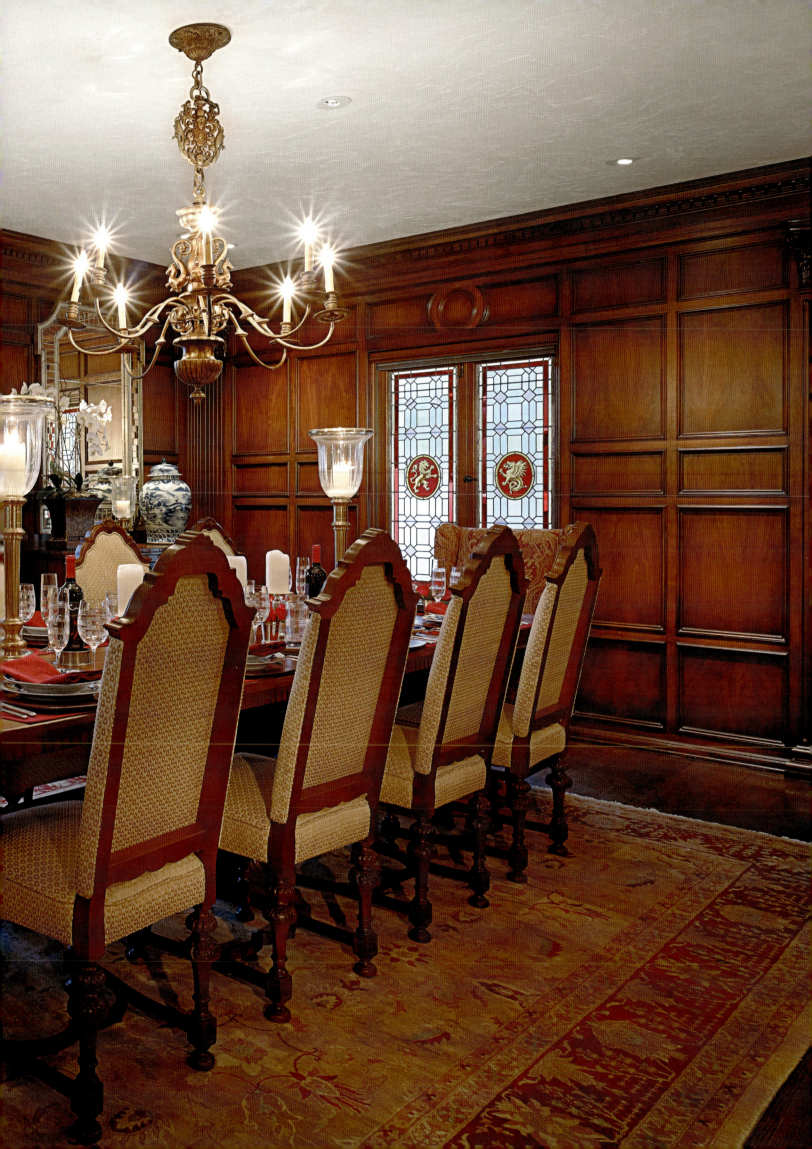

Situated off the main entry hall, the library offers the perfect afternoon escape with built-in bookcases, a marble fireplace, and an eight-foot-high window.

work, the column capital variations in shape and design, the carved wood doors that match the tiled floor patterns, or the incredible door knobs that vary from one side of the door to the other."

Everywhere one turns are arches, none more prominent than the hand-carved wood arches visible through the repeated view from the dining room to the breakfast room. The house is also graced with Corinthian columns in both wood and plaster. It is within the owners' favorite room, the dining room, that the wood columns are most spectacular. Here Hatton and Young usually set the table for twelve, light the candles, uncork and pour the wine, and toast their friends, old and new. They say the laughter is generous and full, shared with all who are fortunate enough to dine in this enchanting home. ✫

The massive fireplace and coffered wood ceiling lend warmth and intimacy to the large living room.

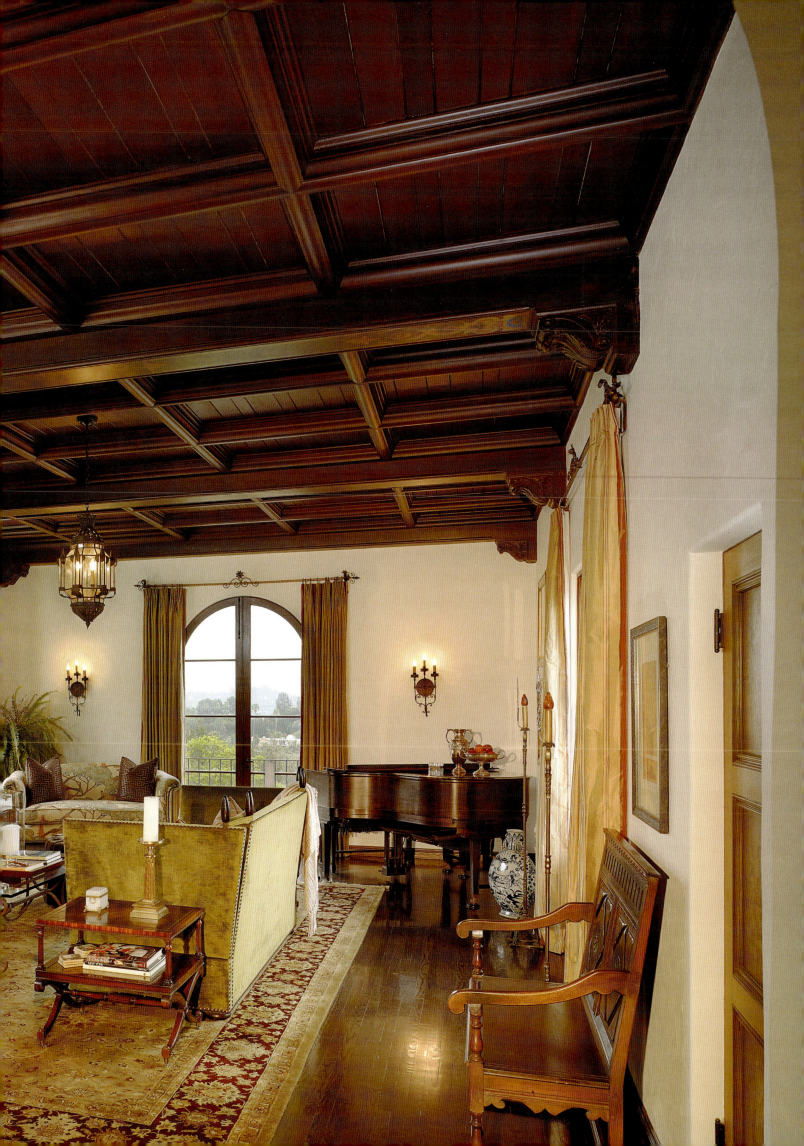

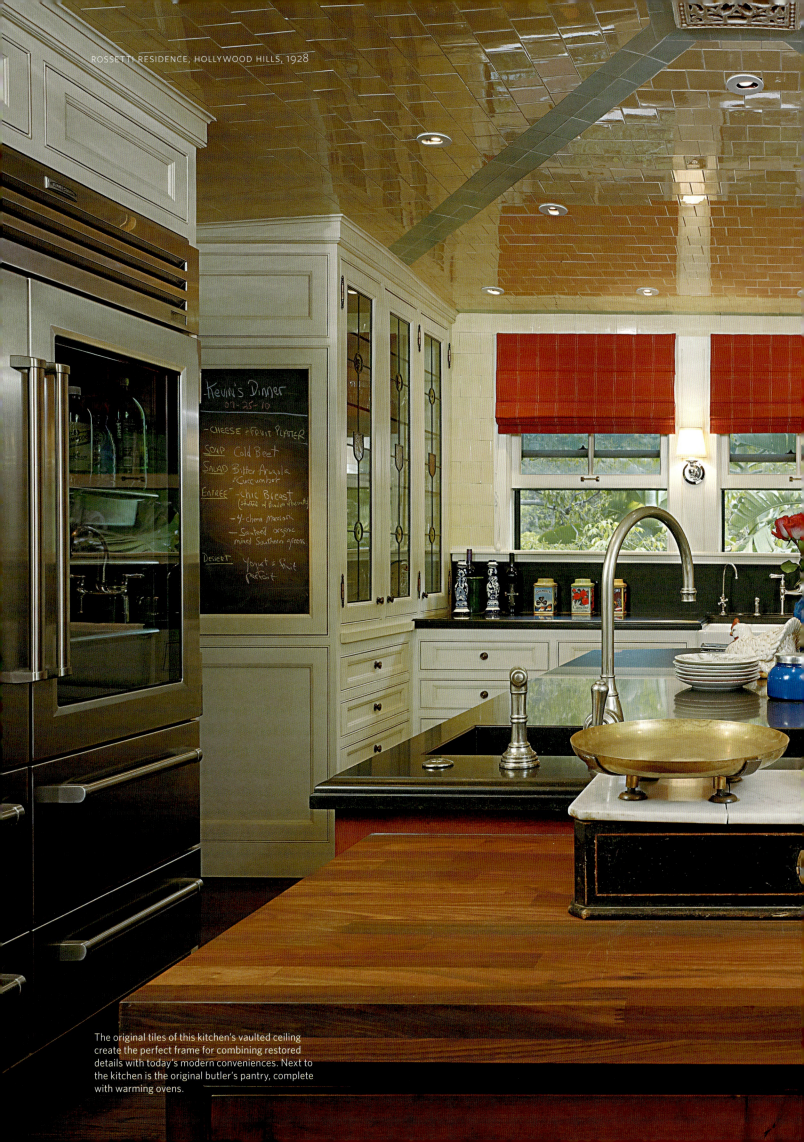

The original tiles of this kitchen's vaulted ceiling create the perfect frame for combining restored details with today's modern conveniences. Next to the kitchen is the original butler's pantry, complete with warming ovens.

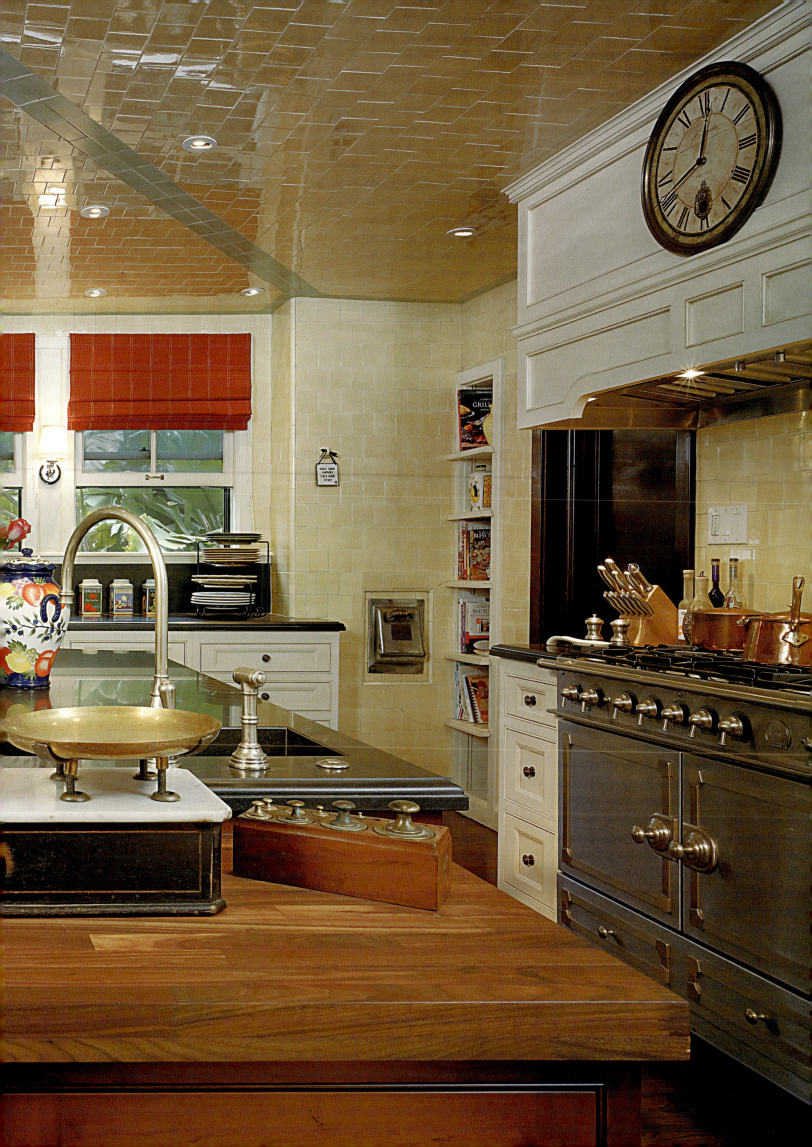

Bastheim Residence
Hancock Park, 1929

READ, LISTEN and THINK. Henry Ford said thinking is the hardest job there is today and millions of dollars are being spent to develop Think factories in the U.S. today. In the architectural field we call it Imagination. It is amazing—once you get tuned in on an idea how many improvements you can think of.

— AUTOBIOGRAPHICAL NOTES

TODAY'S OWNERS of the Bastheim Residence knew that they were home from the moment they first walked through the front door. This Monterey Colonial house with lavish gardens must have also given that "first love" feeling to Edmund and Irene Bastheim, the original owners. Edmund was a wholesale jeweler who shortly after building the home became the first president and chairman of the board of the Jewish Vocational Service of Los Angeles, which helped Jewish refugees find work in the midst of the Great Depression.

Judging from the original design of the kitchen and butler's pantry, the Bastheim's enjoyed entertaining. By the time singer and movie star Nelson Eddy, best known for the films he starred in with Jeanette MacDonald, and his wife bought the house, it had undoubtedy already weathered a number of soirees. The current owners enjoy the dining room, which is both formal and relaxing. When asked about the most special thing about living in the home, they didn't hesitate to note the impeccable dignity of the design and the extraordinary quality of construction. Earthquakes over the years have caused virtually no structural damage at all. Perhaps, says the current owner, that is why "everyone seems to feel calmer and safe within its walls."

The understated elegance of the generous balcony, pristine white exterior, and black shutters would become among the most popular design elements of Williams's houses. Once again arches appear throughout the home, but here they are adorned with fine details. The living room, the largest room in the house, exudes a feeling of intimacy and coziness in spite of it size. The room's innate balance and harmony is a design feature not lost on the current owners. They also love the alcove off the master bedroom, even though they have never quite figured out what it was designed for. The kitchen is their favorite gathering spot, and they have remodeled it to reflect their love of cooking and casual entertaining, enjoying the company of friends who never fail to congregate there. ☆

OPPOSITE:
Southwestern-style rugs collected by the owners accent the stair hall, viewed here through a masterfully detailed wooden arch.

FOLLOWING PAGES:
The homeowners can greet visitors from the expansive veranda. Williams is known for detailing white Colonial Revival houses with black shutters.

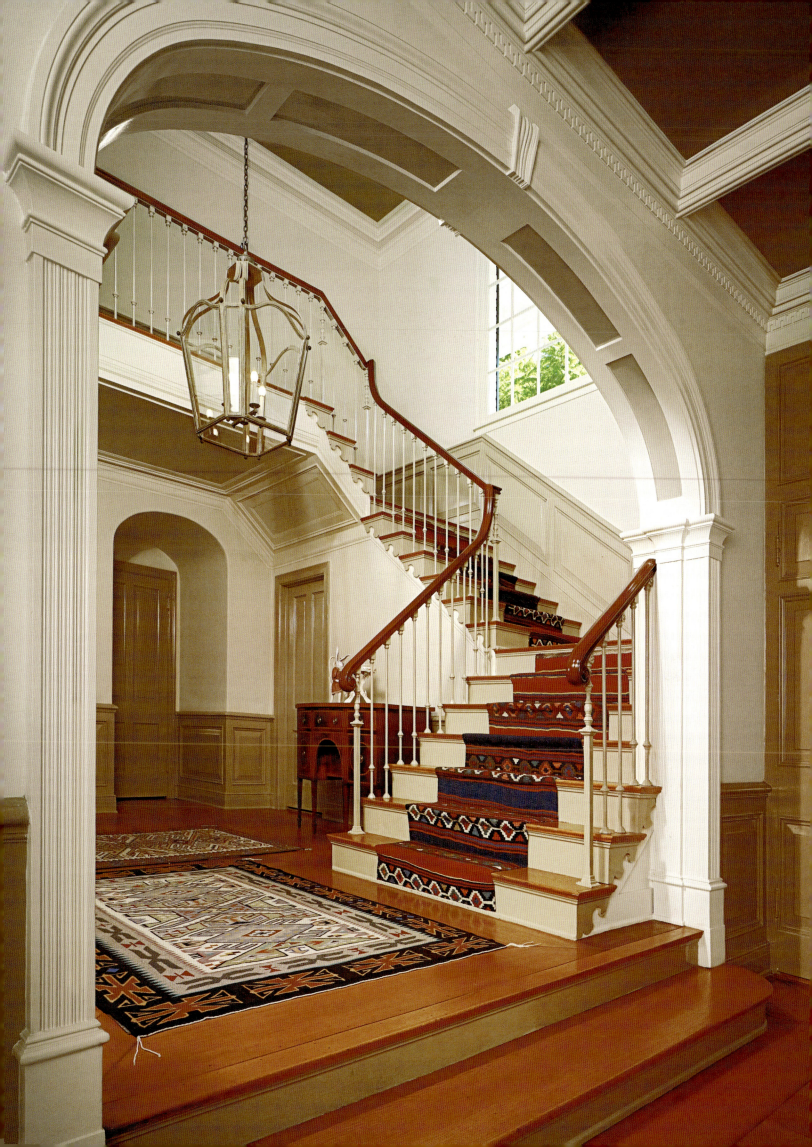

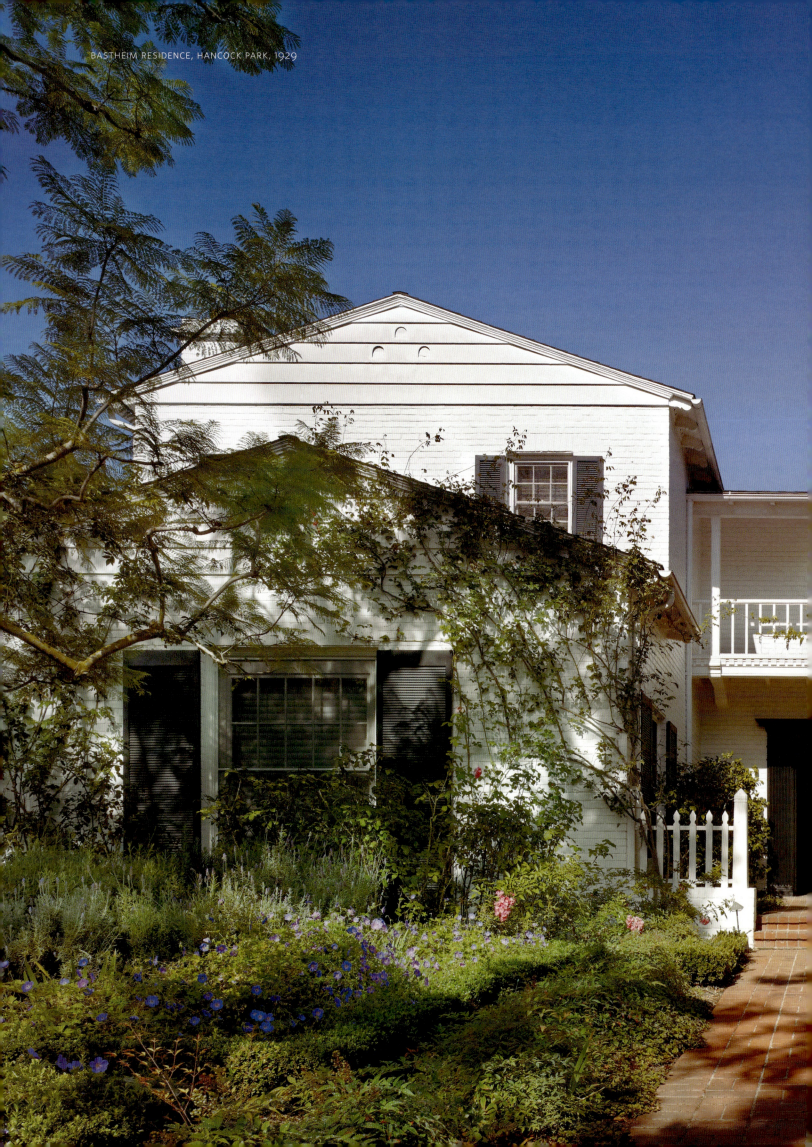

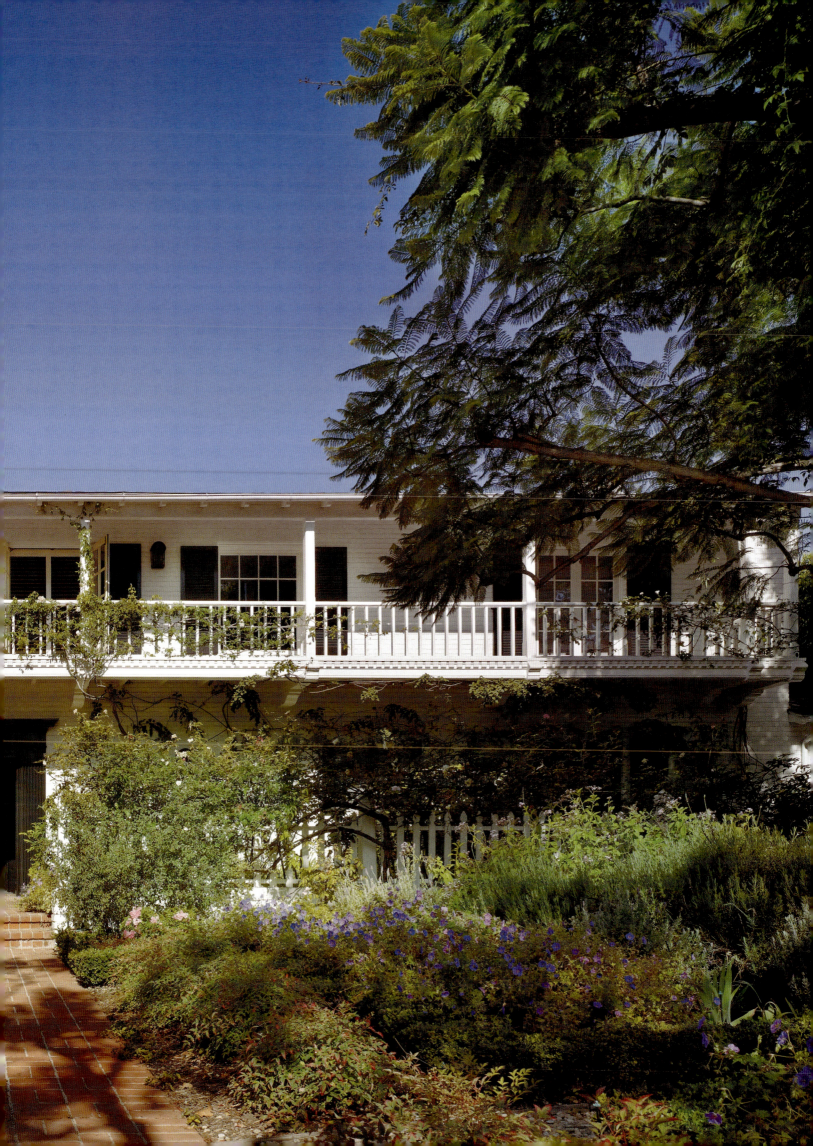

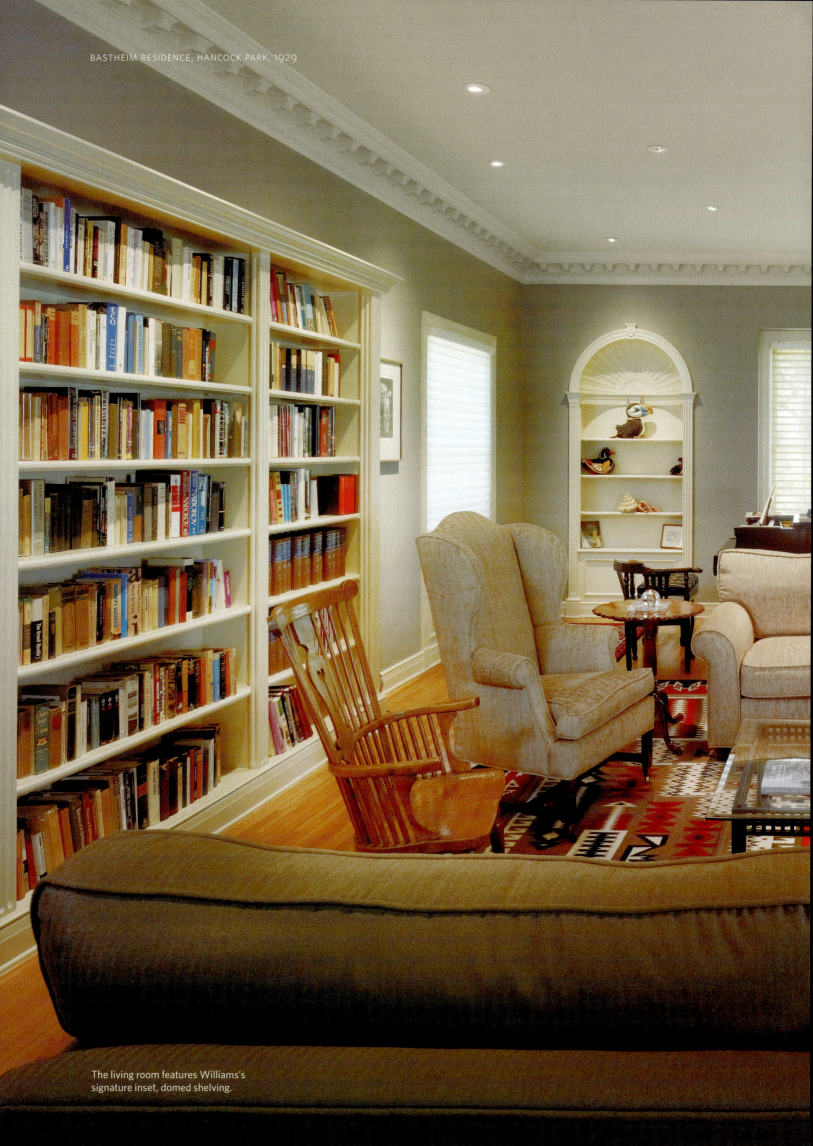

The living room features Williams's
signature inset, domed shelving.

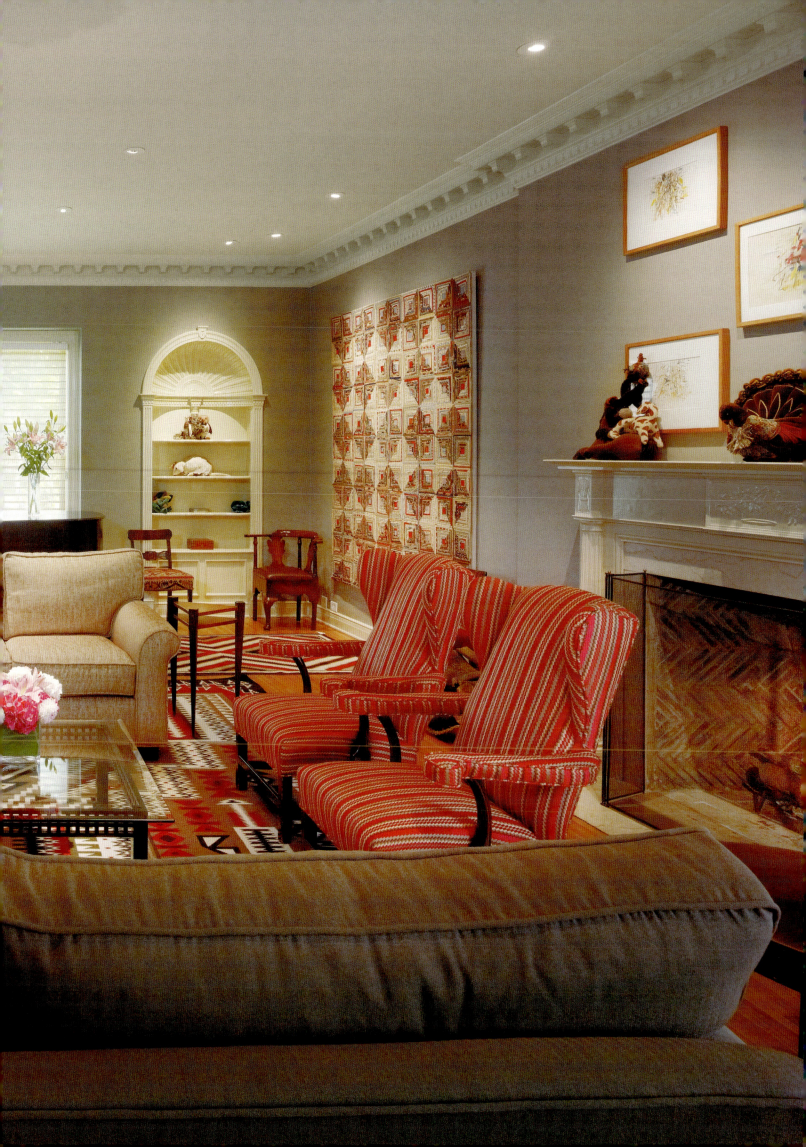

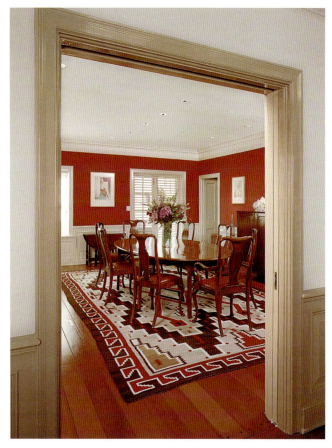

ABOVE:
View of the light-filled
dining room.

RIGHT:
Updated for today's most
demanding gourmet culinary
endeavors, the kitchen has been
remodeled for entertaining
friends while preparing meals.

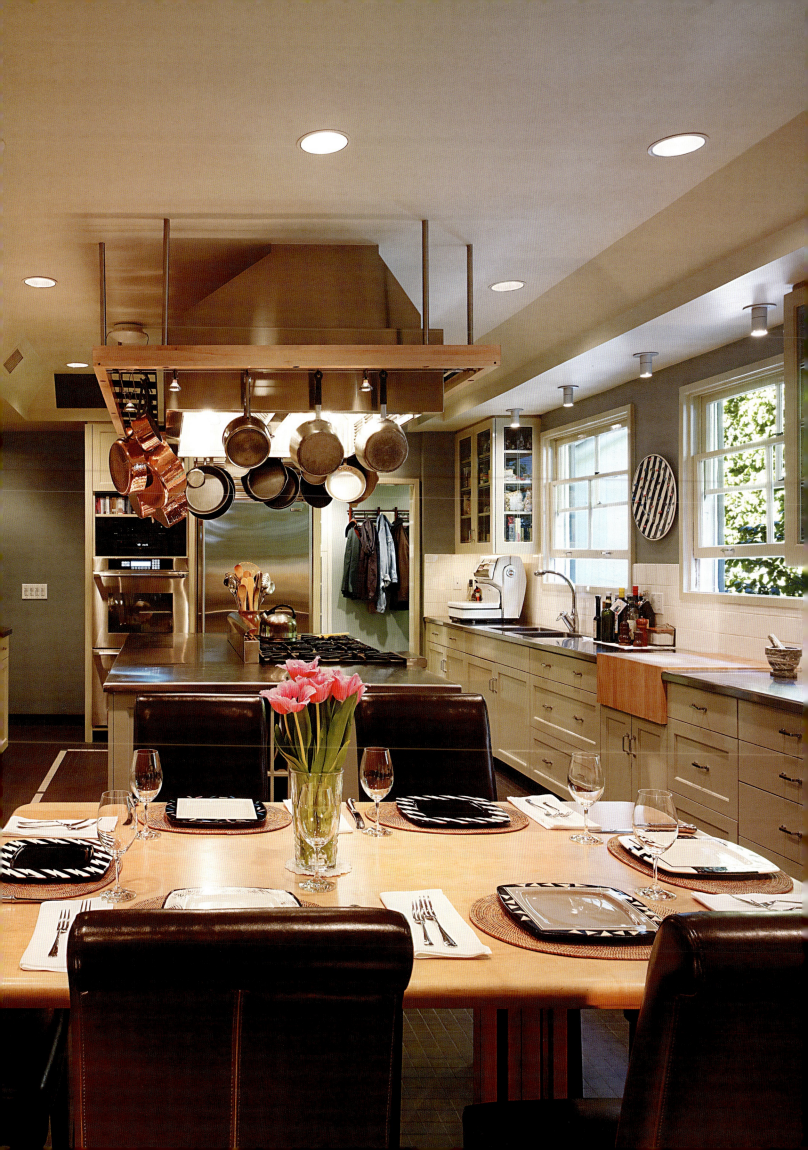

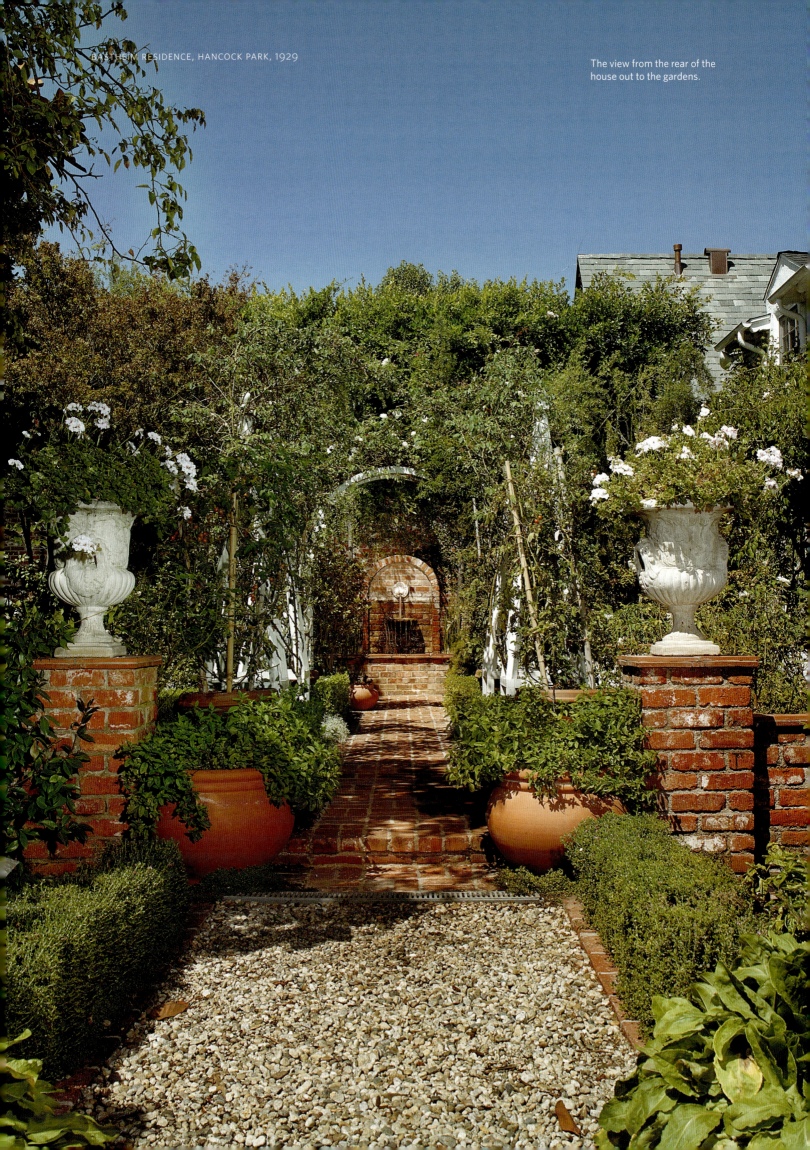

The view from the rear of the
house out to the gardens.

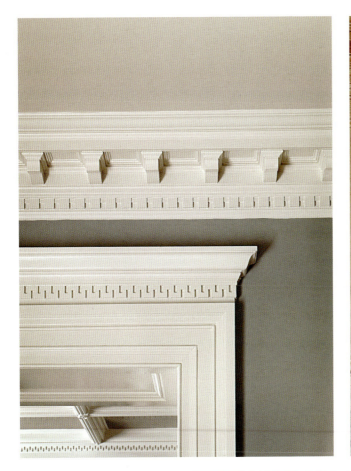

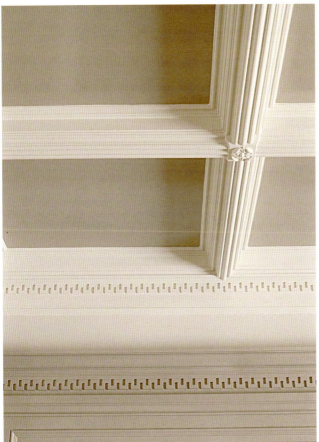

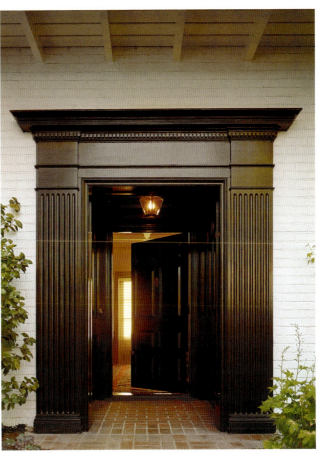

Paul Williams was one of the few architects who knew how to combine grace, elegance, and warmth. Living in his house was as close to a perfect environment as one could find. He provided the owner with a gracious space to both live and entertain. And do you want to talk about his moldings? I could go on and on!

— JOAN RIVERS

ABOVE, CLOCKWISE FROM TOP LEFT: Ceiling and door moldings; the copper hood of the fireplace in the pinewood-lined library; main entrance; ceiling details.

Ford Residence
Ojai, 1929

My first approach to architecture is to create a
pleasant environment for human beings to work in
and live with. And, to try to win back the freedom
that the automobile has taken away.

— AUTOBIOGRAPHICAL NOTES

BY THE TIME WILLIAM FORD, cousin to Henry Ford, chose
Williams to design his Spanish Colonial Revival house, Williams's
second in the Ojai Valley, the Great Depression was in its early
stages. Fortunately, Ford, CEO and the largest stockholder of the
Libbey-Owens-Ford Glass Company, would not be deterred. (The
largest glass company of its time, Libbey-Ford manufactured
bottles for Coca-Cola and the innovative laminated safety glass
that was first used by the Ford Motor Company.)

The 14,000-square-foot house was one of the first to be built
in the Country Club Estates division of Ojai. Composed of sixteen
rooms built around a central courtyard, the house today lays
claim to being exactly the way it was the first time Ford and his
family walked through the front door after a four-year renovation
by the current owners, Stephen Rose and Rob Johnson. The house
and grounds were designed for grand entertaining and family
living, facts not lost on Rose and Johnson.

The home is deceptively simple in appearance. One drives up
to what appears to be a Spanish-style cottage, with a protective
facade that in no way suggests it is a large estate. In keeping with
its Spanish hacienda roots, a painted brick loggia welcomes
visitors and connects the generously proportioned and stately
public rooms with the central courtyard. A series of paired arched
doors face the courtyard, allowing natural light to illuminate the
loggia. The living room, Rose and Johnson's favorite room for
entertaining, is anchored by a majestic fireplace. One side opens

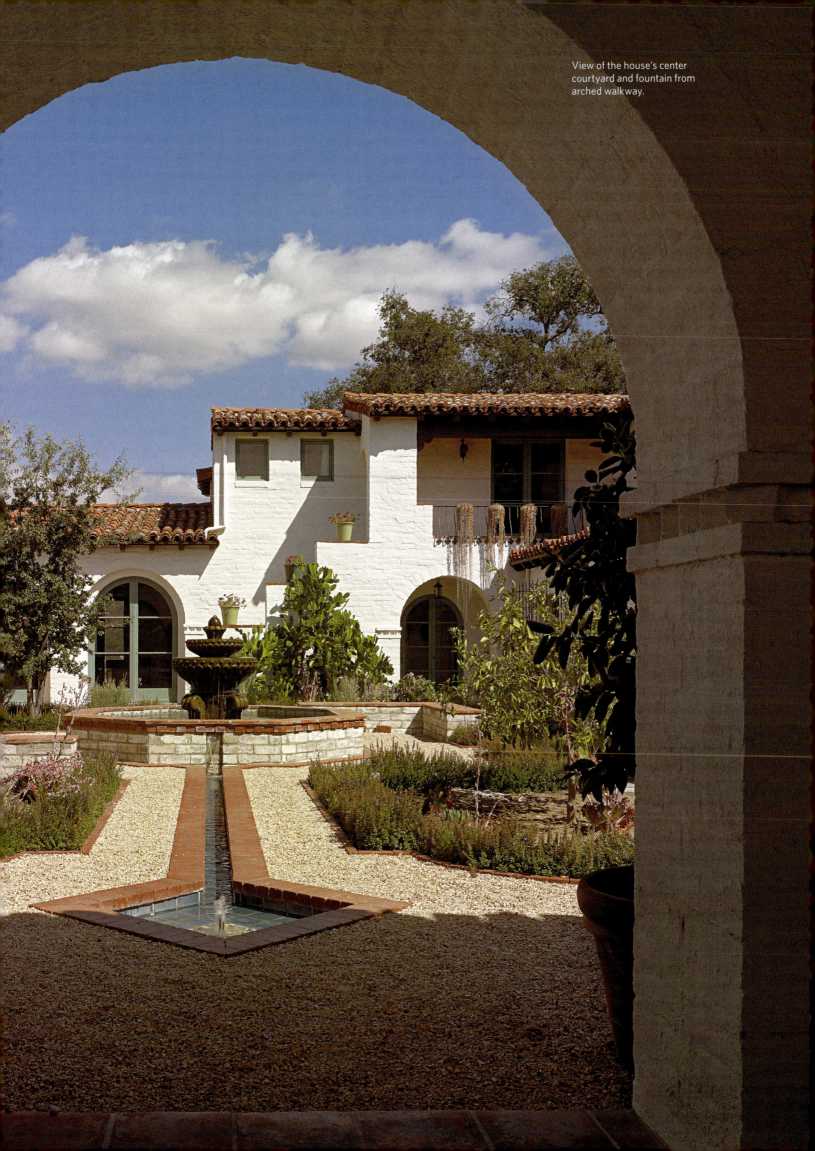

View of the house's center courtyard and fountain from arched walkway.

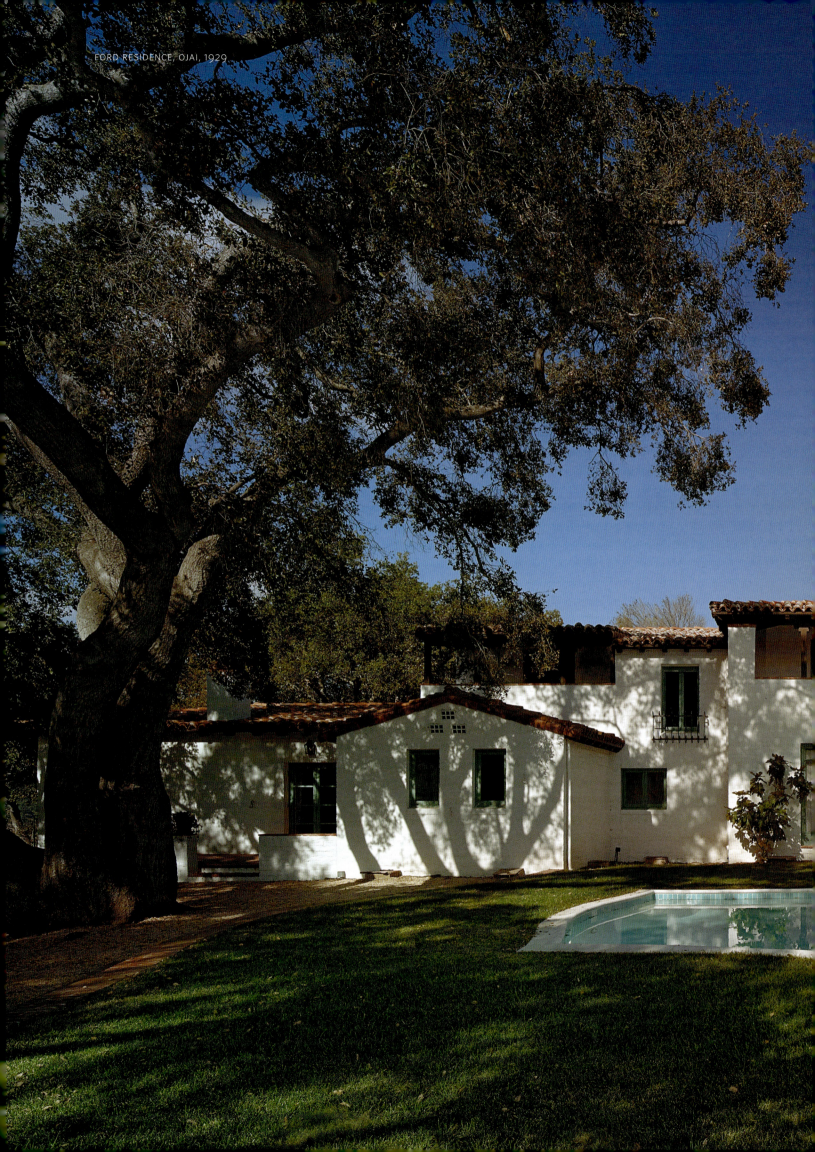

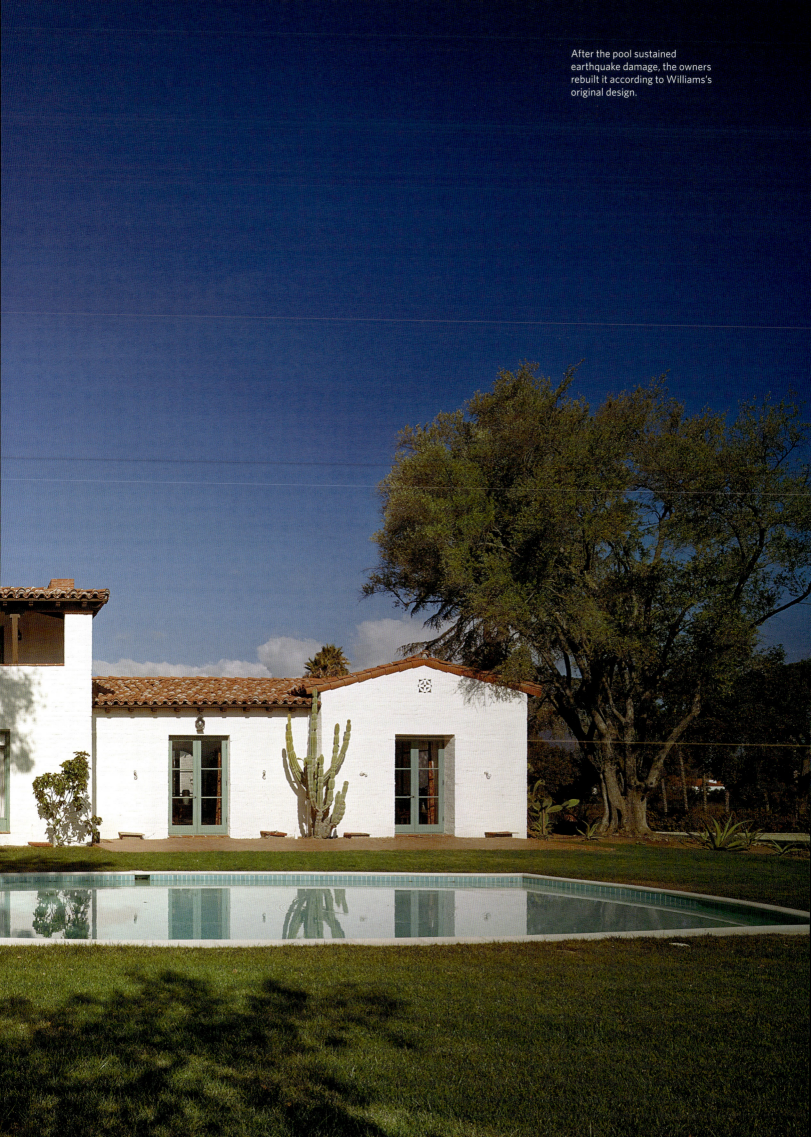

After the pool sustained earthquake damage, the owners rebuilt it according to Williams's original design.

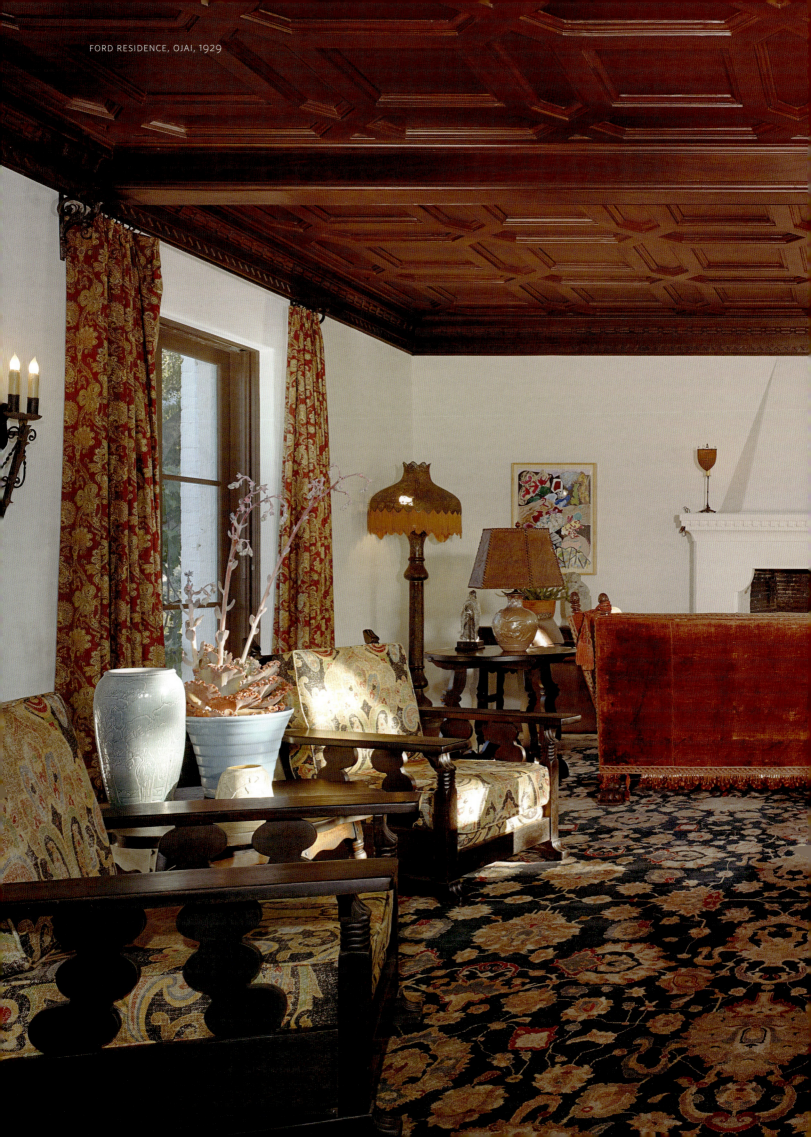

FORD RESIDENCE, OJAI, 1929

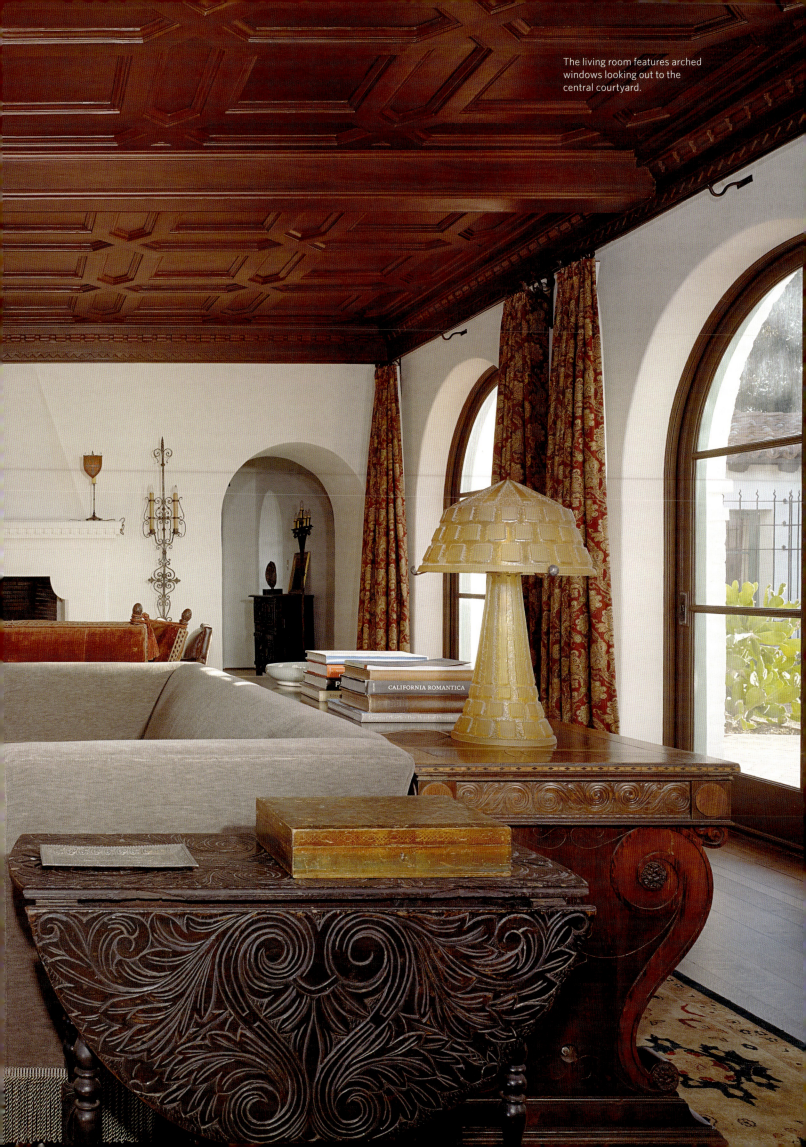

The living room features arched windows looking out to the central courtyard.

ABOVE:
The wood-paneled library with
fireplace and built-in bookcases.

RIGHT:
The beautifully detailed dining
room is simple yet elegant.

up to the elegant pool, designed by Williams to take advantage of
sweeping views of pastures and grazing horses.

Rose and Johnson had been searching for a Paul Williams
house for many years, but they eventually engaged one of the finest
Spanish period architects in the country to design a hacienda-style
ranch to be built on property they owned in the area. However,
when the Ford house became available, they took their architect to
see it and he graciously, and unselfishly, recommended they buy
the house saying he could never re-create this classic Williams
home. Rose says, "It was a unique, once in a lifetime convergence
of opportunity and desire."

And so their journey began. Their methodology was one of
restoration, as opposed to replacement. From the 1929 plumbing
fixtures to the hardware, doors, windows, and kitchen stove, no
detail was overlooked. Says Rose, "This experience of restoring,
living, and entertaining in this Paul Williams masterpiece has
been one of the greatest joys and honors of our lives. We hope that
we have not only restored a special home, but in some small way,
also helped to preserve the legacy of Paul R. Williams." ★

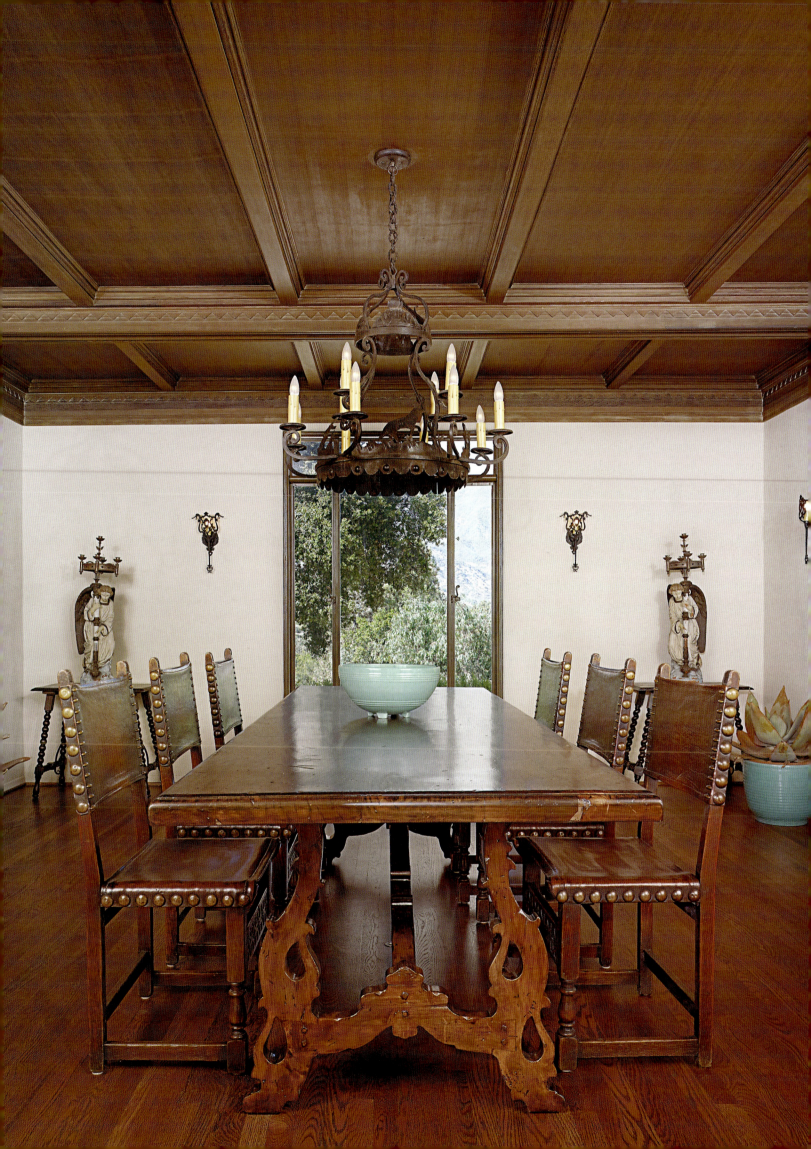

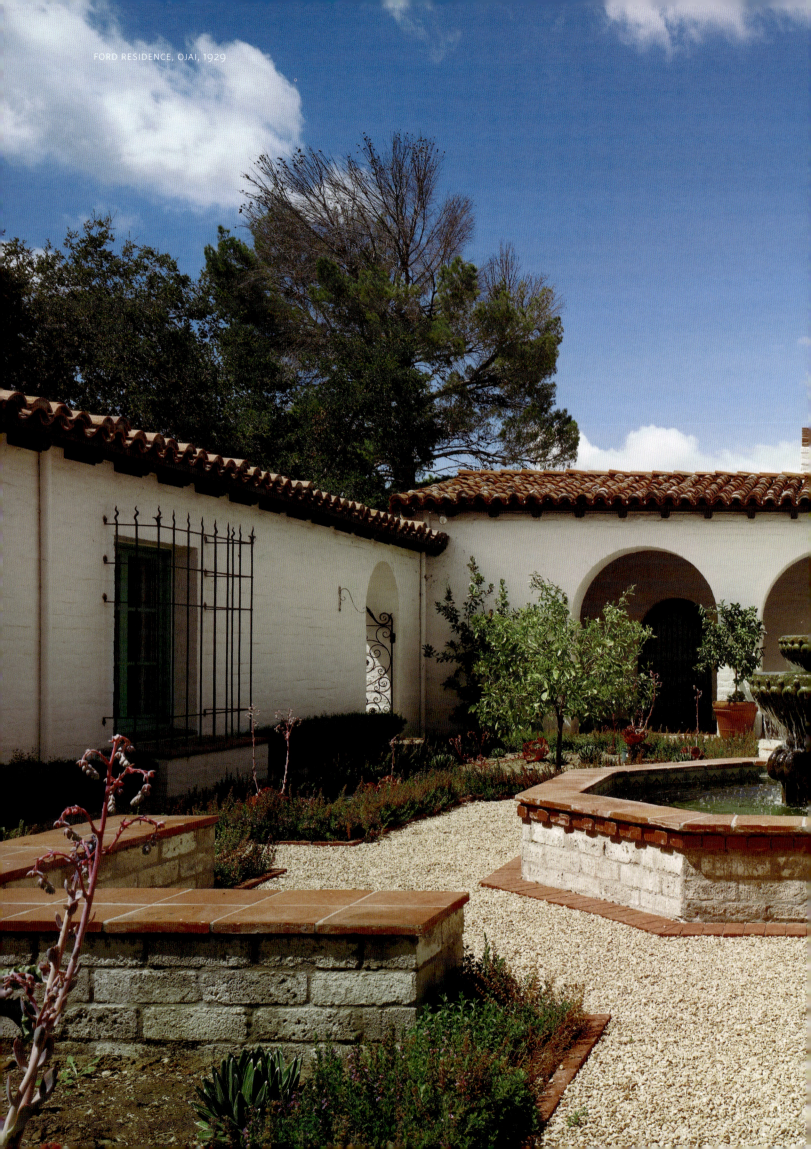

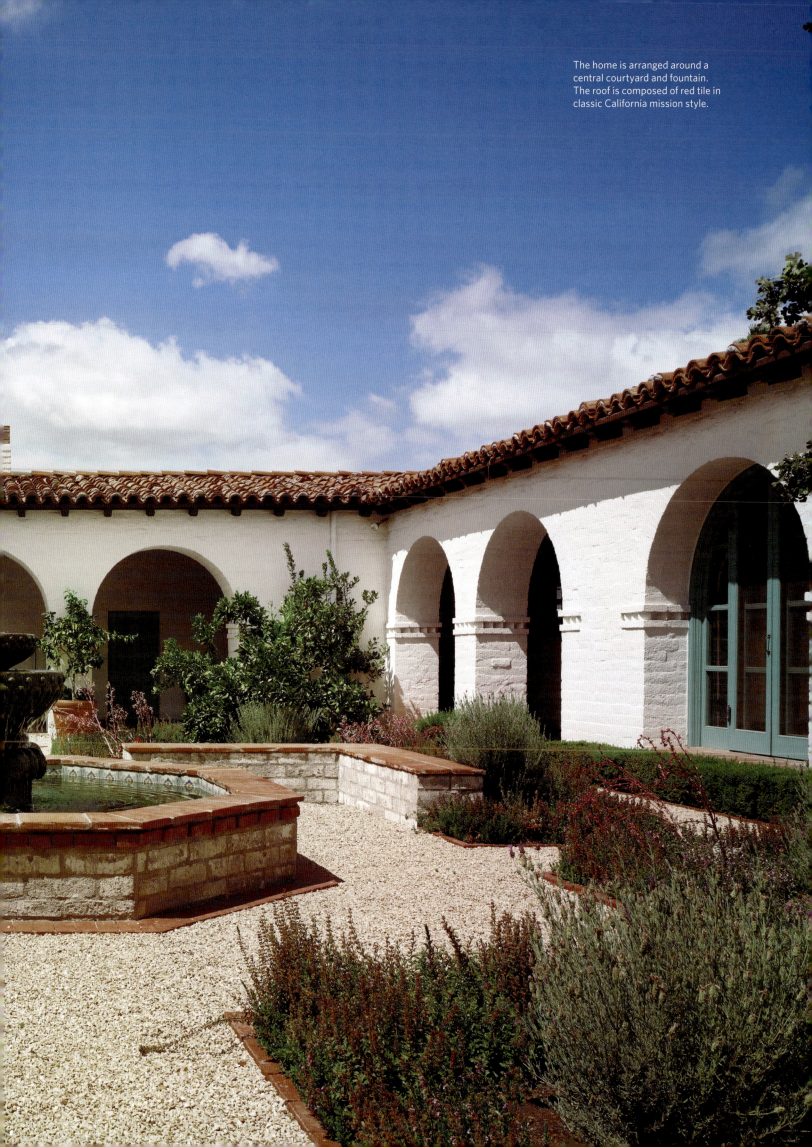

The home is arranged around a central courtyard and fountain. The roof is composed of red tile in classic California mission style.

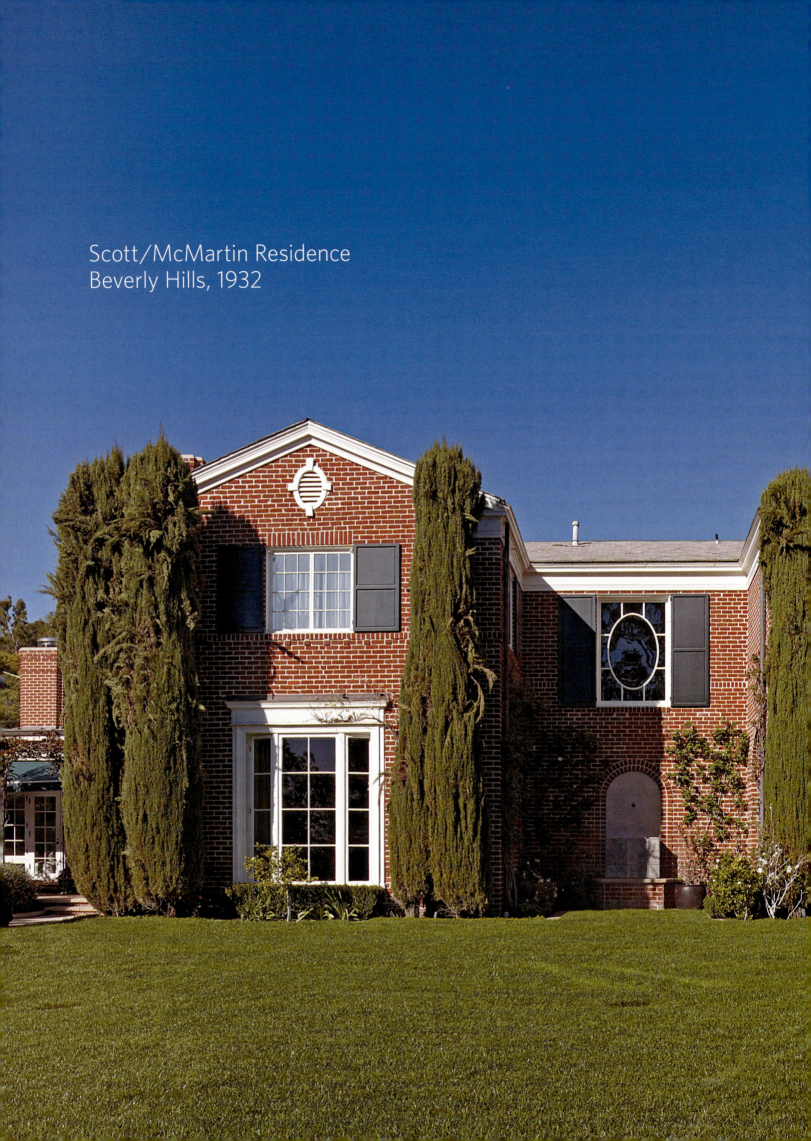

Scott/McMartin Residence
Beverly Hills, 1932

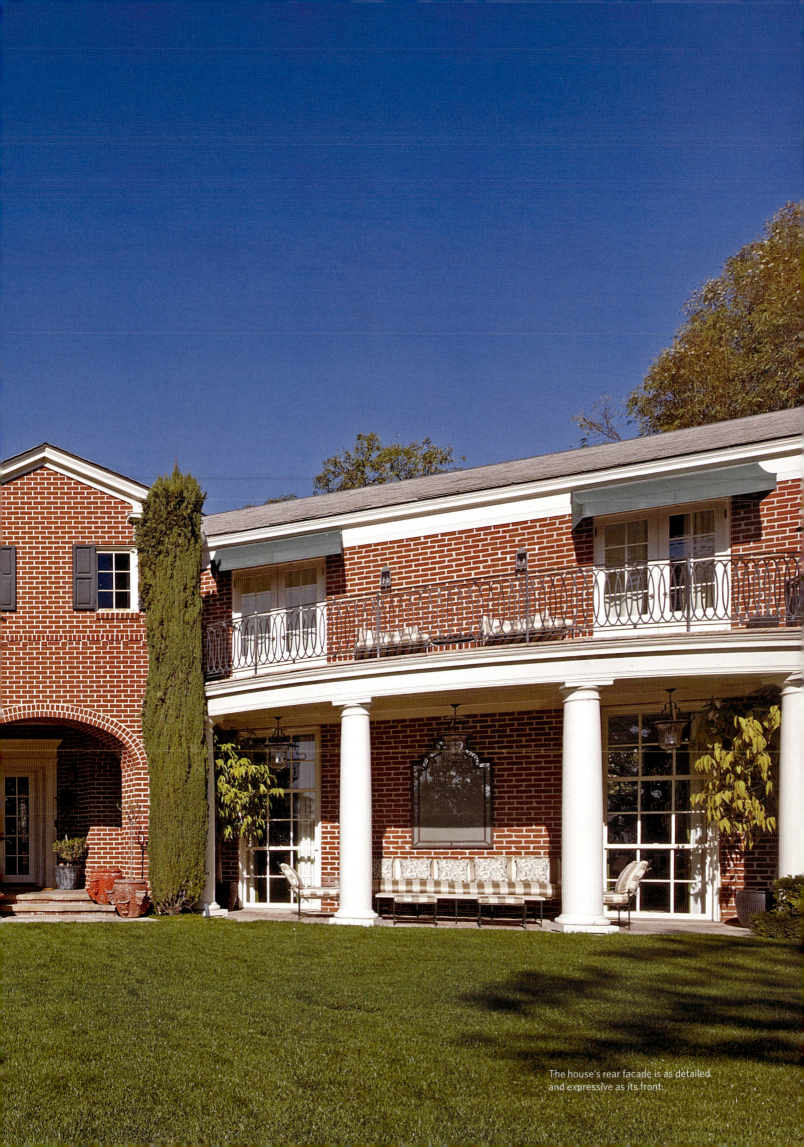

The house's rear facade is as detailed and expressive as its front.

A safe formula for interiors is keep the architecture simple but dignified and the furnishing should be done by two people—one to create and the other to tell him when to quit. The California approach still prevails in planning a home. Try to give the guest as he enters the front door a surprise view of a flower garden.

— AUTOBIOGRAPHICAL NOTES

FOR ALMOST EIGHTY YEARS this sprawling Colonial Revival house has been home to Hollywood's elite. Little is known about the Scott family who originally commissioned the home but lived there so short a time that within a year of the house's construction Duncan McMartin, a bit of a bon vivant who had recently relocated from New York with his latest bride, not only purchased the house but also hired Williams to remodel it.

For film and television producer Steve Tisch, the house's current owner, the journey to the Scott/McMartin house was nothing short of serendipity. He grew up on the east coast, and a trip to California when he was fifteen brought him on a visit with his parents to see talent manager Freddy Fields and his wife, actress Polly Bergen. This afforded young Steve his first glimpse at what would be his future home. Even as a teenager he recognized the style and elegance of the home, which made a lasting impression on him. The home went on to be owned and enjoyed by Bill and Camille Cosby, Michael Landon, and Bernie Brillstein before Tisch laid eyes on it again. Over the years, the interior design has changed with the tastes and needs of each family, but the elegance has remained. Michael Landon brought the Ponderosa to Beverly Hills with a wagon wheel chandelier over the grand staircase. Thirty-five years later, when the house went on the market, Tisch couldn't quite put his finger on it, but he had a special feeling about the home. How gratifying it was to realize that the home he fell in love with as a teenager would finally become his.

The expansive motor court immediately imparts a sense of the understated elegance to be found throughout the home. The majestic oval stair hall, with its sweeping staircase, offers an uninterrupted view of the gardens. Immediately adjacent, flanked by inset niches for art, is the entrance to the living room, which Tisch finds "peaceful and gorgeous," a description Williams surely would have relished. Through the arched doorway into the dining room can be glimpsed the same crown molding that graces much of the home, as well as a working fireplace. The simplicity of the living room is also found in the memorabilia-filled library. Tisch holds the distinction of being the only person to have both a Super Bowl ring and an Academy Award. Tisch is chairman and executive vice president of the New York Giants, whose 2008 Super Bowl win earned him the Vince Lombardi trophy, which joins Tisch's Oscar for producing *Forrest Gump*. What fun Williams would have had sharing creative visions with Tisch in these light-filled rooms.

Tisch says that his favorite social events hosted here have been his children's birthday parties, but he also enjoys entertaining in the ivy-covered poolside cottage which houses a screening room. The family room and kitchen have been remodeled to reflect the needs of today but were designed in keeping with Williams's theory of comfort and family-centered architecture. But perhaps it is the view from the garden that makes the most lasting statement—and showcases Williams's elegant, simple, and timeless sensibility. ✭

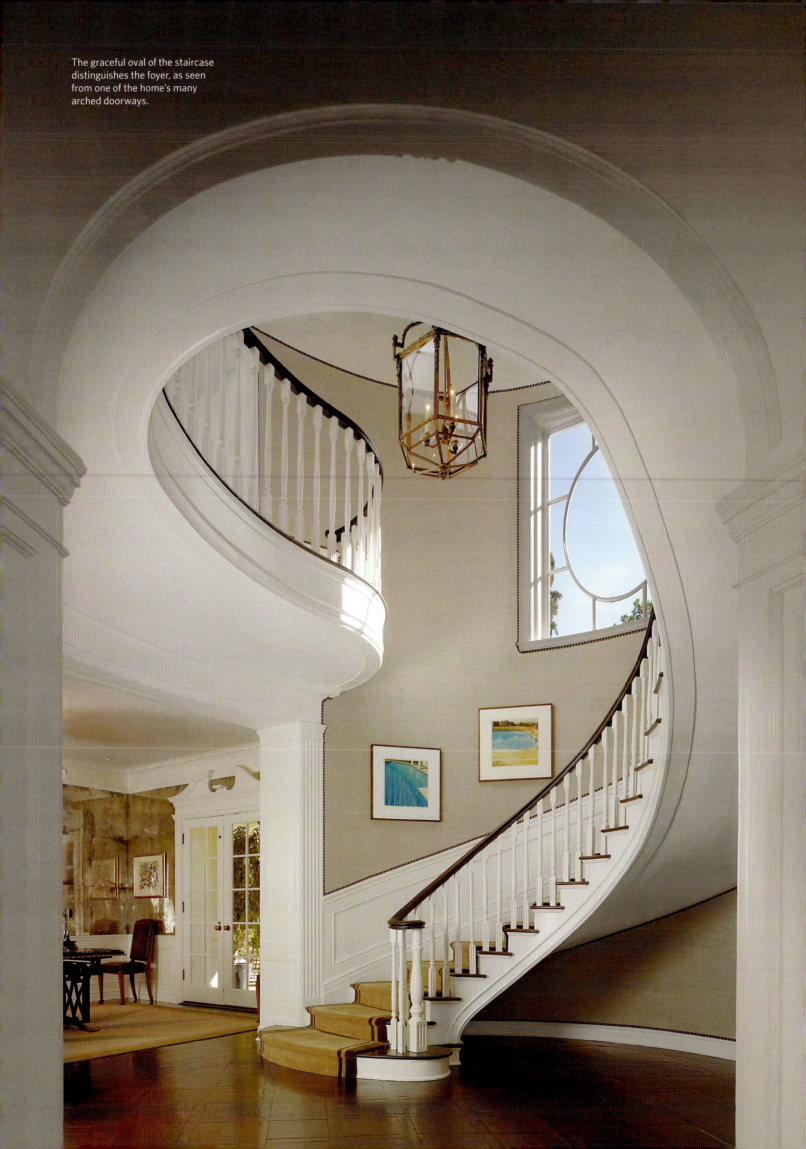

The graceful oval of the staircase distinguishes the foyer, as seen from one of the home's many arched doorways.

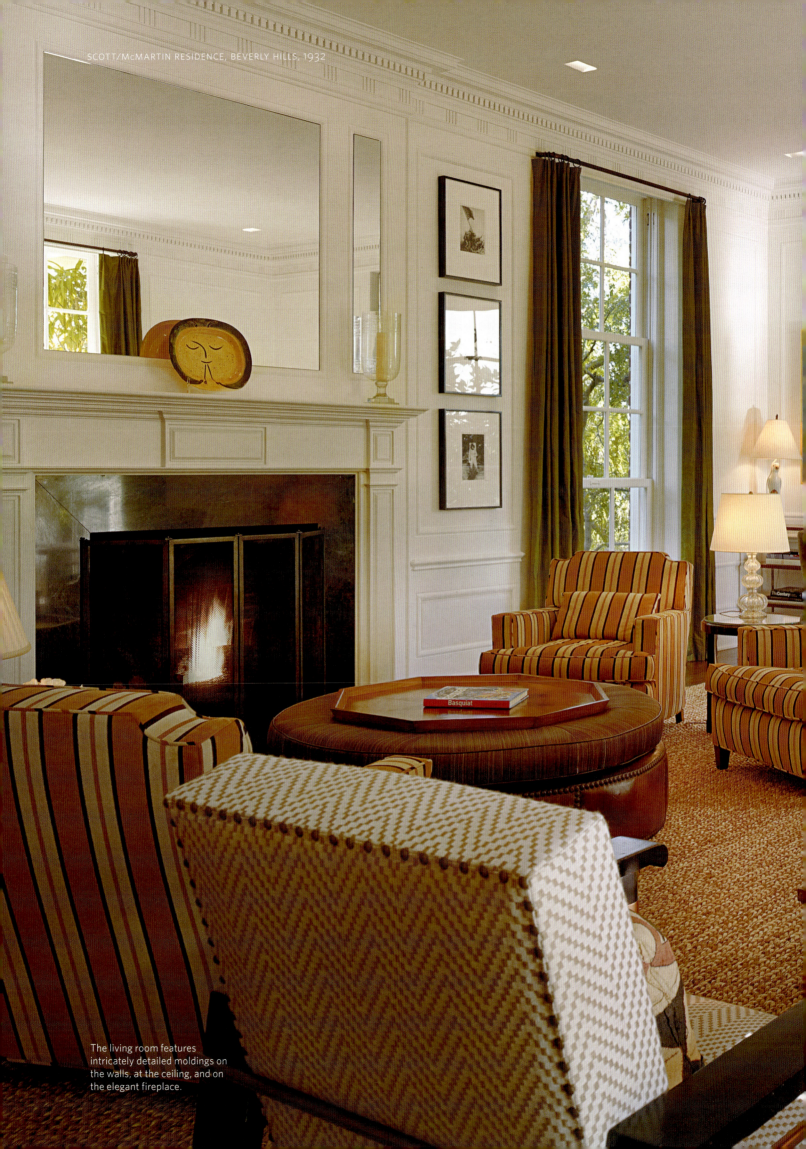

The living room features
intricately detailed moldings on
the walls, at the ceiling, and on
the elegant fireplace.

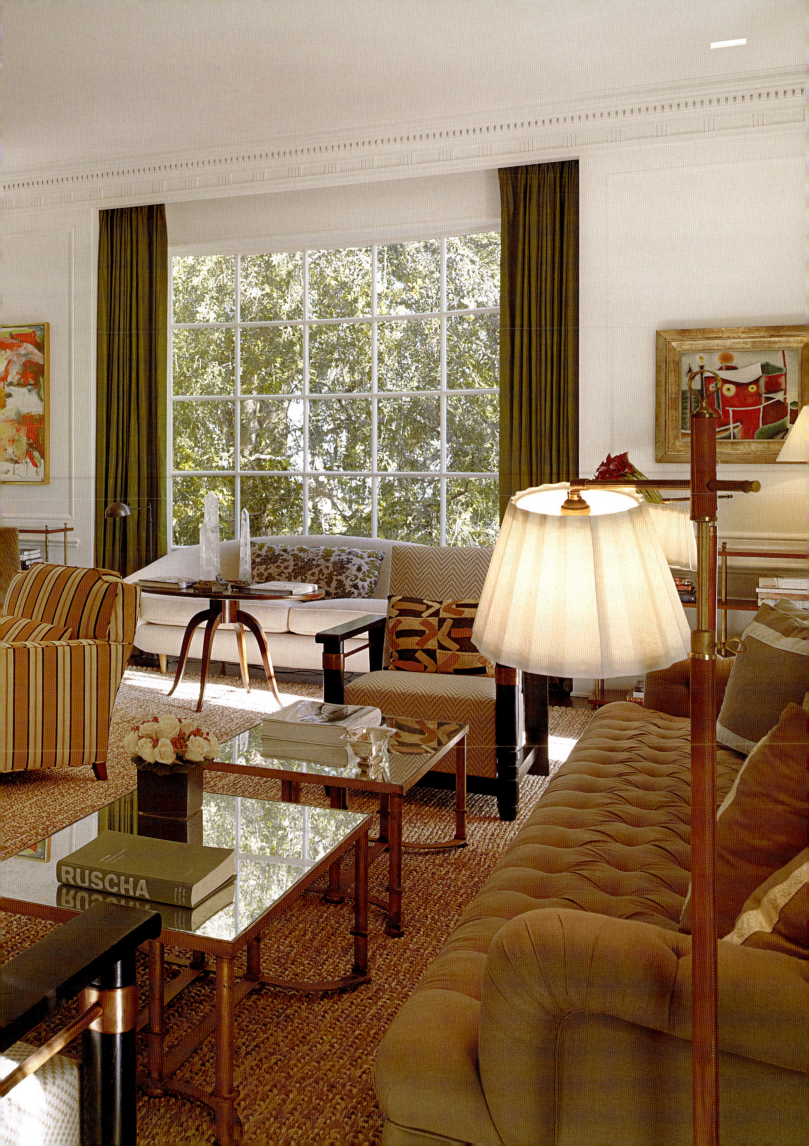

The wonderful little powder room with its octagonal waiting room, oval breakfast room perfectly situated to capture the morning light, and the oval stair hall. These shapes enveloped you and held you in such comfort and safety.

— DEBORAH BRILLSTEIN FLAVIN

We lived in a home, designed by Paul Williams, from 1969 to 1971. It was the last structure on top of a steep hill in Beverly Hills. Our former Williams home is in our souls. We loved it! Even after forty years, we can walk blindfolded through that house and know and feel every room.

What memories! For example, the legendary trumpeter Miles Davis stayed in our home during his engagement at a famous jazz club, Shelley's Manhole. His guestroom overlooked the swimming pool. Also, Muhammad Ali was our guest for several days during the time he refused to serve in the U.S. military. Ali was banned from boxing because of his unequivocal objection to the Vietnam War.

Most importantly, our magnificent Paul Williams home was the first home for our third child, our only son, Ennis William Cosby.

We thank Mr. Williams for his architectural intelligence and expertise that, ultimately, shaped an environment of beauty, warmth, family unity, and, in retrospect, a whole lot of history.

— CAMILLE AND BILL COSBY

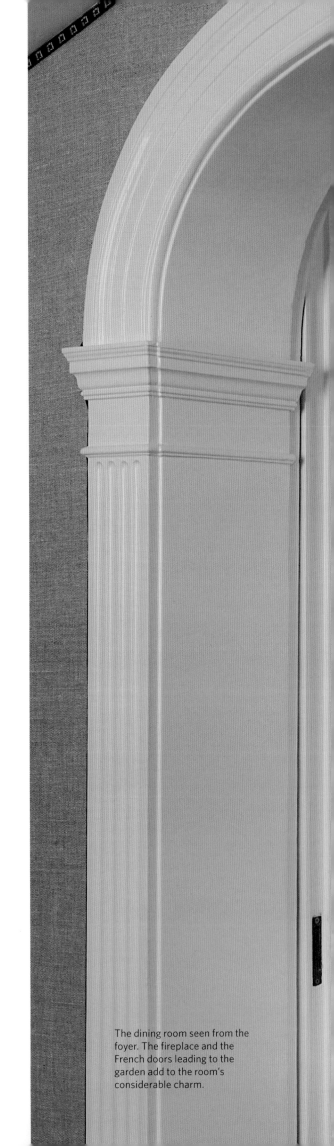

The dining room seen from the foyer. The fireplace and the French doors leading to the garden add to the room's considerable charm.

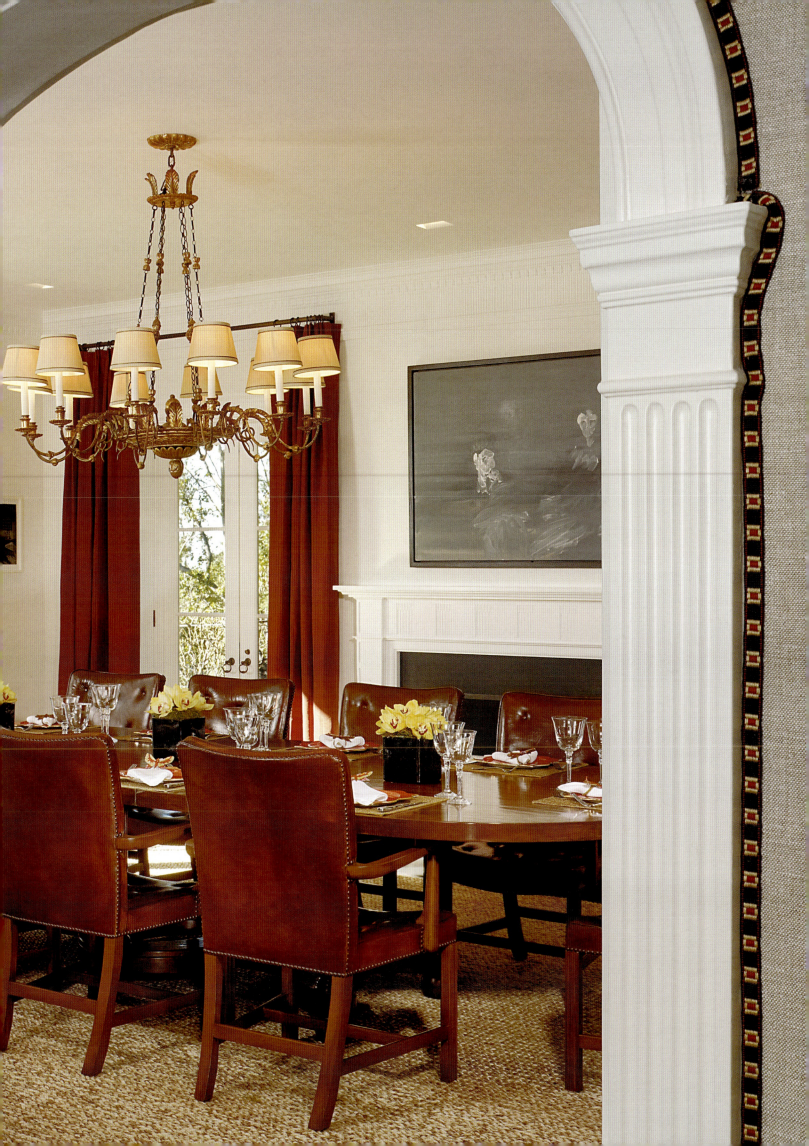

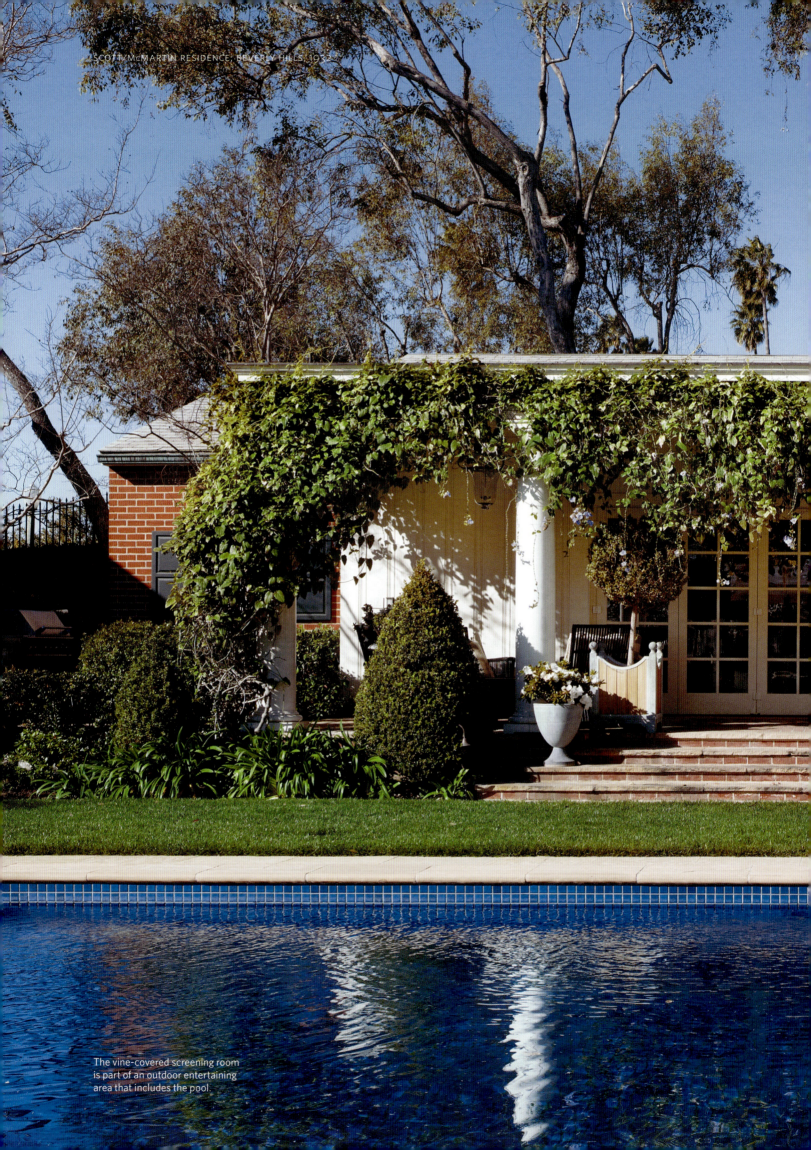

The vine-covered screening room
is part of an outdoor entertaining
area that includes the pool.

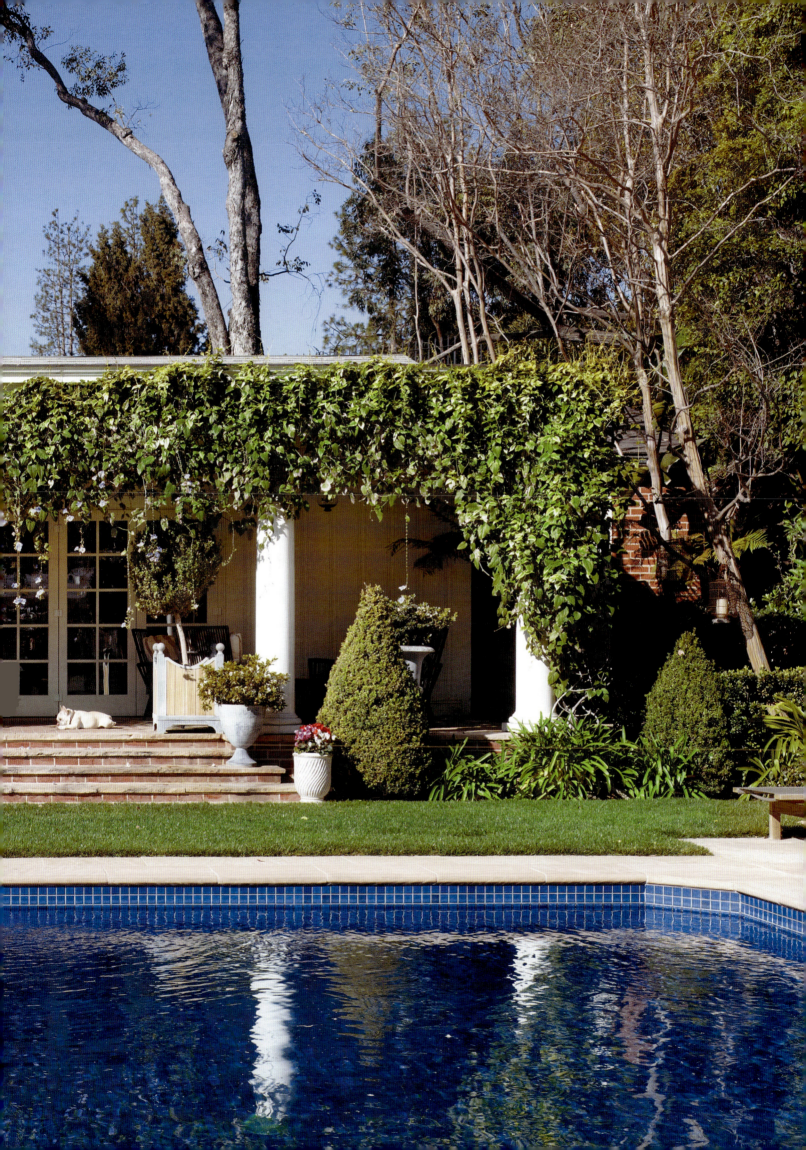

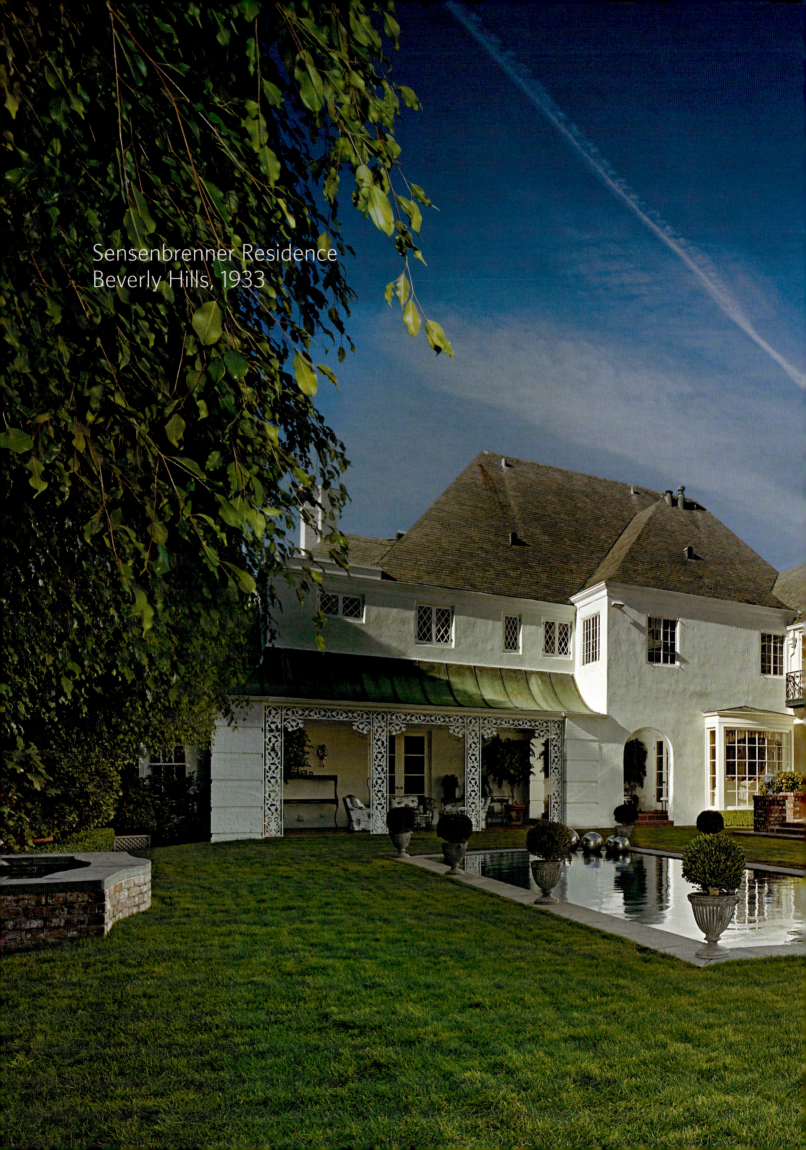

Sensenbrenner Residence
Beverly Hills, 1933

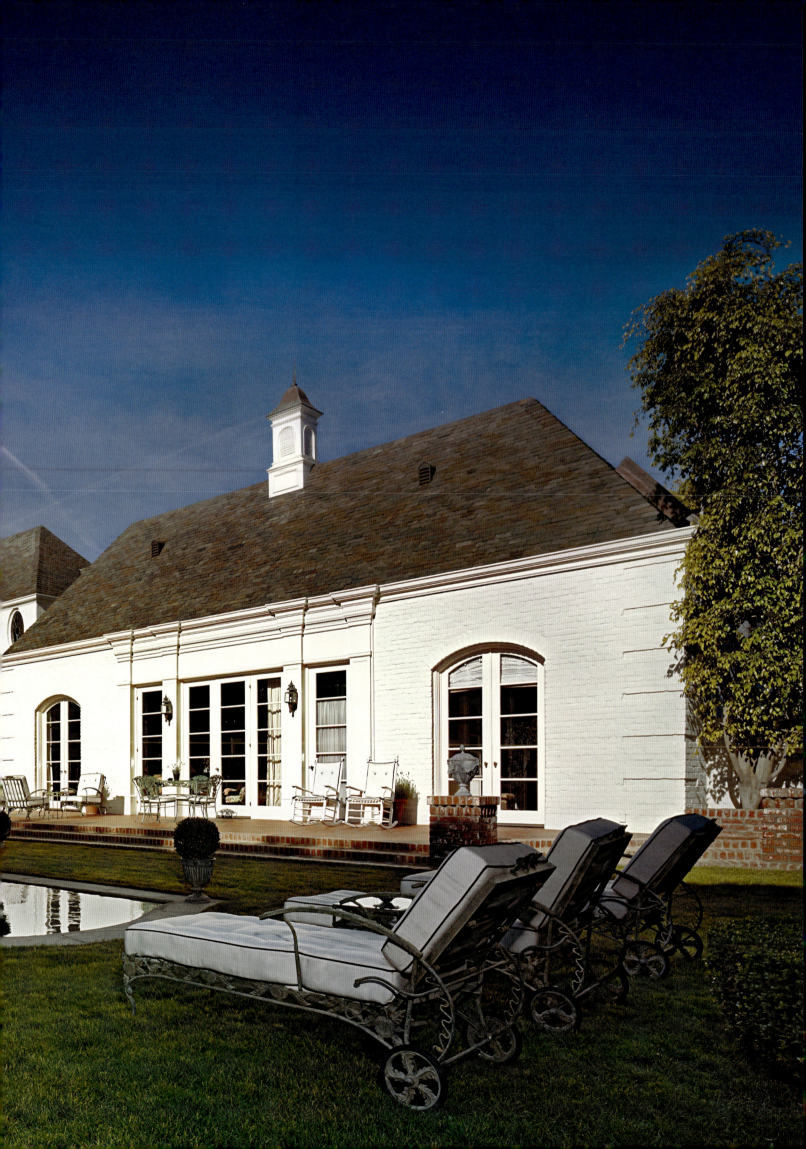

One of the greatest assets in preserving our democratic society is the American home, and, even though the industrial revolution has caused many families to break up their old homes and move to greener pastures elsewhere, we are still the greatest nation of homeowners in the world.

— AUTOBIOGRAPHICAL NOTES

LIKE MANY OWNERS of Williams-designed houses before them, Arlen and Michele Andelson knew this home was meant to be theirs the first time they drove by. It wasn't for sale, but they knocked on the door anyway, seeing that this was a home built with a family in mind filled with warmth, light, comfort, whimsy, and impeccably rational organization. The original breakfast nook, which is still used today, was just one of the unique details requested by the original owner, August Sensenbrenner. A cigar maker and tobacco importer, Sensenbrenner had two other special requests that are reflected in the original design: a humidifier was installed in the den and a "smokeless cooker" in the laundry room. By the late 1930s, family illness caused the owners to remove the "flower arranging room" on the ground level in order to build a state-of-the-art elevator, with the cab landing upstairs in a portion of the daughter's dressing room. The elevator remains in use today. Prior to the Andelsons, this French Normandy-style house, with its signature slate roof, was owned by a prominent Los Angeles attorney, William Cruikshank, with whom Williams joined forces on a proposed office building in downtown Los Angeles.

The Andelsons take pride in having decorated the house as they imagine Williams would have intended, from the foyer to the living room, dining room, and breakfast room, to the loggia and garden. When it comes to entertaining, the Andelsons use every room in the house, including the loggia as an outdoor living room.

Their favorite room is the cherrywood-paneled library, which features not only a fireplace, here rendered in marble, but also a series of secret panels. The appeal of the cozy library is matched by the grace and elegance of the foyer and dining room. The entrance to the dining room is framed to draw one into the room, just as the light-filled breakfast room invites one to spend the morning embraced by the California sun. The Andelsons added the family room with careful attention paid to Williams's original design, creating a room that Williams himself might have drawn, seamlessly extending the exterior.

Michele Andelson remarked, "The beauty of the architectural details and Williams's central floor plan lend itself to graceful living. The placement of the French doors and window take full advantage of the parcel of land the home sits on. Our Paul Williams home has been our haven, our family's center. I can't imagine ever living anywhere else. Paul R. Williams designed for 'forever.'" ✪

PREVIOUS PAGES:
The rear view of the house from the well-manicured garden. The large portion of the structure on the right is a virtually seamless addition that meticulously follows the roofline of Williams's original design.

OPPOSITE:
The wrought-iron railing's details add to the elegance of the sweeping staircase. The exquisitely framed French doors at the base of the stairs lead to the garden.

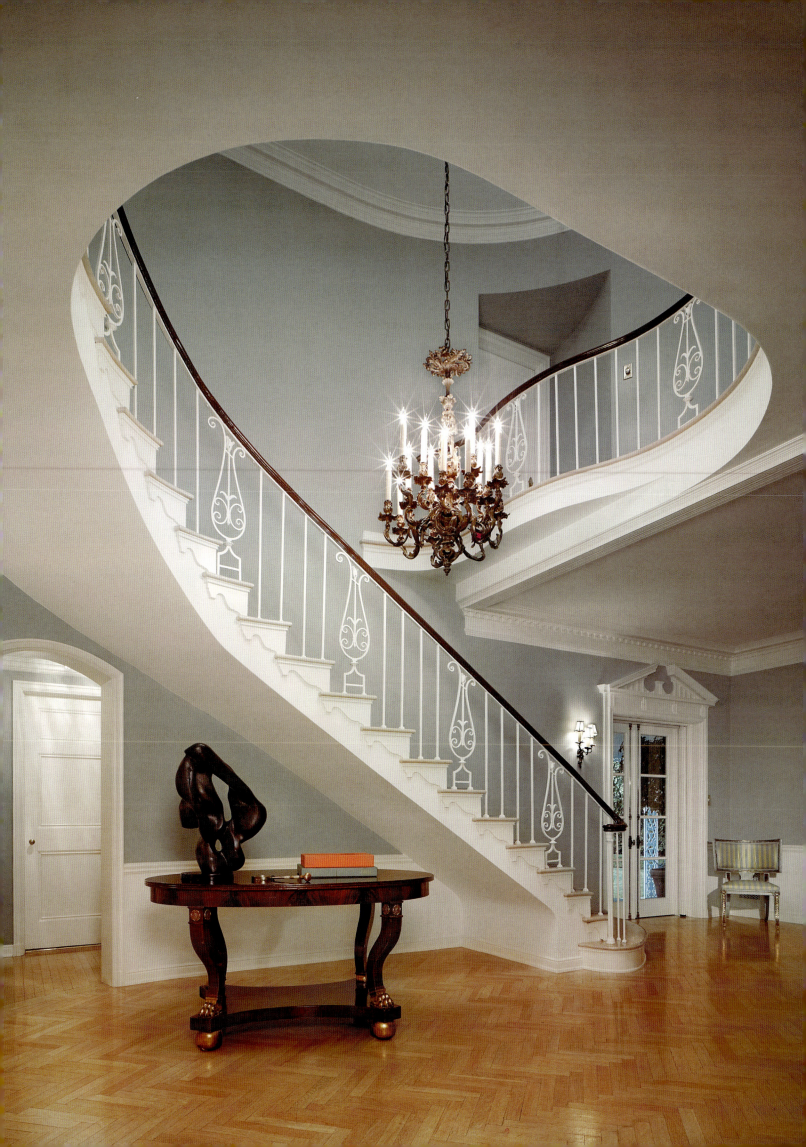

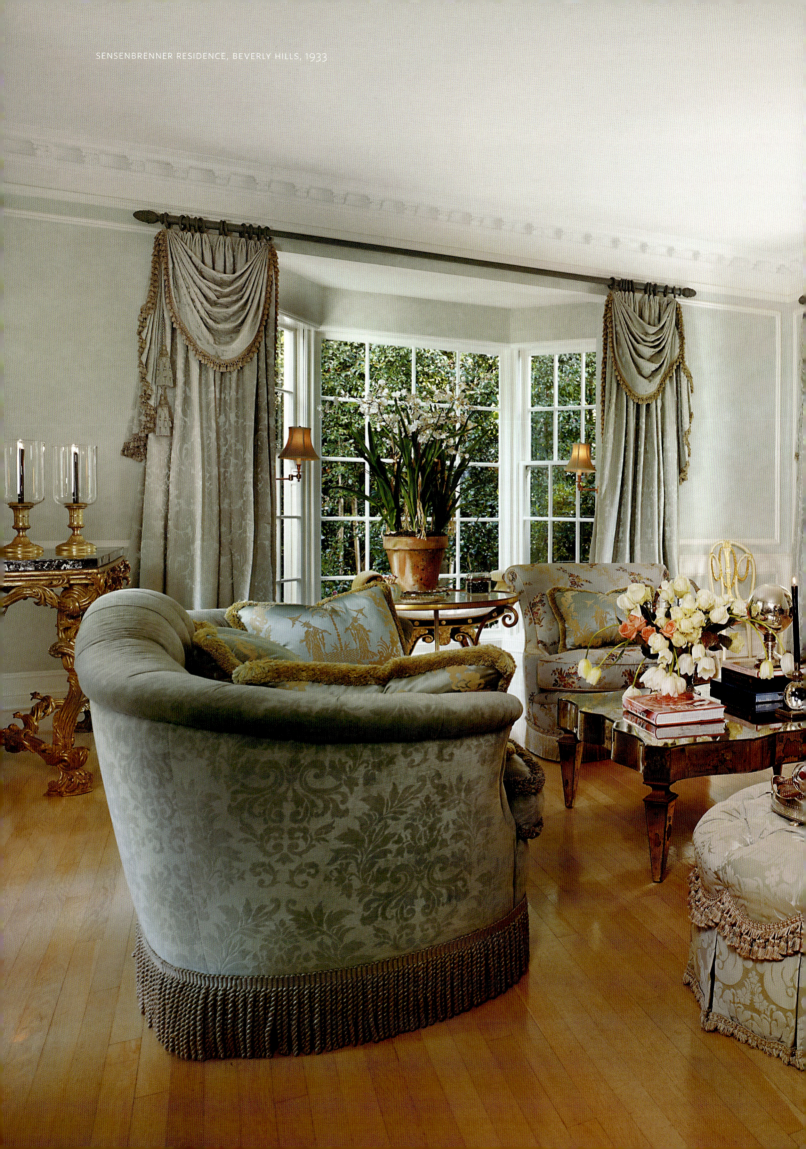

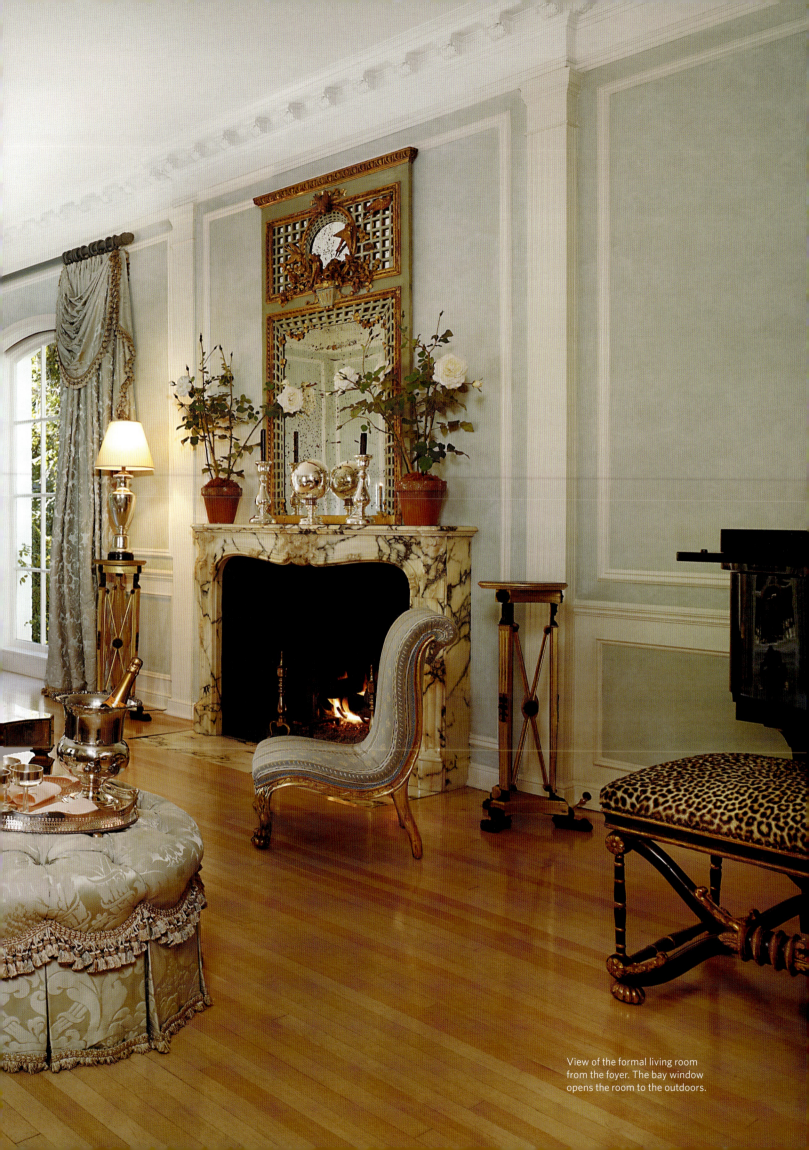

View of the formal living room
from the foyer. The bay window
opens the room to the outdoors.

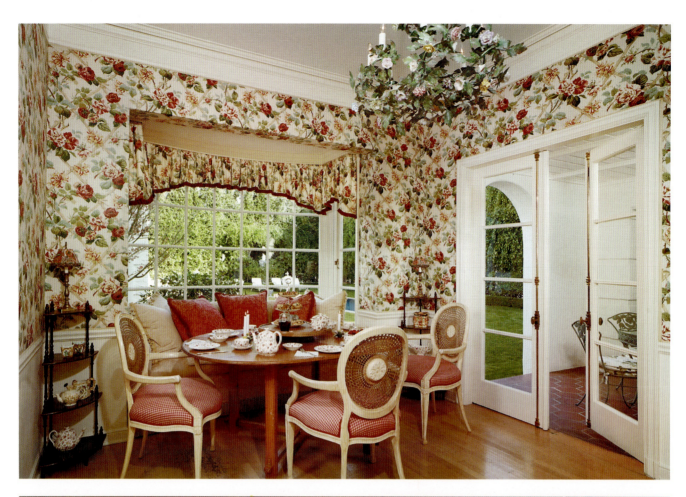

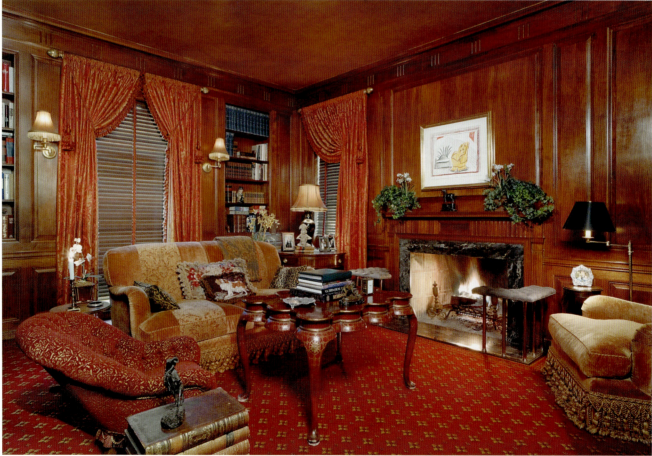

TOP:
This floral-wallpapered breakfast room opens directly to the rear terrace.

ABOVE:
The dark wood- and marble-lined fireplace, with built-in bookcases, contributes to the traditionally elegant yet cozy ambience of the library.

OPPOSITE:
The dining room viewed from the entry hall. In true Paul Williams style, one's eye is led from molding to molding to molding.

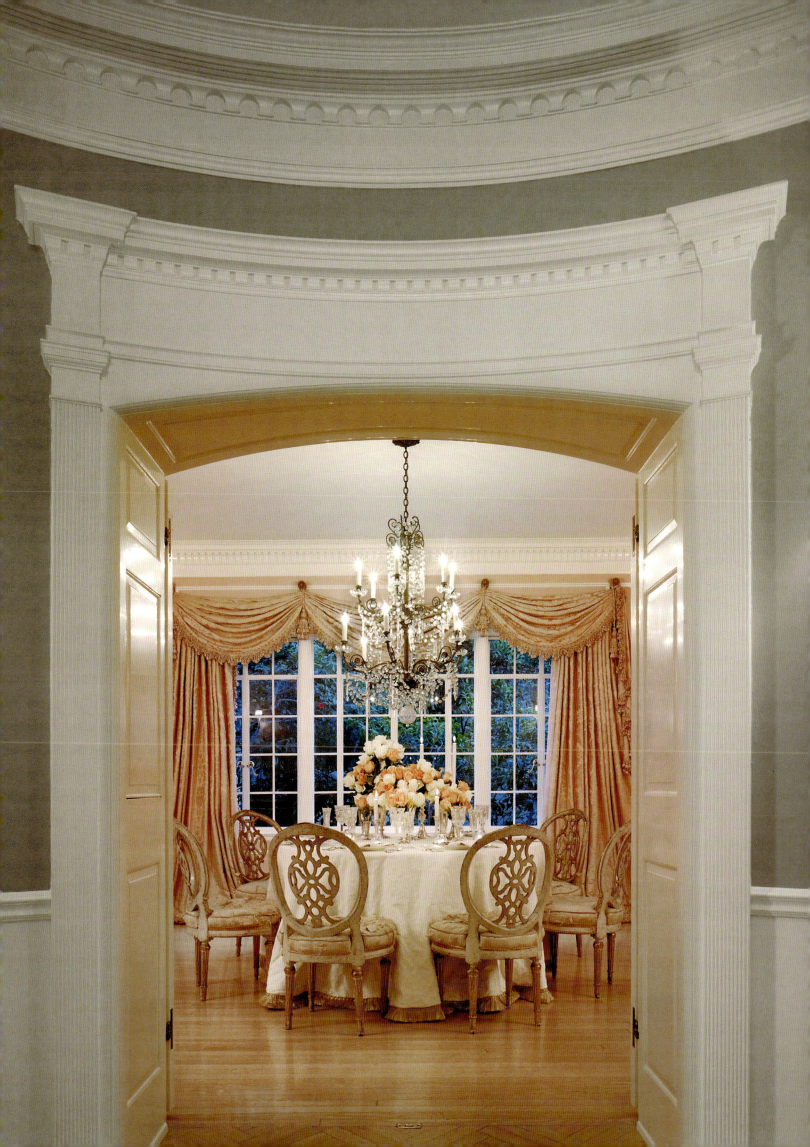

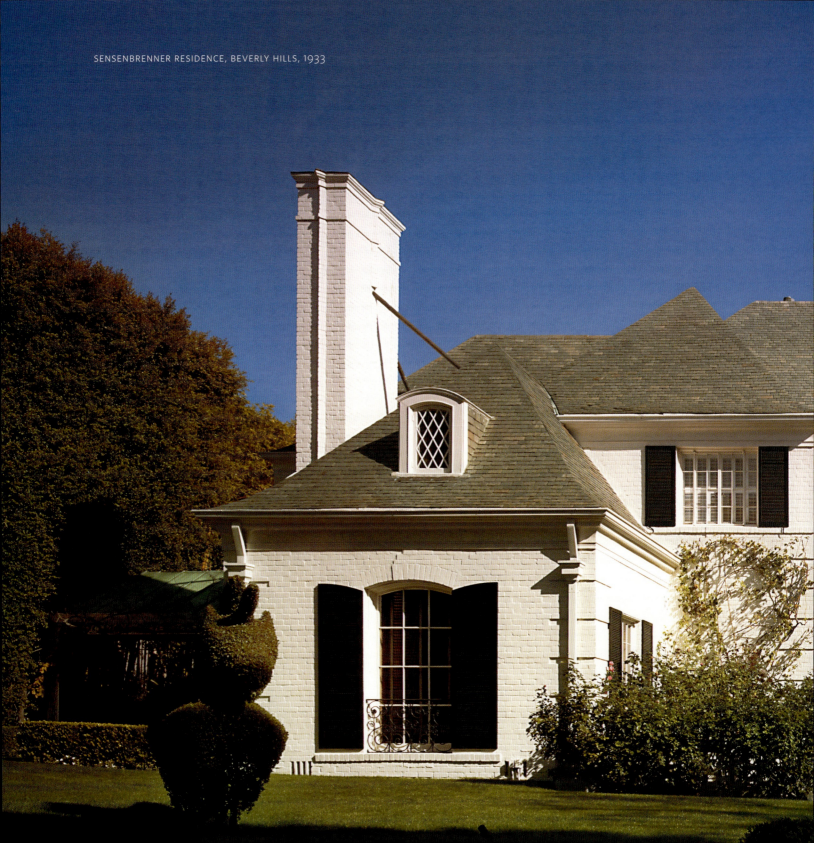

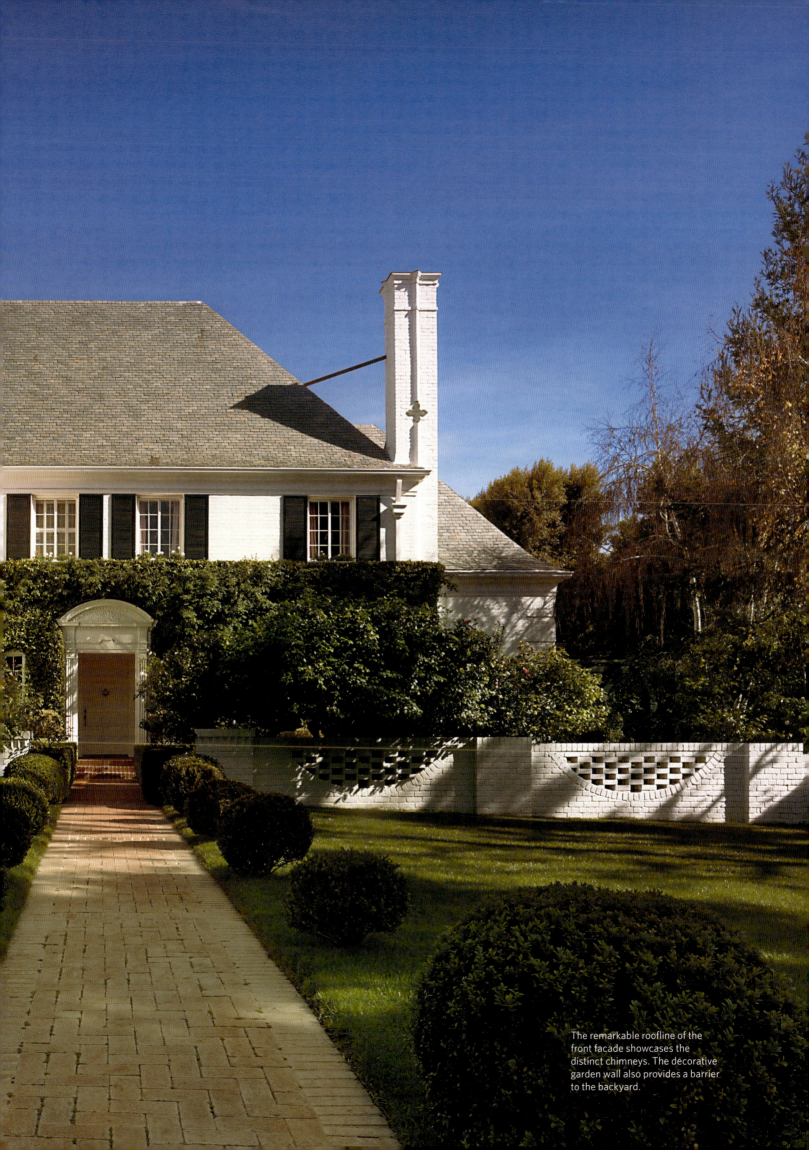

The remarkable roofline of the front facade showcases the distinct chimneys. The decorative garden wall also provides a barrier to the backyard.

Paley Residence
Holmby Hills, 1936

I spent hours learning to draw upside down. Then, with a prospective client seated across the desk from me, I would rapidly begin to sketch the living room of his house. Invariably his interest would be excited by this trick. But it was more than a trick, for, as the room developed before his eyes, I would ask for suggestions and for approval of my own ideas. He became a full partner in the birth of that room as I filled in the details of the drawing.

— "I AM A NEGRO"

THE PALEY RESIDENCE may be familiar as the exterior location for the television show *The Colbys*, a spin-off of *Dynasty*, but in real life it has been home to the Barron Hilton family as well as the Paleys. When Jay Paley decided to sell his interest in the Congress Cigar Company at age forty-two, his wanderlust kept him traveling the world for the next seven years. But as an original investor in the Columbia Broadcasting Company (CBS) through his nephew William Paley, his fascination with the entertainment industry eventually led him to settle in Beverly Hills. He commissioned Williams to design a tour de force structure signaling his presence among the Hollywood elite as an independent producer. The final design is one of Williams's most iconic houses. One of more than twenty-two mostly large houses Williams designed as Los Angeles began to recover from the Depression, the Paley house boasts thirteen bedrooms, twelve bathrooms, and more than 15,000 square feet of total living space.

Williams incorporated the outdoors as an integral part of the living space, treating the garden, pool, and pool house as extensions of the main house. One enters this Georgian Colonial home through a motor court with an inlaid directional axis, a design feature Williams continued throughout the home and leading to the pool. According to Williams's notes, the exquisite tiles that form the sunburst and zodiac signs of the pool were brought from Europe, along with the craftsmen to lay them. This remains one of the most exquisite pools in Beverly Hills.

It has been said that Paley spent his days learning to rumba and play poker, and there is no doubt his poker games were legendary. He played poker for whopping stakes with the likes of film executive Joseph Schenck and theater-owner Sid Grauman. And some of his antics lasted throughout the night. June Lockhart, star of *Lassie* and *Lost in Space*, recalled weekends at the house with her childhood friend Jackie Paley, Jay Paley's daughter. She loved swimming in the pool, riding horses on the bridle path that surrounded the bottom of the property, and having a driver take Jackie and her to the movies. However, one morning they woke up only to be told not to go into the projection room because the grown-ups, including actress Constance Bennett, had been playing poker since ten the night before and Sid Grauman was desperately trying to win back his theater.

Bored with sitting around, Jay Paley and Joseph Schenck called on their Hollywood buddies and formed an investment group that included Darryl Zanuck, William Goetz, Constance Bennett, and Al Jolson, among others, who asked Williams and Gordon Kaufman to join forces to design a new hotel. Completed in 1939, the Arrowhead Springs Hotel never gained financial stability and within two years was sold. By 1951, Conrad Hilton purchased the hotel as part of his growing empire, retaining it for only a few years. However, Elizabeth Taylor honeymooned in the penthouse suite with husband Nicky Hilton, and the swimming pool was formally named for Esther Williams, whose movies were often shot there. ✮

Columns grace the outdoor seating area at the rear of the house, facing the lawn and pool area.

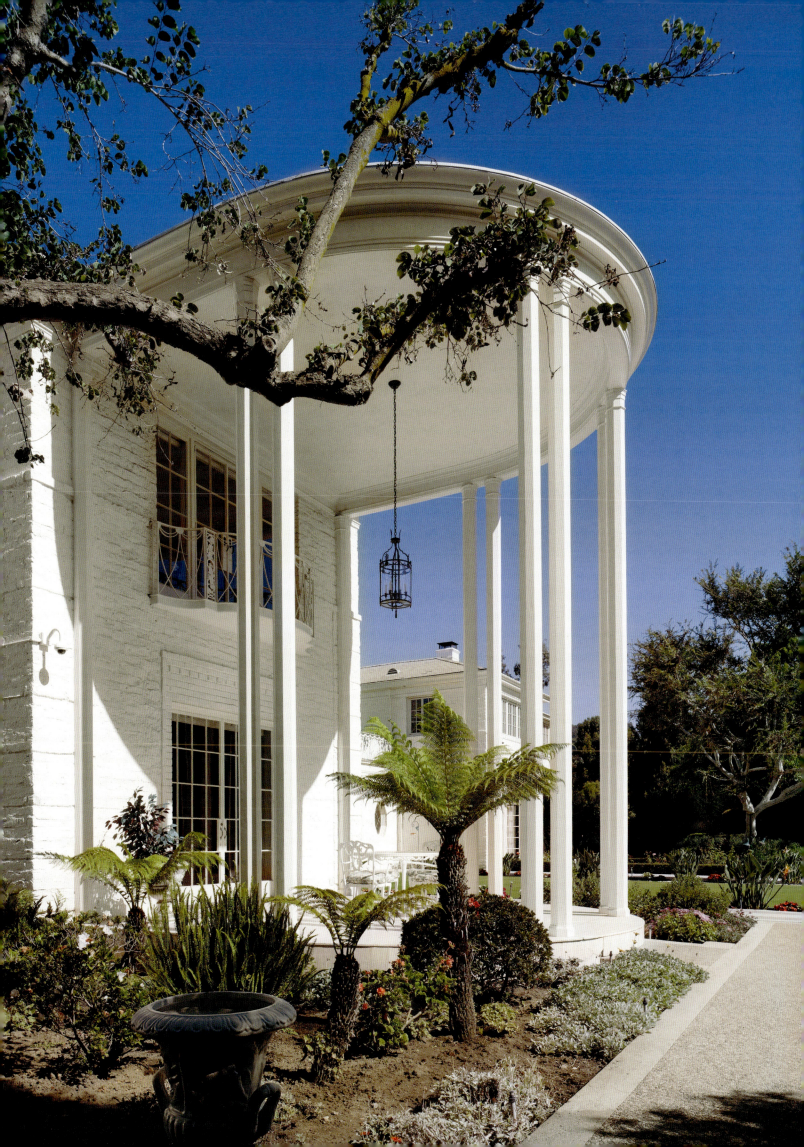

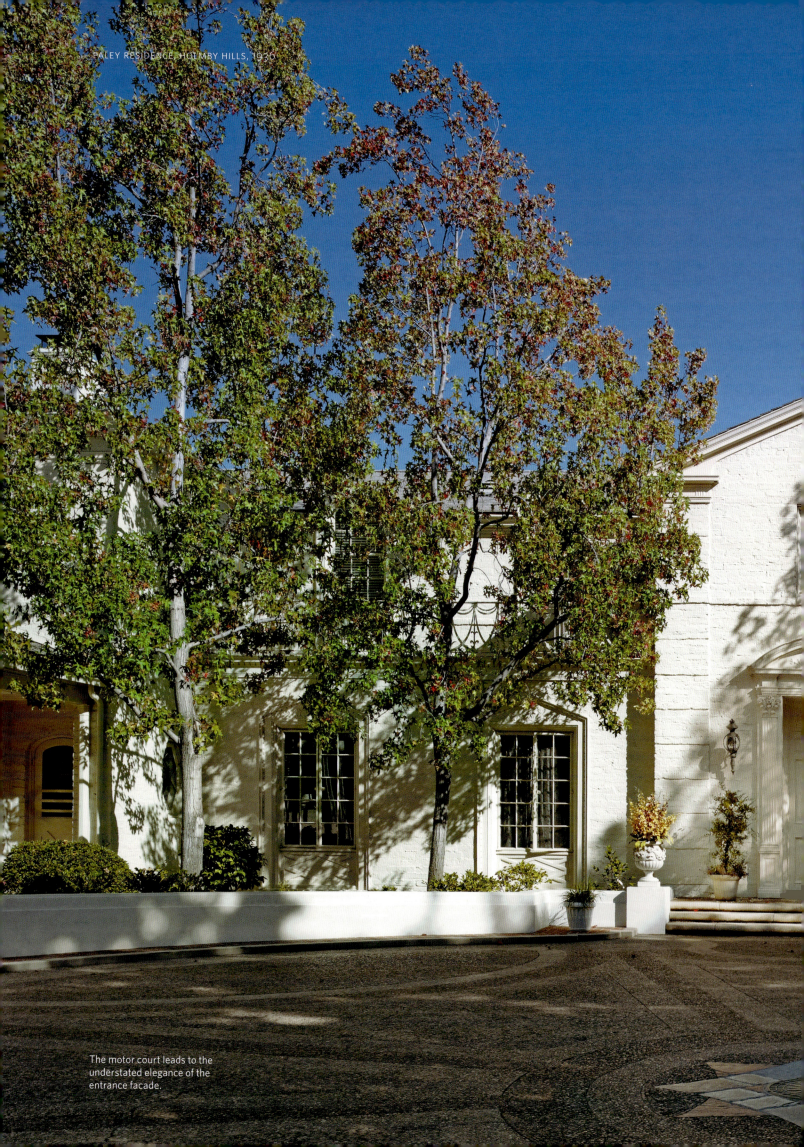

The motor court leads to the
understated elegance of the
entrance facade.

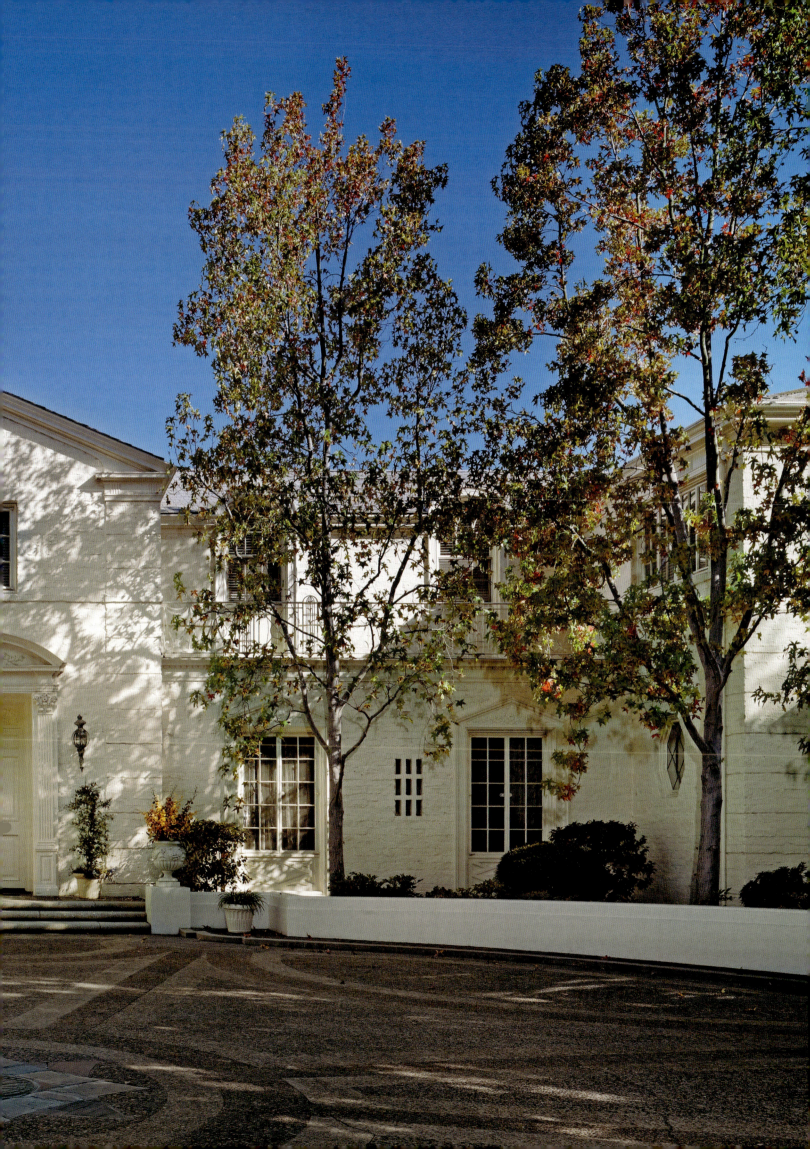

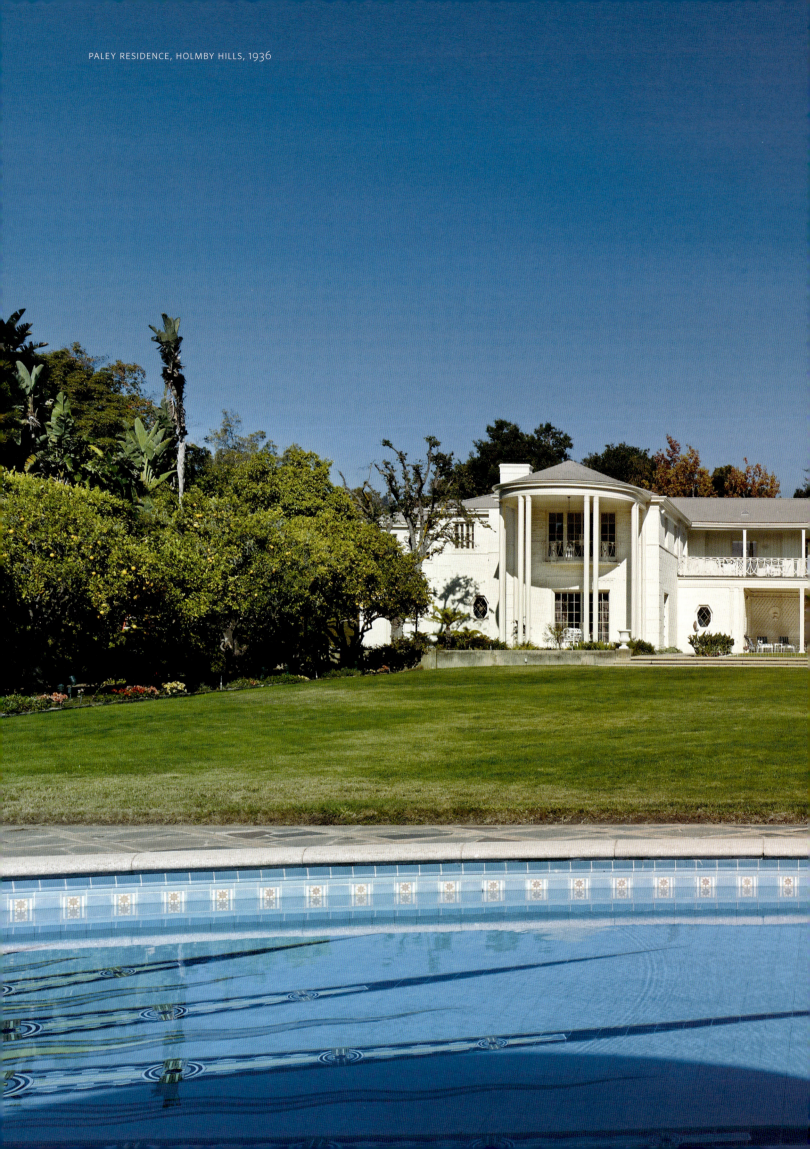

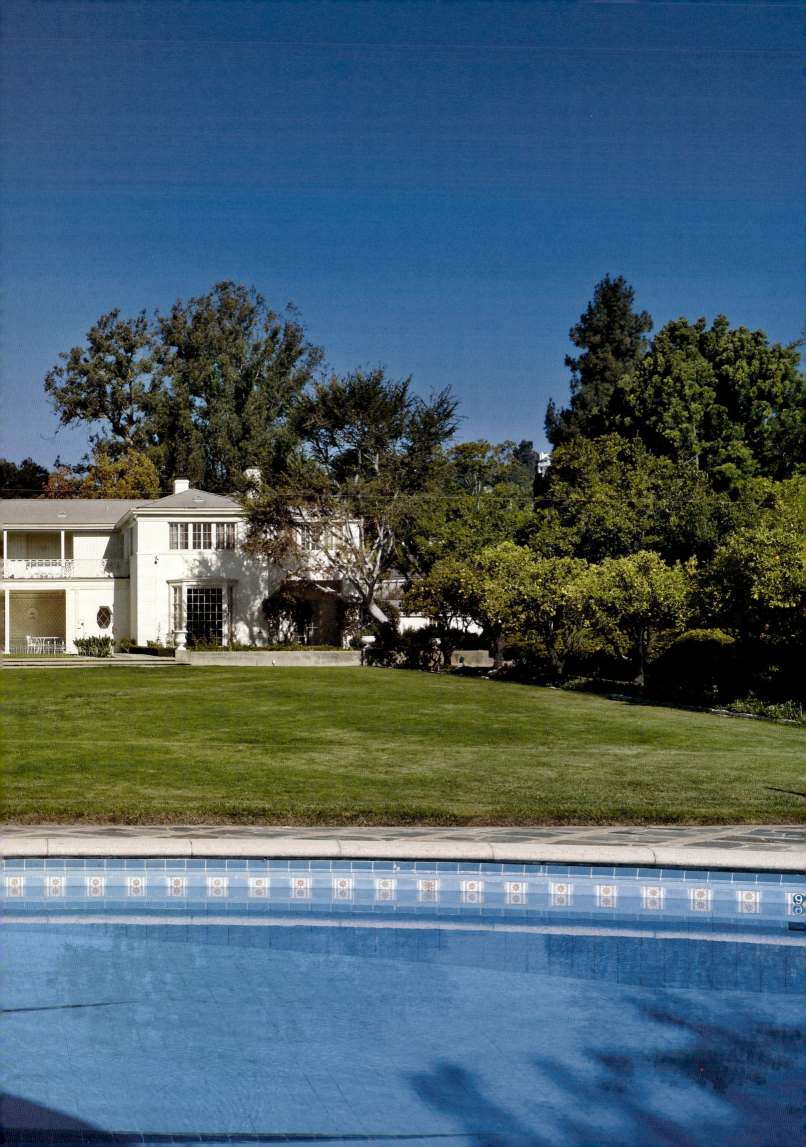

PALEY RESIDENCE, HOLMBY HILLS, 1936

PREVIOUS PAGES:
The rear facade of the house from the pool. The balconies allow guests to fully enjoy the view of the glorious grounds with ease.

RIGHT:
The pool house and iconic zodiac-decorated pool.

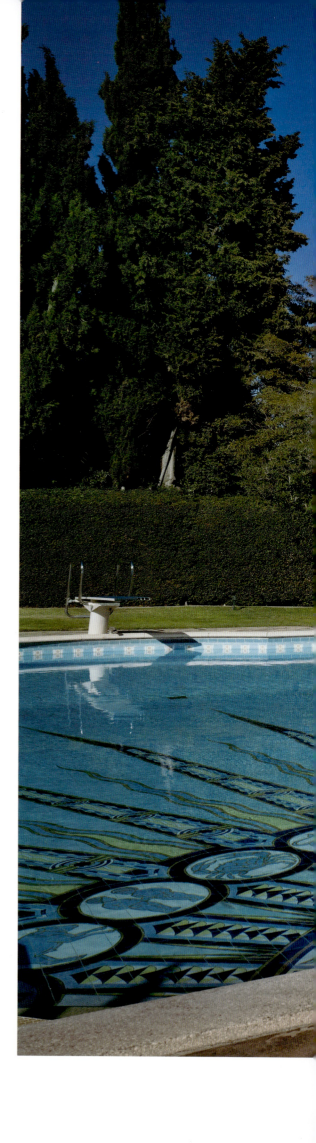

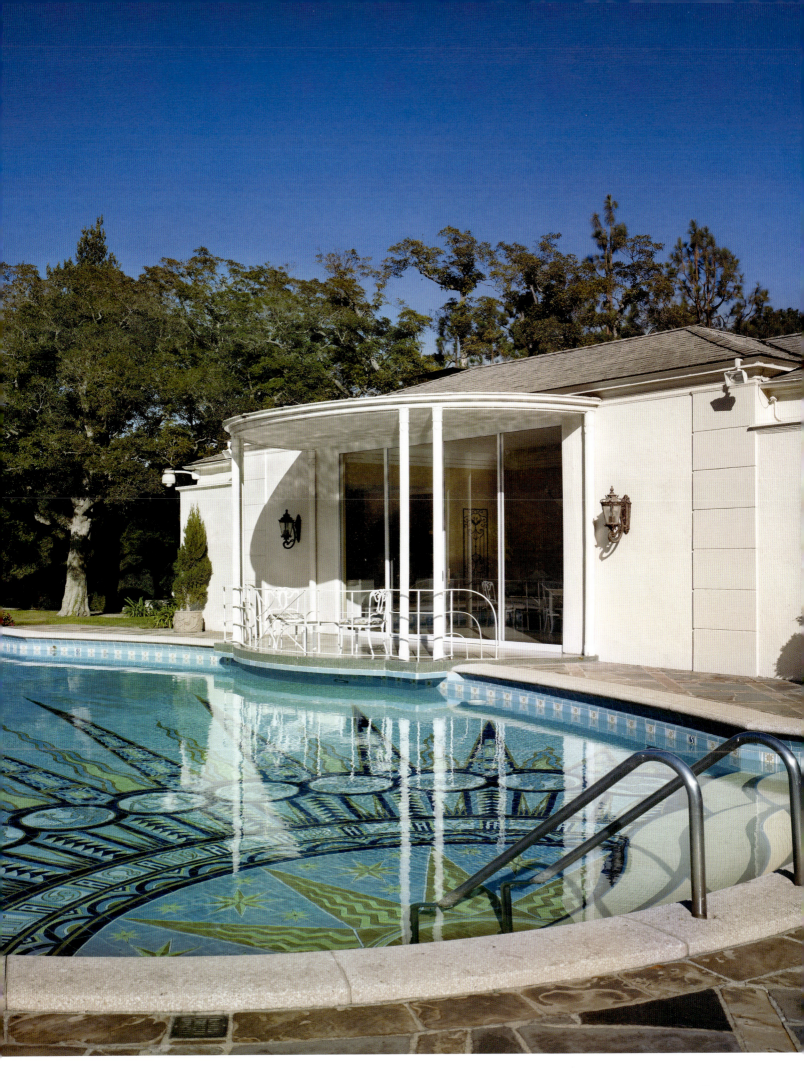

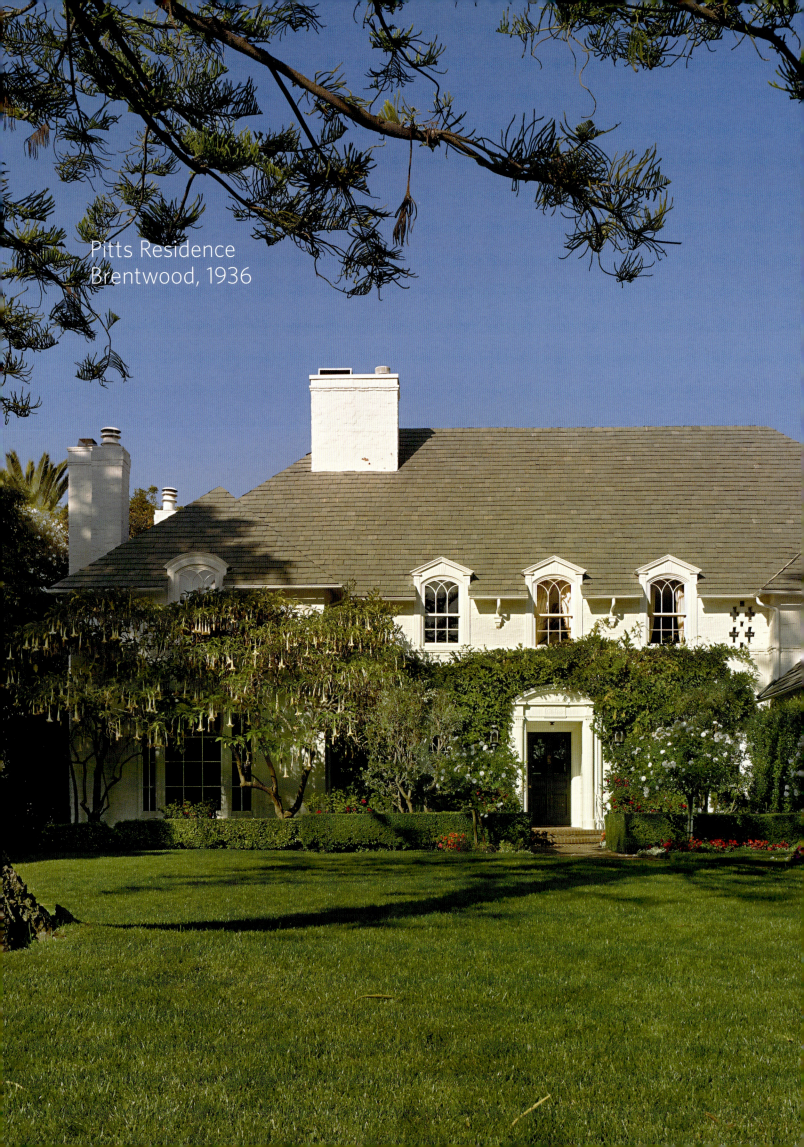

Pitts Residence
Brentwood, 1936

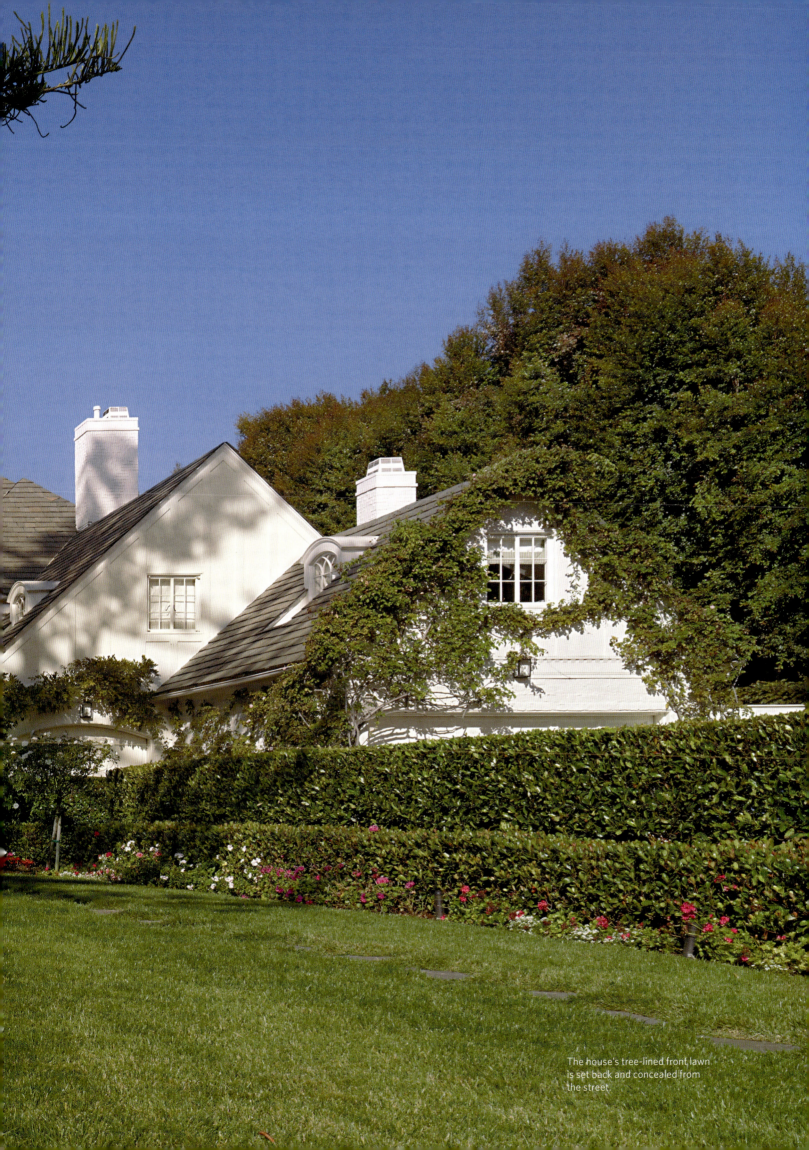

The house's tree-lined front lawn is set back and concealed from the street.

I am an architect . . . today I sketched preliminary plans for a large country house which will be erected in one of the most beautiful residential districts in the world, a district of roomy estates, entrancing vistas, and stately mansions. Sometimes I have dreamed of living there. I could afford such a home. But this evening, leaving my office, I returned to my own small, inexpensive home in an unrestricted, comparatively undesirable section of Los Angeles . . . because I am a Negro.

— "I AM A NEGRO"

IT CAN BE SAID that comedic actors in Hollywood rarely resemble the persona they portray on the screen, and zany actress ZaSu Pitts was no exception. The inspiration for Olive Oyl in the *Popeye* series, with her high-pitched voice and incessant hand wringing, Pitts began her film career as a silent screen actress with Mary Pickford in *Pretty Ladies*. From vaudeville to Broadway and finally to film and television, Pitts made a name for herself as second banana to a host of stars. Perhaps best known as Elvira Nugent, the shipboard beautician on *The Gale Storm Show*, she ended her career as the switchboard operator in Stanley Kramer's *It's a Mad, Mad, Mad, Mad World*. She was like everyone's favorite aunt.

Although married to real estate broker John Woodall, it was clearly Ms. Pitts who commissioned Williams to design her dream home. This Georgian-style house, inflected with a touch of Hollywood Regency, is an excellent example of Williams's penchant for mixing styles to suit his client's desires. With its impressive entrance, set back from the street, the home is a stately, yet warm and comfortable, an oasis in a neighborhood that had long been a favorite of the entertainment industry. In fact, Shirley Temple lived next door.

Entering the home, restored by Tichenor & Thorp Architects, one is greeted by a series of graceful arched doorways and Williams's signature curved staircase. Arches greet the visitor at every turn, drawing one into the rooms off the main hall. The

sunroom, or "Morning Room" as it is called on Williams's plans, has remained a favorite of the house's many owners for its quiet beauty and exquisite sunlight, a perfect spot for a quiet conversation, to lose yourself in a good book, or to stop the world for an afternoon cup of tea.

The formal dining room, distinguished by extensive moldings, offers views to the garden through its elegant curved windows. The adjacent living room, with its beautiful beamed ceiling, continues to be the current owners' favorite room for entertaining. The exquisitely detailed moldings on the fireplace mantel are characteristic of Williams's designs of the time. Off the living room is the loggia, a relaxing outdoor room with columns and curved stairs that make the rear facade as inviting as the front. Perhaps the house's most intriguing feature is the hidden staircase concealed behind one of the den's wood-paneled walls and leading up to a secluded loft.

Pitts was an excellent cook and asked Williams for a large kitchen, unusual for homes of the day that more often than not had smaller kitchens with butler's pantries fit for the household staff. Pitts collected candy recipes and compiled a book, *Candy Hits by ZaSu Pitts*, published posthumously in 1963. The kitchen, which today is almost exactly the same as it was when it was built in 1936, features niches created to house Pitts's extensive cookbook collection, and her kitchen was the core of her beloved home. ✪

View from the living room through the entry hall to the dining room and on to the kitchen.

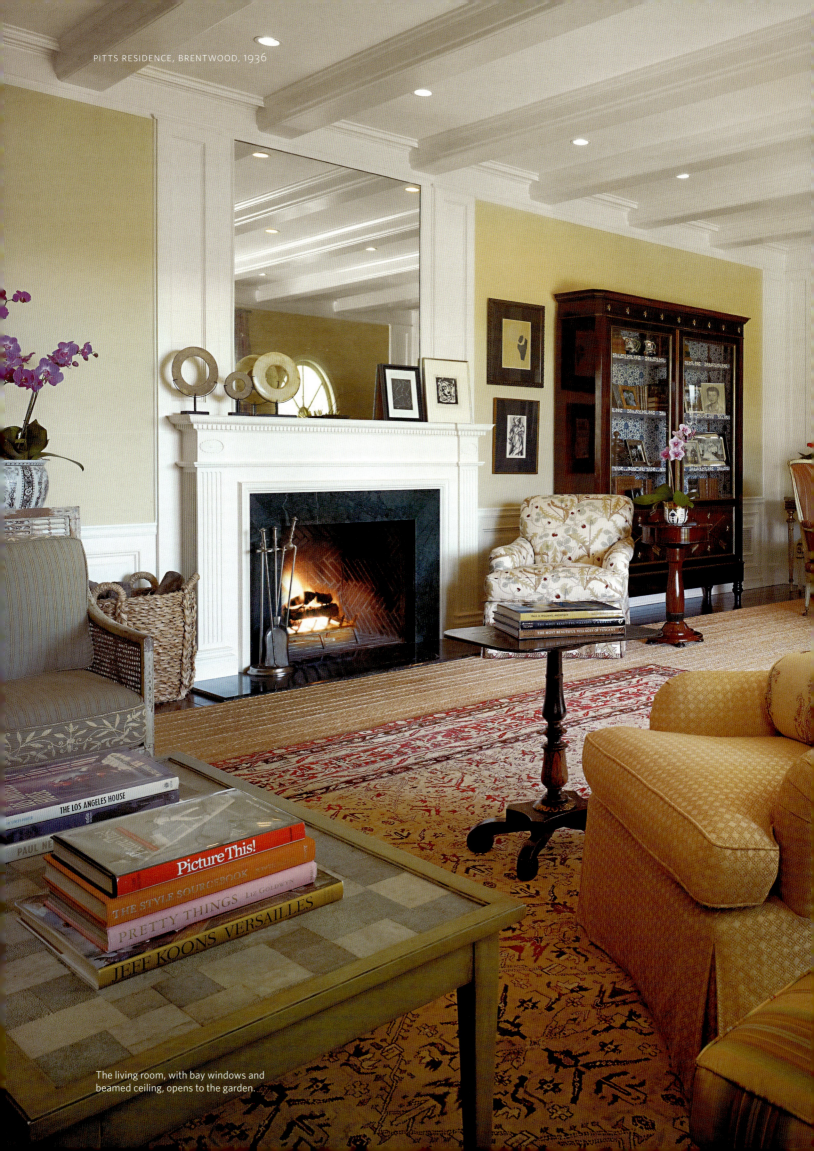

The living room, with bay windows and
beamed ceiling, opens to the garden.

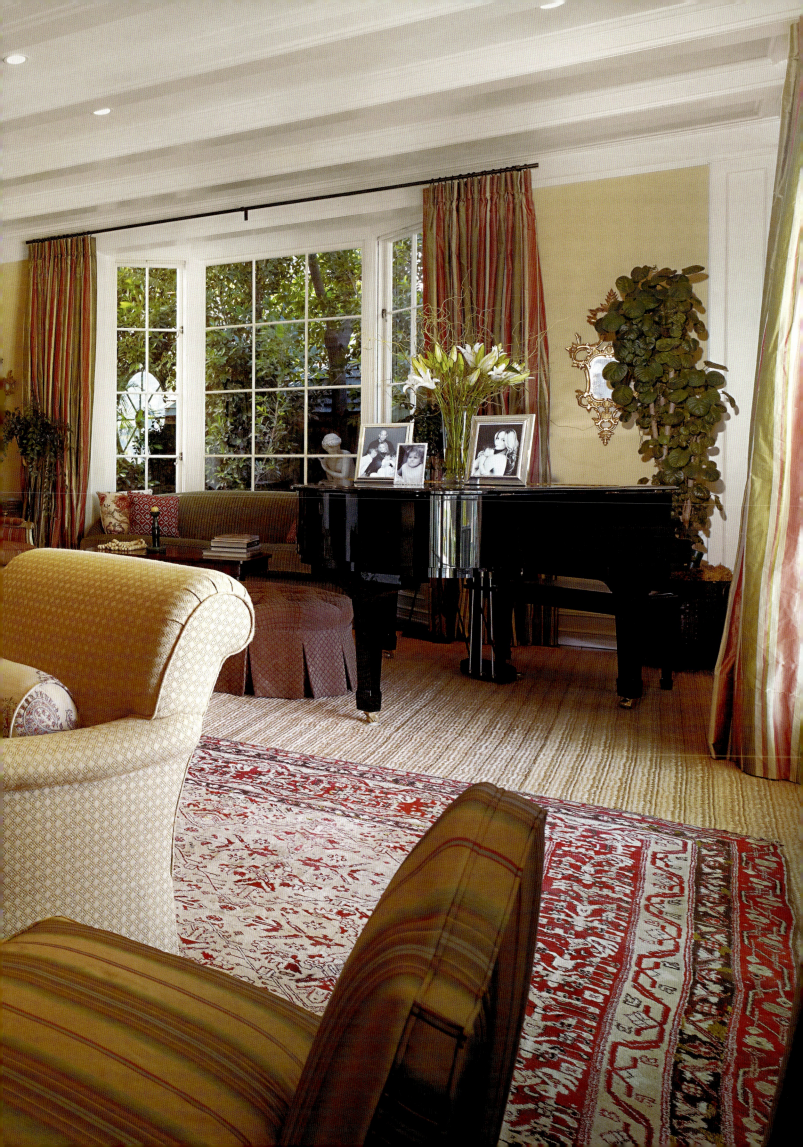

TOP:
The morning room is light filled, the perfect place for having a cup of tea and thinking about the day.

ABOVE:
The dining room's wall of windows looks out onto the garden.

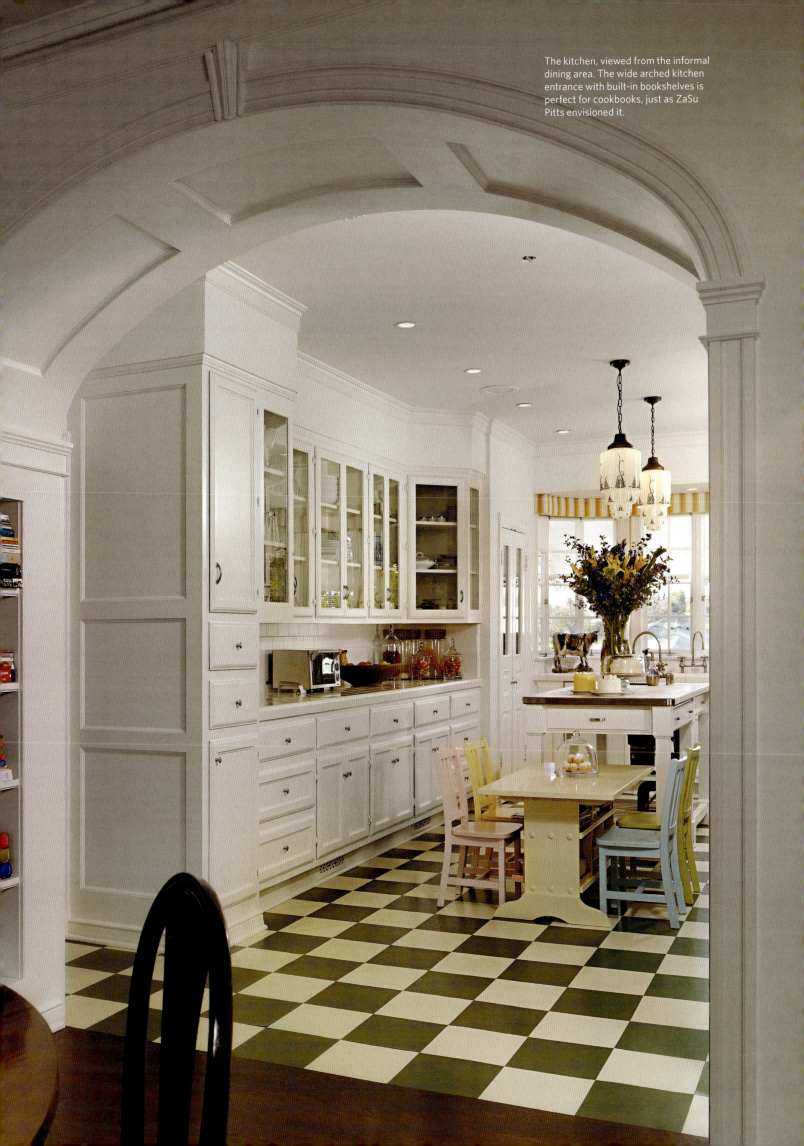

The kitchen, viewed from the informal dining area. The wide arched kitchen entrance with built-in bookshelves is perfect for cookbooks, just as ZaSu Pitts envisioned it.

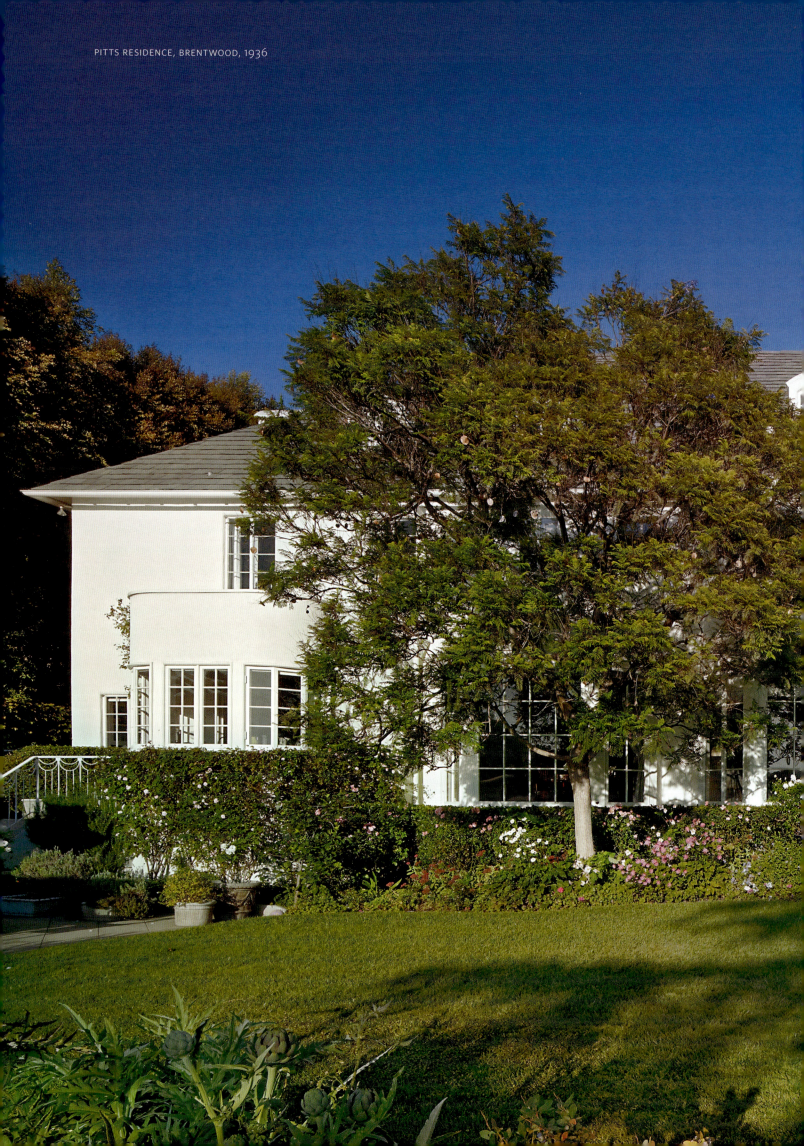

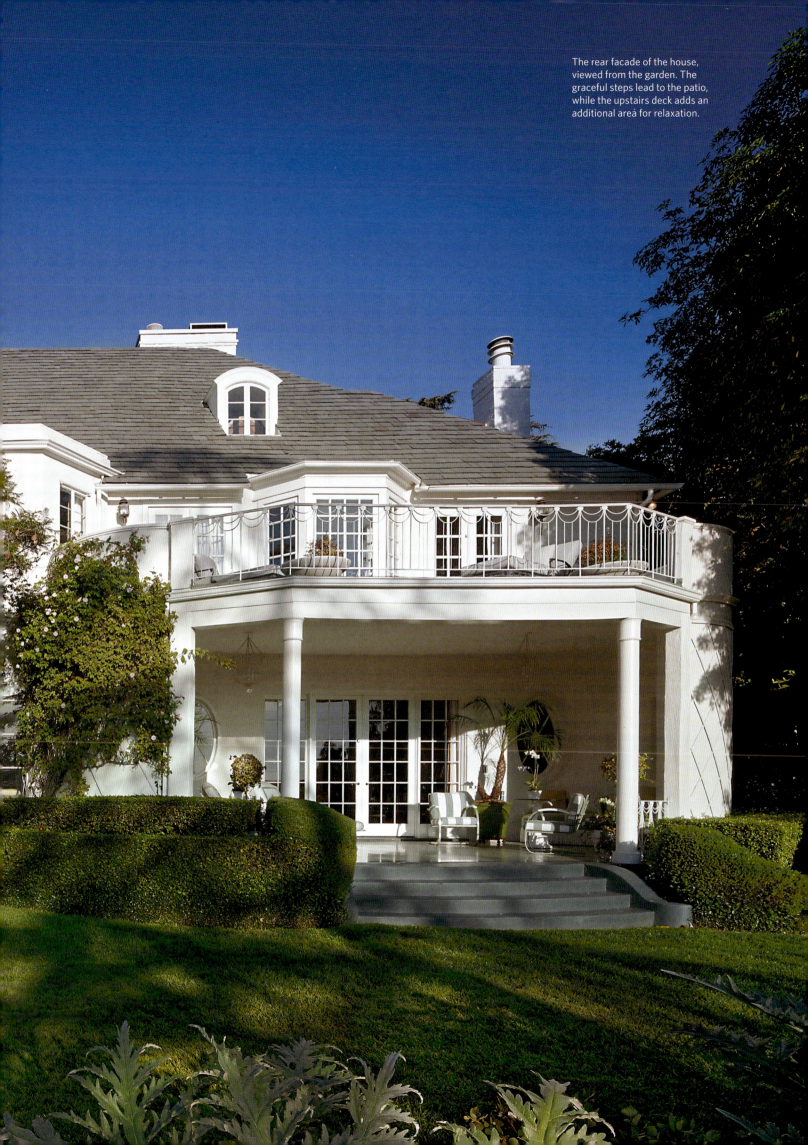

The rear facade of the house, viewed from the garden. The graceful steps lead to the patio, while the upstairs deck adds an additional area for relaxation.

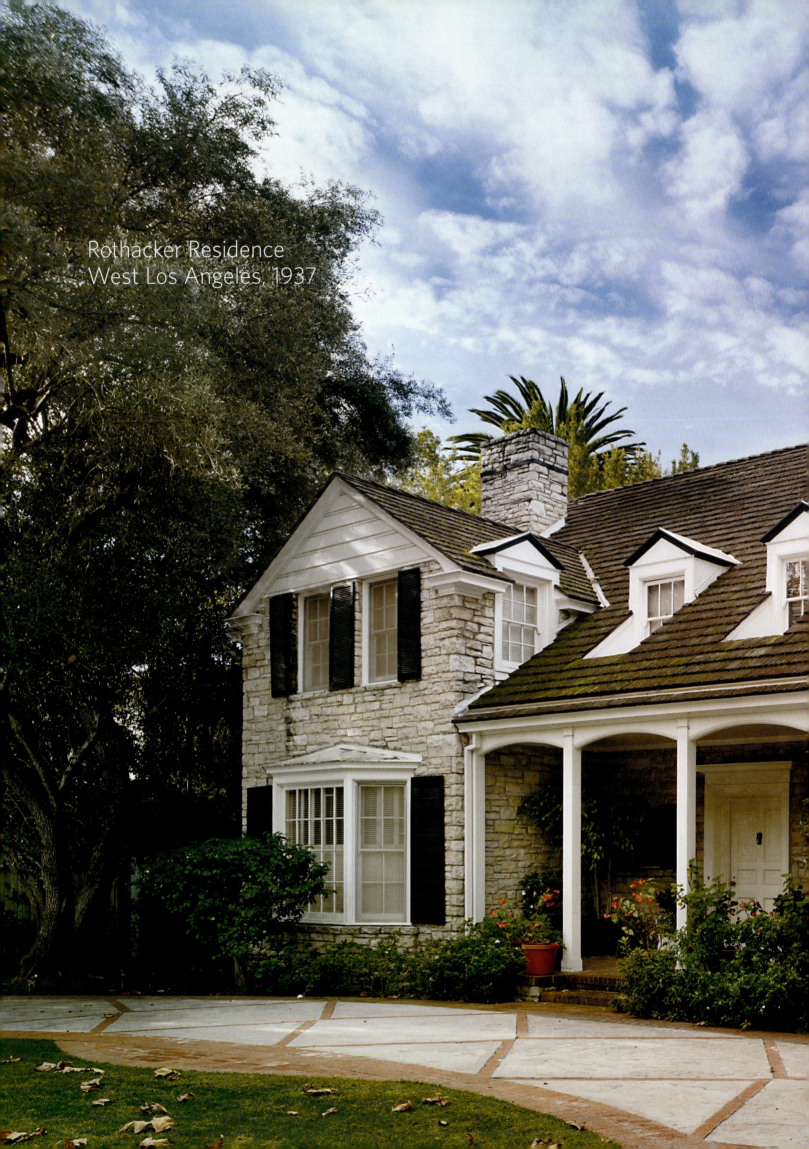

Rothacker Residence
West Los Angeles, 1937

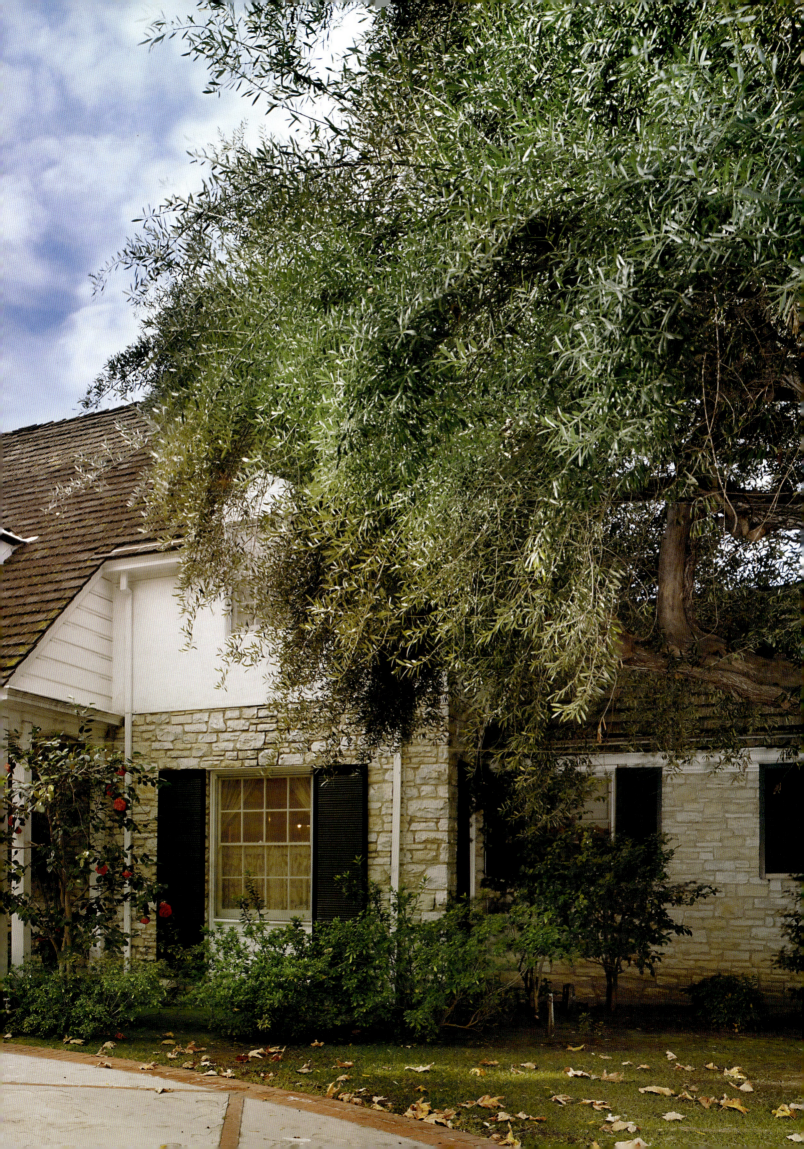

This is the reason we paint bright yellows and greens in rooms on the shady side of the house and less vibrant colors on the sunny side. Colors also have the effect of making a room seem larger or smaller. For example, a dark paneled room appears smaller than a bleached paneled room.

— "THE INFLUENCE OF PLANNING ON MAN'S DESTINY"

WHEN INTERIOR DESIGNER Ann Ascher first set eyes on this Colonial-style house, it was love at first sight. In a career spanning more than forty years, Ascher has dedicated the same loving attention to detail that Williams showered on this house, which he designed for silent film and documentary producer Watterson Rothacker. In 1922, Rothacker acquired the rights to Sir Arthur Conan Doyle's novel *The Lost World*, and the making of the film ensured his place in history as a pioneer in the film industry. Like so many of Williams's clients, Rothacker was a creative visionary in his own right who shared with Williams his belief in the future of a still-growing Los Angeles.

Williams joined with contractor William C. Warmington, who had begun custom home building in Los Angeles in 1926 and, like Williams, became unofficially known as a "builder to the stars." Shortly after the house was built, Warmington broadened his scope by creating well-planned neighborhoods. While less grand, the houses in these neighborhoods received the same attention to quality and craftsmanship as the estates of the movie industry's elite.

As an interior designer, Ascher had hit the jackpot when she found the house. It is deceptively small at first glance; as Ascher notes, "Its charm invites you to enter." When you do, "a surprise is your gift, as you see a home where every room placement, molding, and light consideration was part of this great architect's

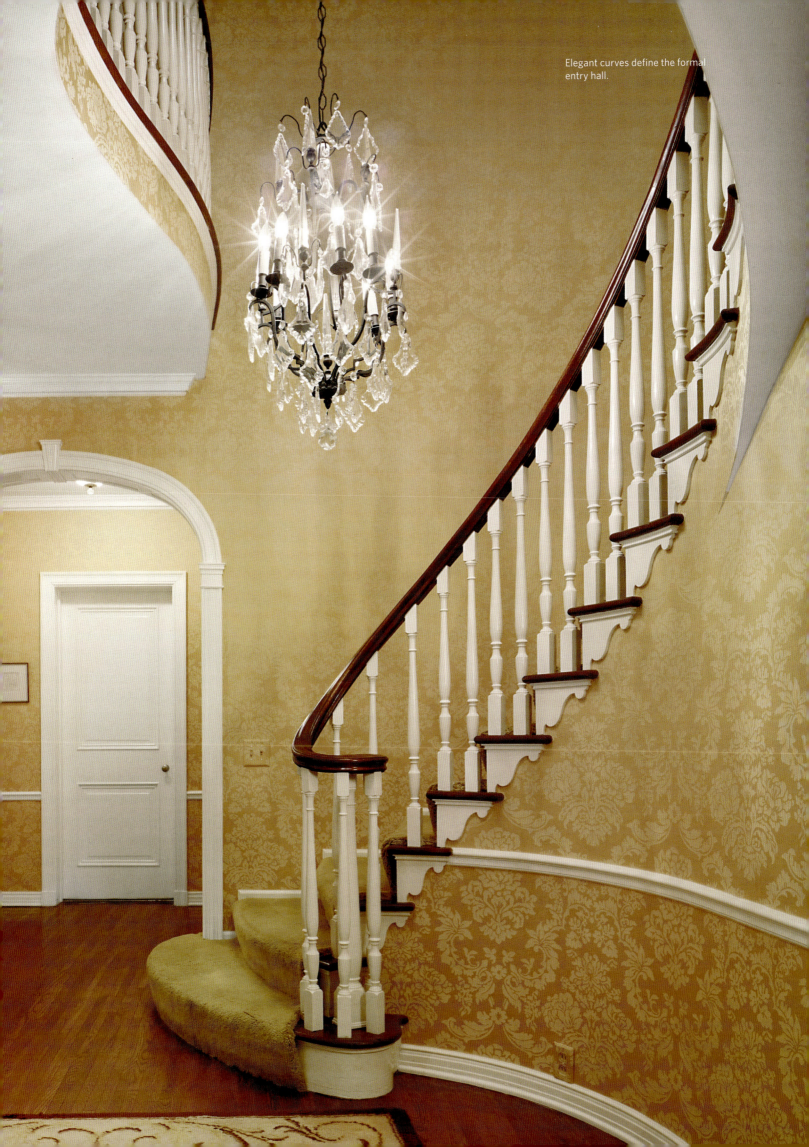

Elegant curves define the formal entry hall.

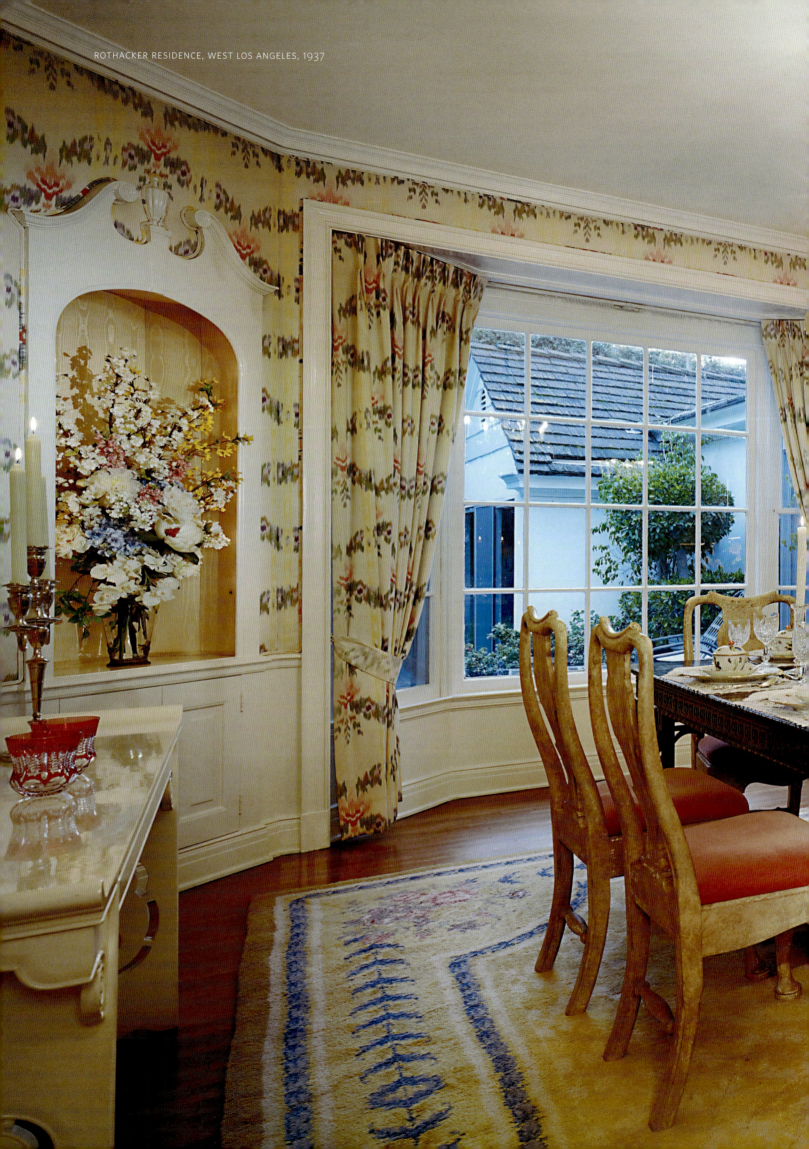

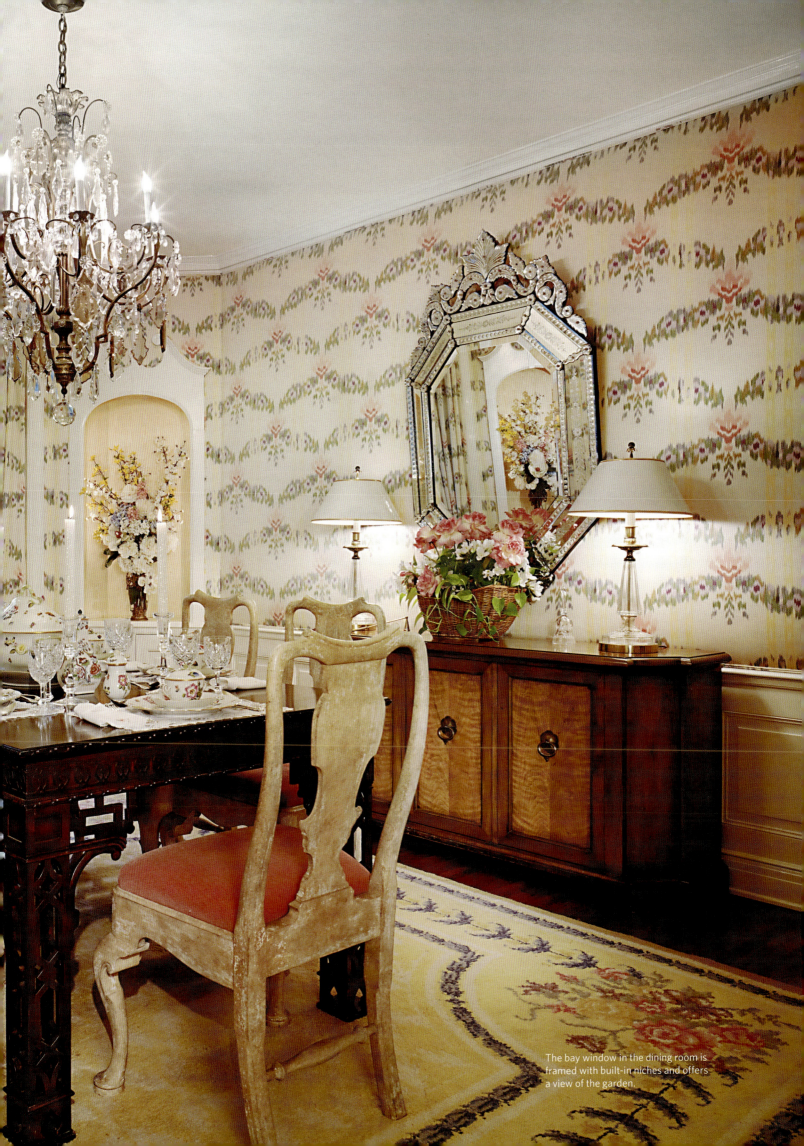

The bay window in the dining room is framed with built-in niches and offers a view of the garden.

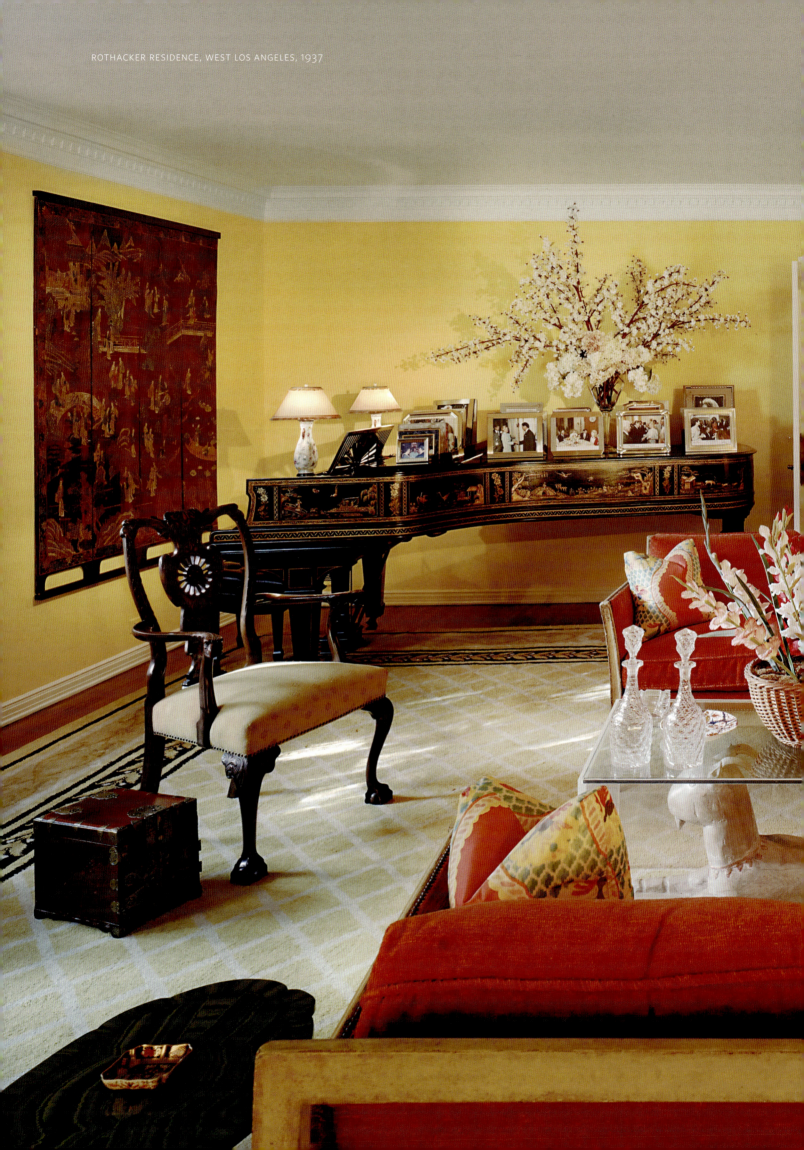

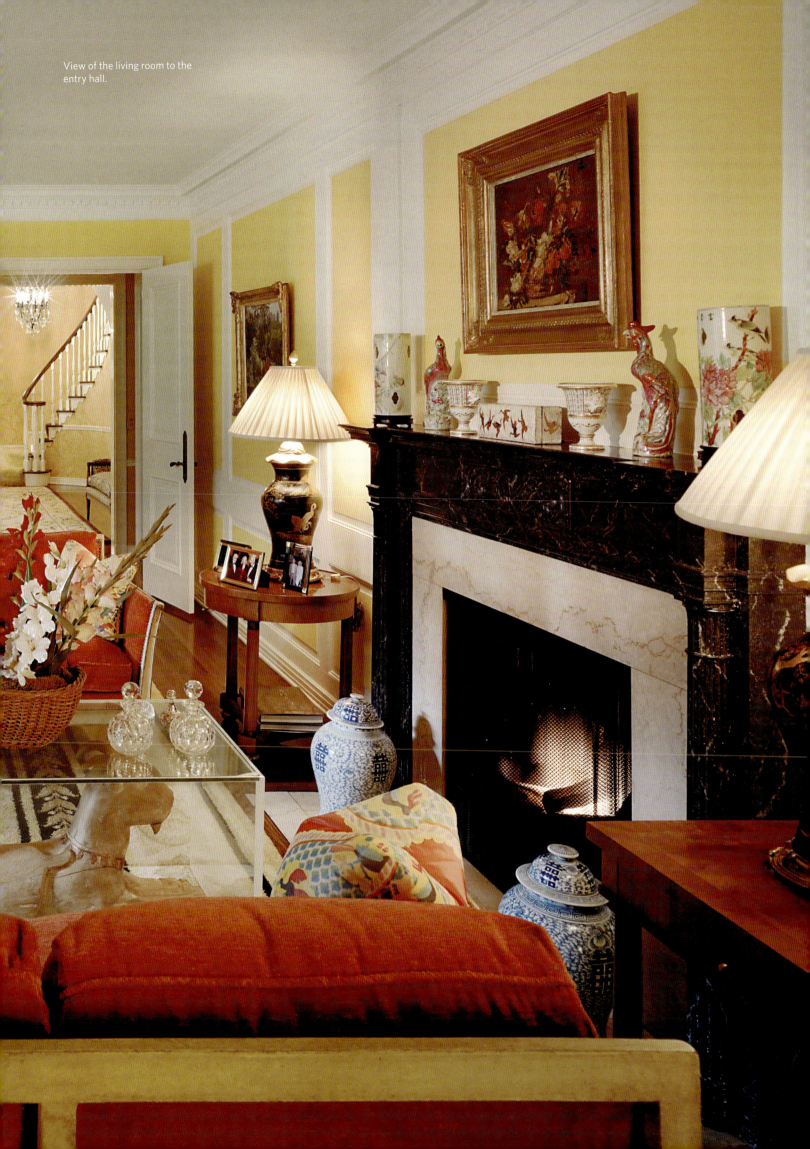

View of the living room to the entry hall.

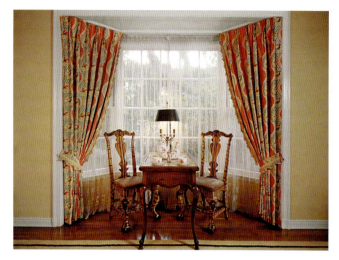

ABOVE:
The bay window was a favorite element of Williams's, and here it provides a private seating area for two.

RIGHT:
The den also boasts bay windows as well as moldings that complement those in the living room.

vision." The exterior is full of precise detailing, but the real gift awaits across the threshold with views through arch after arch, room through room to the outdoors. The entry hall, decidedly elegant, offers a view of the garden through the less formal lanai, inviting the outdoors in. Decorated entirely by Ascher, the formal living room, with its intimate seating for two in the cozy bay window, is comfortable and filled with treasures, while the dining room is her favorite room for entertaining. Here again Williams bathed the room in light from the garden, and installed built-in niches for art and collectibles. When guests join her for dinner, Ascher says, the room becomes "magical with candlelight, as it flickers against the architecture and the flowers."

Anchored by yet another of Williams's magnificent staircases, the center hall design allows one to peak into room after room, finding new "gifts" in each. From the breakfast room with its abundant morning light to the den with its extensive molding and bay window, each and every room is warm and inviting. ✩

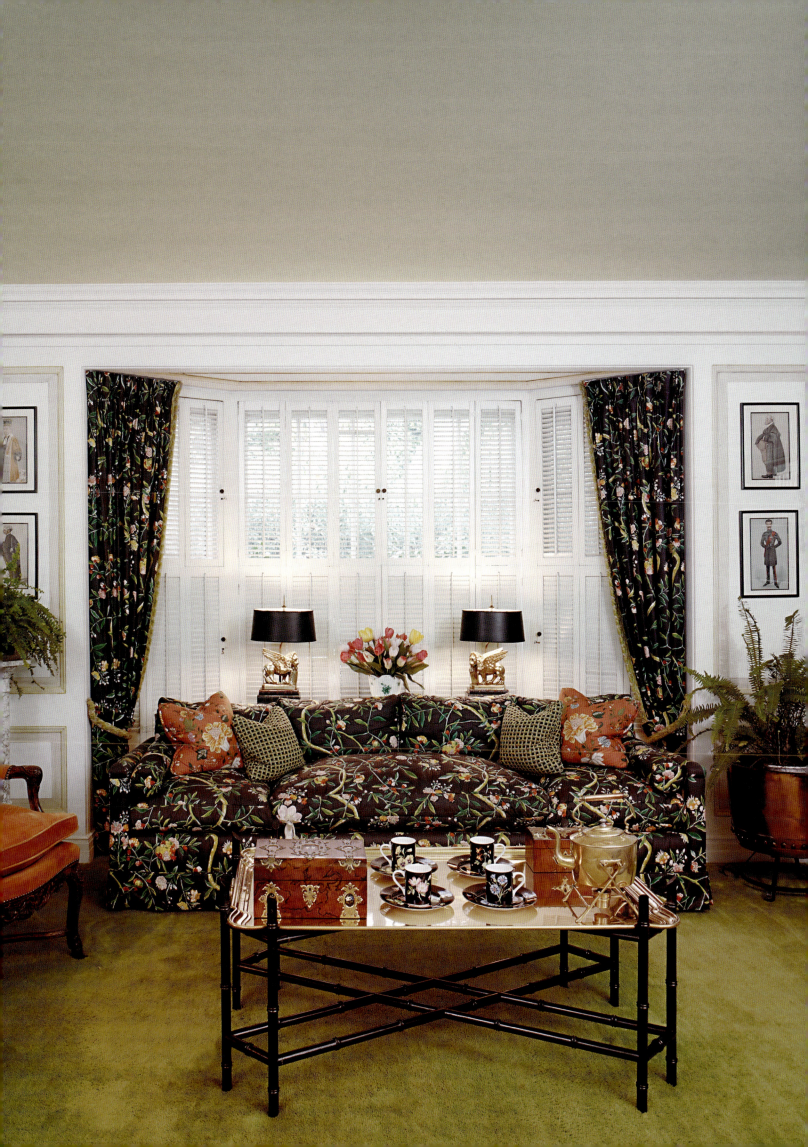

Harris Residence
Holmby Hills, 1937

A room should have a single focal point regardless of how much money is spent on it. A magnificent collection of furnishings, antiques and so forth, if arranged insensitively, can look like a very expensive junk shop. Restraint, then, is a matter of choosing and placing with care for the total effect.

— AUTOBIOGRAPHICAL NOTES

THIS HOME MAY HAVE BEEN BUILT for a physician and his family, but its locale is an enclave of Beverly Hills after all, and Dr. Joseph Harris was not just any doctor: he is famous for having delivered the son of Lucille Ball and Desi Arnaz, Desi Arnaz Jr., on the very day that Lucy's delivery of "Little Ricky" aired on television. And the Hollywood story attached to this home did not stop there. The house went on to be the home of television producer Aaron Spelling—creator of *Charlie's Angels*, *Dynasty*, and, of course, *Beverly Hills 90210*—and his family prior to the constuction of their dream mansion just a few blocks away.

The current owners were sold when they first approached the house up the long driveway and were overcome by the idyllic setting with its mature landscape. Determined to make the house "theirs" while maintaining the glamour of 1930s Hollywood, they embarked on an extensive renovation that ultimately enhanced the home's original elegance. Under the watchful direction of interior designer Craig Wright, they preserved the original design during the renovation, all the while being careful to follow Williams's original vision.

In the formal living room, Williams's use of crown moldings, impressive mantelpiece and fireplace, and floor-to-ceiling windows give the expansive space a warm feeling. The windows that grace the less formal areas, and once again look out to the lush gardens, offset and complement the extensive use of wood paneling in the den and family room.

The kitchen, with its black-and-white checkerboard floor, typical of the period of the house's original construction, leads to a charming breakfast room filled with light and cozy enough for weekday meals for the family. The family added a "Winter Room," which extends the kitchen and breakfast room view onto the garden and, though a contemporary addition, meticulously follows the spirit of Williams's original design elements.

The elliptical dining room is the owners' favorite space, and Wright retained the original moldings and embellished the room with carved palm tree pilasters. In fact, the family entertains throughout the house, but they especially enjoy spending time with friends in the vintage 1930s bar area.

Whether you find yourself sitting at the alluring dressing table in the guest powder room, having a drink at the bar, or enjoying a family holiday dinner in the light-filled Winter Room, this is Hollywood glamour at its best. ★

The understated moldings give the dramatic entry hall a hint of Art Deco sensibility.

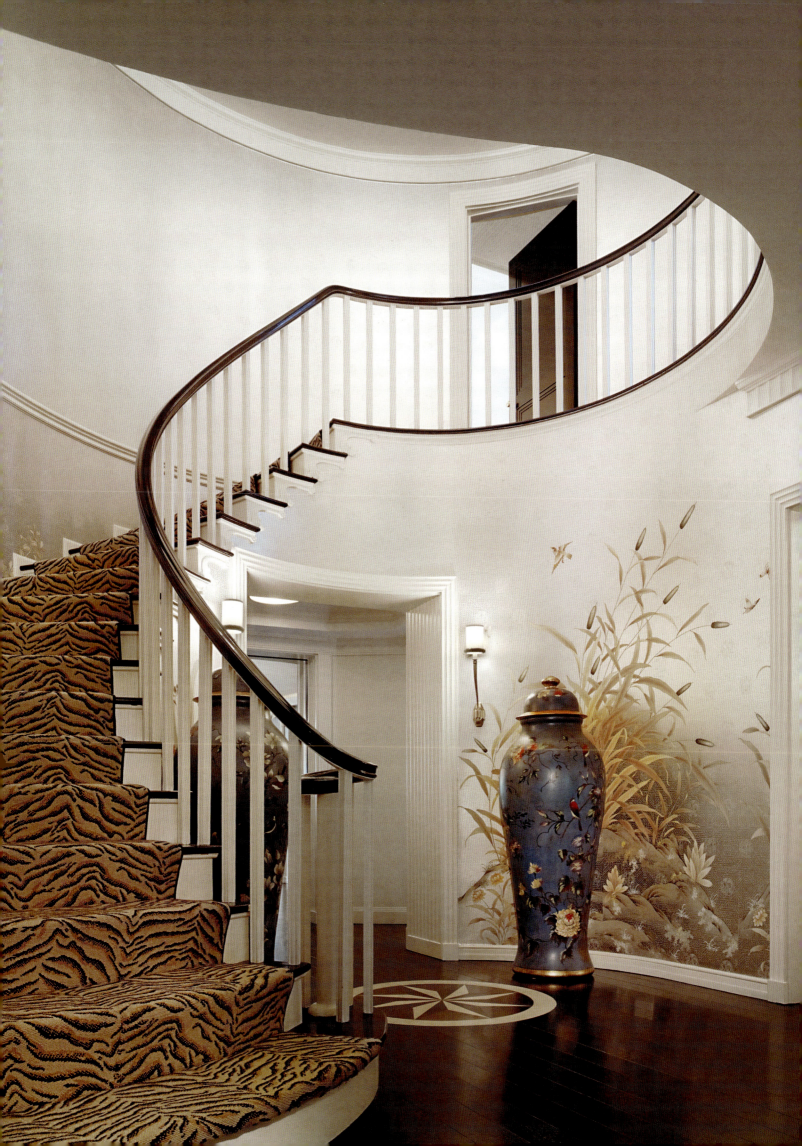

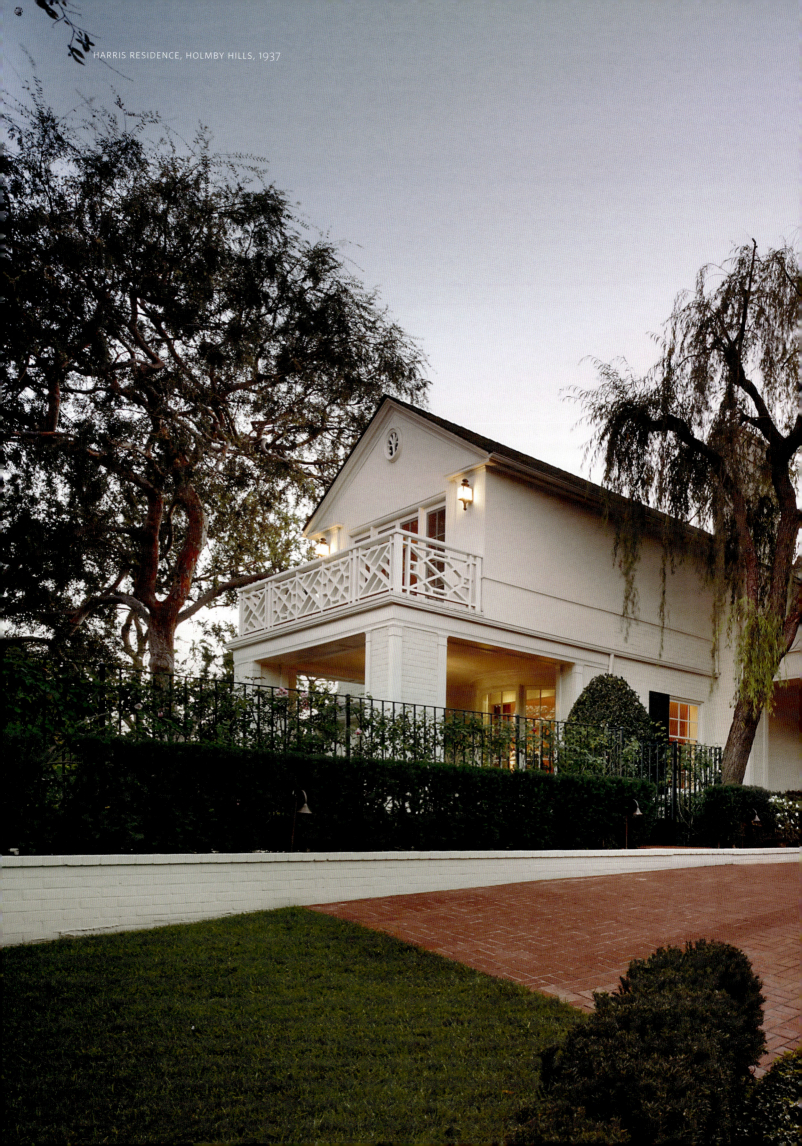

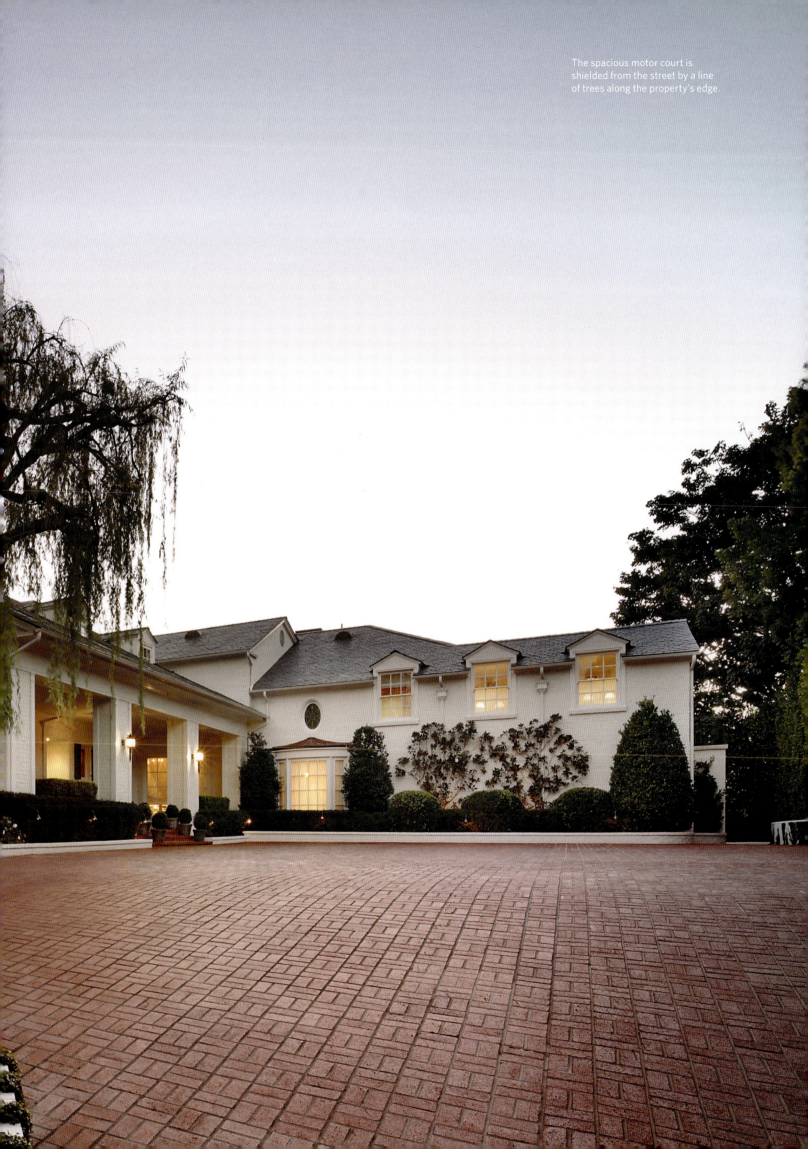

The spacious motor court is shielded from the street by a line of trees along the property's edge.

ABOVE:
An exquisite molding surrounds
the threshold between the entry
hall and the living room.

RIGHT:
The oval formal dining room looks
out onto the "Winter Room."

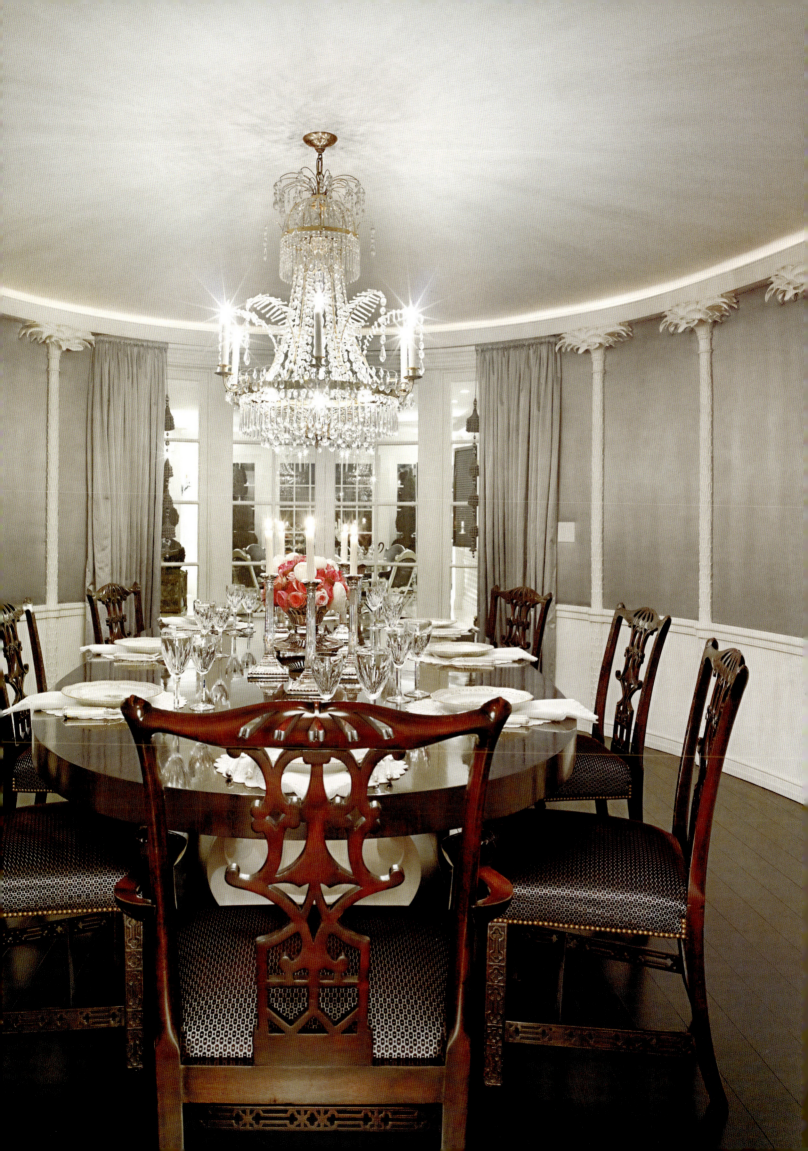

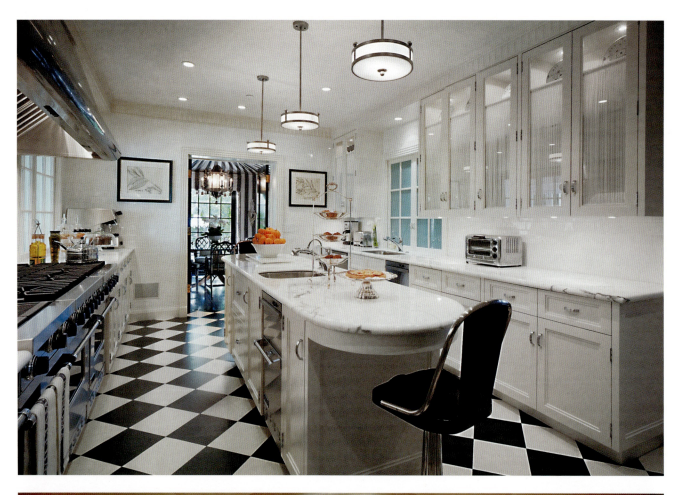

TOP:
The view from the updated kitchen, with signature black-and-white checkerboard floor, to the breakfast room.

ABOVE:
The bar area is a favorite gathering place and part of the renovation that honored Williams's original design.

OPPOSITE:
The "ladies' powder room" in the entry was designed for the comfort of the many party guests.

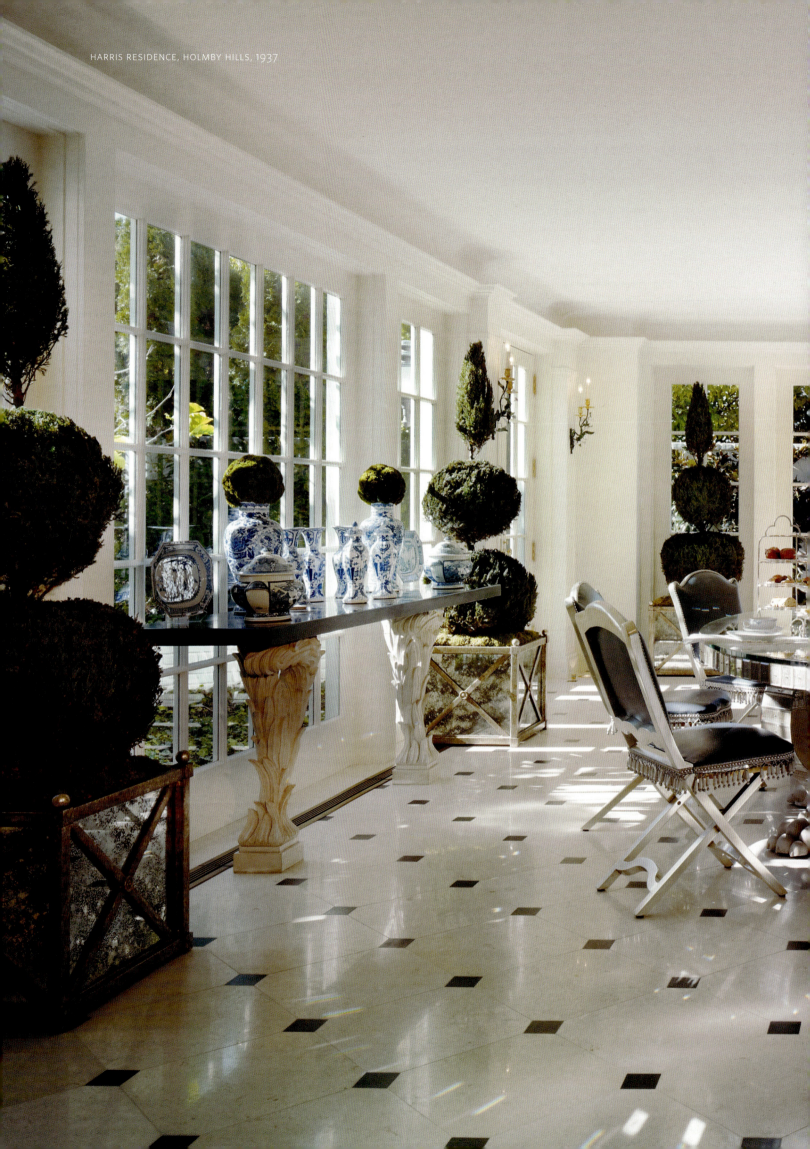

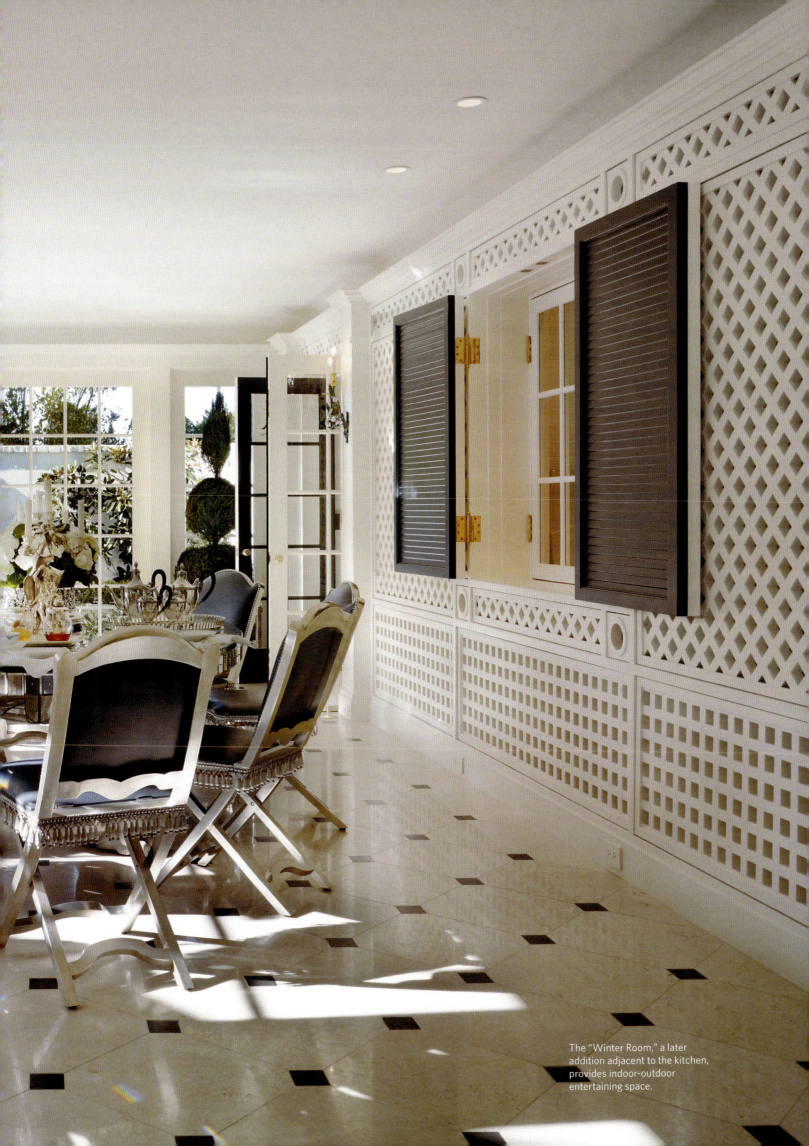

The "Winter Room," a later addition adjacent to the kitchen, provides indoor-outdoor entertaining space.

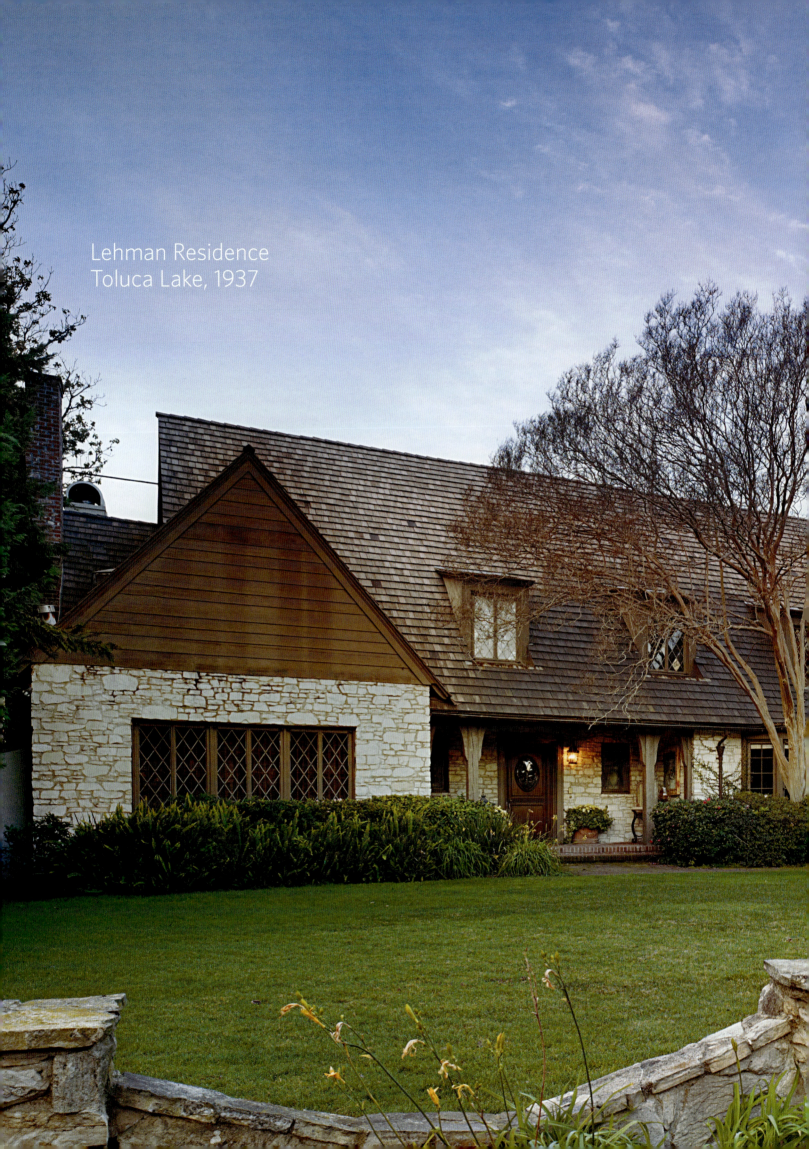

Lehman Residence
Toluca Lake, 1937

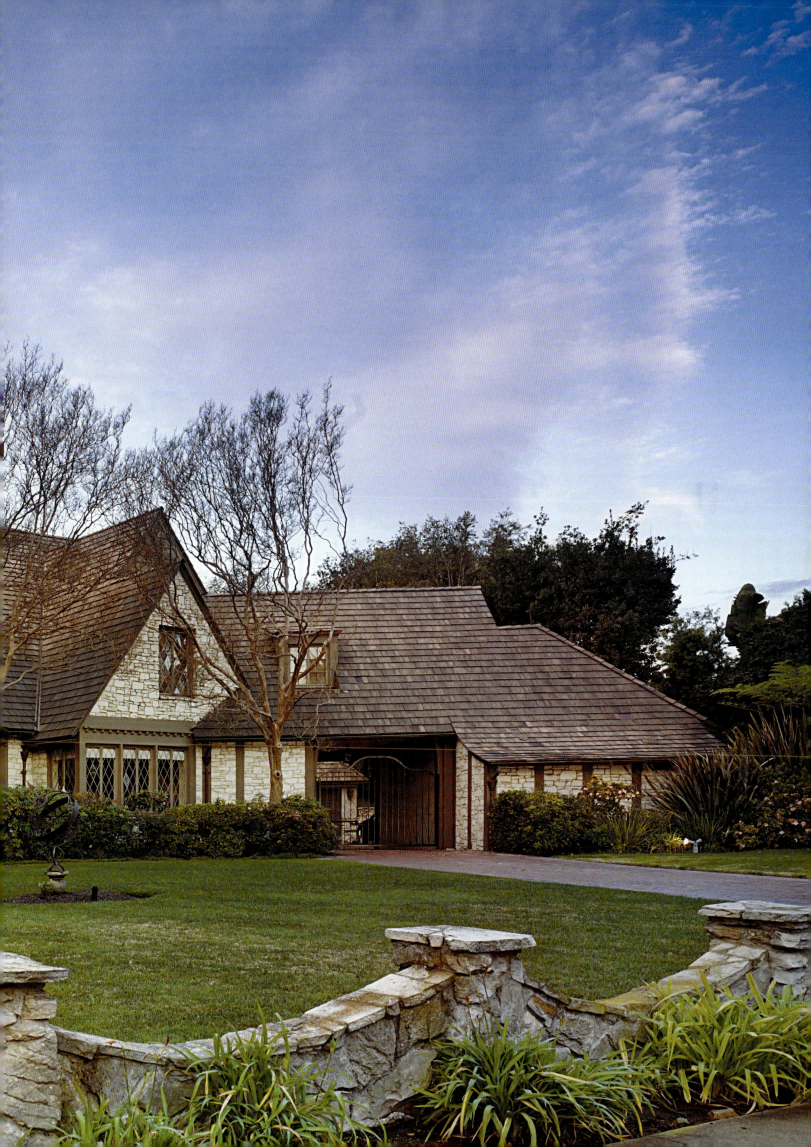

Color makes a very influential contribution to the happiness and mood of the occupant . . . If you were in a very colorful garden on a sunny day and while admiring the brilliant colors of the flowers a cloud passed in front of the sun, it would suddenly mute all the bright colors and you would probably have a depressed feeling in comparison to the previous uplift of the bright hues.

— "AN ARCHITECT PREVIEWS TOMORROW'S PROGRESS"

THE PLANS FOR THIS HOUSE have always held a special fascination for me because rarely was a woman's name listed as the client for a house designed by my grandfather. But though this client, Gladys Lehman, was married, she was also a strong, successful woman who knew what she wanted. According to Williams's longtime secretary, Lehman usually would saunter into the office dressed in trousers—attire that both amused and horrified her. A well-known screenwriter who made her name with the 1932 film *Back Street*, Lehman was well respected in Hollywood circles. Her prolific career included the screenplays for multiple films starring Shirley Temple, including *Poor Little Rich Girl* and *Little Miss Marker*, and the screenplay for *Death Takes a Holiday*, on which *Meet Joe Black*, starring Brad Pitt, was based.

This English Tudor-style house, located on Toluca Lake, would go on to become the backdrop for a true-life Hollywood love story starring Bob Wian, founder of the iconic Southern California hamburger chain Bob's Big Boy. From the very beginning, the home played host to countless parties, including the one where Wian, as a guest, would meet his future wife, June. As the story goes, Wian fell in love with June at the bar, then at the first opportunity he bought the house for her!

Elegant yet unpretentious, the exterior of the house maintains the grace of an English country lake house. Extensive wood paneling is used throughout the home, but is most prevalent in the

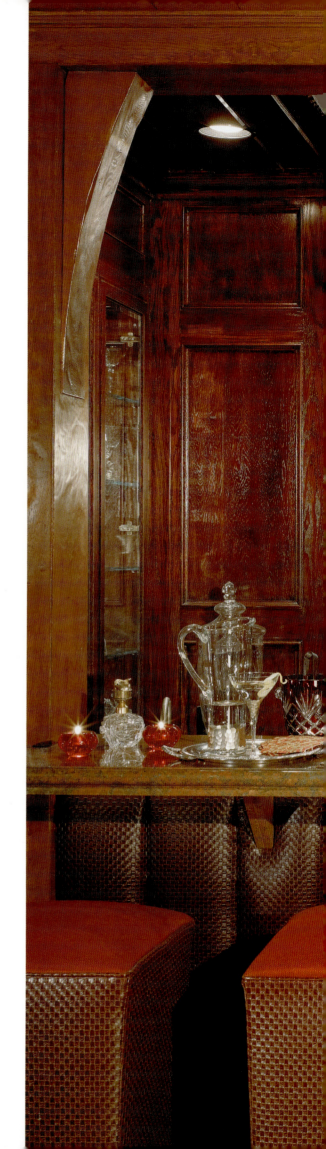

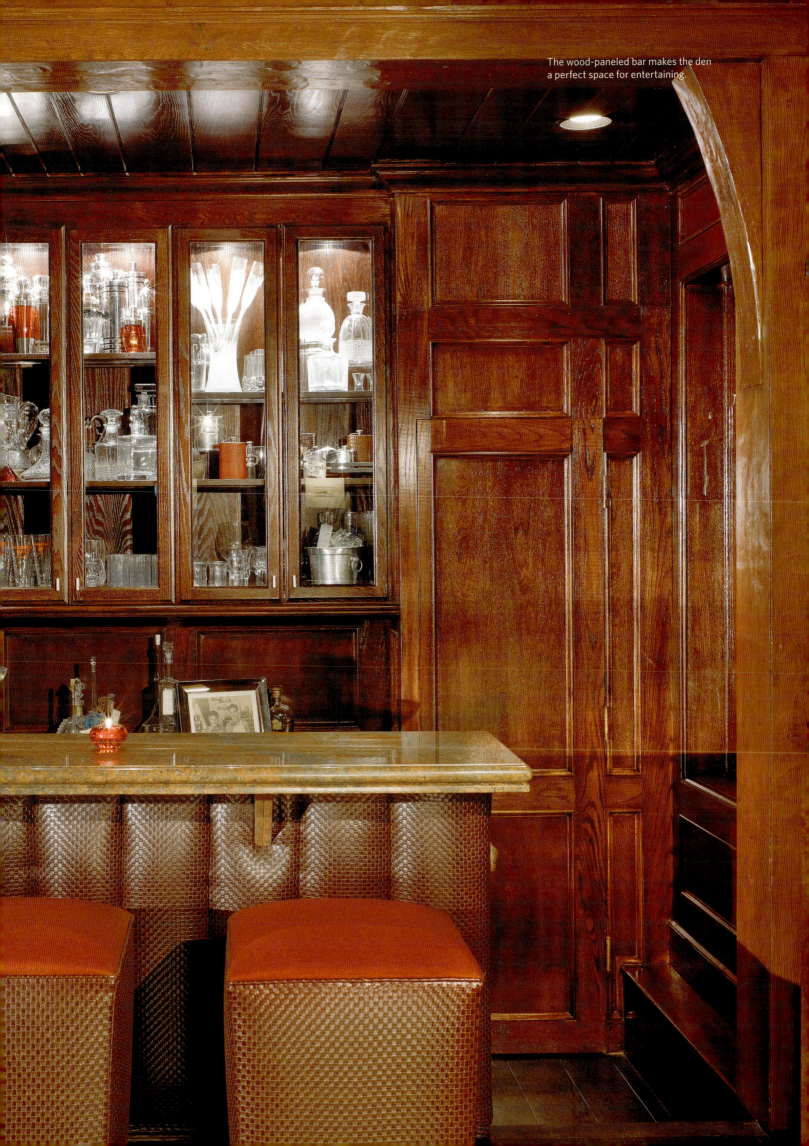

The wood-paneled bar makes the den a perfect space for entertaining.

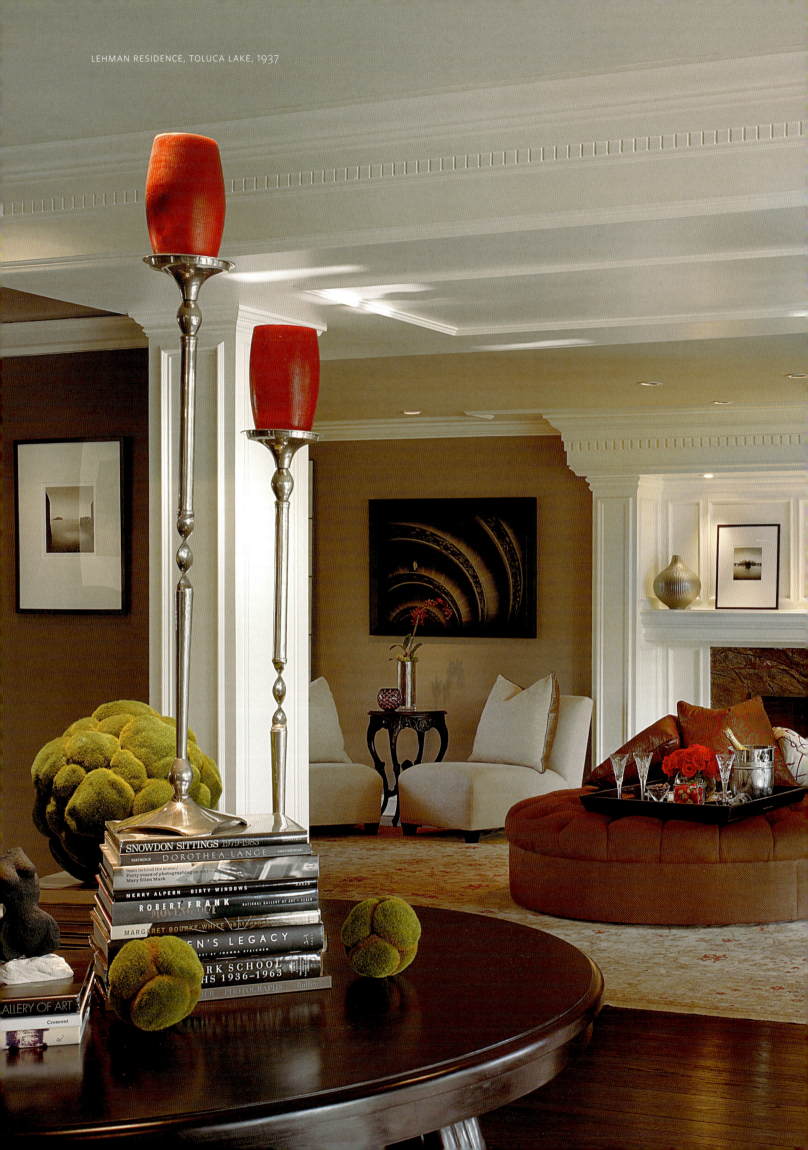

View of the living
room from the foyer.

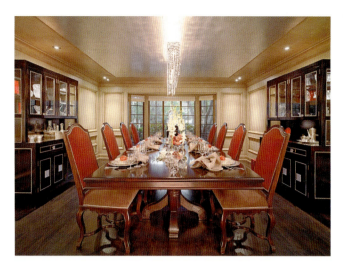

The dining room is as comfortable
as it is elegant.

den. As with most of Williams's houses, the den faces the garden,
this time with a view of the lake, a gazebo, and a dock. There are
several outdoor entertaining spaces, enhanced by a fireplace and
an extension added by the current owners. The dining room
windows overlook the front yard, while the den remains the
ultimate "party" space, with its hidden room concealed by a
hidden door. The living room features Williams's signature
molding and fireplace, while the dramatic entrance hall is graced
by a sweeping staircase that is classic Williams. And even the
crimson and white elliptical passageway between the kitchen and
den exudes Golden Age Hollywood glamour. ✩

FOLLOWING PAGES:
The dramatic red color and series of curved forms in
the entry hall are echoed in the adjacent circular
gallery area, which is the perfect place to showcase
art and collectibles.

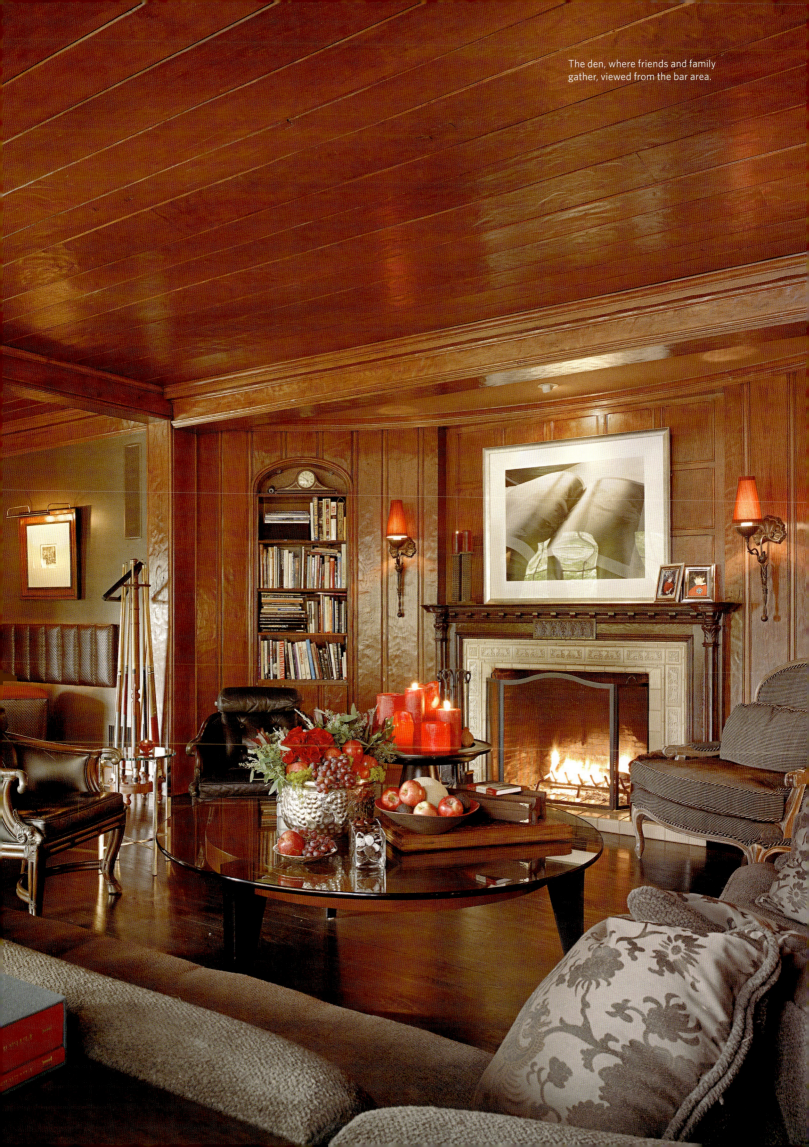

The den, where friends and family gather, viewed from the bar area.

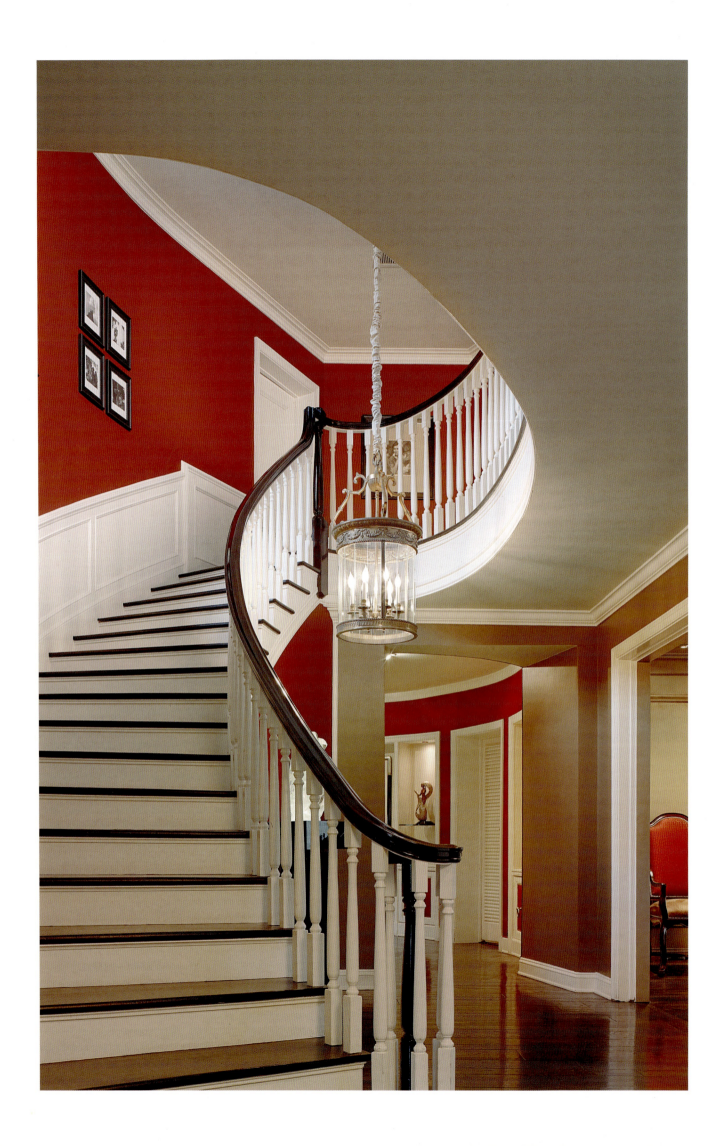

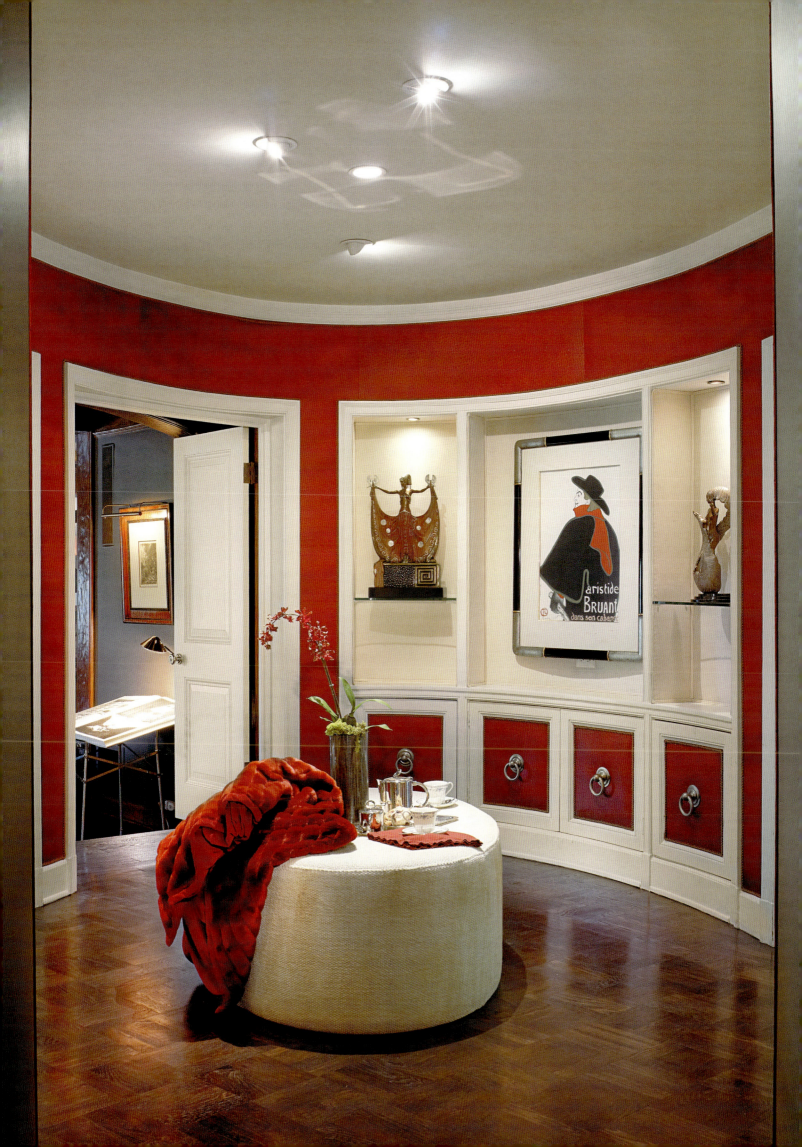

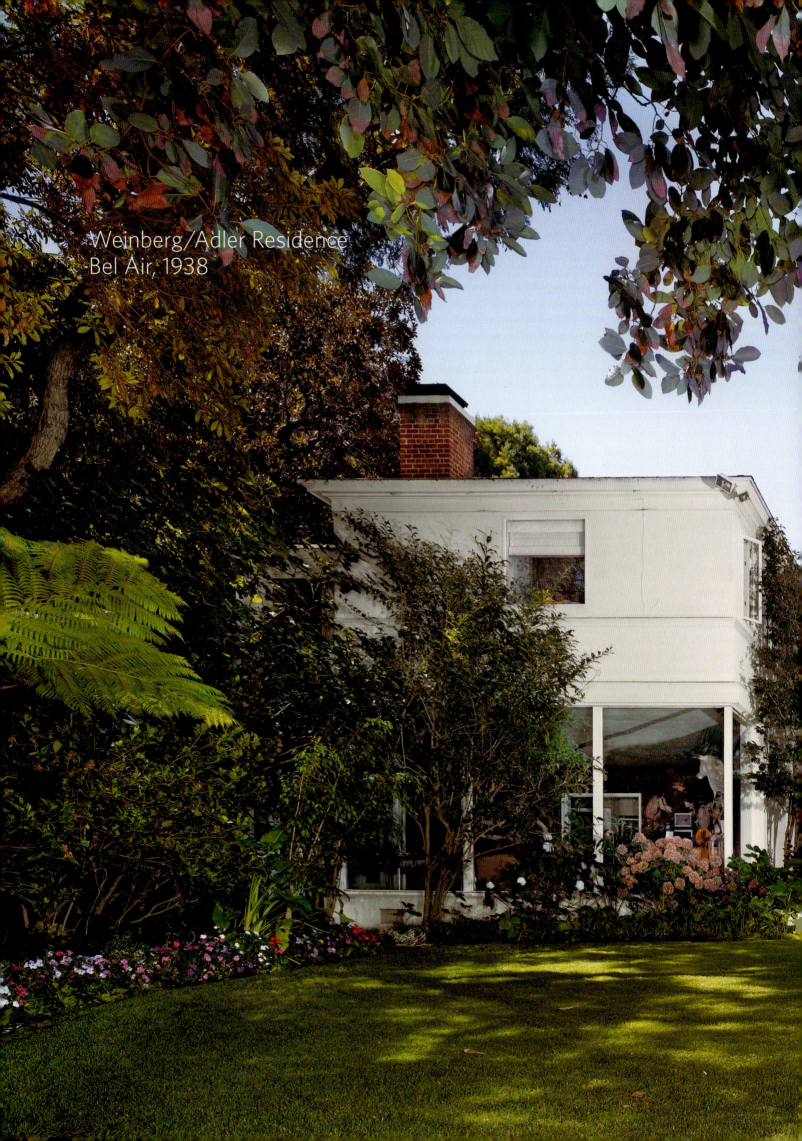

Weinberg/Adler Residence
Bel Air, 1938

I have a definition for good design that I would like to tell you. It is one that can be used for music, dress, design, architecture and interior planning. "Good design is the pleasing assemblage of parts—and not the assemblage of pleasing parts." For example, in designing a home one might have a collection of a beautiful entrance, doorways, several stained glass windows, exciting stone work, which individually could be masterpieces, but try to put them all on one facade and you would have a "hodgepodge." On the other hand, the doorway surrounded by plain marble and simple windows could be magnificent.

- "AN ARCHITECT'S APPROACH TO PLANNING"

CHARLES WEINBERG, WHO HAD PREVIOUSLY COMMISSIONED Williams for other residential projects, again called upon him to design his dream home, this time in exclusive Bel Air, adjacent to Beverly Hills. Unfortunately, Weinberg died before he was able to move into this relaxed essay in Colonial Revival style. Within a short time, Maurice "Buddy" Adler fell in love with the house and became its first occupant. A true Hollywood legend, Adler was head of production for 20th Century Fox, succeeding Darryl Zanuck in 1956, until his death in 1960. Perhaps best remembered for his production of *From Here to Eternity*, which won the Best Picture Oscar at the 1954 Academy Awards, Adler was responsible for many other iconic films, *Bus Stop* (starring Marilyn Monroe) and *South Pacific* among them. In the living room, Adler had a projector installed behind a hidden panel in one of the bookcases, making the home the venue for countless screening parties.

Adler and his wife, actress Anita Louise, enjoyed decades in the home, and later rented it to visiting actors. Conveniently located near the studios, the house became "home" to a number of actors who were in Los Angeles filming or were between homes of their own. Among these were Audrey Hepburn and Mel Ferrer when she was shooting *My Fair Lady*, Frank Sinatra and Mia Farrow, and David Niven. The Adler family later sold the property in the early 1970s to Eva Gabor.

When Margaret Black and her husband purchased the house, they transformed it into a showcase for their love of big game hunting. While not the traditional Hollywood couple, the parties were no less extravagant. They enjoyed the home for a number of years before Margaret's husband passed away, leaving Margaret to decide whether or not she would stay, but in her heart she always knew she would. Today, she and her husband, former astronaut David Scott, enjoy dinner parties in the formal dining room surrounded by the mirrors installed by Eva Gabor, Williams's signature crown moldings, candlelight, wine, good food, and wonderful friends.

The sweeping staircase surrounds an antique Baccarat chandelier purchased by Gabor from a church in France. The walls are accented with Margaret Black-Scott's prized collection from her big game hunting days, now mingled with souvenirs from Scott's spaceflights and moonwalk.

The kitchen's extensive windows overlooking the garden give a sense of openness, and the breakfast room's curved wall of windows and French doors leads out to the lush gardens. The "Trophy Room," which serves as the family room, functions as another extension of interior space leading to the garden. The property hosts a tennis court, swimming pool, greenhouse, separate office, two caretakers' cottages, rose

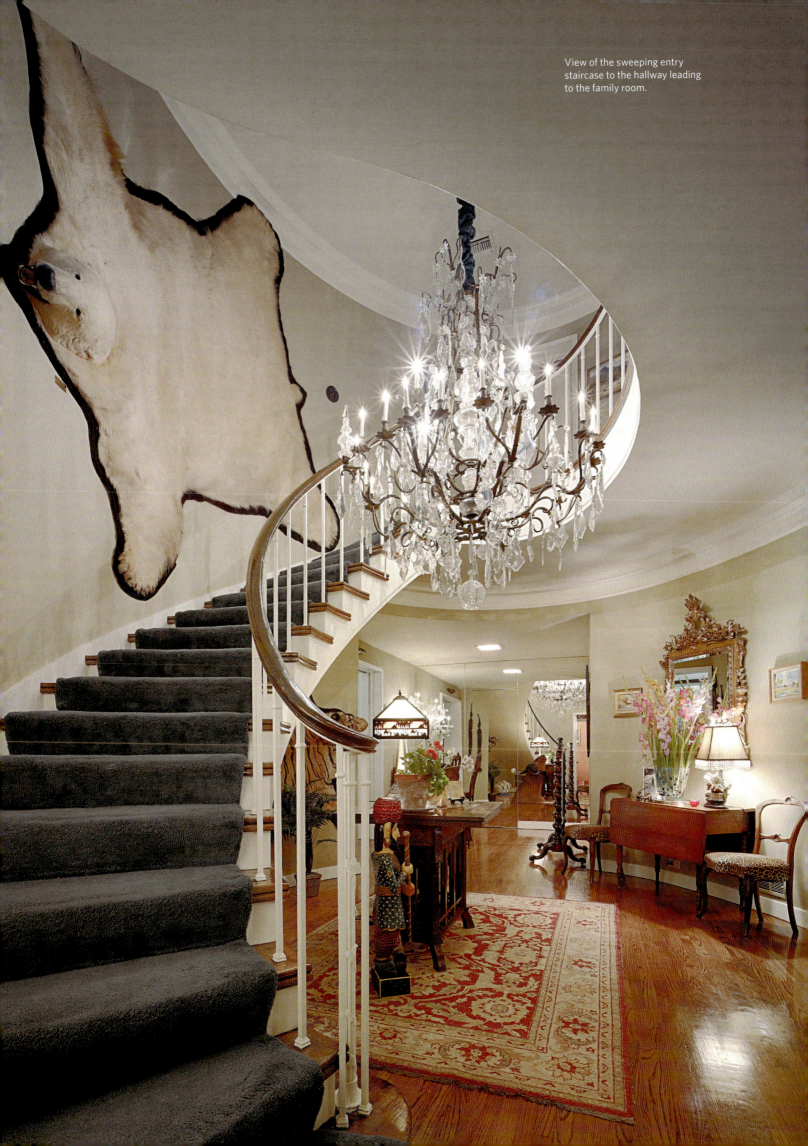

View of the sweeping entry staircase to the hallway leading to the family room.

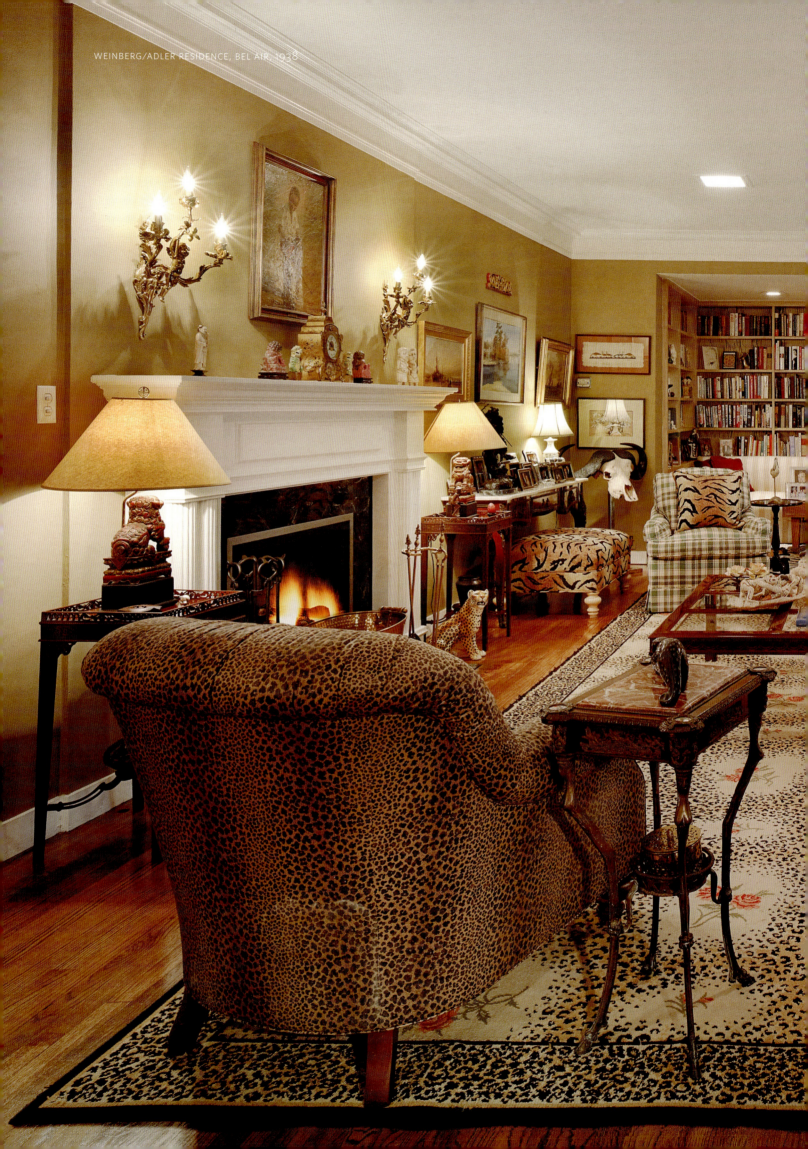

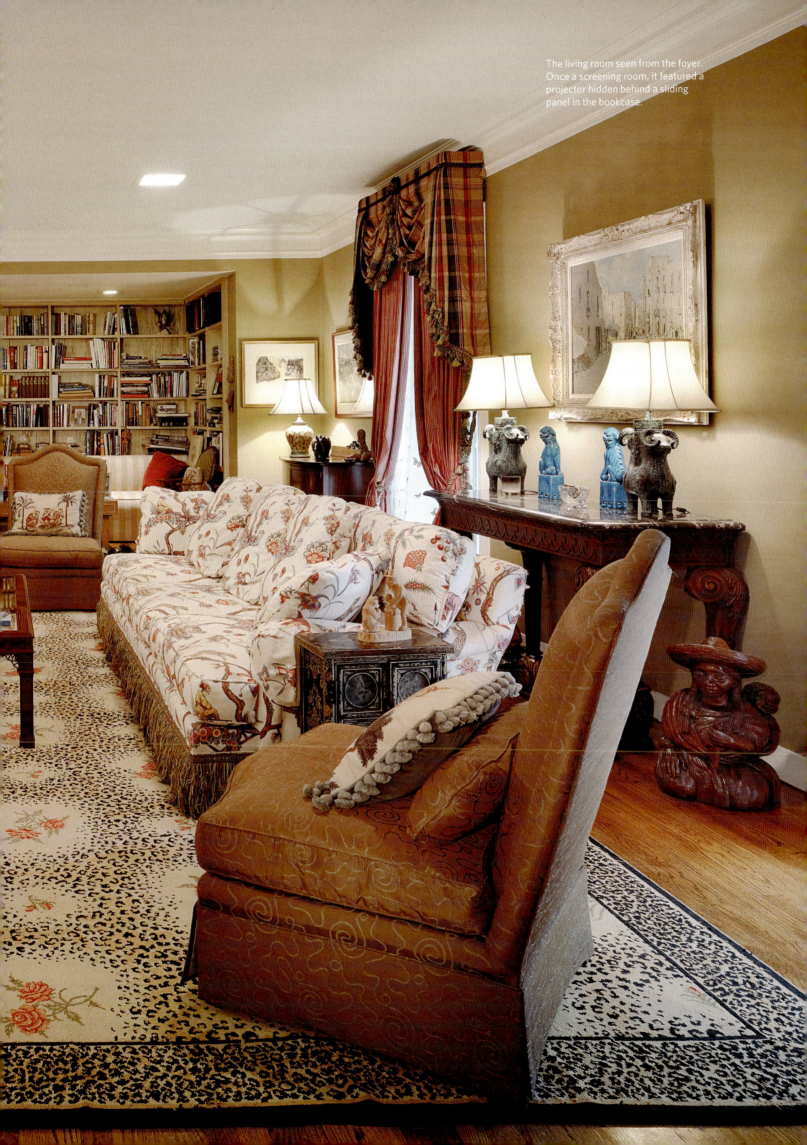

The living room seen from the foyer. Once a screening room, it featured a projector hidden behind a sliding panel in the bookcase.

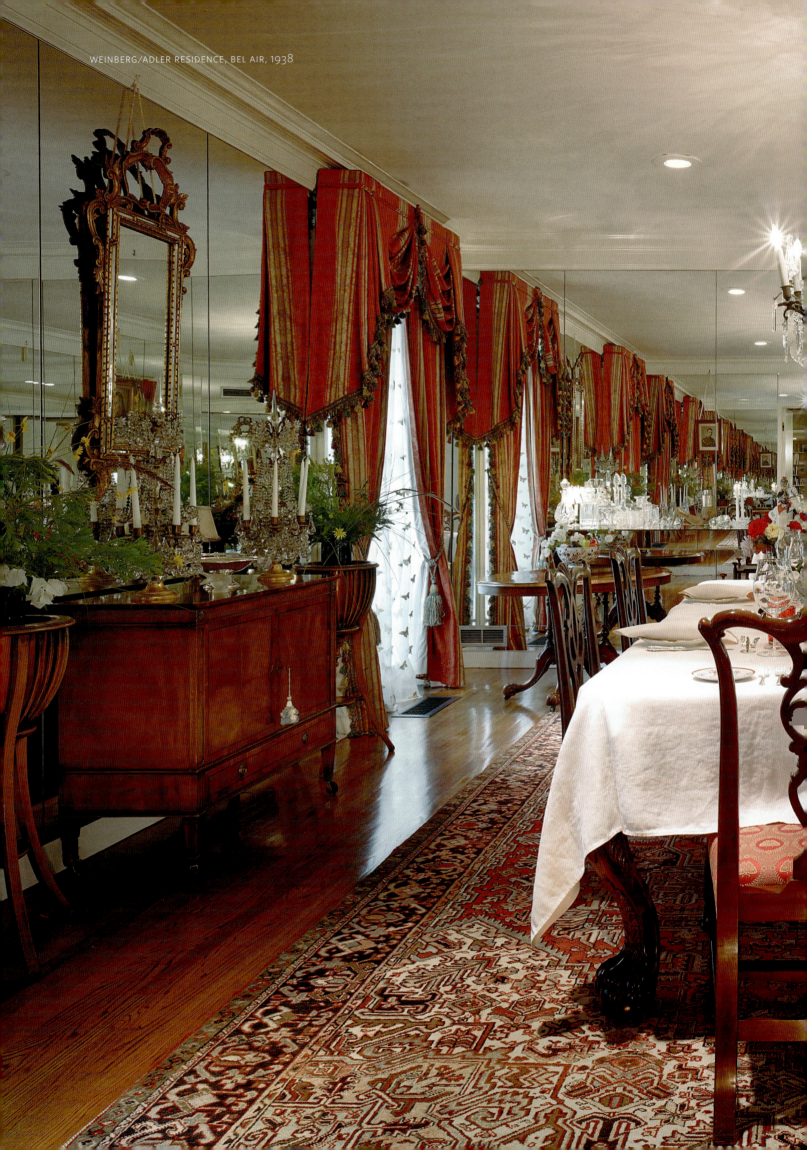

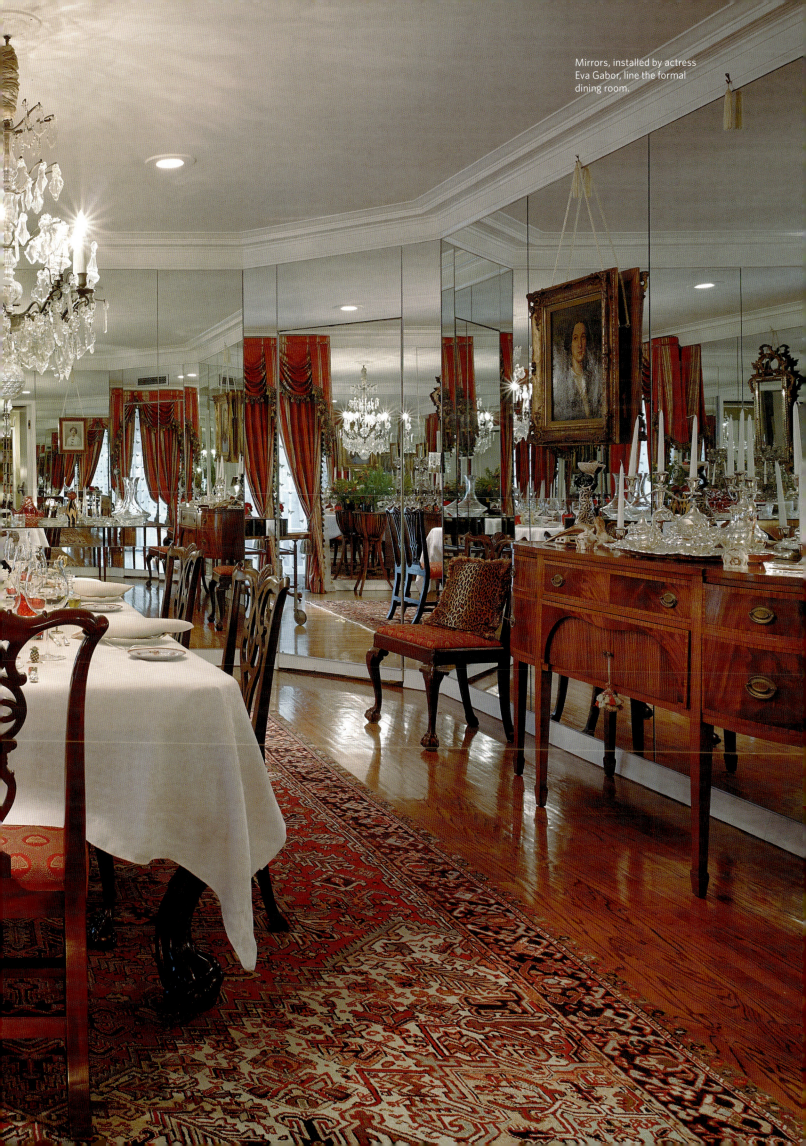

Mirrors, installed by actress Eva Gabor, line the formal dining room.

garden, and an herb garden, yet the house's siting belies its size and protects the privacy so valued by its owners. The mature trees, along with the extensive flowerbeds, add to the idyllic private setting. But it is the attention to detail, from the moldings to the door hardware, from the closets to the well placed bar area, that have the Scotts's friends exclaiming how lucky they are to live in a house designed by Williams. ✭

A circular driveway leads to the front entrance.

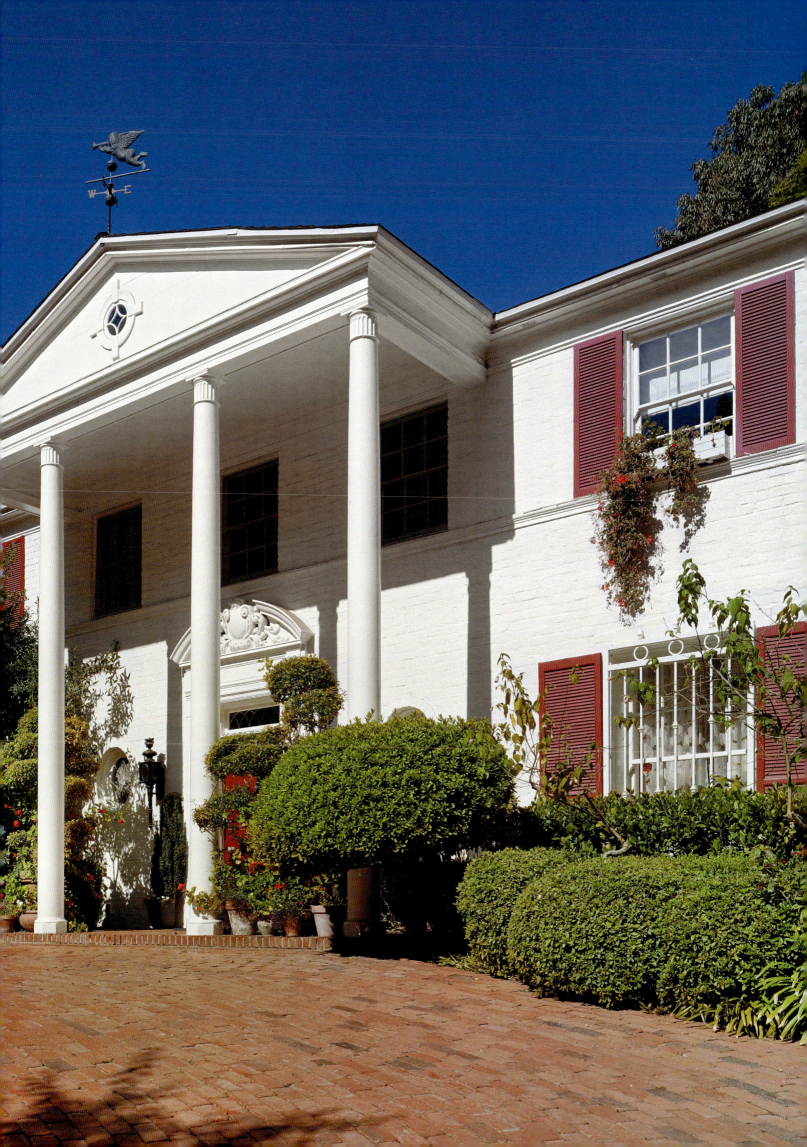

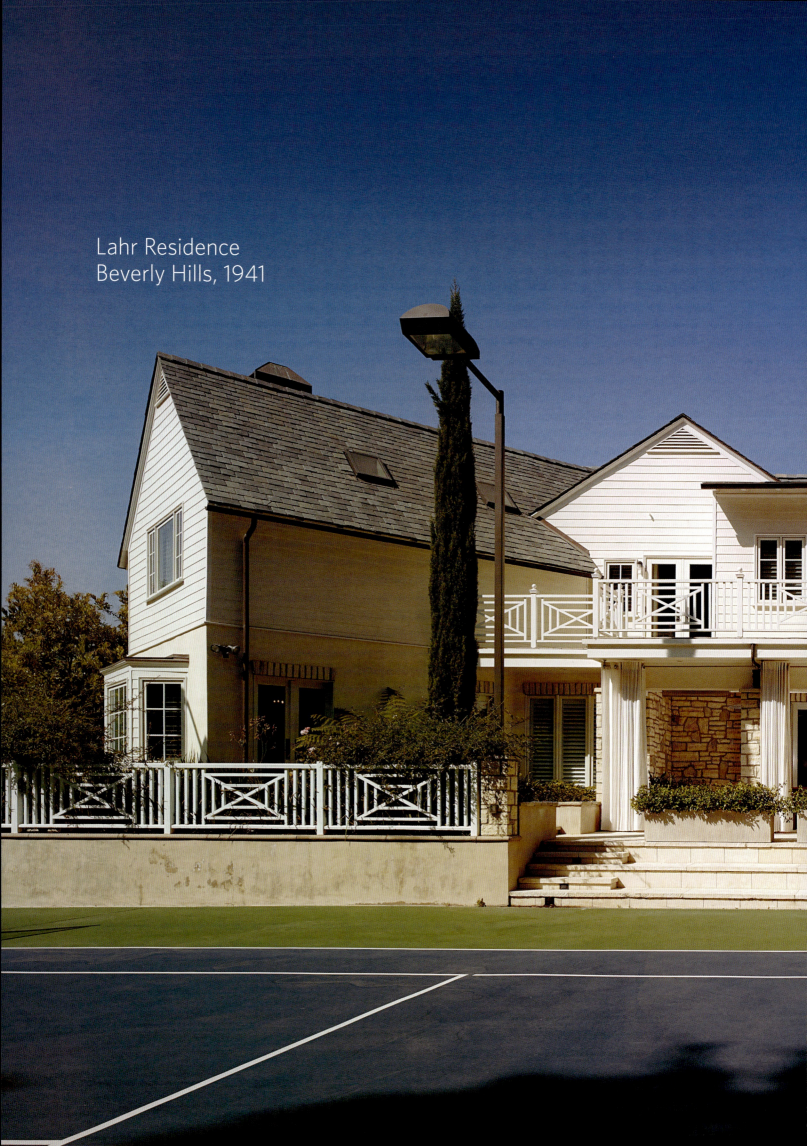
Lahr Residence
Beverly Hills, 1941

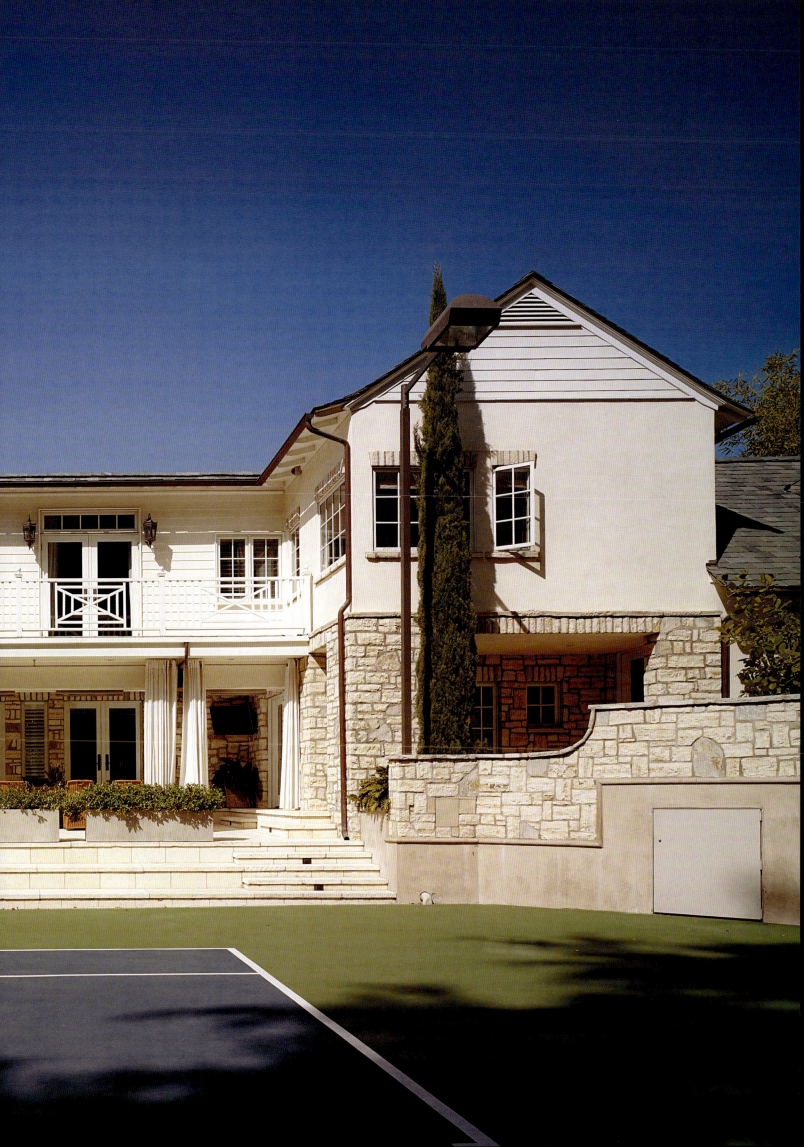

While it is great to build your home around the way you live, remember you might wish to sell someday— will the buyer like it the way you live?

— "THE INFLUENCE OF PLANNING ON MAN'S DESTINY"

BERT LAHR HAD JUST COMPLETED his iconic role as the Cowardly Lion in *The Wizard of Oz* when he commissioned Williams to design this Colonial Revival home. The transplanted New Yorker, who conquered vaudeville and Broadway before establishing himself as a comedic film actor, loved gardening, and the California climate allowed him to surround himself with fruit trees and incredible plants. Williams paid particular attention to landscaping the 1.4-acre property, bringing in avocado, fig, lemon, lime, and grapefruit trees. He built a gazebo amidst the palm trees and ferns so Lahr and his family could sit outside and simply enjoy the parklike setting.

The dining room, which is the current owners' favorite space for entertaining, has been restored to its original glamour. However, it sees just as much service as a homework table when extra space is needed for the children's projects as it does for dinner parties. The living room also functions as a venue for formal gatherings, but its beamed ceiling maintains a sense of warmth in the room. The kitchen, where the family spends most of its time, has been redesigned with state-of-the-art appliances, while the wooden panels and shelving are based on Williams's original details and design.

The gazebo, hidden in the lush landscaping, is an original feature of the house.

The view from the tennis court showcases Williams's extensive use of exterior stone, while the interior's wood paneling and fireplace details are firmly in line with his interior design tradition. "Williams designed from the heart . . . that's why he continues to bring happiness to all the people who are lucky enough to live in his homes," remarked one of the current owners, the latest in a line that includes Betty Grable and bandleader Harry James and Don Johnson and Melanie Griffith during their marriage. "There is a mystery and romance in every room, like opening an old book covered in dust. Your mind wonders at the untold stories of people who lived here and who visited them. It is a place to escape from everyday reality. My favorite day is when I do not have to leave my house." ✩

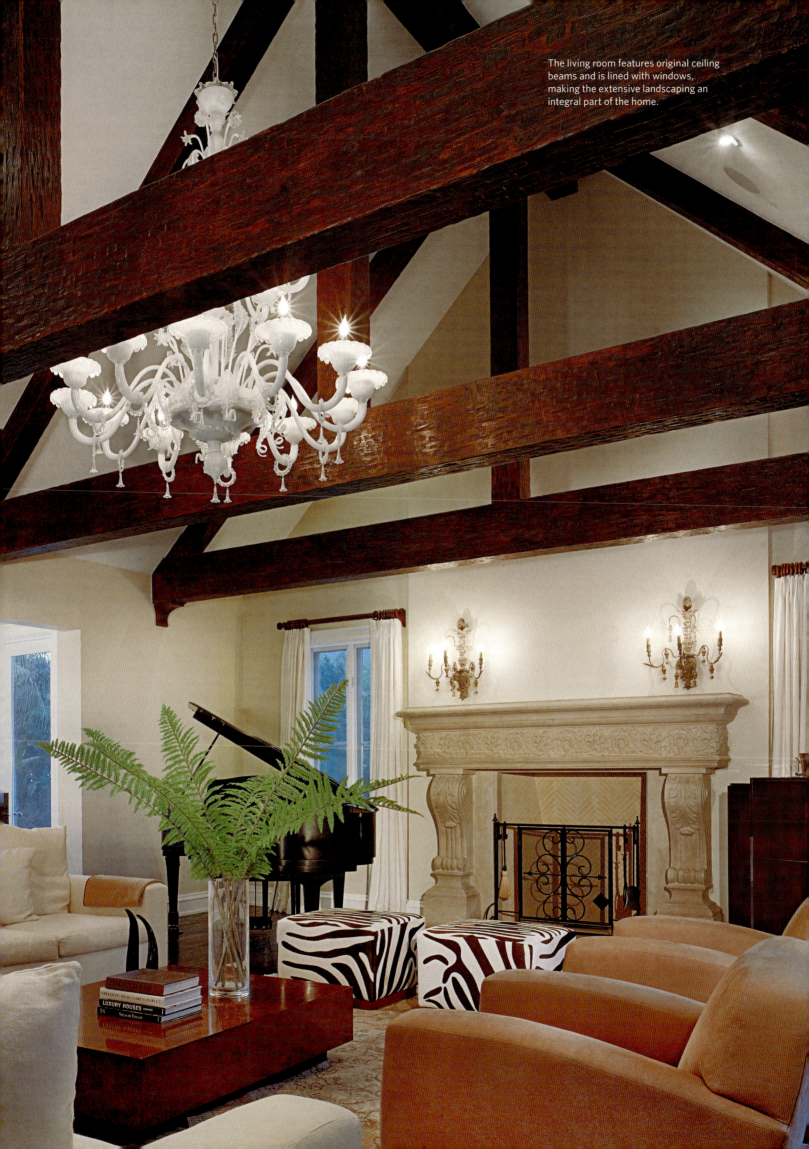

The living room features original ceiling beams and is lined with windows, making the extensive landscaping an integral part of the home.

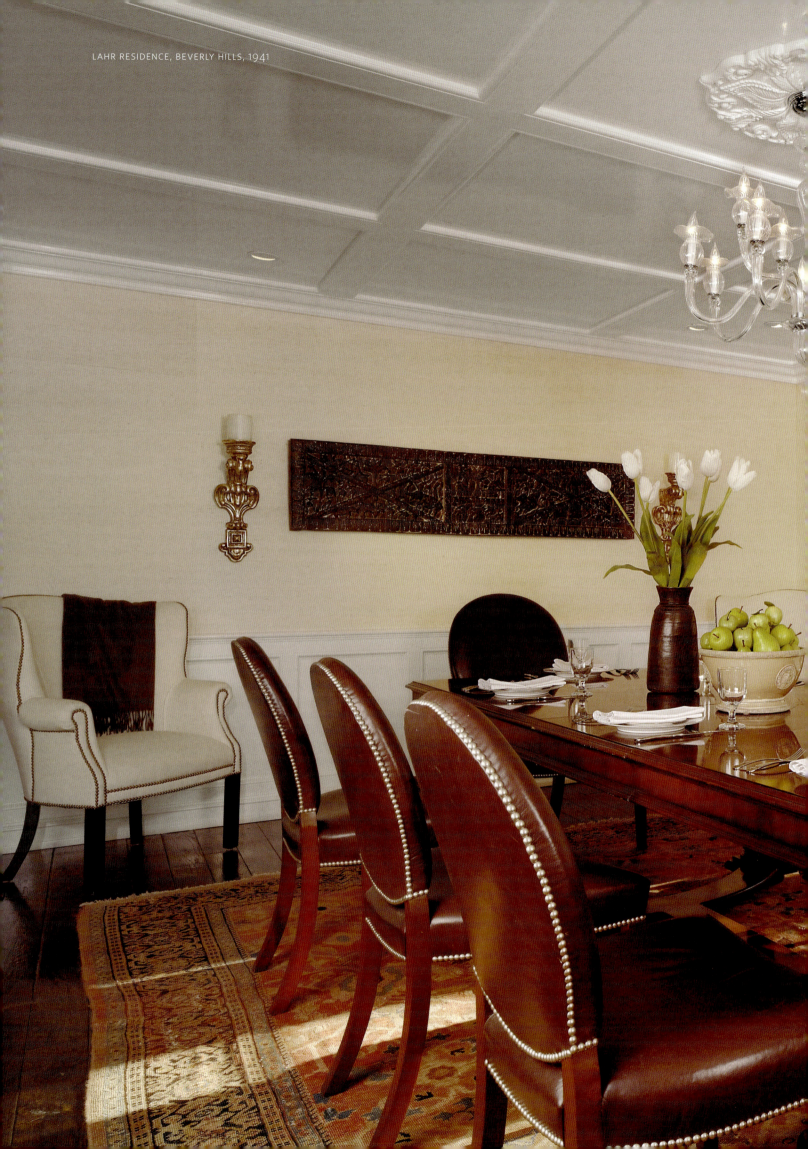

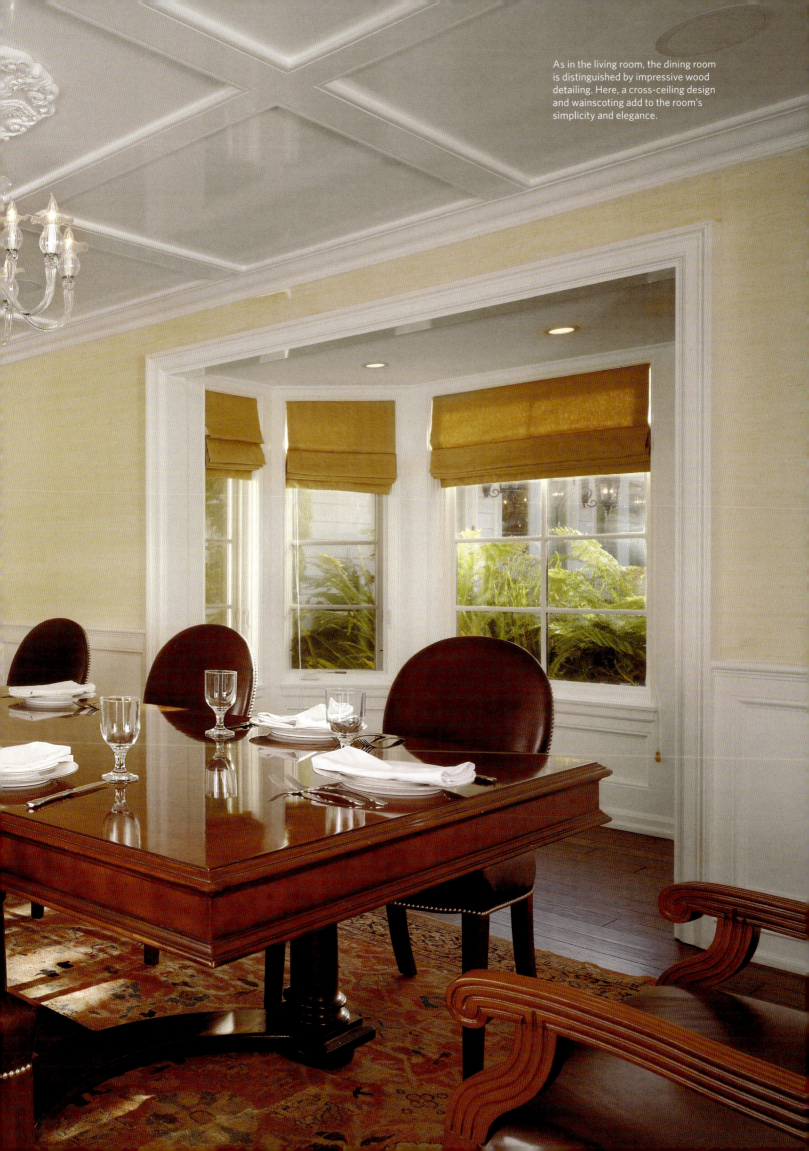

As in the living room, the dining room is distinguished by impressive wood detailing. Here, a cross-ceiling design and wainscoting add to the room's simplicity and elegance.

Williams Residence
Los Angeles, 1951

Color is very important, it adds to the design. The background of a home should be subtle—the guests and the host and hostess should provide the color.

— NOTES FROM INTERVIEW FOR *THE LOS ANGELES TIMES*

WHEN PAUL WILLIAMS FINALLY DECIDED to undertake designing his own home, he was faced with his most important client to date, his wife, Della. Della had definite ideas as to what she wanted in her dream home, and she would settle for nothing less. Foremost was the desire to have a home that suited the couple in their later years and that would require low maintenance. An elegant yet unpretentious essay in mid-century modernism, the home is unlike any other Williams designed before or after. He chose a corner lot in a neighborhood that had recently opened up to blacks, but not everyone welcomed its forward-looking design.

Williams employed an open, free-flowing plan and used extensive glazing to open the interior spaces to a secluded garden. Designed for entertaining and bringing the outdoors in, the "lanai" room is particularly distinctive, from floor to ceiling. The slate floor comes complete with radiant heating beneath it, and the geometric pattern that graces the ceiling serves to deftly modulate the room's acoustics. The curved walls and windows add depth; the cork planter is a charming built-in touch. Like much of the furniture in the house, the sofa was specially designed by Williams for its place, in this case to follow the curve of the wall behind it. Della had seen a similar room on a trip to Jamaica, and she was quick to let her architect husband know she wanted just such a room in her future dream home. Glass "pocket" doors close the room off from the living and dining

rooms while still offering a view of the plant-filled indoor-outdoor space.

Though smaller than the large residential commissions on which Williams built his career, the house meets the same key criterion as those mansions: it is the home his client wanted. The predominant color is green, Williams's favorite color, and it appears not only on the walls but also in the stone in the living room, the finishes on the custom-designed furniture, and of course on the slate floor.

Upon entering the home, visitors are welcomed by the wrought-iron stair railing and delicately rendered gazelles that grace the staircase. The wrought iron is repeated in the whimsical birdcage on the wall of the powder room. If you look closely, you can see the original birdcage murals that complete the powder room walls. The home conjures a vision best described as "*I Love Lucy* Goes to Hollywood." The kitchen, with its built-in appliances by Thermador, and like so much of the house, is a pure expression of its time, redolent of the Golden Age of television's modern suburban life. Beyond the service porch are maid's quarters with a separate exterior entrance.

At the living room's entrance, within the folded design of the wall, is a music station, complete with turntable and a place for record albums. The speakers were built into an adjacent end table. The sofa was also designed to follow the curve of the wall, and the

View from the foyer and staircase, with brass and wrought-iron baluster and "floating" steps, looking into the ribboned entry of the living room.

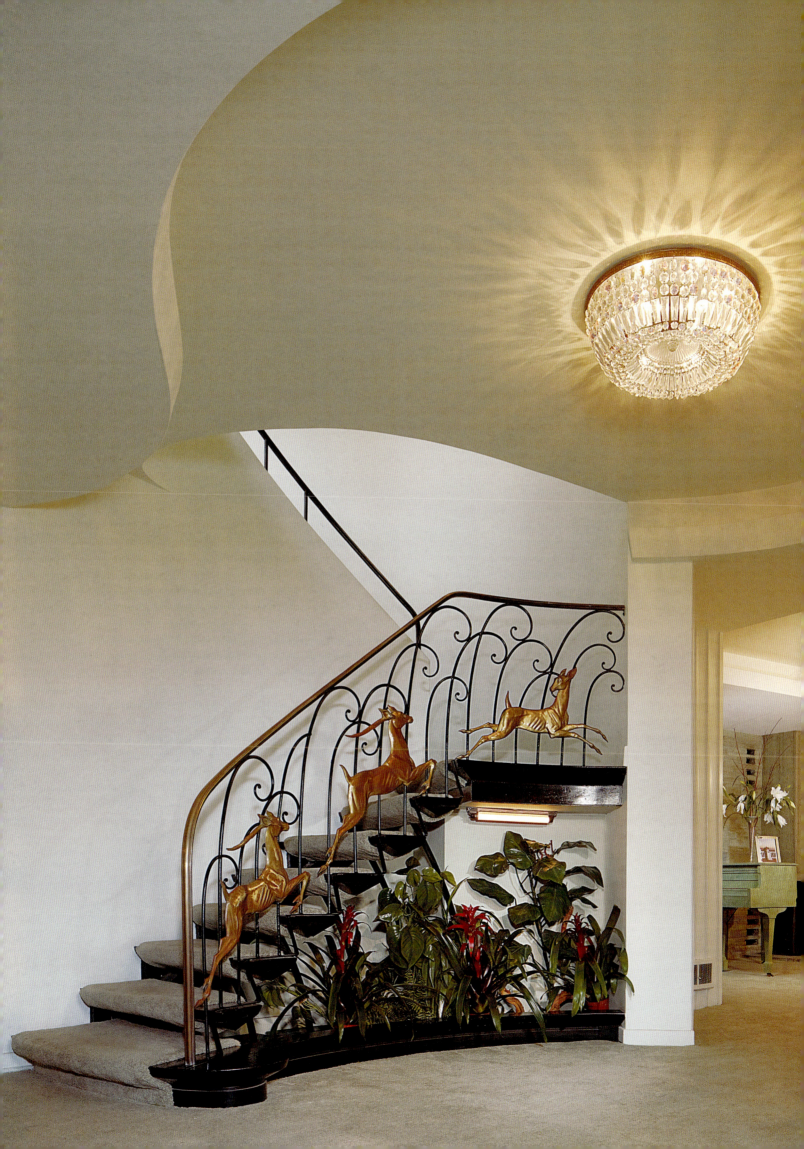

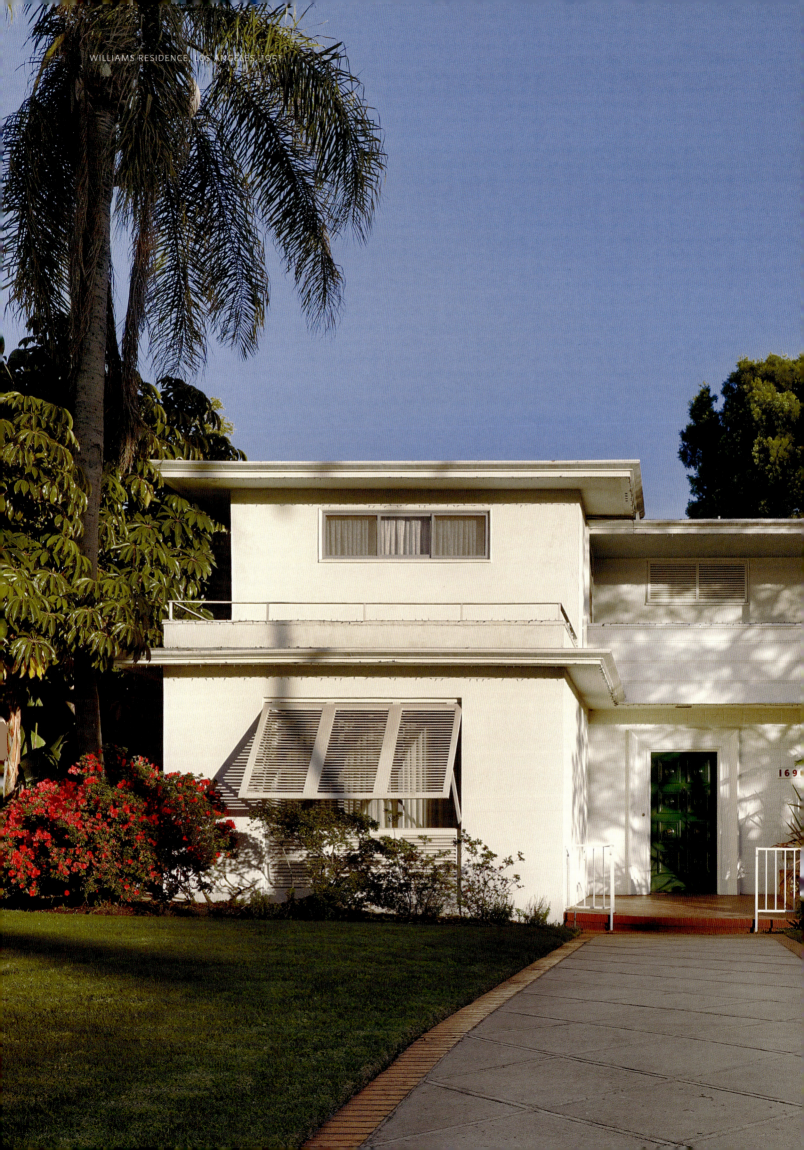

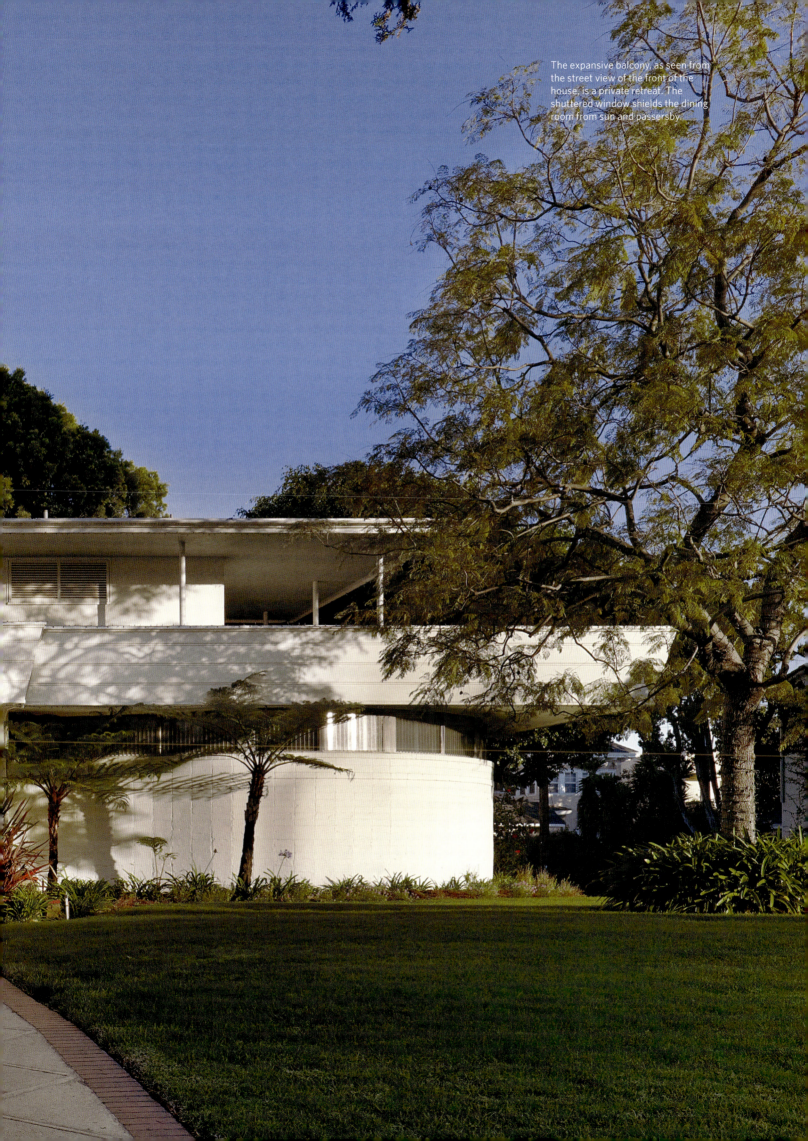

The expansive balcony, as seen from the street view of the front of the house, is a private retreat. The shuttered window shields the dining room from sun and passersby.

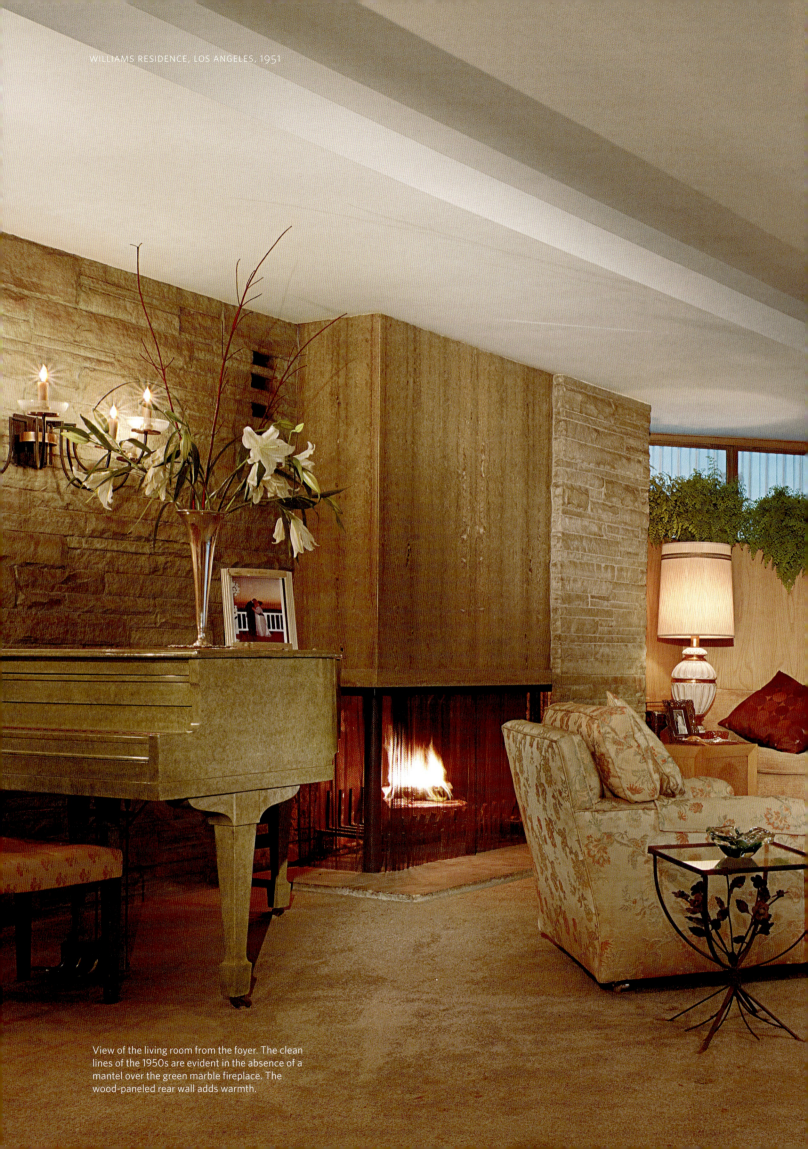

View of the living room from the foyer. The clean lines of the 1950s are evident in the absence of a mantel over the green marble fireplace. The wood-paneled rear wall adds warmth.

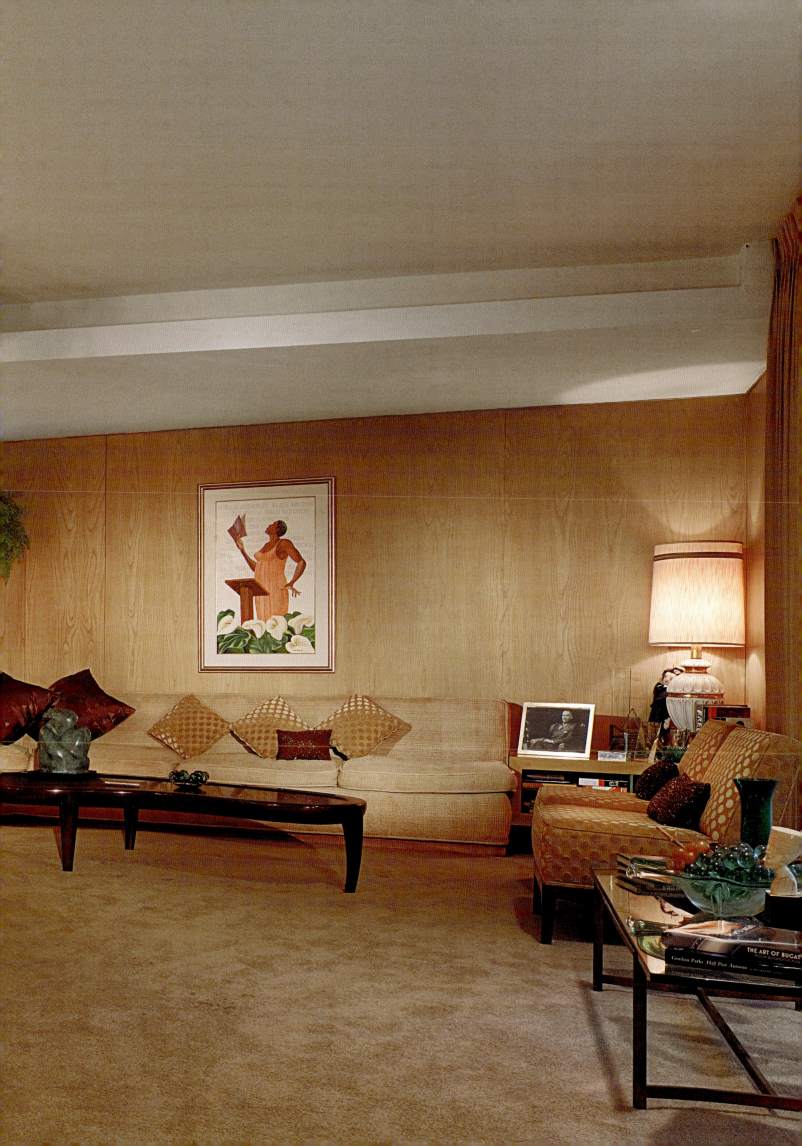

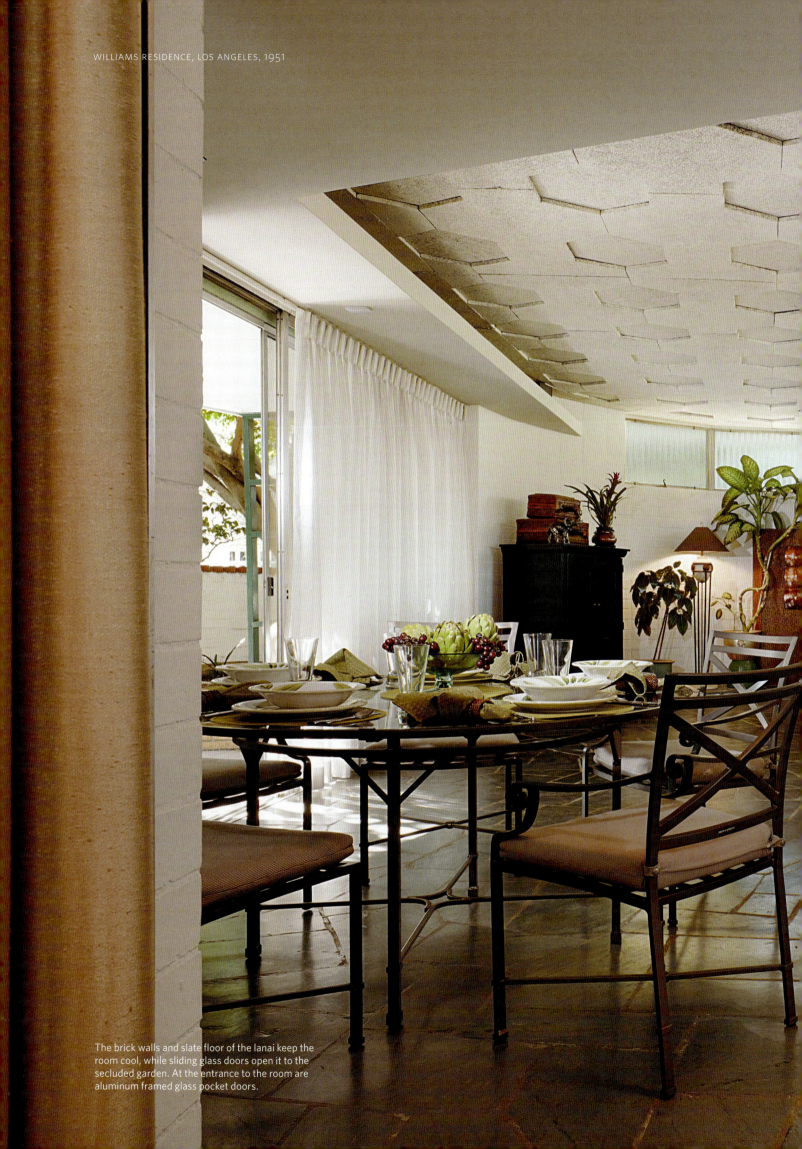

The brick walls and slate floor of the lanai keep the room cool, while sliding glass doors open it to the secluded garden. At the entrance to the room are aluminum framed glass pocket doors.

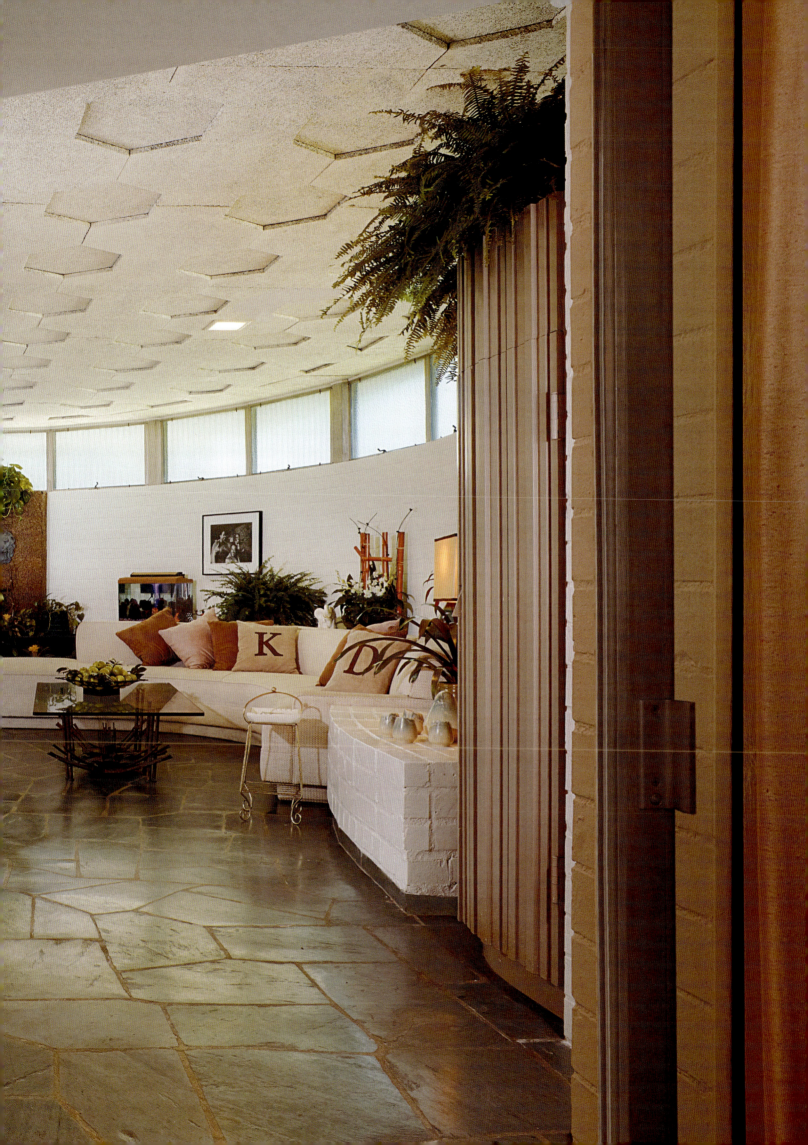

coffee table was built of green marble. The bar is camouflaged behind sleek wooden doors and houses a biographical mural painted by Ben Mayer. The cabinet doors within the bar, which perfectly match the cabinet doors in the dining room, open out to reveal a built-in wine rack.

The dining room has been the backdrop for countless dinner parties, as Della was a consummate hostess. Family remained the most important thing in Williams's life, and the home became the gathering place for holiday celebrations. Following the clean, uncluttered lines of the rest of the house, the dining room features built-in storage for china and crystal: the sideboard frames a mirror and is the pefect spot for informal buffet dishes or elaborate floral arrangements. Two cabinets flank either side of the window, which faces the front yard, and are inset to allow for niches to house large silver pieces. The dining table and the freestanding display piece are both treated with the speckled green finish found throughout the home's custom-designed furniture. In addition, Williams designed the room's elegant chandelier.

Williams worked with designers Helen Franklin and Dorothy Thorpe on the interiors, and all of the original fabrics were specially designed by weaver Maria Kipp. It has been noted that Williams was reluctant to take suggestions, particularly when it came to the proposed color palette for a home, but he relished working with other creative individuals.

But in the end it was Della Williams who was the client to please, from start to finish. The day she moved in, she left everything behind in their old house, except for one treasured table that found a place in the basement and was never used in the new house. Never one to be committed beyond her means, Della refused to move into the house until everything had been completely paid for. Bringing only their personal belongings, the Williamses moved into their dream home and never looked back. The home remains in the family to this day. ★

ABOVE:
The house's floor plan allows one to look into all the first-floor rooms, including the dining room. With the exception of the powder room and kitchen, all the rooms flow from one to another without doors.

OPPOSITE:
The breakfast area, separated from the kitchen by the plant-filled room divider.

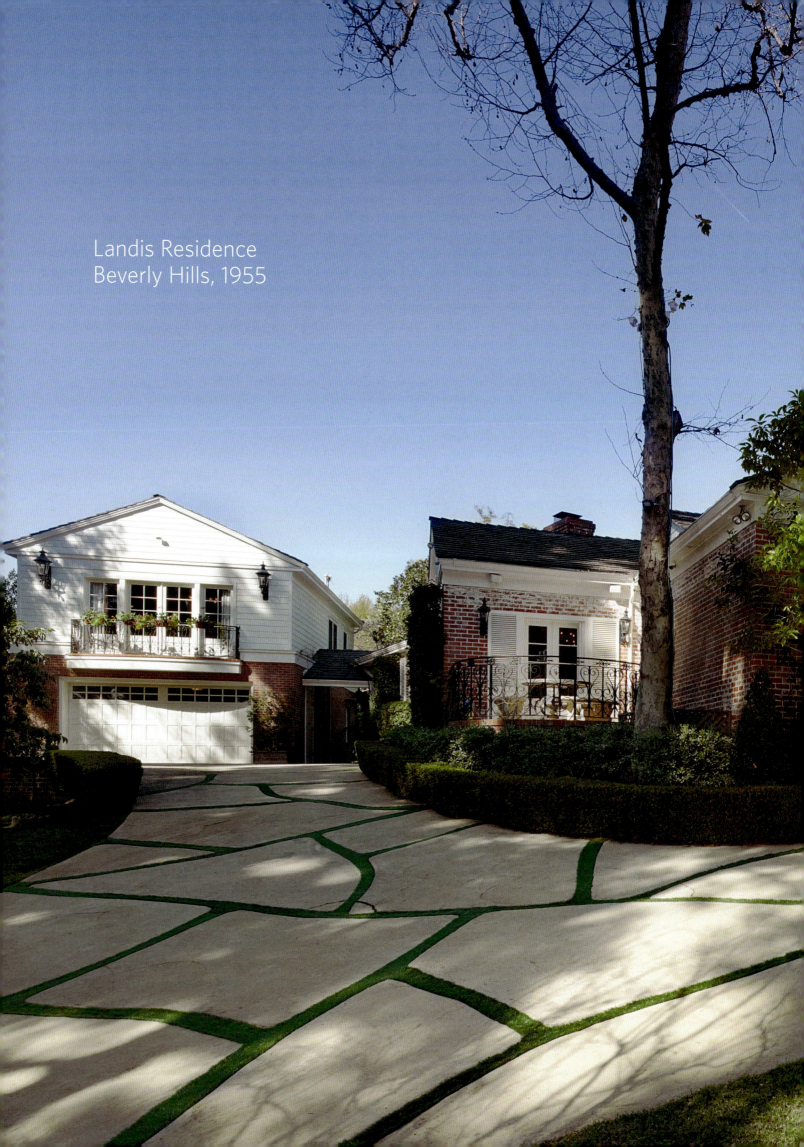

Landis Residence
Beverly Hills, 1955

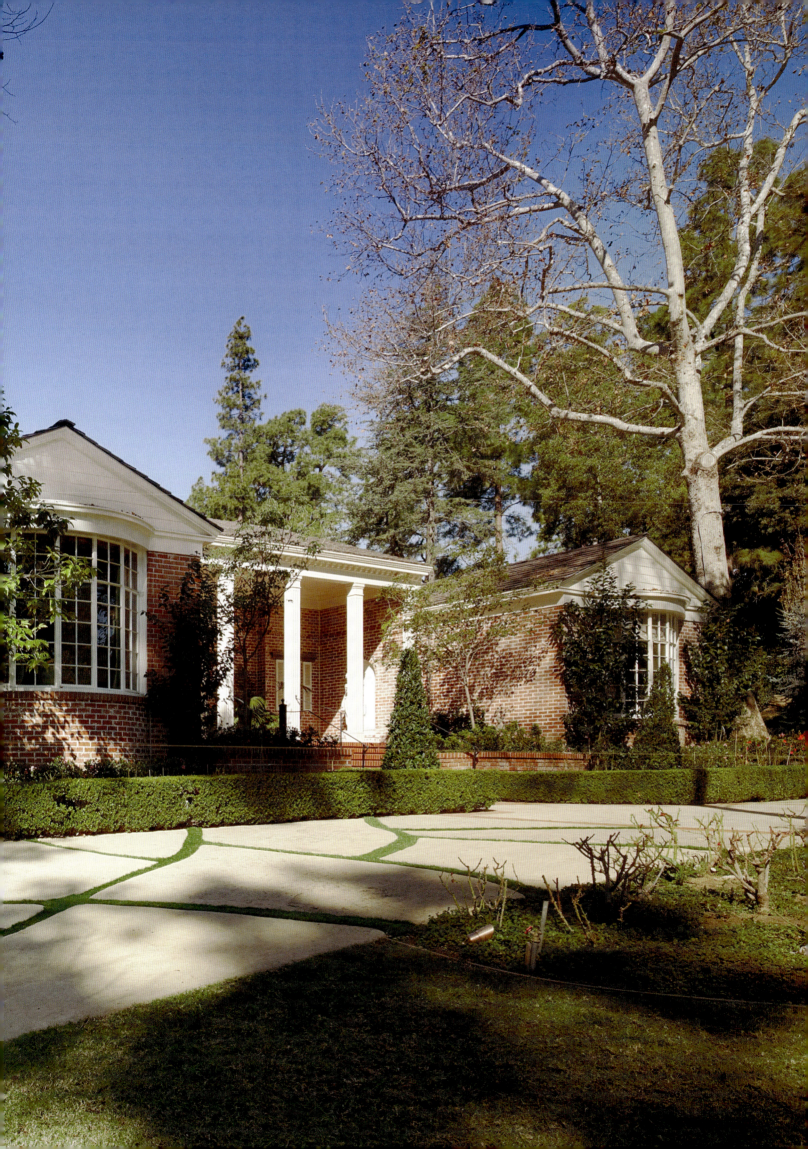

Our first problem is to obtain the proper relation of shelter to land which will develop the greatest opportunity for individual use. Next is the relation and coordination of ground planning with the vertical structure, which in architect's language would be equivalent to making the exterior elevations of a house fit the floor plans.

— "AN ARCHITECT'S APPROACH TO PLANNING"

MRS. JOHN LANDIS, wife of the president of Mission Pak, which at the time was the world's largest shipper of fancy fruit baskets, had for a long time hoped to live in a house designed by Paul R. Williams. It would take a number of years before she got her wish, but this Colonial Revival house was just what she had always dreamed of. When friends and family suggested she get a modern home rather than this more traditional, seemingly staid house, she did not falter in her resolve to own the home she had envisioned so long before. In the single-story, rambling house, with expansive outdoor areas for entertaining, the Landises had found the perfect background for their busy lifestyle.

The Landis family clearly valued entertaining and welcoming guests into their home, and the house's gracious entrance, with its traditional columns and generous double doors, were certainly inviting. While the style of the house is pure Colonial Revival, the single-story plan reflects its postwar period. Williams planned to welcome visitors with a surprise by placing a large star on the entry floor and on the ceiling. Small but incredibly tasteful, everything opens off the central hallway. As is usual in Williams's houses, the refined yet relaxed living room opens to the garden with copious windows that invite guests to enjoy the view. The morning room is large enough for informal meals and entertaining, yet small enough for cozy breakfasts. French doors open to the brick walkways, pool, pool house, and extensive landscaping that combine to form a virtual outdoor living room.

When the current owner first saw the house, he simply fell in love with it, to him it was majestic. In fact, it was the dining room that sealed the deal: with its wood paneling, built-in niches, and

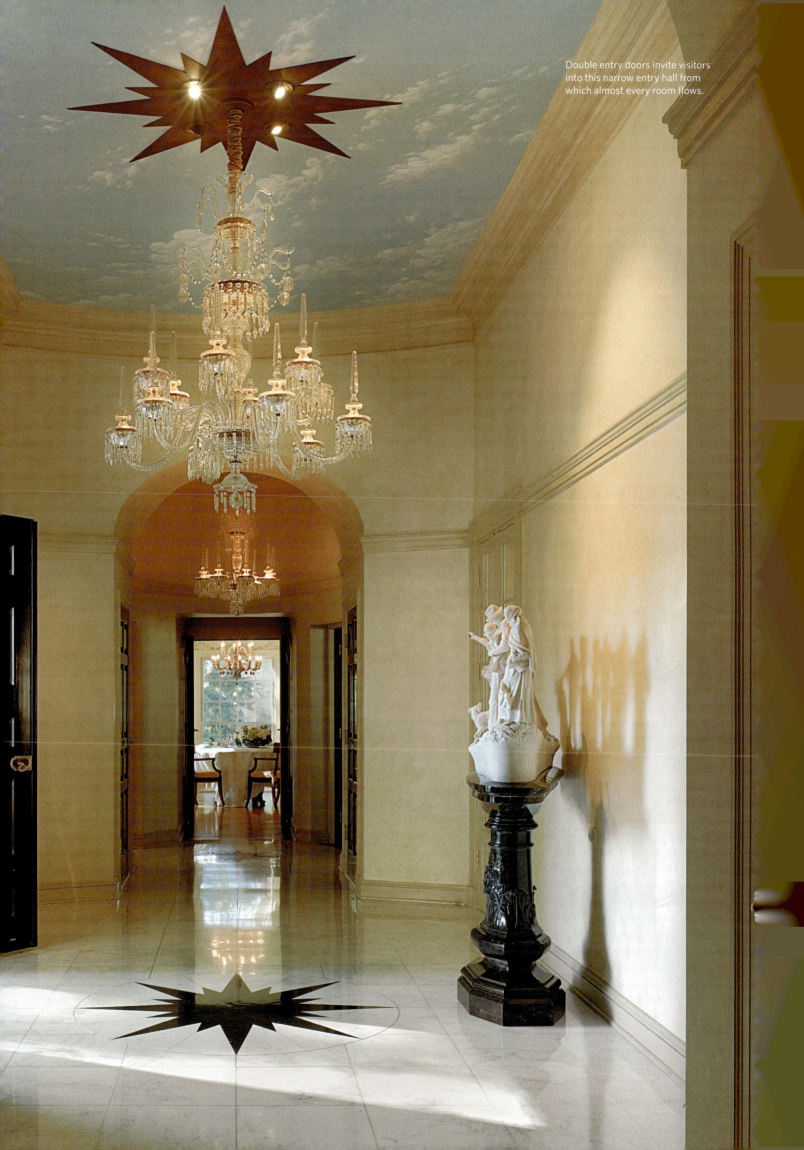

Double entry doors invite visitors into this narrow entry hall from which almost every room flows.

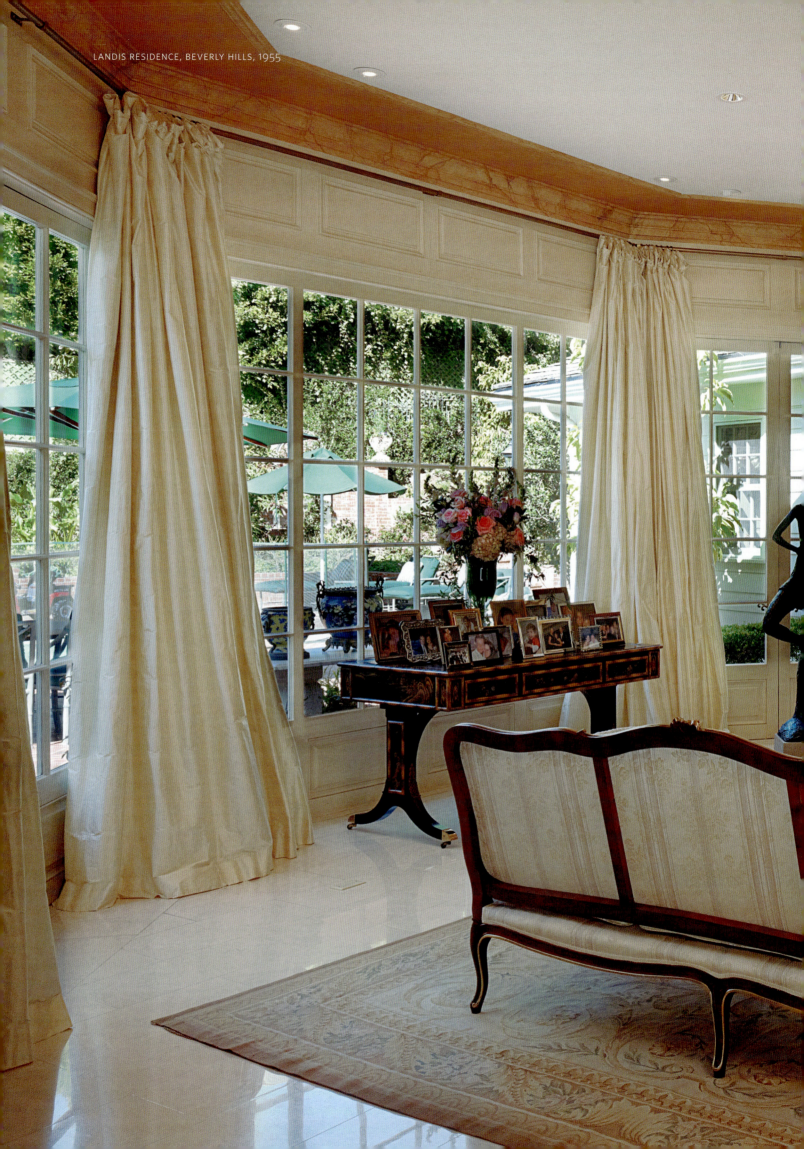

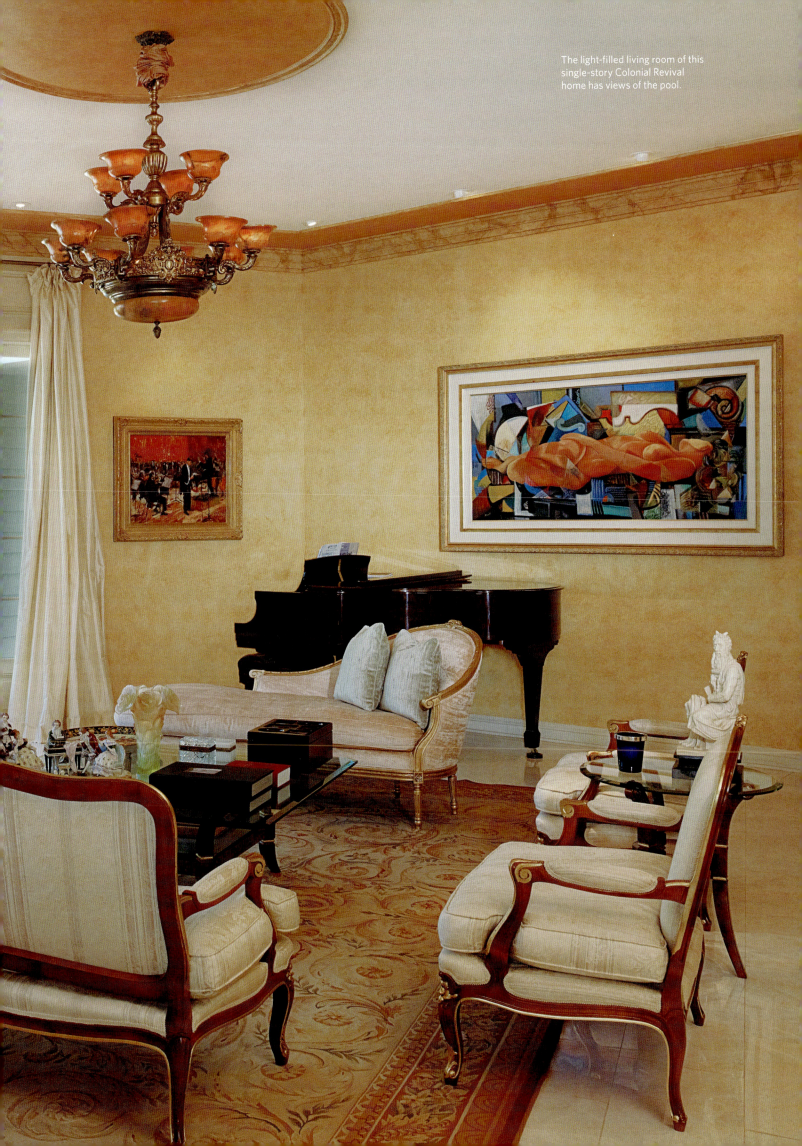

The light-filled living room of this single-story Colonial Revival home has views of the pool.

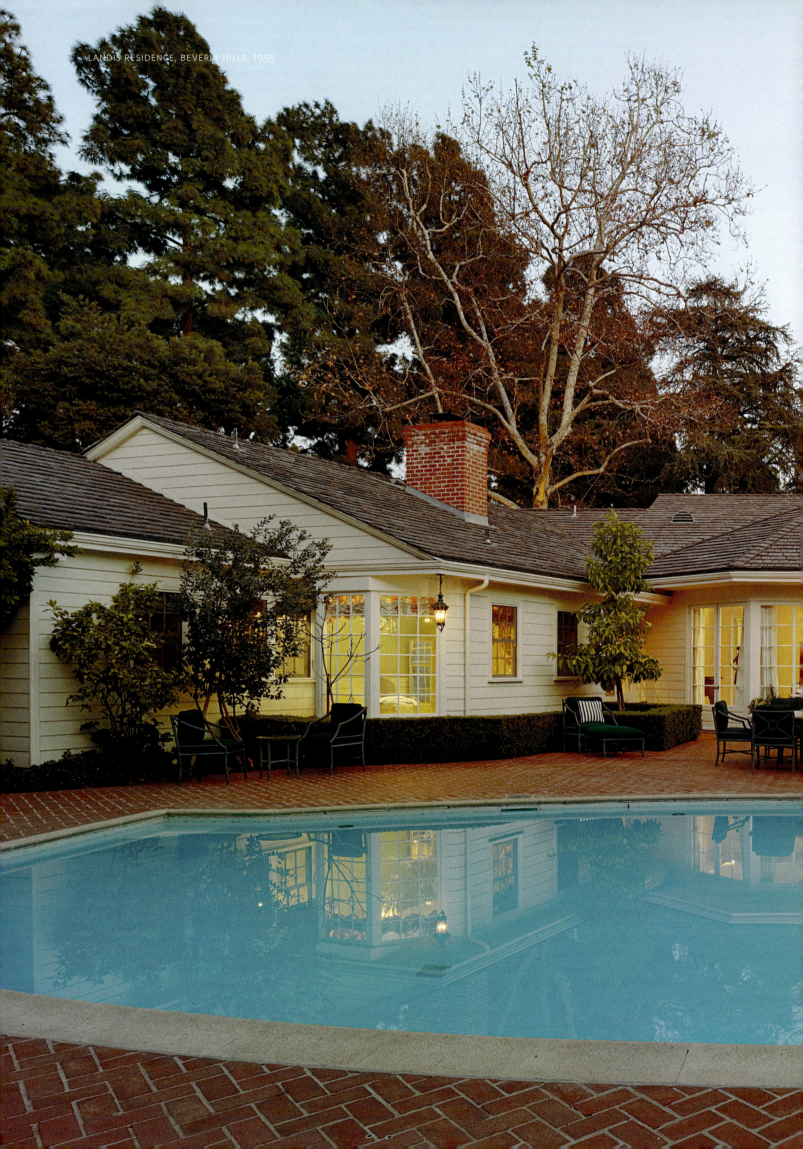

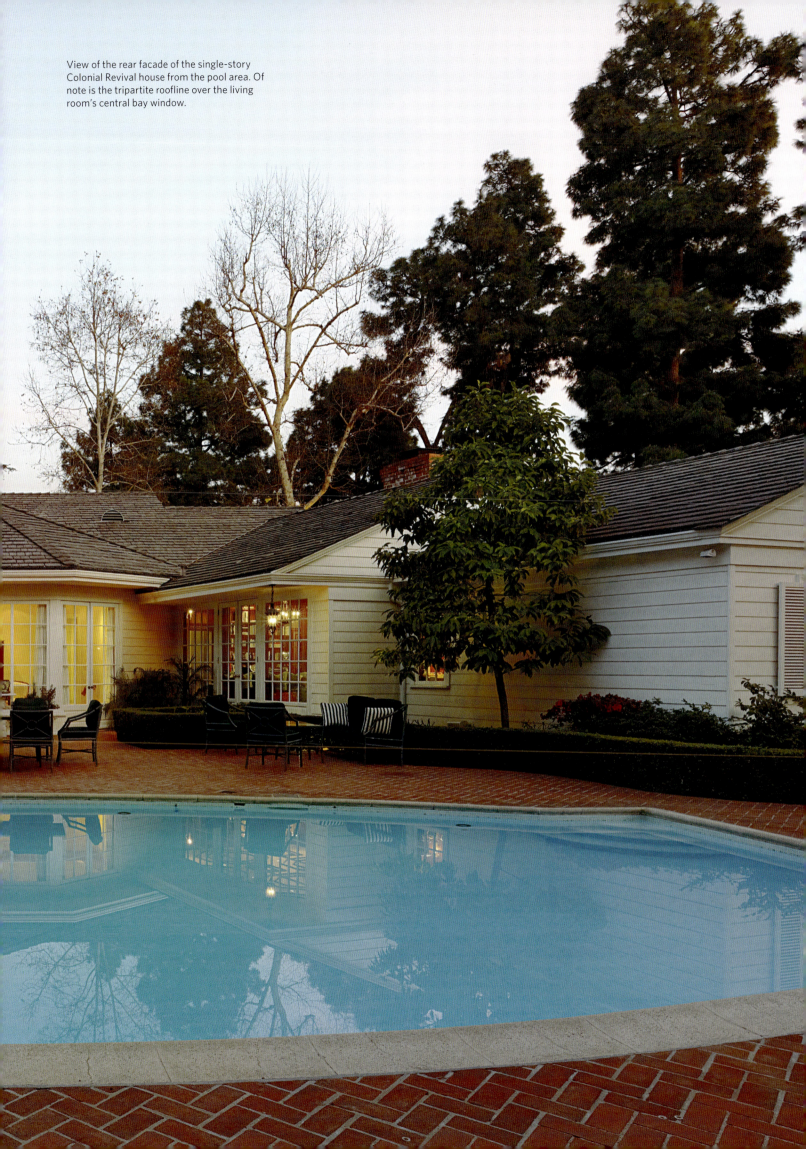

View of the rear facade of the single-story Colonial Revival house from the pool area. Of note is the tripartite roofline over the living room's central bay window.

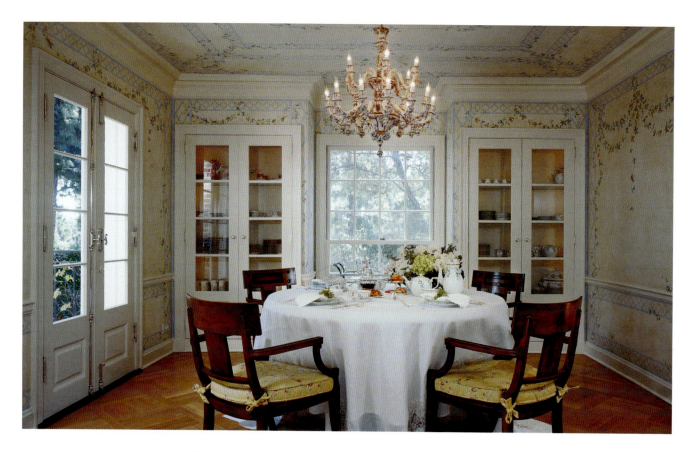

curved windows, creating a classically formal space that offers charming garden views. The den serves as the family room, and although it required a much-needed remodeling, it was done in keeping with the original design details that Williams utilized throughout the home.

A particularly delightful touch is the Hollywood Regency-style powder room. And detailed woodwork and an impressive fireplace make even the guest bedroom a special space. ☆

ABOVE:
This delightful breakfast room is intimate and inviting, with built-in china cabinets and French doors leading to the garden.

OPPOSITE:
The dining room, large enough to seat sixteen, also features built-in cabinets and overlooks the garden.

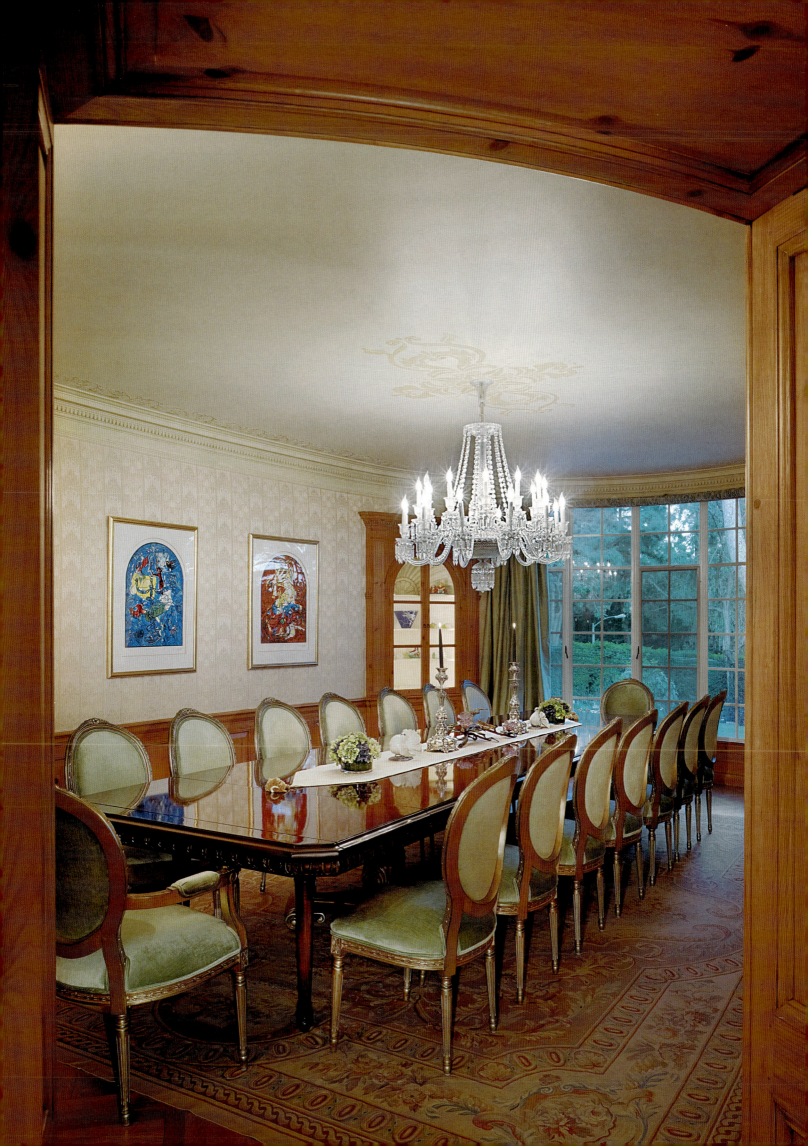

London Residence
Encino, 1958

Good design is merely an expression of good taste, and while the average citizen often cannot tell you why he likes a certain building or home, the fact that when one attractive home is built in a neighborhood the houses that follow try to keep up the standard set is a good indication of improvement in public taste.

— "AN ARCHITECT'S APPROACH TO PLANNING"

ONE LOOK AT THIS HOLLYWOOD REGENCY-STYLE HOME and there can be no doubt it was designed for an honest to goodness star. Soldiers in World War II made Julie London a pinup girl, and her incredible voice and presence gave her a career as a torch singer, and she also enjoyed great success as a television actress. By the time London asked Williams to design her dream home, she had divorced her first husband, actor and producer Jack Webb, of *Dragnet* fame, and was about to marry musician Bobby Troup.

Bobby Troup was a bandleader, songwriter, piano player, and actor. Best known musically for writing "(Get Your Kicks on) Route 66" and producing London's hit "Cry Me a River," together London and Troup entertained music royalty. Gathered around Troup's grand piano in the music room, they sang with friends Nat King Cole, Frank Sinatra, Ella Fitzgerald, and Sarah Vaughn. The room, simultaneously grand and warm, is acoustically perfect. Like London, Troup had two daughters from a previous marriage, and together they had three more children. Cooking, eating, and playing and listening to music together, theirs was a warm and loving home that was a magnet for their celebrated friends.

It was love at first sight when homeowners Michael Rabkin and Chip Tom first laid eyes on this Hollywood Regency jewel. As only the second owners of the house, Rabkin and Tom live in their home the way London and Williams meant for it to be enjoyed.

The oval foyer, while large and elegant, is both welcoming and understated, and it is distinguished by another in the series of magnificent curved staircases employed by Williams throughout his career. With family being of paramount importance to

London, the relaxed family room served as the center of day-to-day living. The formal living room set the stage for more intimate evenings and houses one of four fireplaces London purchased in France and which Williams incorporated into the house's design. The Williams-designed moldings framing the fireplaces make them perfect showcases for art. While the Troup family loved to entertain in the music room, today the dining room boasts the title of favorite room for entertaining. Again graced with Williams's signature moldings and dominated by mesmerizing mirrored walls and ceilings, the room is completely over the top. In typical Southern California style, the pool area and backyard are an integral part of the house's design, which by the use of extensive windows extends the living space outdoors. ✫

This graceful home was designed for a star, singer and actress Julie London, and one can easily envision her descending the stairs.

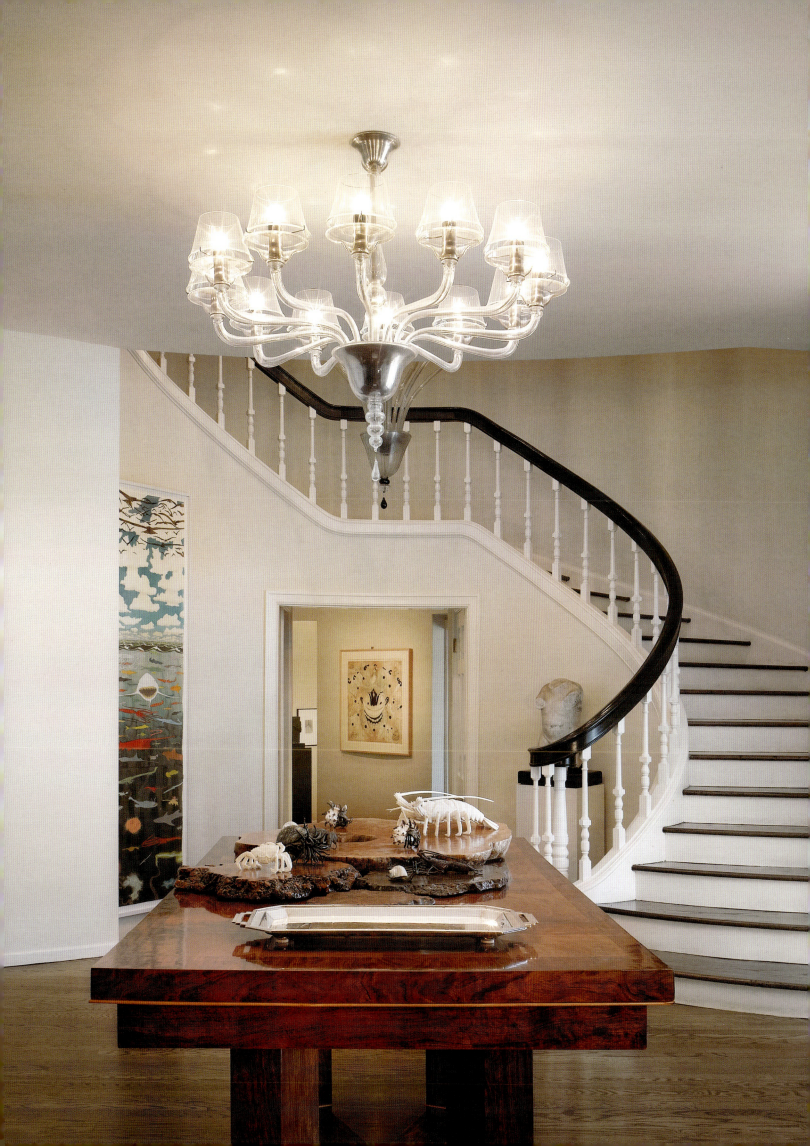

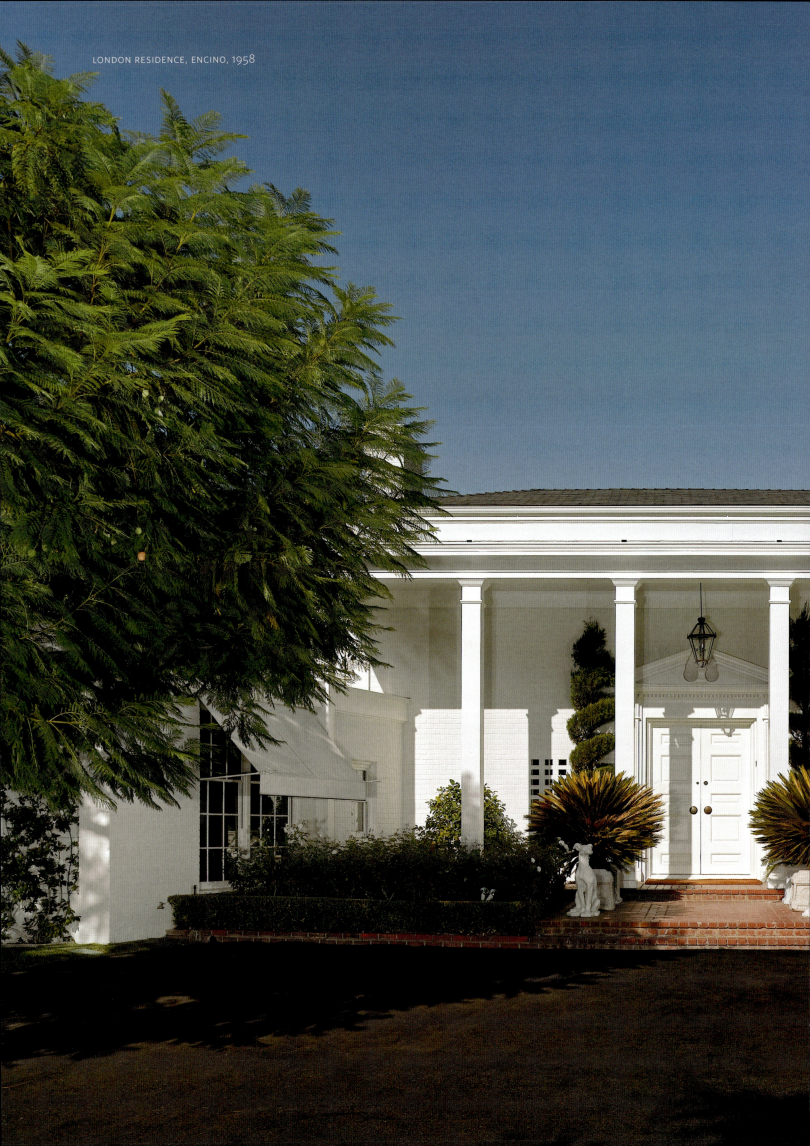

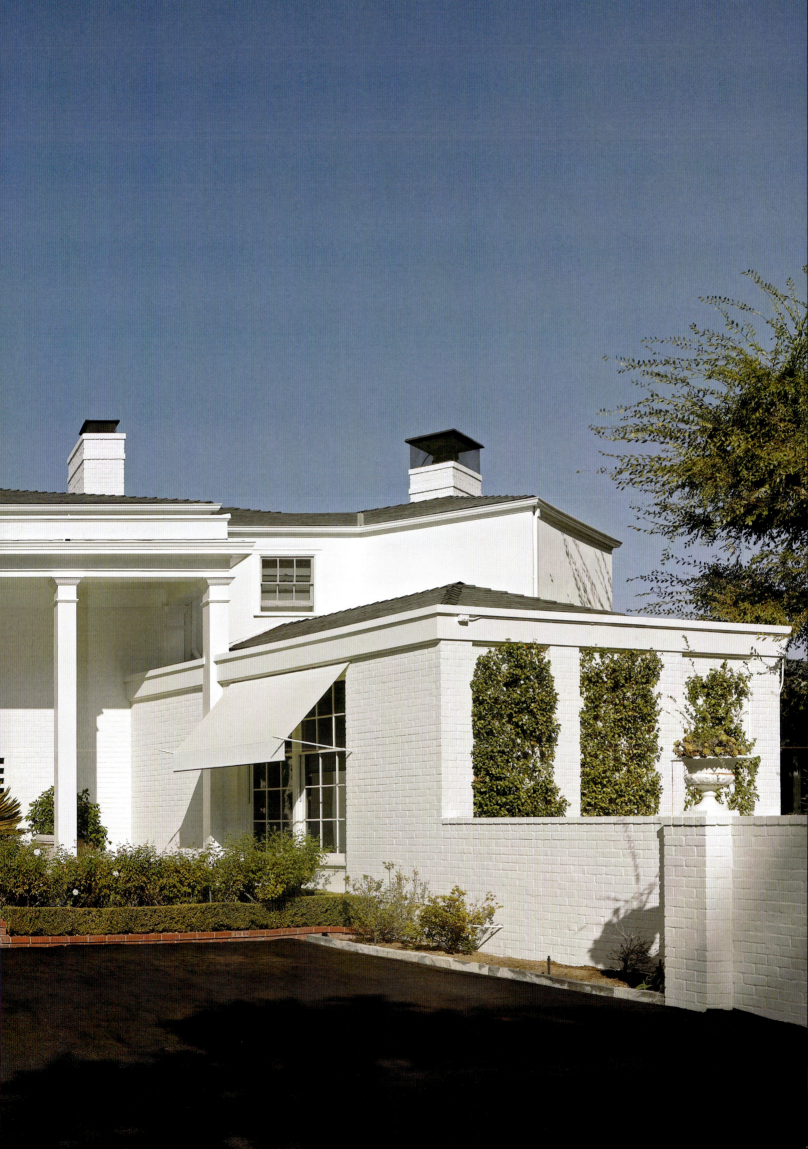

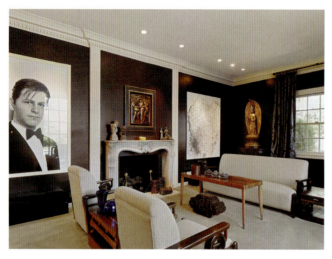

ABOVE:
The living room features a
fireplace that London purchased
in France.

RIGHT:
The wood and brick used in the
family room give the large space
a sense of intimacy and warmth.

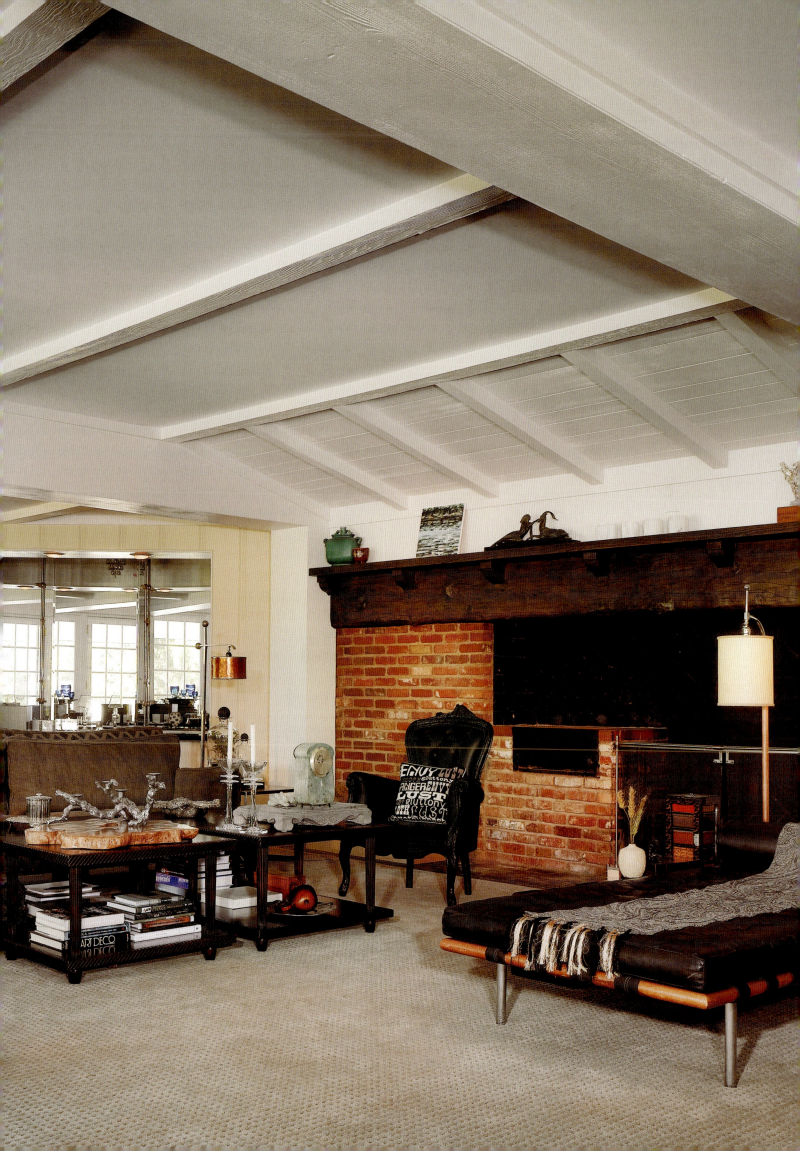

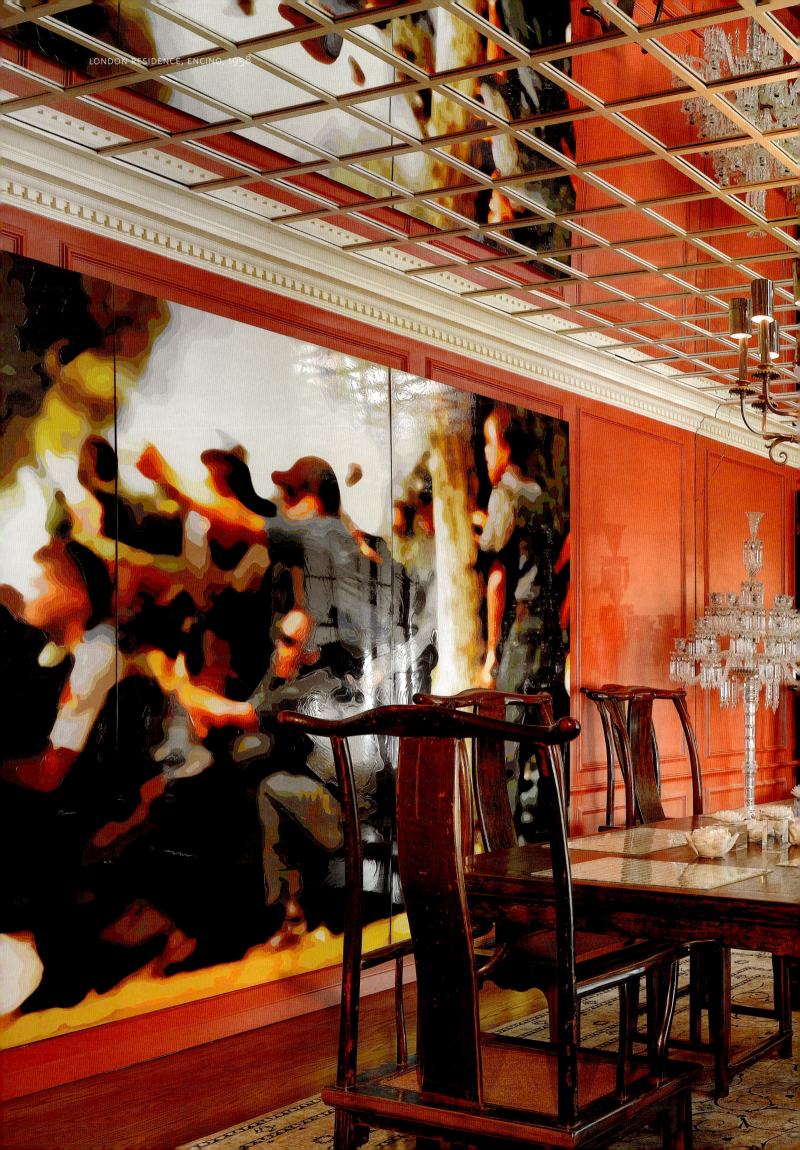

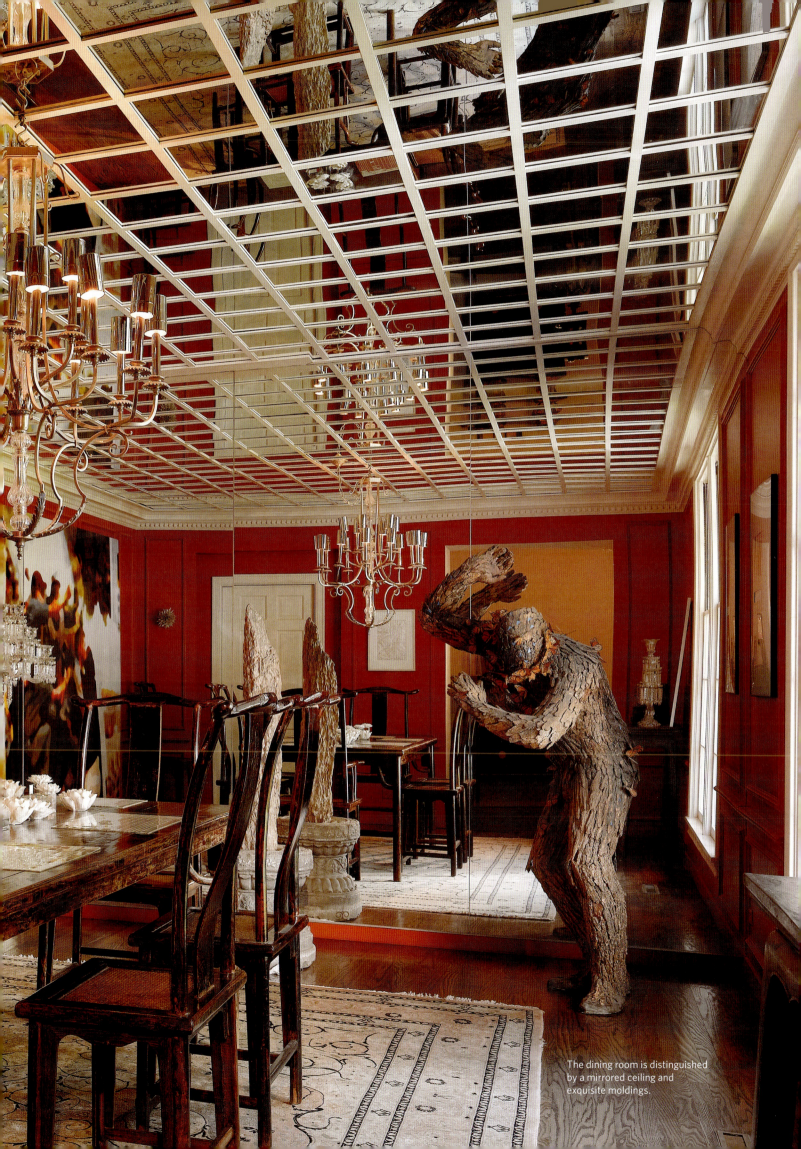

The dining room is distinguished by a mirrored ceiling and exquisite moldings.

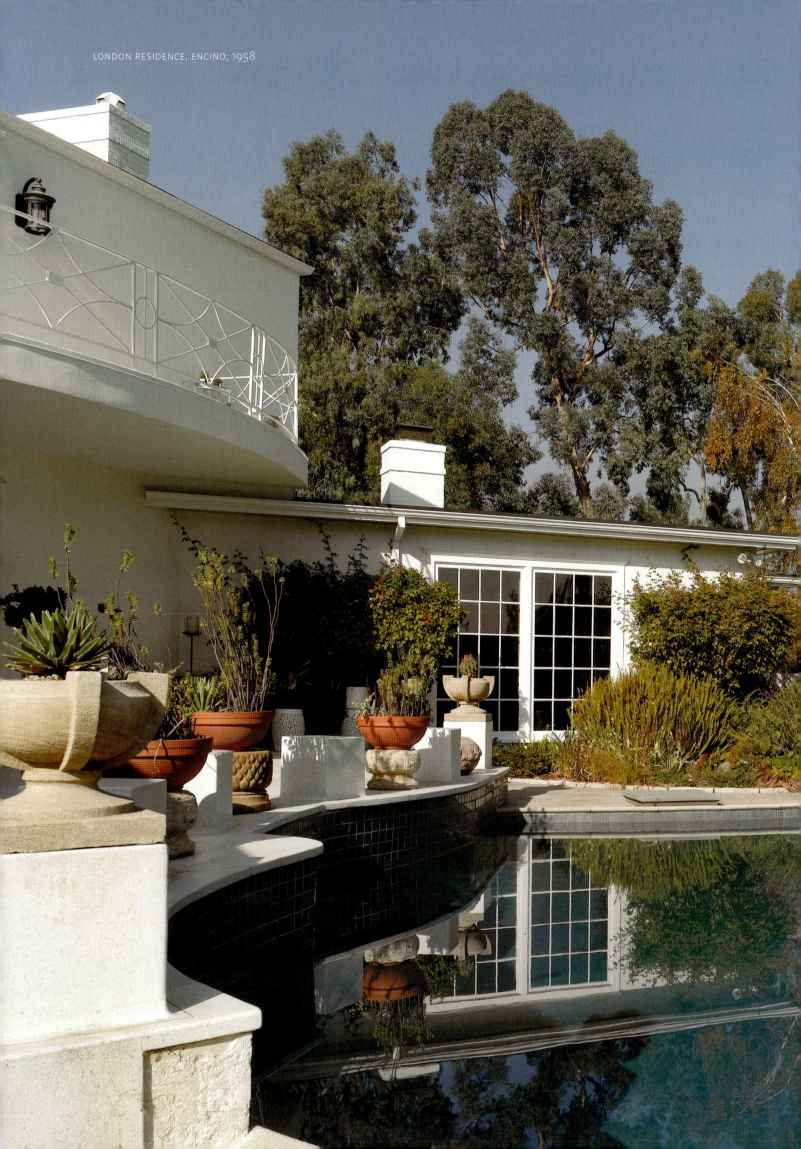

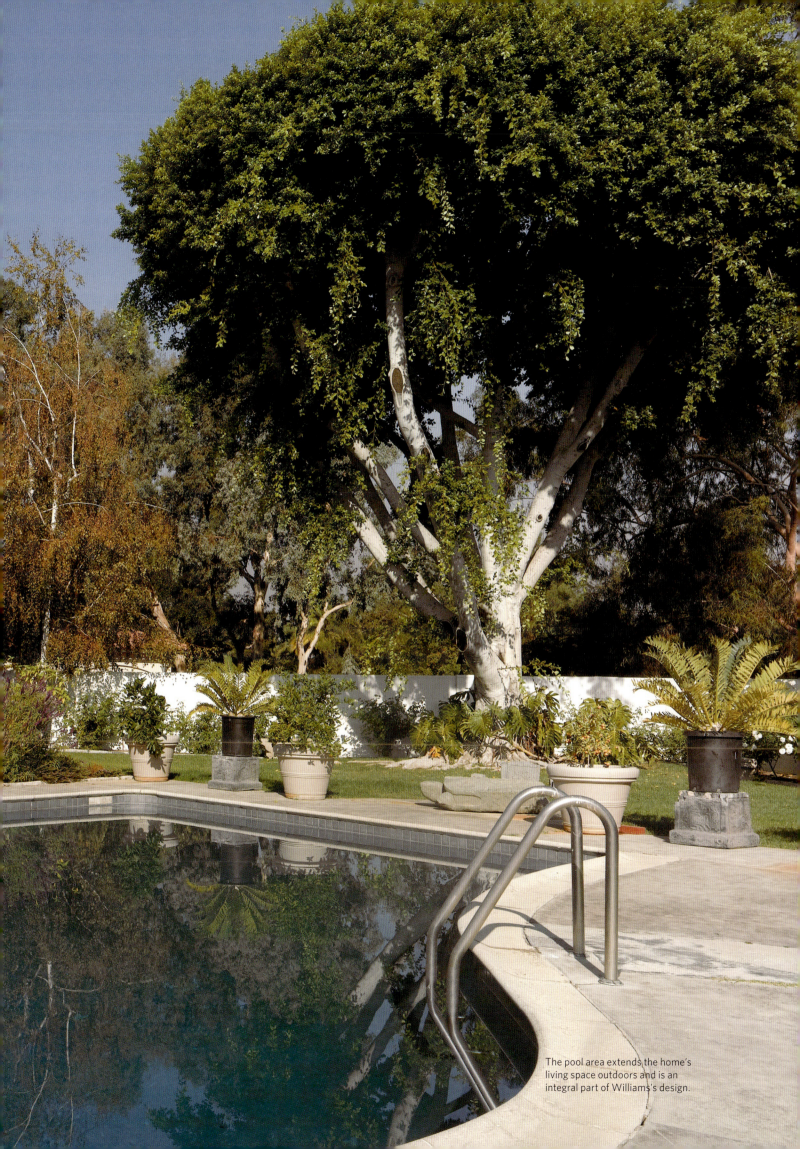

The pool area extends the home's living space outdoors and is an integral part of Williams's design.

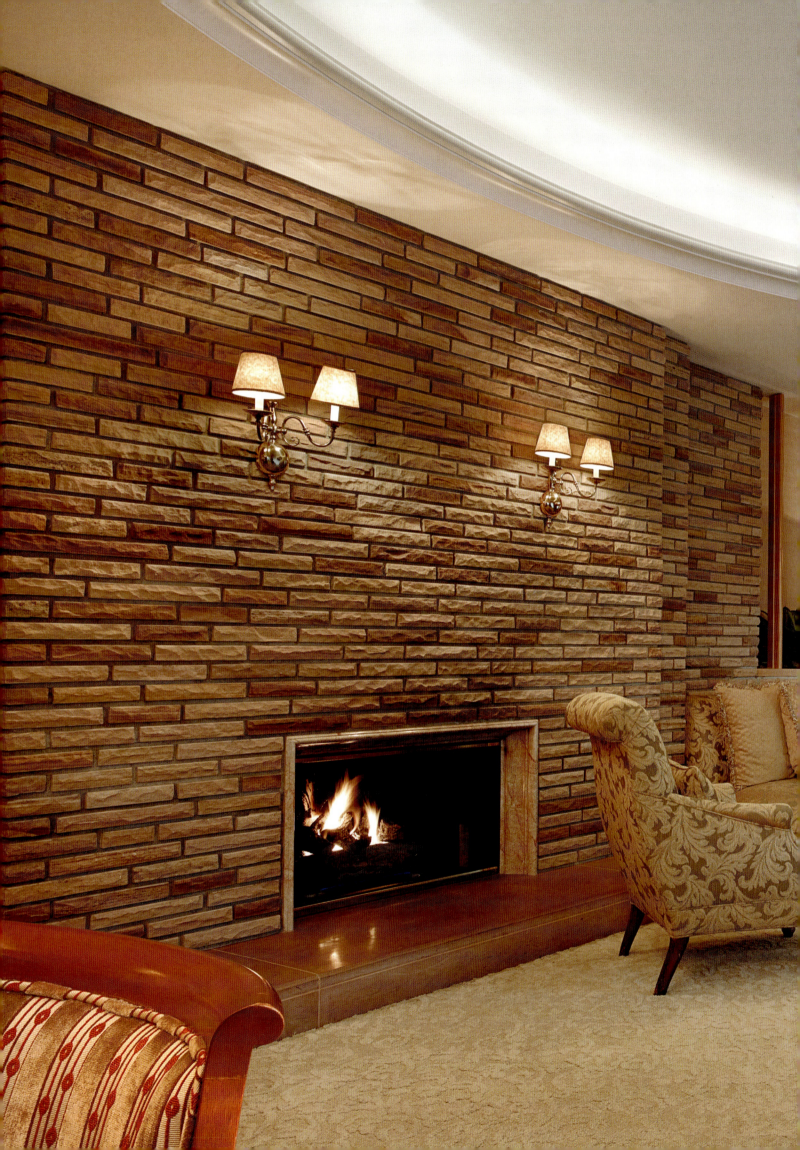

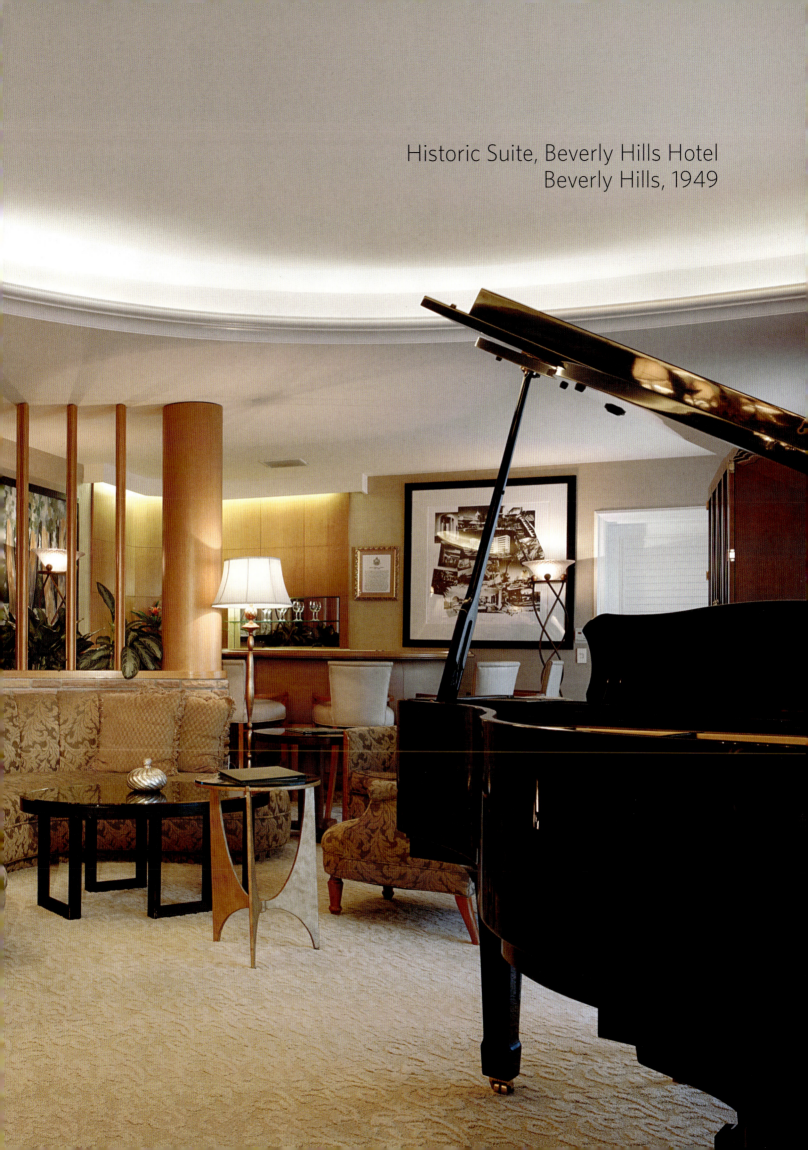

Historic Suite, Beverly Hills Hotel
Beverly Hills, 1949

Virtually everything pertaining to my professional life, during those early years, was influenced by my need to offset race prejudice, by my effort to force white people to consider me as an individual rather than as a member of a race. Occasionally, I encountered irreconcilables who simply refused to give me a hearing, but on the whole, I have been treated with an amazing fairness.

— "I AM A NEGRO"

PAUL WILLIAMS'S CONNECTION TO THE BEVERLY HILLS HOTEL is long and everlasting. The original Mission-style hotel was built in 1912 with landscaping by Wilbur D. Cook, one of Williams's first employers. The hotel enjoyed a quiet reputation until it was purchased in 1941 by a consortium of Hollywood luminaries headed by bon vivant hotelier Hernando Courtright. Under his direction, the so-called Pink Palace entered its heyday. His investors included Loretta Young, Irene Dunne, and Harry Warner of Warner Bros. studio. The hotel began to flourish under Courtright's command, and changes were in the wind. The original restaurant, El Jardin, was renamed the Polo Lounge, to honor the celebrity polo players who used the bean fields surrounding the hotel as playing grounds and who celebrated their victories, and defeats, at the restaurant. Will Rogers, Darryl Zanuck, and Spencer Tracy were among those who enjoyed their polo ponies and their rounds at the Polo Lounge. The guests over the years are legendary and too numerous to mention. From Humphrey Bogart's evenings drinking at the Polo Lounge to Katharine Hepburn diving into the pool fully clothed following a game of tennis to the infamous Rat Pack of Frank Sinatra, Dean Martin, Sammy Davis Jr., Peter Lawford, and Joey Bishop, the hotel played host to the icons of the industry. In 1957, the hotel's pool and Cabana Club had a featured role in *Designing Woman*,

starring Gregory Peck and Lauren Bacall. And frequent guest Neil Simon set his *California Suite* at the hotel.

In 1943, Courtright hired Williams to bring his vision of a redesigned playground for the stars alive. The Crystal Room and the cabana area of the pool were redesigned, and the new porte cochere, lobby, and coffee shop were completed in 1947. The Polo Lounge, which was originally a bar with a smaller restaurant area more in keeping with the Mission style, was transformed into the iconic venue it remains today. With a change of booths, the addition of the garden area, the sliding glass doors opening to the outdoors, a change in color palette, and the addition of the curved ceilings, the restaurant would become one of Williams's signature projects. One need only descend the sweeping staircase to the lower-level coffee shop with its classic curves to feel the Williams touch. Williams introduced, along with the interior designers and decorators, the pink, green, and white color scheme that remains today. Renowned decorator Don Loper designed the iconic banana leaf wallpaper that can be found throughout the hotel. But it is Williams's handwritten logotype for the Beverly Hills Hotel signage that is perhaps most unforgettable.

The newly constructed Crescent Wing, meant to be a major advertisement for the hotel and named for the street on which it sits, was completed in 1949. Underestimating the costs involved,

View of the dining area toward the suite's foyer, which houses a powder room for guests.

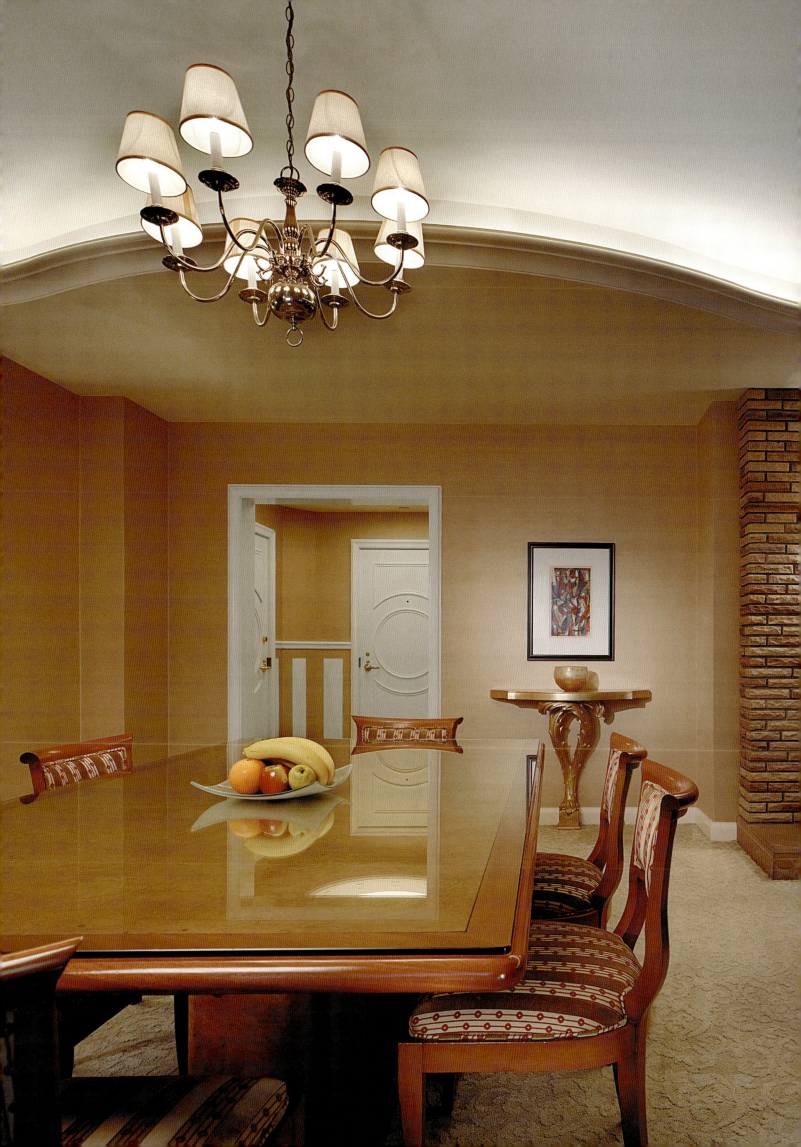

Walking into that suite is like walking into Dick Van Dyke's living room. It's the best hotel room I've ever stayed in!

— JIMMY FALLON

yet not to be deterred from completing this massive addition, Courtright sold off co-op apartments within the wing as permanent residences. Williams was commissioned by new owners to design personalized apartments within the wing. The Historic "Paul Williams" Suite presents the design of one such apartment. Originally designed for a family on the upper floor of the wing, it was moved to the first floor during the 1990s renovation of the hotel from the original plans to re-create the suite just as Williams had designed it in the late 1940s.

The Historic Suite represents the ultimate home away from home. True to Williams's designs of the era, the suite features a stone fireplace, built-in curved sofa and wet bar, and a large patio for outdoor relaxation and entertaining. The suite is fully equipped with piano, dining room, guest powder room, and a signature inlaid marble foyer in addition to the usual bedroom, master bath, and dressing room. Not even the most expansive suite at the trendiest luxury hotel achieves the understated elegance of Williams's residential designs the way this suite does. ★

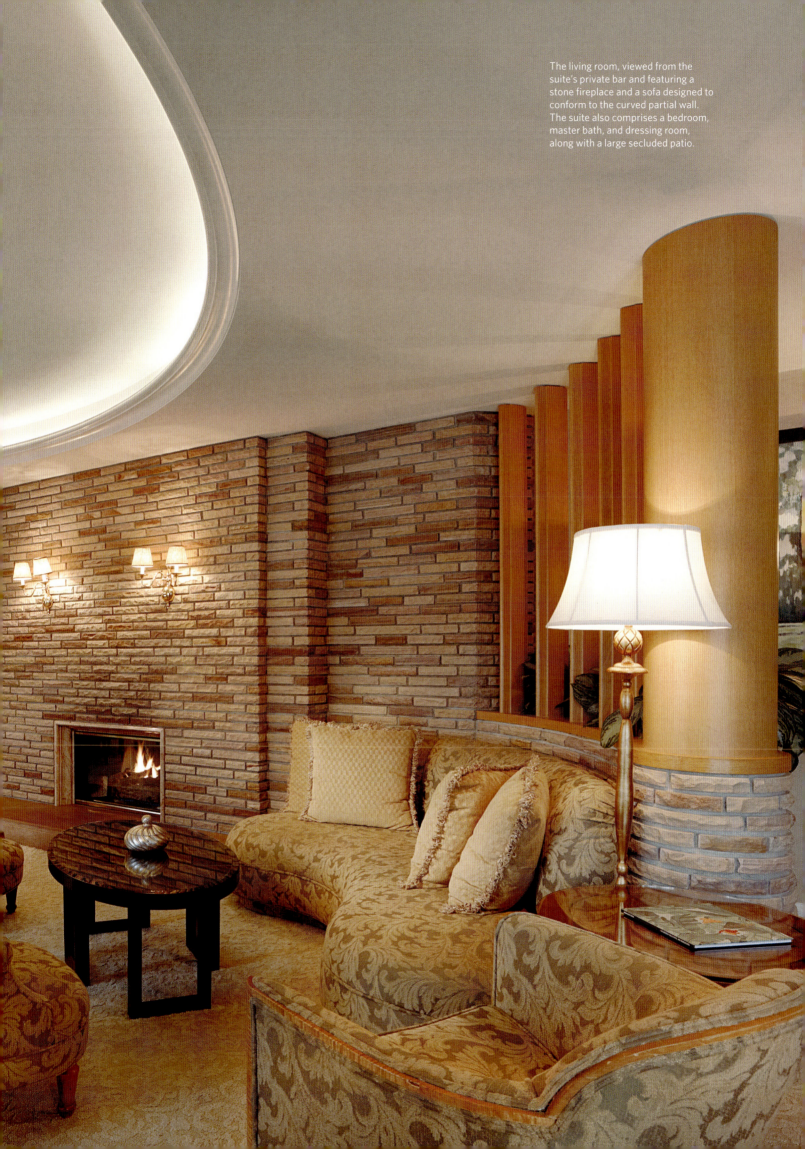

The living room, viewed from the suite's private bar and featuring a stone fireplace and a sofa designed to conform to the curved partial wall. The suite also comprises a bedroom, master bath, and dressing room, along with a large secluded patio.

Letter to My Grandfather

Dear Da,

WHAT AN INCREDIBLE JOURNEY THIS HAS BEEN, and continues to be. Since the first book chronicling your life was released, the "legacy of style" you have left us has been embraced by friends and strangers alike. I don't think I could have ever imagined the endless ways in which your story would inspire and enrich the lives of both young and old. The book came out on your precious Della's birthday, November 18, and what a party we had! *The Will and the Way*, the children's book on your life, came out in February 1994, in celebration of the 100th anniversary of your birth. Together the two books fulfilled Mama Dee's wish to document, and to celebrate, your contributions to our city and to architecture. In her last years, she looked at the books each and every day, but she adored looking at the pictures of the two of you in *The Will and the Way*. Eager to share your incredible life and work, I accepted just about every book signing and speaking engagement that came my way. As I crisscrossed the country, every appearance brought yet another slew of jaw-dropping expressions as I recounted the story of your drawing upside down to sidestep the racial and cultural mores of your day: when others of your color shied away from meetings with potential clients because it was inappropriate to lean over a white person, you chose a road less traveled, and learned to draw upside down, allowing the client's wishes to come alive before their eyes. Your brilliance never shone more brightly than in your ability to use your creativity for everyday problem solving. From tackling a challenging hillside to facilitate the design of a client's dream home to your impeccable proportions and your ability to incorporate every available inch of space into your designs, yours has always been a special gift.

While most, if not all, of my travels on your behalf have been wonderful, it was a trip to a small school in Detroit, Michigan, that would have brought the biggest smile to your face. The fifth grade students at the Nataki Talibah Schoolhouse of Detroit put on a play, written by founder Carmen N'Namdi, and based on *The Will and the Way*. They all became part of your story as they acted out a birthday party where members of our family recounted stories. I visited the school prior to the evening performance and each of the students stayed in character. I introduced myself with, "I'm Karen, what's your name?" One young man replied, "Don't you know me? I'm your brother Paul!" That night the play began with a group of students coming out singing "California Dreamin'" on a stage lined with palm trees. All I could think about is how much you and Mama Dee would have loved being there. As impressed as I was with the play, nothing prepared me for the gift they presented to me following the performance. The students had made a quilt adorned with photos of your signature work and quotes from your writings. They carried themselves with grace, their manners were impeccable, and the

Paul Williams taking photographs, as grandchildren Karen and Paul Hudson watch.

sincerity they showed in the pride they felt about telling your story was heartwarming. You always wanted to be an inspiration to young people, and the outpouring of creativity and energy would indeed make you smile, for, as you always believed, they are our future.

When I think of the racism you encountered nearly a century ago, I find myself dumbfounded when on more than one occasion someone has questioned the reality of you as master architect. "Whom did he front for?" My response remains the same. "He possessed a God-given talent that allowed him to reach heights others only dreamed of, he studied his craft, he learned all he could, and he had a vision for gracious living that surpassed anything he had personally experienced." Then I remind them that even revisionist history would not allow for a black man to professionally "front" for a white man those many years ago. You'll be happy to know the American Institute of Architects (AIA) finally got its first black president in Marshall Purnell, a scant eighty-five years after you became its first black member. You would be sorely disappointed to know the African American membership of licensed architects within the AIA remains below 2 percent.

Every time I look at a photo of you and Mama Dee, your dear Della, I am reminded of the team that you were. To you, having grown up an orphan, she was your "everything," and the life you shared continues to be a model for me. I often reflect on Mama Dee's admonition "not to get married unless they were as good as your grandfather." I'd laugh and remind her that was an awfully tall order, but she assured me she wasn't speaking of someone who was a world-renowned architect, but rather someone who was hardworking, honest, kind, generous, and who valued family above all else. She told me to find a true partner, just as you and she had been to each other. You'll be happy to know I found that in Don. Oh how I wish you could have known him. As a contractor, he has a special appreciation for your work, especially when he joins me to visit homes of your design. He sees things I don't see and never fails to point out details that previously escaped my attention. We find ourselves on lazy Sunday mornings glancing at the real estate section to see if there's a Paul Williams home on the market that we may have missed, and sometimes go to open houses just for the fun of it. I'd like to say each visit has been a treasure, but some have been no less than painful reminders of original designs that have been so completely remodeled that any remnant of its once glamorous ambience is destroyed. Certainly change is something to embrace in these uncertain times, but to drive down a street that once held a PRW home and find that it's been torn down and replaced with something that can only be described as a residential supermarket is painful indeed. This only serves to reinforce my resolve to preserve your legacy and let your life and work stand on its own as an example of excellence.

Your personal story, this orphan who rose from the fields of Los Angeles to international acclaim, has brought offers of plays, documentaries, books, and feature films—not because of me, but because your story still resonates with people, just as it continues to inspire. Of course, I didn't have the good sense to respond to all the opportunities, like when Ossie Davis and Charles Nelson Reilly encouraged me to write a play. And for a while I wouldn't speak on your behalf in February suspecting that many only wanted to hear your story during Black History Month. But your birthday is in February, so of course I relented, because we always celebrate you!

Yes, you were "Hollywood's Architect," and a documentary of the same name is in the works. I often read of today's stars purchasing one of your homes and I think of how you continue to share your gifts with others.

I see my water-stained, dog-eared copy of A Legacy of Style staring back at me each day from its perch on my bookshelf and think of all the changes there have been since its release. The home that graced the cover was one of my favorites, built in 1929 in the midst of the Depression for $500,000. Naively, I believed it would always stand tall overlooking the Arroyo. I cried when it burned to the ground in 2005, not because of the estimated loss of $15 million, but because it felt like I'd lost a cherished friend. A part of early Hollywood history, the property was rented out to movie studios by owner Jack Atkin as a way for him to finance a soup kitchen during the lean days of the Depression. And many films were shot on location there, including Topper (1937), The Bells of St. Mary's (1945), Sweet Bird of Youth (1962), Clue (1985), Mobsters (1991), Hollywood Homicide (2003), and Just Married (2003). No stranger to television, the house was featured frequently, most notably in numerous episodes of Murder, She Wrote.

While my emotions have ranged from utter disbelief to unsurpassed pride, one fact is undeniable: Everywhere I have traveled to speak, from the Museum of Contemporary Art in Los Angeles to the Huntington Library to Hampton University to the Chicago Art Institute to the Savannah College of Art and Design, I have been greeted by the most wonderful people who feel a bit like they have "joined the club" and have helped to share your legacy. I am constantly amazed by homeowners' attention to detail and their desire to preserve your vision, constantly asking, "What would Paul do?"

I have been privileged to learn so much more about you along the way. The generosity of spirit as people share information never fails to warm my heart. I wonder if you ever knew that your parents migrated from Tennessee because they had tuberculosis and came west for their health? When speaking in Memphis, I met Roberta Church, a family friend. She recounted finding a letter from her uncle to you, lost for years. Apparently, you had written asking for any information about your parents, and he responded just before traveling to visit his son, where he unexpectedly died. He said they didn't want to leave, but left for the climate, taking your mother's brother with them, for he was stricken with tuberculosis as well. And then there's Kate Edelman Johnson, who found me when her PRW home was to be featured on a home tour. Kate connected a number of dots for me. First, she shared that she had grown up in a PRW home, that you had designed W. & J. Sloane's furniture store for her grandfather in Beverly Hills, and that you also designed an entire planned community in North Kansas City, Missouri. She told me of your visits to Kansas to oversee the project and being denied residence at the local hotel because of the color of your skin. Her family invited you to stay in their home, cementing a long relationship.

Sometimes, when I'm feeling overwhelmed, I hear Quincy Jones's voice reminding me of the importance of telling our own stories. Other times, I think of the Saturday afternoon when Bill Cosby called, out of the blue, to reflect on the Beverly Hills Hotel and the importance of continuing to tell your story, sharing both the obstacles you faced and the contributions you

have made to our cultural landscape. I tell people that I try to make decisions you would make, and no doubt you would tell me to listen to these two creative geniuses.

As your first two grandchildren, Paul and I were privileged to get the best of you in your creative years. We cherish our memories and have continued to celebrate your style and your favorite color, green. Paul sits at your desk every day, his favorite place for creative problem solving. Like you, he thinks outside the box. Each and every day our respect and admiration for you grows. I remember one day, so long ago, when, fascinated, we watched as you took some snapshots—the lessons you taught us and the legacy you have left made it clear you never needed a camera to capture your vision, it was simply a reminder of the importance of recording that which we treasure.

Finally, when people remark on what a wonderful gift it is for me to tell your story, I remind them yet again that this journey has not been my gift to you, but will forever be your gift to me.

karen elyse,
with love
2011

the journey continues...

Dear Da,

TODAY, AS I SAT IN THE COURTYARD OF THE Polo Lounge at the Beverly Hills Hotel, I was reminded, some things change...and some things remain the same. Surrounded by your brilliant design, it warmed my heart to see the diversity of lunch guests—something unheard of in the 1940s when you designed the space. In contrast, I was pleased to note that your designs at the hotel have remained the same. One cannot pick up a real estate brochure for Beverly Hills without noting the incredible prices your homes are commanding. Today, forty years after you left us, your designs, and your impeccable attention to detail, continue to inspire, uplift, and amaze those fortunate enough to experience them. In 2017 you were awarded the AIA's Gold Medal, once again becoming the first African American to win their highest honor. Yet today, 98 years after you became AIA's first black member, African Americans make up barely 2% of the membership. How can that be? Some things change, some remain the same. More and more of your designs are being hit with wrecking balls, yet you, and your work, have become more appreciated. I know how pleased you would be to know your Collection was acquired by your alma mater, the University of Southern California (USC) and The Getty. One can only hope this will lead to more acquisitions, and a greater awareness, and understanding, of the immense creative talent in the African American community. Once undervalued and unappreciated, the voices of underserved communities and their many contributions are finally beginning to be heard. As a new generation of architects emerges, I look forward to the day when I can stop saying...some things change, and some remain the same.

We miss you,
karen elyse
with love
2021

Biographical Chronology

c. 1890
Williams's parents move from Memphis, Tennessee, to California in an effort to fight their tuberculosis.

1894
Paul Revere Williams, the son of Chester Stanley Williams and Lila Wright Williams, is born on February 18 at 842 Santee Street, Los Angeles.

1896
Chester Stanley Williams dies.

1898
Lila Wright Williams dies.

c. 1900
Paul attends Sentous Avenue Grammar School on Pico Boulevard. The only African American in his class, he excels in art and is encouraged to pursue a career in architecture by a local builder.

1912
Graduates from Polytechnic High School, Los Angeles.

1912–16
Attends the Los Angeles School of Art and the Los Angeles atelier of the Beaux-Arts Institute of Design, where he is awarded the Beaux-Arts Medal.

1913–15
Works for landscape architect Wilbur D. Cook, Jr.; learns to integrate the planning of house and garden and gains experience in town planning.

1914
His competition entry for a neighborhood civic center in Pasadena, California, wins $200 first prize over submissions from many more experienced designers.

1915
Williams is certified as an architect.

Wins first honorable mention in architecture at the Chicago Emancipation Celebration.

1916–19
Is one of eight students studying architectural engineering at the University of Southern California.

1917
Marries Della Givens on June 27.

1919
Wins Hollow Tile House Competition with design for one-story, $5,000 house.

1920–22
Works for John C. Austin, where he first designs large public buildings. Assists in the preparation of construction drawings for projects including the Shrine Civic Auditorium and the First Methodist Church. Later he will participate in joint ventures with Austin.

1920
Appointed to the first City Planning Commission of Los Angeles; serves until 1928.

1921
Licensed to practice in California.

1922
Establishes his own firm, Paul R. Williams and Associates, with offices in the Stock Exchange Building.

1923
Becomes the first African American member of the American Institute of Architects (AIA), Southern California Chapter.

1927
Moves offices to Wilshire Arts Building, at Wilshire and Manhattan.

1929
Appointed to the National Monuments Committee by President Calvin Coolidge.

1933
Appointed to the first Los Angeles Housing Commission by Mayor Frank Shaw; serves until 1941.

1936-54
Serves as a director of the Metropolitan Los Angeles YMCA.

1936
Licensed to practice in Washington, D.C.

1938
Receives Citizens of Los Angeles award.

1939
Wins Award of Merit, Southern California Chapter AIA, for Music Corporation of America Building (MCA).

1940-45
Appointed by President Franklin D. Roosevelt to the State Selective Service Board.

1941
Receives honorary Doctor of Science degree from Lincoln University, Missouri.

Wins National Award from Omega Psi Phi.

Opens office in Bogota, Columbia.

C. 1942
Serves as an architect for the U.S. Navy during World War II.

1945
Wins Distinguished Service Award from the U.S. Treasury Department, War Finance Program.

Serves as re-employment committeeman for State Selective Service.

Publishes first book, *The Small Home of Tomorrow*.

1946
Publishes second book, *New Homes for Today*.

1947
Helps found and serves as vice president and director of Broadway Federal Savings and Loan, the oldest federal African American savings and loan west of the Mississippi. After retirement, and until his death, acts as director emeritus.

Selected to design three-million-dollar Psychopathic Unit of the Los Angeles County Hospital; it is the first time an African American has been chosen to design a large public building in Los Angeles.

1947–49
Appointed to the California Redevelopment Commission by Governor Earl Warren.

1948
Receives Veterans of Foreign Wars Award of Merit, Civil Architecture.

Licensed to practice in New York.

1949–55
Appointed by Warren to the California Housing Commission.

1951
Receives Distinguished Service Award from the National Conference of Christians and Jews, Builders and Trades Committee.

C. 1951
Moves offices to 3757 Wilshire Boulevard.

Designs his dream home, in Los Angeles.

1952
Receives honorary Doctor of Architecture degree from Howard University, Washington, D.C.; degree is presented by President Harry Truman.

Acts as delegate to the Republican National Convention.

1953
Appointed to the National Housing Commission by President Dwight D. Eisenhower.

Receives NAACP Spingarn Medal.

Appointed to twenty-member Advisory Committee on Government Housing Policies and Programs by President Eisenhower.

1953–65
Serves on the Municipal Art Commission; serves as president for eleven years.

1954
Serves as chairman, AIA Competitions Committee.

1955
Appointed to Special Study Commission on California Correctional Facilities and Services by Governor Goodwin Knight.

Serves on AIA Materials Research Committee.

1956
Receives honorary Doctor of Fine Arts degree from Tuskegee Institute.

1957
Elected to the AIA College of Fellows, becoming the first African American Fellow.

Receives Los Angeles Chamber of Commerce Award for Creative Planning.

1960
Licensed to practice in Tennessee.

Serves as delegate to the Republican National Convention.

c. 1960
Serves as president of the Advisory Committee of the State of
California, U.S. Commission on Civil Rights.

1961
His portrait is presented to Howard University on the fiftieth
anniversary of the founding of the School of Engineering and
Architecture. In association with Hilyard Robinson, Williams
had designed the new Engineering and Architecture building.

1962
Receives Institute Mexicano Silver Award.

1963
Is a Fellow of the Chicago Defender Roundtable.

1964
Receives honorary Doctor of Fine Arts degree, Atlanta
University.

Licensed to practice in Nevada.

1965
Receives National Society of Interior Designers Design Award.

1966
Receives University of Southern California Alumni Merit
Award.

1973
Retires from architectural practice.

Receives a commendation form the AIA Los Angeles Chapter.

Receives Minority Architects and Planners Award.

Receives various state, county, and city commendations.

1977
Awarded City Council Commendation for Artistic
Contributions to Los Angeles.

1980
Paul R. Williams dies on January 23 in Los Angeles.

2000
Receives, posthumously, with Della Givens Williams, Triangle
of Service Award (Community-Collaboration-Education) from
Southeast Regional African American Preservation Alliance.

2004
Receives, posthumously, Lifetime Achievement Award, Los
Angeles Chamber of Commerce, Building Industry Awards.

2008
Receives, posthumously, The Donald Trump Award, Beverly
Hills Greater Los Angeles Association of Realtors.

2017
Posthumously awarded the American Institute of Architects
(AIA) Gold Medal, its highest honor, becoming the first
African American to be so honored.

MEMBERSHIPS AND AFFILIATIONS

PROFESSIONAL
Consulting Architect, Bank of America,
 Southern California Division
Consulting Architect, Fisk University, Nashville
Feature Editor, AIA Bulletin
Member, AIA Civic Development Committee
Member, California Council of Architects
Member-Lecturer, National Technical Association

EDUCATIONAL
Trustee, Howard University, Washington, D.C.
Trustee, Meharry Medical School, Nashville

POLITICAL
Occupation Director, WIN with Nixon-Lodge Program
Member, Nelson Rockefeller Election Committee
Member, Republican Community Service Center

COMMUNITY
Director, Big Brothers of Greater Los Angeles
Director, Red Cross, Los Angeles Chapter
Director, Southern California Heart Association
Treasurer, Southwest March of Dimes Foundation
Director, Travelers Aid Society, Los Angeles Area
Director, United Service Organizations

BUSINESS
Director, American City Bank
Chairman, International Opportunity Insurance Company

SOCIAL-FRATERNAL
Member, Omega Psi Phi
Member, Xi Boulé Chapter
President, Member, Pacific Town Club
33rd Degree Mason, Masonic Order
Life Member, NAACP
Member, Los Angeles Urban League

Selected Bibliography

Paul R. Williams's autobiographical notes, unpublished speeches, and other writings may be found in the Paul R. Williams Collection in Los Angeles.

WRITINGS BY PAUL R. WILLIAMS

"I Am a Negro." *American Magazine*, July, 1937.

"An Architect's Approach to Planning." Unpublished speech, University of Southern California, Los Angeles, June 13, 1939.

The Small Home of Tomorrow. Hollywood: Murray & Gee, 1945.

New Homes for Today. Hollywood: Murray & Gee, 1946.

"An Architect Previews Tomorrow's Progress." Distinguished Service Award of Scottish Rite Mason of the Year speech, Oakland, California, October 1956. Transcript, *The Scottish Rite Informer*, January–March, 1957.

"The Influence of Planning on Man's Destiny." Unpublished speech, Mexico City, October 25, 1962.

"If I Were Young Today." *Ebony*, August, 1963.

"Blacks Who Overcame the Odds." *Ebony*, November 1986.

WRITINGS ABOUT PAUL R. WILLIAMS

Adams, Michael. "A Legacy of Shadows." *Progressive Architecture*, February 1991, 85–87. Discussion of nine African American architects in the late nineteenth and early twentieth centuries.

"Ambassador Plans Top $5,000,000." *Los Angeles Times*, June 12, 1949, V1.

Angelenos—Then and Now. Los Angeles Unified School District, 1966.

Architect and Engineer *features Williams's work in several issues (see articles cited by author or title):*
Plans for Jay Paley residence: December 1936, 3; March 1946, 18–19.
Plans for W. & J. Sloane department store: March 1951.

"Architect for the John T. Kelly, Jr., Building, Westwood Village." *Architect & Engineer*, August 1930, 39.

"An Architect's High Style in Home-Life." *Los Angeles Times*, February 28, 1987, V5–6.

Architectural Digest *features Williams's work in several issues; many issues from the 1930s through the early 1960s are undated (see also articles cited by author or title):*
Walter S. Bachman residence, Los Angeles; L. E. Lockart residence, Pasadena; Miss Fanchon Beerup residence, Beverly Hills: AD 7, no. 4 (1930).
Jack P. Atkin residence, Pasadena; Fred A. Price residence, Bel Air Bay: AD 8, no. 1 (1930).
Steel House, California House and Garden Exhibition; French House, California House and Garden Exhibition; William Collins residence, Hancock Park; Bel Air home; Henry Isaacs residence, Beverly Hills; Seth Hart residence, Beverly Hills: AD 9, no. 3.

Jay Paley residence, Bel Air; O. B. Howd residence, Beverly
 Hills; Hart Isaacs residence, Holmby Hills: AD 9, no. 4.
Charles Correll residence, Holmby Hills; Lloyd Bacon
 residence, Toluca Lake; Richard Arlen ranch, Northridge;
 Gladys Lehman residence, Toluca Lake: AD 10, no. 2.
Tevis Morrow residence, Pacific Palisades: AD 13, no. 3.
Louis Kelton residence, Beverly Hills: AD 15, no. 1.
Dave Chasen residence, Los Angeles: AD 15, no. 2.
R. P. Gildred residence, Beverly Hills: AD 16, no. 4.

Architectural Forum 65, no. 1. (1936)

Architecture, March 1980, 114. Obituary.

"Around the Foothills—The Worth of an Architect." *Los Angeles
Times*, March 8, 1990, J2.

Arts and Architecture 64, no. 4 (1947).

Bates, Karen Grigsby. "He Was (and Is) the Architect to the
Stars." *New York Times*, July 26, 1990.

Bell, Ervin J. *The Architectural Index for 1953*. Chicago:
The Architectural Index, 1954.

"Black Architects and Craftsmen." *Black World*, May 1974, 4.

Boich, Bob. "A Man with $100,000 Ideas." *Los Angeles Times*,
April 19, 1964.

Brawley, Benjamin. *The Negro Genius*. New York: Biblo &
Tannen, 1966.

"Buildings for the San Bernardino Fair." *The Sun Telegram*,
August 1, 1965, C3.

"Chamber of Commerce Raise L.A. Sights for Future."
Los Angeles Herald & Express, July 24, 1957.

"Colleagues Honor Paul R. Williams." *Los Angeles Times*,
May 27, 1973, VIII2.

"Construction Plans for Courthouse." *Los Angeles Times*,
April 17, 1955, V1.

"Designs for Living." *Ebony*, February, 1946, 25.

Drotning, Phillip T. *A Guide to Black History*. New York:
McGraw-Hill, 1970.

Duncan, Ray. "Paul Williams Tells How to Build a Home for
Less Than $5,000." *Ebony*, March, 1949, 42.

"Fairyland in the Forest." *Los Angeles Times Home Magazine*,
August 22, 1948, 3-4. "Hamiltair," Thomas Hamilton estate,
Arrowhead Springs.

"The Family Keeps Changing, but the Design Remains."
Los Angeles Herald-Examiner, California Living, April 11, 1976,
28–29. Pi Beta Phi sorority, University of Southern California.

"Farewell to a Mansion." *Los Angeles Herald-Examiner*, June 18,
1962, D1. Farewell party for E. L. Cord residence, Beverly Hills.

"Five Men & a New Look for Los Angeles." *Los Angeles
Herald-Examiner*, September 18, 1963, 5. Includes Williams's
comments on Los Angeles's architectural future.

Gebhard, David, and Harriette von Breton. *L.A. in the Thirties 1931-1941*. Salt Lake City: Peregine Smith, 1975.

Gebhard, David, and Robert Winter. *A Guide to Architecture in Los Angeles and Southern California*. Salt Lake City: Peregrine Smith, 1977.

"Historic Mansion Destroyed." *PreserveLA.com*, October 10, 2005.

Hudson, Karen E. *Paul R. Williams, Architect: A Legacy of Style*. New York: Rizzoli International Publications, 1993.

Hudson, Karen E. *The Will and the Way: Paul R. Williams, Architect*. New York: Rizzoli International Publications, 1994.

"Interiors by Paul R. Williams." *Pittsburgh Courier*, May 4, 1940.

Kanner, Diane. "He Would Overcome, Remembering Architect Paul Williams." *Discover Hollywood Magazine*, Winter Issue, 2010-2011.

Kelly, David. "Paul Revere Williams, A Legend in Architecture." Documentary is discussed, *Inside California State University at Long Beach*, vol. 59, no. 8, August 2007.

Kennard, Robert. L.A. Architect, March 1980. Obituary.

Koyl, George S. *American Architects Directory*. New York: R. R. Bowker, 1955.

"Large Hospital Plans Advance Toward Finish." *Los Angeles Times*, January 24, 1954, 1-2. Los Angeles County General Hospital.

Leipold, J. Edmond. *Famous American Architects*. Minneapolis: T. S. Denison & Co., 1972.

Libman, Gary. "Architect's Legacy Lives on in Lafayette Square." *Los Angeles Times*, January 13, 1985.

"Litton Announces Plan for Showcase Building and Mall on Present Site." *Beverly Hills Courier*, March 17, 1967.

The Los Angeles Times *discusses Williams and his work in numerous articles (see also articles cited by author or title):*
Ensenada resort: June 5, 1927, V9.
Exhibition featuring designs of new houses, July 28, 1929, V12
Appointment to board for Negro memorial: December 1, 1929, II2.

"Men of the Month." *The Crisis*, June 1917, 82-84.

"New Building Planned by Home Furnishers." *Los Angeles Times*, July 12, 1948, V1. W. & J. Sloane department store, Beverly Hills.

"New Major Building Set." *Los Angeles Times*, August 30, 1953, V.

"Opportunities for the Negro Architect." *Negro History Bulletin*, April 1940, 104.

"Pasadena Showcase Home—160 San Rafael." *Designer's West*, September 1985.

"Paul R. Williams, Famous Designer of Mansions, Public Buildings, Dies." *Jet Magazine*, February 14, 1980, 55-56.

"Paul R. Williams—A Project in Imagination." *Designer's West*, September 1967, 35.

"Paul Williams." *Architectural Forum*, April 1949, 140.

"Paul Williams." *California Arts and Architecture*, November 1942, 51.

"Paul Williams." *California Arts and Architecture*, April 1947, 32.

"Paul Williams." *House Beautiful*, June 1946, 62.

"Paul Williams Builds His Dream Home." *Ebony*, September 1953.

"Paul Williams Builds Homes of Movie Stars." *The Panama Tribune*, May 21, 1944, I, 4.

"Paul Williams Gets Spingarn Medal." *Chicago Defender*, May 29, 1953, I.

"Paul Williams Honored at Homes Tour." *The Historical Observer*, Windsor Square-Hancock Park Historical Society, Spring 1977.

"Plans for Lon Chaney Residence." *West Coast Builder*, August 1930, 9.

"Plans Submitted for Huge Customs House, Office Unit in Civic Center." *Los Angeles Times*, November 27, 1960.

Ploski, Harry A., and James Williams. *The Negro Almanac: A Reference Work on the African American*. 5th edition. Detroit: Gale Research, 1989.

Progressive Architecture, March 1980, 56. Obituary.

Puente, Maria. "Paul R. Williams Built on Black History." *USA Today*, March 11, 2004.

"Recent Work of Paul R. Williams, Architect." *Architect and Engineer*, June 1940, 19–30.

"Required Reading." Review of *The Small Home of Tomorrow*, by Paul R. Williams, *Architectural Record*, July 1945, 126.

"Required Reading—Houses to Build." Review of *New Homes for Today*, by Paul R. Williams. *Architectural Record*, June 1946, 26.

Rivers, Lynda. "Historic La Cañada Home Chosen as 2011 Pasadena Showcase House of the Arts." *La Cañada Flintridge Patch*, February 8, 2011.

Ryon, Ruth. "A Forgotten Black Architect Who Designed Mansions for Movie Stars." *Los Angeles Times*, July 23, 1989.

———. "Kin of Black Architect Get More Data for Book." *Los Angeles Times*, October 1, 1989. VIII14.

Savoy, Maggie. "Fifty Years of Home Design." *Los Angeles Times*, October 11, 1970, K.

Schmidt, Mary Louise. "Exhibition House Group." *Architectural Forum*, July 1936, 37-46. Houses from California House and Garden Exhibition.

"$6,500,000 Luxury Apartment-Hotel To Go." *Los Angeles Examiner*, August 30, 1953, C4.

Southwest Builder & Contractor *features Williams and his work in numerous issues:*
Receipt of certificate to practice architecture in California: June 10, 1921, II.
Appointment to Los Angeles City Planning Council: August 19, 1921, 12.
Dacotah Street School, Los Angeles: July 3, 1926, I.

"Spingarn Medal Winner 1953." *Sepia*, September 1953, 35.

"Tennis Club." *Arts & Architecture*, April 1947, 32-33. Palm Springs Tennis Club.

"Terminal Island Site of Center." *Los Angeles Times*, August 25, 1963, J2.

"33 Designers Invade a Mansion." *Los Angeles Times Home Magazine*, October 11, 1970. 1970 Design House West, Beverly Hills.

"Three Angelenos Put on New GOP Group." *New York Times*, March 13, 1959.

Time, January 1, 1964, 19.

Town and Country, April 1959, 74-75. Dave Chasen residence.

"Traditional Setting for Active Young Family Living." *Architectural Digest*, Fall 1968, 72-83. Barron Hilton's Beverly Hills residence, originally built for Jay Paley.

Treanor, Tom. "The Home Front." *Los Angeles Times*, April 14, 1941, 2. Plans for Nutibara Hotel in Medellín, Columbia.

"12-Story Medical Center Framework Completed." *Los Angeles Times*, May 19, 1961, J6. Linde Medical Plaza.

"View of the Jay Paley Residence." *Saturday Night*, November 20, 1937, 22-23.

Waggoner, Walter H. "Paul Williams Dies: Architect on Coast." *New York Times*, January 26, 1980.

Webb, Michael. "Architects to the Stars." *Architectural Digest*, April 1990, 36-48. Williams and three other Hollywood architects.

"Williams Alters Southland's Face." *Los Angeles Mirror*, August 1, 1961, III.

"Williams the Conquerer." *University of Southern California Trojan Family Magazine*, Spring 2004.

Williford, Stanley O. "Early American Black Architect, 85, Dead." *Los Angeles Times*, January 28, 1980.

Wormley, Stanley L., and Louis H. Federson, eds. *Many Shades of Black*. New York: William Morrow, 1969.

ADDITIONAL RESOURCES

www.paulrwilliamsarchitect.com

www.paulrwilliamsproject.org

Acknowledgments

I CAN'T BELIEVE it has been more than thirty years since the passing of my grandfather. It seems like just yesterday that I sat at his funeral listening to Danny Thomas give his eulogy, thanking him for designing St. Jude Children's Hospital in Memphis free of charge. I remember that as the exact moment when I realized just how many lives my grandfather had touched, and how very little I knew about his professional life. Thus began my journey to chronicle his life and work. I made a promise to my grandmother Della that I would do whatever I could to preserve his legacy, encourage others to follow in his footsteps as an architect, and hopefully inspire young people to use their imagination. My grandfather had wanted to write a book himself until illness robbed him of his eyesight and the project was shelved. Just as I did with the first book, *A Legacy of Style*, I relied on the articles and notes that were so precious to him. But this time I looked at the boxes and boxes of information that framed his life with a different eye. Years ago I could never have imagined I would be going into homes today and see the first book I wrote on people's coffee tables. Granted, I wanted to write these books to have a written record of his life's work that would withstand fires and miscellaneous loss—but I still couldn't see further than four or five years out. With more than three thousand projects worldwide, I knew the book just scratched the surface, but it was more than existed before. I mistakenly believed I had completed all of the research on his work, but as the journey continued, following the publication of the first book, each step brought new and exciting information. Scholars and university students had begun to study his work, and African American historians showed renewed interest in his life and contributions to the community. The rich mosaic that comprised his life was becoming richer each and every day. And just as these houses' original owners had become co-creators with PRW, as he encouraged them to take an active part in expressing their

wishes for their dream home, homeowners who have occupied PRW homes throughout the years have become co-authors in telling his story. I could not have completed this project without the help of realtors, designers, friends, old and new—but most of all the homeowners who had been fortunate enough to have lived in the quiet elegance of his residential designs: Serena and Gary Duff, Amy and Craig Nickoloff, Merle and Peter Mullin, Carol Goodson and Larry Berkowitz, Gina and Rod Guerra, John and Cheryl Sweeney, Bruce Hatton and Tom Young, Margaret and Philip Hess, Stephen Rose and Rob Johnson, Steve Tisch, Michele and Arlen Andelson, Barron and Rick Hilton, Natalie and Jeff Haines, Ann Ascher, Laurie and Mark Cohen, Vana and Bob Farina, Margaret Black-Scott and David Scott, Yuko and Guy Attal, Lisa and Alex Sandel, and Michael Rabkin and Chip Tom. Thanks also to Lynne and Oz Scott, Bret Parsons, Jeff Hyland, Craig Wright, Richard Stanley, and Douglas Woods.

For those who lent their voices, your perspective adds a unique texture to the blossoming mosaic. Heartfelt thanks to Pauletta Washington, LaTanya R. Jackson, Jimmy Fallon, Joan Rivers, Winifred Y. Smith, Kate Edelman Johnson, Camille and Bill Cosby, and Quincy Jones Jr.

Thanks also to my doctors and their staffs who keep me healthy enough to carry on with the project: Amanuel Sima, MD, William Chow, MD, and Richard Gould, MD.

Special thanks to my editors at Rizzoli—who have believed in Paul Williams since the beginning—David Morton, Douglas Curran, and Ron Broadhurst.

To Benny Chan, whose photographs grace these pages—you accepted the challenge and exceeded my wildest imagination.

As always, I thank my family—Marilyn, Elbert, Paul, and Don for always being there for me on this path.

The journey continues.

First published in the United States of America in 2021 by
Rizzoli International Publications, Inc.
300 Park Avenue South
New York, NY 10010
www.rizzoliusa.com

This is a revised and updated edition of the work first
published in 2012 by Rizzoli International Pubications, Inc.

ISBN: 978-0-8478-3847-9
LCCN: 2011944851

Distributed to the U.S. trade by Random House, New York

Designed by Hahn Smith, Toronto

Typeset by Nancy Sylbert

Printed in Hong Kong

2021 2022 2023 2024 2025 / 10 9 8 7 6 5 4 3